SCALED FOR SUCCESS

Dedicated to Alison and to our year in Fairlight.

SCALED FOR SUCCESS

The Internationalisation of the Mermaid

Principally authored and edited by
Philip Hayward

with
Persephone Braham
Nettrice R. Gaskins
Sarah Keith
Sung-Ae Lee
Lisa Milner
Manal Shalaby
Pan Wang

British Library Cataloguing in Publication Data

Scaled for Success
The Internationalisation of the Mermaid

A catalogue entry for this book is available from the British Library

ISBN: 0 86196 732 2 (Paperback)

ISBN: 0 86196 948 7 (ebook-MOBI)
ISBN: 0 86196 951 7 (ebook-EPUB)
ISBN: 0 86196 952 4 (ebook-EPDF)

Published by
John Libbey Publishing Ltd, 205 Crescent Road, East Barnet, Herts EN4 8SB,
United Kingdom e-mail: john.libbey@orange.fr; web site: www.johnlibbey.com

Distributed Worldwide by
Indiana University Press, Herman B Wells Library—350, 1320 E. 10th St., Bloomington,
IN 47405, USA. www.iupress.indiana.edu

Contents

 Mermaids in Australian public culture
 Philip Hayward 171

Chapter 10 Mama Wata Remixed: The Mermaid in
 Contemporary African-American Culture
 Nettrice R. Gaskins 195

Chapter 11 Shoreline Revels: Perversity, Polyvalence and Exhibitionism
 at Coney Island's Mermaid Parade
 Philip Hayward and Lisa Milner 209

 Bibliography 227

 Chronological catalogue of audiovisual productions
 featuring mermaids and mermen referenced in the volume 241

 Index 245

Acknowledgements

Thanks to John Libbey for giving the go-ahead for this volume hot on the heels of its predecessor – *Making a Splash: Mermaids (and Mermen) in 20ᵗʰ and 21ˢᵗ Century Audiovisual Media* – published in April 2017. Thanks also to Adam Grydehøj for organising the Mermaids, Maritime Folklore and Modernity conference in Copenhagen in October 2017, which connected me to some of the authors who have contributed to this volume.

I am grateful to the State Library of New South Wales and the University of Technology Sydney library for their efficiency and to the staff of Manly and Waverley public library local history sections for their positive and proactive support. Thanks to Alison Rahn for various assistances, to Hannah Murphy for diligent proofing, to Lucy Guenot for the front cover design and to Isis Blue Fire for permission to reproduce her mermaid cosplay image on the cover.

My parents – Ruth and Roy – were, as ever, intrigued by and enthusiastic about my latest publication project. I trust they find it of interest.

Note: Every effort has been made to identify the original sources and obtain necessary permissions to reproduce photographic material used in this volume. Any inquiries on matters related to this should be addressed to the author.

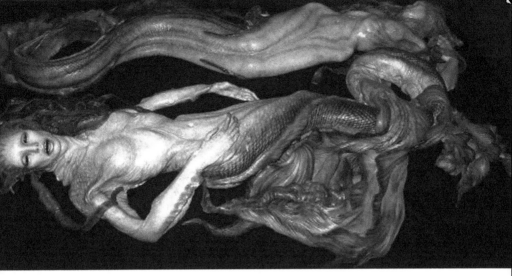

Figure 1

Introduction

The Mermaid Abroad

Philip Hayward

August 2014 - Nkandla, South Africa. Following sustained criticism for misappropriating 246 million rand to improve his private residence, President Jacob Zuma's reputation was further tarnished by reports that he had used witchcraft against his opponents during the Apartheid era.[1] Another, even more sensational, story appeared soon after. Combining the opulence theme of the former and the supernatural theme of the latter, a report alleged that he had kept two mermaids in his private swimming pool in order to use their magical power to his advantage (Nchee 2014). The story was accompanied by a photo purporting to depict the corpses of the mermaids in question, supposedly found after a fire at his residence (Figure 1, above). While there are some folkloric accounts of mermaid-like creatures in South Africa,[2] the figures in the photo were more akin to Western examples of the species and, more precisely, to a number of recent cinematic representations of them. This was unsurprising, given that the photo actually showed two mermaids made as props for the Hollywood film Pirates of the Caribbean: On Stranger Tides *(Rob Marshall, 2011).[3] While the accusation that Zuma had used mermaid power was greeted with considerable scepticism in South Africa, it illustrates the extent to which contemporary cinema and television have established the mermaid as a figure that can be inserted into*

1

various national discourses and contexts.[4] *As this Introduction – and the volume as a whole – demonstrates, the nature of such insertions is multifaceted and its outcomes are varied.*

<p style="text-align:center">★ ★ ★</p>

Over the last two centuries the mermaid has become increasingly standardised in Western culture, with a form that comprises the upper half of a (usually young and attractive) female human and the lower half of a fish. This volume analyses the introduction of this figure (and, to markedly a lesser extent, her male counterpart, the merman) into a range of non-European cultures and the various patterns of diffusion, syncretisation and/or innovation that have occurred. Individual chapters contextualise these processes with regard to local traditions that existed prior to the introduction of Western mermaids that have been variously complementary to and/or overlaid by the new figure. Reflecting this, individual chapters address:

- **Transnational cultural spaces,** such as India and Thailand (which are considered together as a result of the influence of Hindu mythology upon their cultures), the Middle East (with its shared Islamic heritage) and the Hispanic cultural sphere of Latin America.

- **Individual countries,** such as Australia, China, Indonesia, Japan, South Korea and The Philippines.

- **Subsets of national cultures** – in the form of two chapters addressing aspects of United States (US) culture – the nature of mermaid/Mami Wata imagery in contemporary African American culture and the development of Coney Island's mermaid parades.[5]

The temporal bases of the case studies vary from those that encompass extended historical periods, through to more specifically contemporary ones (such as Coney Island's mermaid parades, which commenced in 1983). This variety facilitates discussion of processes of adoption, syncretisation and/or innovation that both precede and include the advent of 20th Century audiovisual mass media and their global reach.

The case studies presented in this volume reflect the highly specific brief that I gave to contributing authors. It should be acknowledged from the outset that inflexible taxonomies of mythical, folkloric and/or media-loric entities are in themselves problematic,[6] let alone taxonomies that attempt to compare figures from different cultural contexts. In this regard, this volume's focus on mermaid-themed imagery has required that its authors approach their material through this lens. In various cases, this has led to what might (in another instance) be considered as somewhat arbitrary extractions of particular aspects of complex mythological/folkloric systems. To that end, such issues are flagged as clearly as possible when they arise.

This project was conceived in tandem with that of my previous publication, *Making a Splash* (2017a), in which I identified that cinema, television and online video have provided a major platform for the representations of mermaids in Western culture. In the Introduction to that volume I made the case that a particular set of psychoanalytic paradigms are particularly illuminating for the understanding and analysis of mermaids (and mermen) in Western cultures, the 'symbolic charge' they carry and the polyvalence they exhibit. This focus arose from and was apparent within a wide range of the material

surveyed in the earlier volume, much of which addressed aspects of sexuality and sexual perception. Before proceeding, it is useful to return to and summarise these aspects.

In Cultural Studies at least, polyvalency refers to the potential for multiple associations and combinations of elements to accrue to a text and/or a cultural entity. There is also a complementary aspect that has been articulated in postcolonial discourse with regard to the multiple identities and identity affiliations available to human subjects in different (and often overlapping) contexts. Mermaids (and mermen) may be considered to be polyvalent in a number of ways, all of which are premised on the symbolic aspect of their physical forms. Often mischaracterised as hybrids, mermaids (and mermen) are *anything but* coherent entities resulting from the *blending* of heterogeneous elements. In physical terms they conjoin two pre-existent entities (i.e. humans and fish) around a transitional midpoint and require considerable suspension of belief to accept their coherence and viability. The linguistic portmanteaus used to describe them in English language combine highly specific characterisations of their female and male forms (i.e. 'maid' and 'man') together with a more general term, 'mer', to indicate their aquatic element. The close association of the terms 'mermaid' and 'merman' with fish-tailed, demi-human creatures is therefore culturally (rather than linguistically) determined. In any case, it is the mermaid's distinct appearance and related associations that have proved highly portable across cultures, resulting in her relatively standard form being referred to by a wide range of previously constituted terms and/or modifications of these in non-European languages.[7]

Mermaids' (and mermen's) polyvalence also has another distinct aspect. Particularly in the former case, the mermaid's distinct physique allows her to manifest diverse and often disjunctive aspects. This derives from the crucial point that she demonstrably lacks anything like human (or any other) genitalia and, instead, from waist down has a smooth, sheath-like (and usually scaled) tail. But while this part of her anatomy may cause ambiguity as to her gender, her upper body compensates for this by offering a number of clear markers of both gender and of socially prevalent conventions of youthful beauty – presenting her with flowing tresses, bared or barely covered breasts and, often, complementary feminine accessories such as mirrors, combs and/or jewellery of various kinds. In terms of heterosexual and/or lesbian sexual discourse her appearance is thereby a *tease*; what the upper half promises the lower half cannot deliver, so to speak. This provides her with both seductiveness and (genital) inaccessibility in equal measure. This split quality gives her a highly potent polyvalence that has had a continuing appeal for creators and audiences. As I have discussed elsewhere (ibid: 151–166), the mer*man's* similar dualities have proved far less appealing to creators and audiences. Drawing on Freudian discourse, I have contended that the marginal presence of the merman in contemporary Western fiction[8] derives from the inherent demasculinisation that results from his possession of a tail that lacks anything resembling human genitalia. The merman, in Freudian terms, thereby lacks both the (actual) physical phallus and the symbolic counterpart that is rooted in the physical object and defining characteristic of masculinity. By contrast, not only does the mermaid's lack of female genitalia *not* diminish her symbolic feminine power (which is strongly retained in her upper body) but the lack is overwritten by the highly phallic nature of her tail. The mermaid's tail is commonly represented as both a powerful limb that gives her considerable propulsion in water and as a lithe and glittering appendage

3

that is attractive in its own right (ibid: 51–73). In Freudian terms the mermaid is thus a phallic female *par excellence* (even before the phallic aspects of her vocality are taken into account; ibid: 75–89). The same creature design can therefore provide us with anything from sweet and innocent individuals to predatory monsters and even, on occasion, alternate between these. But even in the case of the former, the mermaid's otherness is always apparent. This is especially the case with regard to mermaids who have the ability to transform into humans (ibid: 91–128), where their appearance as conventional women is (however charmingly or humorously) both affected and liable to reversion.

The chapters on mermaid imagery and thematics in Australia and on Coney Island that I have contributed to in this volume follow on relatively smoothly from the analyses of popular cultural productions that I developed in *Making a Splash*. Other chapters have more complex relationships to the cultural field and theorisations I offered in the previous study. In the case of the non-Western locations addressed, I and other authors proceed with recognition that the particular psychoanalytic paradigms I drew on in *Making a Splash* were formulated within a highly specific context; that is, the bourgeois milieu of late 19th/early 20th Century Vienna, where Freud and colleagues practiced and, more broadly, Europe and the Eurocentric metropolitan society of North America where psychoanalysis became established and formalised in the 20th Century.[9] There has been a substantial tradition of Asian voices (in particular) that have pointed to just such issues[10] and, in the form of psychoanalyst Girindrasekhar Bose, a highly original theorist who developed a significantly Indianised version of the discipline (including a substantial critique of the Oedipus complex).[11] Appropriately in this regard, none of the authors contributing to the volume attempt to retro-introject Freudian significance and/or motivation into symbols and narratives formed independently of psychoanalysis's Western contexts. However, the research and analysis presented in this volume suggest that the Western mermaid has retained substantial elements of her symbolic charge as she has been inserted into different cultural traditions. This is apparent in various examinations of the mermaid's points of intersection with prior cultural figures. As individual chapters demonstrate, assimilation processes are, in some instances, relatively smooth and tenable and, in others, create various types of dissonance that play out in cultural texts in various ways.[12] To this end, we pay particular attention to the manner in which mermaids are named – or else are referred to by terms coined to signify pre-existent entities – in various locations. As individual chapters detail, these acts of naming are far from incidental, but rather represent attempts to variously comprehend or constrain the imported entity within existing terminologies and perceptual frameworks.

As I also discussed in the Introduction and in various chapters in *Making a Splash*, mermaids and mermen have another set of associations and expressive potentials that derive from their original development within aquapelagic contexts. The latter term refers to locations in which the aquatic spaces between and around areas of land have been fundamental .to social groups' livelihoods, senses of identity and of belonging and, consequently, the cultural figures and patterns that have developed within them (Hayward 2012a, 2012b and Suwa 2012). Drawing on these concepts, it is possible to assert that folkloric and subsequent popular cultural depictions of mermaids and related aquatic entities are manifestations of what might be termed an 'aquapelagic imaginary' that

4

explores the boundaries between marine and terrestrial worlds and experiences in various ways. Given the close – and, as I argue, generative – association between mermaids, maritime and island cultures in their original European context, it is unsurprising that a number of the socio-geographical locations to which the mermaid has been exported to and been depicted and elaborated within have close associations with aquatic spaces. With regard to the scope of locations covered in this volume, three are archipelagic (and, to some degree, aquapelagic) nation-states (Indonesia, Japan and the Philippines) and one is an island (Coney Island). The remainder of locations also have close associations with the liminal zones of their shorelines (such as Thailand, South Korea, China and Australia) or else occur in regions with coastal cultures and major river systems that have spawned complementary riverine mythologies, such as the Middle East (where, as Shalaby elaborates, mermaid imagery is associated with the Nile and Euphrates), South America (with its major river systems) and India (where the Ganges and other major rivers have played a key role in Hindu mythology).

However, while the abovementioned aspects may offer explanations as to the complementary contexts for the insertion of mermaids into non-European cultures, it should be acknowledged that there is little that is aquapelagic about the locales or lifestyles of contemporary Jakarta, Mumbai, Sydney or many of the other locations discussed in this volume. In the latter regard, it is more precisely the combination of residual maritime heritages and the polyvalent sexual-symbolic signification of the mermaid that has given them the ability to be successfully inserted into such contexts. Indeed, given the increased weakening of many traditional connections to marine and riverine livelihood patterns and related cultural beliefs in modern urban contexts, the mermaid may increasingly be perceived to circulate as a self-referential entity. The transformative mermaid exemplifies this. First coming to prominence in Hans Christian Andersen's short story 'Den lille Havrue' (1837) (better known by its English-language title 'The Little Mermaid'),[13] the transformative mermaid's currently popular form originated with the Hollywood film *Splash* (Ron Howard, 1984). Unlike the intense and gruesome process of transformation offered by Andersen (and, with some softening, in Disney's 1989 animated adaptation), *Splash* gave its transformative mermaid character a pain-free transition between mer- and human forms. This approach was taken up as a core element in the two Australian TV series, *H20: Just Add Water* (Jonathan M. Shiff, 2006–2010) and *Mako Mermaids* (Jonathan M. Shiff, 2013–2016), that set the template for a throng of imitative broadcast television and amateur video series that followed them (Hayward 2017a: 129–149). In such contexts the mermaid is largely an alter ego for particular characters with that aspect giving colour, difference and/or quirkiness to those involved (just as aficionados' performance of that role in mermaid videos offers them opportunities to temporarily escape prescribed social roles [ibid]).

While the scope of this volume's case studies is extensive it is far from exhaustive. Although the areas selected for case study are particularly significant for the book's project, there were also a number that had to be omitted due to the restricted length of a single volume. With regard to Asia, Sri Lankan, Cambodian and Malaysian cultures also have cultural traditions that merit attention. Similarly, Brazil has both regional folkloric entities, such as the *Iara*, and modern beliefs in mermaids such as those that feature in the

contemporary Ubanda religion in Rio de Janeiro (Hale 2009). Similarly, while Drewal's two 2008 anthologies have analysed mermaid/Mami Wata imagery and associations in West Africa in considerable depth, the last decade has also seen a significant body of video film material produced in Nigeria and Ghana that merits sustained attention. Consideration must also be given to Persephone Braham, whose single chapter (Chapter 8) on Hispanic America and the Caribbean surveys a wide and diverse region that merits a book in its own regard.

The abundance and continuing development of the mermaid in global popular culture serves to underline the mermaid's importance as an object of study. As befits her form, she swims through a variety of cultural spaces, traversing borders and beaching in a range of locations. On these journeys her symbolic charge remains fundamental to her form and is not so much 'baggage' that can be variously lost or displaced, but rather represents her essence as a cultural figure. In this manner, the extra-European contexts in which she increasingly manifests are just as important as any original folkloric ones in understanding her current cultural form. In media-lore, as in folklore, figures negotiate fluid, evolving contexts – or otherwise decline and recede from view.

Notes

1. See, for instance, Newling (2014: online).

2. A mermaid-like creature, known as the *Kaaiman*, has been reported in the Buffeljags River (see Pekeur 2008). The humans with wing/fin extensions that feature in Klein Karoo rock art have also been identified by some as mermaids (see the South Africa Direct video report *In Search of Mermaids in the Karoo* [2009] and Wheeler [2012] for discussion).

3. These are on permanent display at the Jack Pierce Memorial Gallery at the Los Angeles Cinema Makeup School.

4. Another illustration of this is that the same image also featured in several other video items uploaded to social media platforms purporting to show mermaids in other locations. One, entitled 'Jalpari (Mermaid) Found in Gujarat on 7th March' (uploaded to YouTube in 2015) has, to date, received close to 2 million views. See: https://www.youtube.com/watch?v=2NK24e2vrm8 – accessed September 7th 2017.

5. Also see Hayward (2013) for discussion of a local concentration of mermaid imagery around California's Catalina Island.

6. See Young (2017) for one detailed example of this.

7. See Hayward (2017a: 7–8, 10 and 22–26) for discussion of terms relating to mermaids and mermen in Europe.

8. It should be noted that there are interesting signs that this is changing, with an increased presence of mermen in literary fiction (see, for instance, Aratare [2014] or Elyon [2016]) and with Imagine Entertainment's 2016 announcement of plans for a gender-inverted remake of the film *Splash* (Ron Howard, 1984) that was slated to feature actor Channing Tatum as a merman (but has not as yet eventuated).

9. Also see Moncayo (2012) for a sweeping critique of psychoanalysis's Eurocentrism that draws on Zen Buddhism.

10. See, for instance, Malhotra's (2007) critique of Western scholars such as Wendy Doniger, who have applied Western psychoanalytic perspectives to traditional Sanskrit material.

11. See Rajiv Vaidyanathan and Kripal (eds) (1999), which includes Bose's seminal 1949 critique of the Oedipus complex with regard to Indian culture.

12. With regard to my previous use of Jungian notions of the *anima* – that is, the perception that certain figures represent archetypes of femininity in masculine consciousness and that the mermaid is one such figure (Hayward 2017a: 10–13) – I view this specific characterisation as one that can be more readily considered in other contexts without forcing an over-determination in these terms.

13. See Hayward (2017a: 21–50).

Chapter One

The Middle Eastern Mermaid: Between Myth and Religion

Manal Shalaby

Introduction

While this volume principally addresses the dissemination of Western mermaid imagery and associations across a range of international locations, the region profiled in this chapter, the Middle East,[1] is notable for having compound human-piscine figures *prior to* their earliest recorded appearances in European material, literary and/or folkloric cultures. While no clear linear pattern of dissemination from the Middle East to Europe has yet been established, the presence of such figures is significant in that they originated within a context that was closely networked to ancient Greece – initially through trade connections and then by the expansion of the Greek Empire initiated by Alexander the Great in the 4th Century BCE. There have been various terms used to refer to lower-half fish and upper-half human creatures in the region over the last 2500 years. In Modern Standard Arabic (MSA), the term *khayilaan* denotes a mythical sea monster/beast that is half-human, half-fish (without specification of the gender of the human part). The more common term for mermaid-like figures, which is used both in MSA and in colloquial Arabic, is *hourriyat al-bahr*.[2] The latter term has some resemblance to the English-language term 'mermaid' by virtue of combining a reference to the sea (*al bahr*) with *hourriya*, a term that refers to a woman with an almost supernatural beauty. The mermaid is also referred to in Arabic as *arous al-bahr* or *arusat al-bahr* – a phrase that literally means bride/maid/doll of the sea. In addition to these terms, there are also a number of others that apply to related entities. These include: *al-naddaha* of the Nile Delta region, a dangerous siren, usually fully human in form but able to shape-shift; the giant,

(usually) human-form, carnivorous *aeisha qandesha* of Moroccan folklore; and the seductive *om al-deiwees* of the Persian Gulf. Equivalent male entities, sometimes referred to as *insan al-maa* ('man of the water'), are far less common in regional folklore and mainly manifest in a small group of literary texts. This chapter provides analyses of early representations of *hourriyat al-bahr* and *insan al-maa*, including those present in the *One Thousand and One Nights* (Anonymous nd[3]) compendium of regional folklore, and of more recent representations in contemporary audiovisual media.

I. Mythology and Ancient Regional Culture

Myth has always been an integral component of the cultural heritage of the Middle East and many manifestations have persisted to the present. In Libya, for instance, the coastal city of Zuwarah holds an annual festival called Awessu. Although the contemporary festival is limited to celebrating traditional food and music, and hosting sporting events, the occasion can be traced back to a Berber ceremony in which people purified themselves in seawater and sought the blessings of a male sea deity similar to the Greek god Poseidon. In Egypt, following a Pharaonic tradition of offering sacrifices to the gods at burial places, people still visit cemeteries with offerings – mainly raisin bread or fruits – to be given to the poor and needy in order to solicit Allah's mercy and favour for the deceased. In Iraq, some people celebrate birth as the Sumerians did by attaching pieces of gold to the newborn's clothes in order to fend off evil spirits. In Turkey and other areas, people continue to believe in the *nazar* amulet's ability to ward off the evil eye – a pre-Islamic notion that has roots in many ancient regional civilizations and religions.

These examples serve as proof that the Middle East's adoption of the three largest Abrahamic religions (Judaism, Christianity and Islam) did not entirely divorce regional populations from their rich cultural histories. The myths and religions of ancient regional civilizations have seeped into the practices of these three religions and have been assimilated into the wider cultural identity of the Middle East. However, as much as the surviving traces of ancient beliefs tell us about the strong impact of certain civilizations, they also highlight the Abrahamic religions' politics of integration. While some beliefs were ultimately deemed pagan and rejected, others were implicitly acknowledged and incorporated within the new systems, not only for the purpose of appealing to the region's masses but as part of the power play between the monotheistic religions. All this emphasises the important role of Sumerian, Ancient Egyptian, Assyrian, Persian and other ancient societies in shaping the cultural and religious identity of Middle Easterners. Since mythology constitutes a significant aspect of those past civilizations, it comes as no surprise that these societies' stories and teachings abound with mythical creatures and legendary feats which, albeit reshaped and appropriated over the years, are still observed (sometimes unbeknownst to modern populations) in cultural traditions, folklore and popular art. *Hourriyat al-bahr* and *insan al-maa* exist in this context as figures that have been represented innumerous times in different cultural contexts.

Insan al-maa's most obvious antecedence is with the Babylonian god Oannes, who is mainly known from fragments of writing from the 3^{rd} Century BCE priest Berossus that were summarised by subsequent Greek historians (see Burstein 1978) and a small group of visual representations. Oannes was believed to have resided in the Persian Gulf and to

have emerged periodically to educate men in the arts and sciences. His form was variously represented as that of a fish with human head and feet, or else as a fish-tailed human. Despite the emphasis placed on his role in enhancing Babylonian civilization in Berossus's writings (ibid), his prominence appears to have been relatively brief and the few references to *insan al-maa* in subsequent cultural works do not represent them as educators. The origins of *hourriyat al-bahr* can be traced back to ancient Mesopotamia, where early Sumerians believed in Ninkharsag, the great mother-goddess, also known as Ninlil, the consort of Enlil.[4] Ninkharsag was worshipped as the goddess of fertility and the source of all life, inspiring other mother-goddesses in later civilizations, such as Isis in Ancient Egypt and Atargatis in Assyria. Both Isis and Atargatis had strong associations with water. According to Egyptian mythology, Isis is the mother of Horus and the most powerful goddess whose domain covers nature, wisdom, magic, health, children and, most importantly, fertility. Egyptians believed that the annual bountiful Nile flood was brought about by the tears she shed over her husband and brother Osiris (who was killed by their brother Set to usurp his holy throne), thus associating her with the basic life-giving function of the water (Bunson 2002: 278). Durdin-Robertson identifies that Isis's ability to provide the yearly flood required for irrigation led to her representation in many wall paintings where she is sometimes "seen as the bed of the River Nile, the river itself representing the parturient waters of the goddess" (1975: 290).[5] Moreover, Isis was often depicted in a lactans pose, nursing Horus, which directly links her to her Sumerian predecessor Ninkharsag, who provided milk for all mankind, thereby establishing her as the ultimate nourisher.

The image of Ninkharsag as the great mother and nature goddess manifested itself in Assyria in the form of Atargatis, the goddess of terrestrial and marine fertility (a combination that might explain her hybrid physical form in various ancient representations). Atargatis's connection to the water is stronger than her Egyptian counterpart; not only does she reign over the sea but, according to Syrian mythology, she was born from an egg that the sacred fish of the Euphrates River found and pushed ashore. In addition to her anthropomorphic genealogy, later accounts following the passing of Atargatis worship into Greek and Roman cultures relate how the goddess fell in love with a human shepherd whom – depending on which version is cited – she inadvertently killed during lovemaking or else murdered after bearing his child. Out of guilt and shame, she jumped into the sea near Ashkelon (in Palestine) and (in some versions) acquired the lower body of a fish while maintaining the upper body of a woman (Johnson 1994: 140).[6] Known by the Greeks as Aphrodite Dercelo, she prefigured subsequent stories concerning upper-half human, lower-half fish entities in Greek and Roman mythology and was later the subject of a cult located in the Roman city of Hierapolis, in southern Anatolia, where her shrine was tended by eunuch priests. A significant representation of her in compound form, which dates from the Seleucid (greater Syria) Kingdom during the reign of Demetrius III (c88 BCE) shows the goddess on the rear side of a coin with a fish's body and female human head (Figure 1).

Isis's and Atargatis's abilities to command water – as one of many aspects of nature – comprised a major element of their power. Isis cried floods after her husband and brother died. Atargatis banished herself to the sea because she accidentally ended a human life.

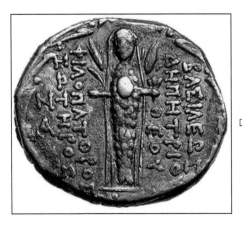

Figure 1 – Coin issued in the Seleucid (greater Syria) Kingdom during the reign of Demetrius III (c88 BCE), showing an image of a fish-like Atargatis on the rear side.

Their responses to calamities become an expression of life and continuity that both myths celebrate. This element is significant in considering one of the most prevalent explanations of origins of the modern-day Wafaa el-Neel (literally 'Fidelity of the Nile') festival, which celebrates the river's fertilising power.[7] In ancient Egypt one element of the event (which is commonly referred to in English as the 'Maid' or 'Bride' of the Nile festival), involves a wooden effigy of a bride being thrown into the river as an offering for a bountiful harvest. As Egyptologist Mustafa Gadallah has noted, each year, in mid-August, ancient Egyptians commemorated the last teardrop shed by Isis by throwing an effigy of her into the Nile to herald the beginning of the flood season and thereby allow her to unite with her soulmate Osiris, symbolised by the River Nile itself (2016: 118–19). Despite this antecedence, the most common explanation of the origins of the current practice that circulated in the West in the late 18th and 19th centuries and that filtered through to Egypt and, to some extent, (mis-)informed national perceptions, was that the current custom was based on a practice of ritual sacrifice of a maiden practiced by ancient Egyptians and then revived by Coptic Christians until being banned after the Muslim conquest of Egypt in the late 7th Century. As discussed by Morgan (2014), this account was derived from a 9th Century Egyptian author and is not corroborated by any other sources. It was, nevertheless, a colourful enough story to inspire German Egyptologist George Ebers to write a florid novel entitled 'Die Nilbraut' ('Bride of the Nile') in 1886 that popularised the myth,[8] with subsequent versions of the tale including a short Italian film adaptation, *La sposa del Nilo* (Enrico Guazzoni, 1911).[9] The effect of this serial reinterpretation was to neglect the likely roots of the practice in an ancient Egyptian ritual that celebrated life in favour of one in which ritual sacrifice was undertaken. The revisionist myth transformed a descendent of the once-powerful female water-deity into a distillation of sexual subjugation and death in the form of a sacrificial virgin. This is emblematic of the shifting cultural politics of the Middle East more generally and parallels interpretations of Isis/Atargatis in representations of *hourriyat al-bahr* in Middle Eastern folklore and art.

In her compound form, Atargatis symbolises the conjunction of two worlds by combining the land and the marine. Both Isis and Atargatis, along with their ancestor Ninkharsag, were idolised for the ability of women's bodies to transform and give life, and their worship celebrated women's interconnectedness with all aspects of nature and Mother Earth in

general. Notably, later retellings and adaptations of the myth in Middle Eastern cultures were influenced by the Greco-Roman variations in their introduction of mermen and in their undermining of the goddess's divinity. One notable example of the latter was provided by Arab historian and explorer Abu al-Hasan al-Mas'udi (896–956 CE), who related tales in which sailors encounter extremely beautiful *banat al-maa* (daughters of the sea) who have fish-like bodies with breasts, long hair and faces like human women. He adds that sightings of *banat al-maa* are not limited to the Mediterranean but also occur in lakes close to the Nile Delta (al-Ahmadi 2005: online). Al-Mas'udi was not the only early Middle Eastern scholar to mention the aquatic humanoids in his writings. In his book *Aja'ib al-Makhluqat wa Ghara'ib al-Mawjudat* ('Wonders of Creatures and Strange Things Existing'), Zakariya al-Qazwini, a Persian Muslim astronomer of Arab descent, describes *insan al-maa* as resembling "a human being with a fishtail":

> *A contemporary once found a mummified merman and put him in display; he looked as previously described and the man who found him said he came from the Mediterranean Sea. Sometimes a merman emerges and stands mid-waist in the water for days. He is referred to as the Old Man of the Sea. Sightings of this creature are greeted with jubilation because they signal fertility. I also heard that one time a living merman was carried as a gift to a king who wanted to understand the strange language of the creature. The king married the merman off to a woman, and she gave birth to a son who spoke the languages of both his parents. He was asked about what his father was saying and the son replied: "He says all animals have their tails on their rears. Why do those people have their tails on their faces!"* (2005: 130-31 – author's translation)

Whereas Al-Mas'udi's tales appear to reflect aspects of Greek mythology in sexualising the female, al-Qazwini's account focuses on the male equivalent and, hence, sidelines women's sacred relation to nature and assigns it to the male who becomes a symbol of wisdom and fertility. The story of the captured *insan al-maa* that al-Qazwini refers to has a substantial affinity to the accounts of merfolk offered in *One Thousand and One Nights* (discussed below) and suggests that after the Middle East's adoption of Abrahamic religions, the celebrated female goddess was systematically 'downgraded' to help consolidate monotheistic and patriarchal cultural paradigms – thereby setting a template for subsequent cultural representations of *hourriyat al-bahr*.

II. One Thousand and One Nights[10]

Alf Leilah wa Leilah (known in English as *One Thousand and One Nights* or *The Arabian Nights*) is a collection of folktales of various types derived from a range of Middle Eastern communities, divorced from their original referential contexts and appropriated into the Islamic culture that flourished throughout the Middle East in the 8th–13th centuries.[11] Sea-dwelling people of various kinds appear in *One Thousand and One Nights* in three different stories, known in English as 'Julnar the Sea-Born', The Adventures of Buluqiya' and 'Abdullah the Fisherman and Abdullah the Merman'. 'The first story refers to a silent (fully human-form) concubine whom the king falls in love with and marries only to discover that she belongs to the sea. The tale then quickly shifts to recounting the adventures of their son Badr Basim. In 'The Adventures of Buluqiya', *merfolk* make a fleeting appearance as the protagonist encounters a community of half-human, half-fish creatures on his journeys. The third story provides a more sustained exploration of merfolk

and their relationship to and differences from terrestrial humans. The story concerns a fisherman named Abdullah and an oceanic counterpart also named Abdullah and explores the mutually beneficial friendship that grows between them. The first Abdullah, an extremely poor fisherman, struggles to provide for his large family – a wife and ten children, including a newborn – after he fails to catch fish for several days. On his way home one afternoon, a kind baker gives the fisherman a considerable amount of bread to feed his family and refuses the fisherman's offer to pawn his net to pay for it. The baker's generosity continues for 40 days during which the fisherman fails to catch any fish to pay off his increasing debt. On the 41st day, he catches a merman (literally a man who is *baharyy*; that is, associated with the sea) whom he initially misrecognises as one of King Solomon's *ifrits* (powerful, elemental creatures mentioned in the Qur'an). The creature introduces himself as a mortal believer in Allah and asks the fisherman to free him from the net if he wants Allah to reward him. Abdullah the fisherman does, and a friendship blossoms between the two, with them talking about their shared faith and exchanging the land's most delicious fruits for the sea's most precious gems and pearls. The fisherman's life begins to prosper. He pays off his debts to the baker and provides his family with all they need. The King hears of Abdullah the fisherman and his exotic friend, appoints the former as a *wazir* (a high-ranking official) and allows him to marry his daughter. One day, while the two are talking about the holy pilgrimage to Mecca, Abdullah the merman asks Abdullah the human to accompany him to his undersea home so that he can give him a pledge to deliver to the prophet Muhammed's tomb. The merman gives the fisherman a special ointment to help him breathe underwater, and on his trip the fisherman encounters a community of merfolk who look different, wear no clothes and eat raw fish.

The highly religious tone of the tale is established from the outset. While the terrestrial Abdullah (which literally means 'the servant of Allah' in Arabic) is a devout Muslim, he faces a crisis of faith after his failed attempts to catch fish and feed his children. Broken-spirited, he wonders to himself: "Hath Allah then created this new-born child without sufficient provision? This may never, never be" (Unattributed, nd: 166). His wife dissuades him from discarding his net by reassuring him that Allah is most merciful. The appearance of the merman becomes the answer to their prayers and the reward for their patience, alluding to the religious belief that good is rewarded with good. In addition to indicating that Allah's rule extends over land and sea, the religiosity of the tale alleviates the exotic effect of its elements. Appearing for the first time, Abdullah the merman introduces himself in the following terms:

> I am a human like thyself ... I am a mortal and a believer in Allah and His Apostle ... I am of the children of the sea, and was going about therein, when you thou castest the net over me. We are people who obey Allah's commandments and show loving kindness unto the creatures of the Almighty, and but that I fear and dread to be of the disobedient, I had torn thy net; but I accept that which the Lord hath decreed unto me. (ibid: 170)

Regardless of their obvious differences, the two males are brought together by their shared faith as Abdullah the merman announces his belief in Allah and his total submission to Allah's destiny – one of the fundamental pillars of Islam.

However, this state of co-existence does not last long as the two friends part due to

irreconcilable differences concerning their faith. If the first part of the story establishes the ideal Muslim world, then the second undermines it because of the limitations of its members (Sallis 1999: 130). The two Abdullahs have a fundamental disagreement over a seemingly insignificant matter relating to how funerals should be held. Whereas in the fisherman's world funerals are considered sorrowful occasions, they are the cause for celebration in the merfolk's world. This difference – more than any more blatant manifestation of exoticism the fisherman witnesses in the merman's world – causes an irresolvable tension. The fisherman marvels at the merfolk, who live in self-sustaining communities and swim around naked, with the females having long flowing hair and faces like the moon. On the other hand, the merfolk make fun of the fisherman and call him 'no-tail' for having legs instead of a fishtail. In the end, the two friends choose to ignore the rich diversity each world offers the other and fall short of assimilating each other's otherness. The exotic merman in the story indicates the opportunities for co-existence that Abdullah the fisherman's and Abdullah the merman's shared religion has facilitated but is undermined by their innate limitations. This corresponds to the Muslim belief that man is incorrigibly lacking in his understanding and practice of the impeccable faith and, thus, needs constant discipline.

On a deeper level, the presence of Abdullah the merman may represent a reflection of the Self or, in Muslim terms, a *qareen*. In Islam, the *qareen* (which translates to 'a close companion' in Arabic) is a double who either lives inside the human or in a parallel underworld. Despite the common belief that the *qareen* is an evil demon that instigates the disobedience of Allah, it can also be an angel who encourages his/her human companion to do good deeds. Aside from strict religious denotations, in recent popular culture the *qareen* has come to represent an alter ego, or a reflective image of the Self. This explains why the tale's two protagonists share the same name, the same gender and the same living conditions and exist in parallel worlds. As previously mentioned, 'Abdullah the Fisherman and Abdullah the Merman' begins with Abdullah undergoing a crisis of faith in which he struggles to understand the divine wisdom behind his impoverished conditions. We are then introduced to his marine double who represents full submission to Allah's will. The two Abdullahs, though physically separate, personify the two sides of the archetypal Abdullah's self-conflict. After Allah changes Abdullah's misfortune to prosperity he experiences a phase of reconciliation with his *qareen*, indicating a temporary appeasement of the self-struggle which soon afterwards resurfaces with the first signs of change. The exoticism of the merman then reflects the depth of the human psyche, which, if explored, would either bring man closer to himself or further distance him from himself like two forces or elements pulling in opposite directions. This brings us back to Atargatis, who achieves reconciliation through combining the two elements – something that Abdullah, or man in general, obviously fails to attain.

III. Contemporary Audiovisual Productions

Around eight centuries after the compilation of *One Thousand and One Nights*, *hourriyat al-bahrs* returned to Middle Eastern culture in a number of audiovisual media productions in which representations of the myth of the mermaid syncretised from Middle Eastern traditions and Western culture are perceived within a framework preoccupied with the politics of Otherness. In the Syrian family television series *Kan Yama Kan* ('Once Upon

a Time') (1992–1999) for instance, there is an episode (directed by Bassam al-Molla) in which a poor fisherman catches *arous al-bahr*, whose representation differs from that of the standard Western mermaid discussed in Hayward (2017a: 12-16) by virtue of her having a less overtly sexualised appearance, behaviour and demeanour. In particular, her whole body is rendered as fish-like by her wearing a fully-sleeved, fish-skin suit that barely suggests her lean figure. She is shown passively reclining throughout (and is never shown underwater), has calmly composed facial expressions and body language and speaks standard Arabic. Her most obvious sensual signifier is her untamed, wavy brown hair.[12]

Arous al-bahr promises the fisherman who captures her that if he releases her she will be forever indebted to him. The fisherman does as requested and she starts fulfilling the fisherman's endless wishes, despite constantly warning him of the unfortunate consequences of greed. The fisherman becomes the wealthiest man on land and marries the woman of his dreams, yet he insatiably asks for more until *arous al-bahr* gives him a piece of stone that he presumes to be invaluable. He heads to the jewellers to exchange the stone with gold. Realising how precious it is, the jeweller agrees to give the fisherman the stone's weight in gold, but he later suspects that the fisherman is fooling him when they both find that no amount of gold would outweigh the small stone. The dispute is settled by a wise old man who informs them that the stone represents a greedy man's eye and can only be outweighed by a handful of earth.

In this overtly pedagogical story, the mermaid assumes a more superior role than Abdullah the merman does. The contradictory premise of *arous al-bahr* failing to free herself from the fisherman's net, yet acquiring the power to fulfil all of his wishes suggests her position as a messenger of Allah or a wish-granting *jinn* (genie) on a divine quest to test the poor fisherman's faith and guide him towards the right path. First, the modestly formed *arous al-bahr* greets the fisherman with the Muslim greeting "peace be upon you" and requires him to answer in a similar way. Second, similarly to the story of Abdullah the merman in *One Thousand and One Nights*, she pledges loyalty to the fisherman if he releases her from his net, establishing the 'good is rewarded with good' credence. Third, unlike the *One Thousand and One Nights* story, the television drama's intentional eclipse of *arous al-bahr*'s world and her command of magical powers – vanishing and fulfilling wishes among others – sets her apart from the human order and associates her with the supernatural/divine. However, this does not negate her role as a medium who brings the fisherman closer to himself or to his *fitra* (good nature). *Arous al-bahr* possesses the omniscient power – by delegation, of course, because she always refers to Almighty Allah – that allows her to impart her wisdom and advice to the fisherman who becomes a symbol of all mankind.

Notwithstanding the obvious fact that she is utilised as a supernatural agent to morally instruct the fisherman around whom the story revolves, *arous al-bahr* in this Syrian narrative bears more traces of Iris/Atargatis than any of her predecessors in *One Thousand and One Nights* in embracing the divine and the mythical. As a superior female benefactor to whom man turns to for help, she reclaims her position as the ultimate giver of wisdom. The manner in which *arous al-bahr* appears to the fisherman at various stages in the episode, majestically reclining on rocks against the glistening water, is in marked contrast to the image of the wet and dishevelled figure we see during her first encounter with the fisherman. Her firm countenance and the change of tone with the fisherman, moving from

meekness to austerity, contributes to subverting the power roles the tale started with. The transition intensifies *arous al-bahr's* ascension to power, and the glorified restoration of her original form. Additionally, the stone that she gives to the fisherman looks like an eye, directly referring to Middle Eastern mythologies (such as the Turkish *nazar* and the Egyptian Eye of Horus) in which the symbol is used to protect man against the evil that lies within himself (as the story implies). It is true that the religious tone in the tale overpowers the supernatural elements, but the subtext maintains a healthy dialectical relation between the religious and the mythical.

While the Syrian television series attempts to represent its source myth in a manner that is essentially faithful to regional traditions, the popular 1985 Egyptian television series *Alf Leilah w Leilah: Arous al-Bohoor* ('One Thousand and One Nights: The Mermaid') is striking for a markedly different approach. Rather than represent one of the previously discussed three episodes that feature aquatic humans of various kinds, the series introduces the tale of *'Arous al-Bohoor'*[13] that was clearly modelled on Hans Christian Andersen's 1837 short story 'Den lille Havfrue' (known in English as 'The Little Mermaid'), albeit with variations necessary to adapt the story for Middle Eastern audiences. The mermaid, played by renowned Egyptian actress, singer and dancer Sherihan, is slender, young and exquisitely beautiful and has long, dark, straight hair. She appears garbed in various long-sleeved, one-piece bodysuits with fish tails that are flamboyantly sparkly and usually match her headbands, turbans and jewellery. The colourful *arous al-bohoor* speaks in rhymed colloquial Arabic and occasionally sings. The show's plot closely follows that of Andersen's original tale until the end when, instead of being transformed into seafoam when her prince marries a terrestrial woman, the Pure Queen of the Sea takes pity on her, reverses the witch's spell and gives the mermaid her voice, tail and life back. This twist precipitates an even more positive outcome for the mermaid. Determined to tell the Prince the truth of her interactions with him, she shows her fish-tailed form to him while he is sitting by the sea and relates her tale. Enchanted by her sacrifice, he confesses his love and breaks off his engagement with his human fiancé. The mermaid then uses a magic spell she borrowed from the sea witch to give the prince (whose name is Nour) the ability to breathe and move underwater. She then introduces him to her father as a noble sea prince and her father holds a contest between all the sea princes to decide who is worthy of marrying his daughter. Nour wins the contest and lives happily ever after under the sea with his new bride after writing a farewell letter to the terrestrial father he has left behind.

The obvious deviation from the ending of Andersen's tale could be related to the fact that the show was aired during the month of Ramadan when TV shows are considered a major source of family entertainment. In this context, a gloomy ending with the main character dying would not have been appropriate for the general mood of the month and for the series, which was marketed as presenting a happily-ever-after fairy tale. Labelling the series as one of the *One Thousand and One Nights* tales and using Scheherazade as a non-diegetic narrator were not the only liberties taken in order to 'Arabianise' Andersen's tale. Syntactically, names like Arous al-Bohoor ('Bride of the Seas'), al-Ameer Nour ('Prince Nour'), and al-Malek Sagoor ('King Sagoor – the mermaid bride's father) were purposefully chosen to rhyme, and the characters themselves speak in rhymed speech so as to follow the Arabic lyrical folkloric tradition of storytelling. Also, all sea inhabitants

– male and female alike – were depicted wearing modest and mostly long-sleeved, sparkling attire with tails that the actors could wave around in a fish-like manner. Appropriately for a show screened during the holy month of Ramadan, most the characters – humans and merfolk – are portrayed as devout believers in God who have faith in his ultimate wisdom/mercy and in a master plan that inevitably has a happily-ever-after ending.

In more recent reinterpretations of mythological tales, Middle Eastern artists have begun to transcend religious frameworks, moving to subvert traditional power paradigms in order to reflect on the complicated cultural identity of the region and its inhabitants. The clearest example to date is Shahad Ameen's *Houreya w 'Ein* (known in English as *Eye & Mermaid*) (2013), a short Saudi Arabian film that directly engages with religion and myth in its exploration of female identity in a restrictive society. The film begins by introducing us to Hanan, the free-spirited younger daughter of a fisherman whose love for the sea motivates her to hide inside her father's boat with the intention of accompanying him on a fishing trip. Upon discovering her presence, the father lovingly sends her back to the land, claiming that the sea is not for girls but consoling her by promising to bring her another black pearl for her necklace. This promise presages a shocking revelation for her. Her father and his fellow fishermen subsequently return from a fishing trip with *hourriyat al-bahr* they have caught in their nets. The creature has a wild, exotic appearance, her hair is extremely long and dishevelled, her skin is shiny grey and she is covered from head to tail in seaweed and patterns of fish scales and pearls. Underlining her difference from humans she appears incapable of speaking or understanding Arabic.

The film's title cleverly uses language to set up audience associations and expectations, and signals the director's intent to contest the constraints and authority of religion over previous representations of Middle Eastern myths. As previously outlined, one of the Arabic terms for mermaid is *hourriyat al-bahr*. This phrase is closely aligned to another, *hoor al-'ein*, commonly used to refer to the Paradise virgins: extremely beautiful maidens who accompany good Muslim men in the afterlife as a reward for their deeds. Many fundamentalist readings of Islam have intentionally sexualised *hoor al-'ein* to appeal to and, hence, gain control over patriarchal mindsets. The terms share the common root *hawara* (most prominently used in standard Arabic in the form *hawaraa*, referring to a beautiful woman with a fair complexion and body, whose eyes are marked by their bright sclera and dart pupils). Playing on this term in the film's title, Ameen suggests particular sexual roles for her *hourriyat al-bahr*, which she attempts to subvert by syntactically and semantically breaking down the phrase *hoor al-'ein* into two: *houreya* and *ein* in her title *Houreya w 'Ein*. The revised form does not have the same connotations and suggests multiple identities instead of the standard, generic, sexualised one.

The very different nature of the version of classic Middle Eastern *hourriyat al-bahr* the director presents is made apparent in the film's most dramatic scene. Hanan sees the men bringing the creature ashore and, horrified, witnesses them butchering her and gouging black pearls out of her flesh. This scene is a striking one. Indeed, referring to *hourriyat al-bahr* with the Western term, Hayward contends that:

> The scene provides the most barbarous and graphically violent treatment ever extended to a mermaid in over 110 years of audio-visual representation.

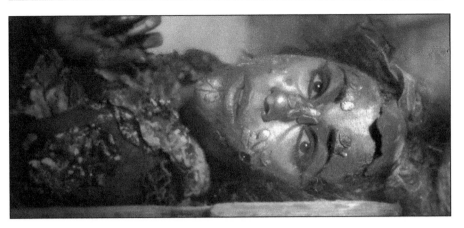

Figure 2 – The passive face of *hourriyat al-bahr* as her body is violated in *Houreya w 'Ein* (2013).

> *Glimpsed through a window, the violence meted out by a gang of men in a closed room is evocative of graphic horror films such as* Saw *(2004) or* Hostel *(2005) and also suggests gang rape – at least allegorically – through its merciless and relentless assault. For its youthful female spectator, it provides a shocking introduction to the brutality of male society. These aspects are made all the more striking by the mermaid's passivity throughout. Accepting her fate (and, perhaps, the inevitable brutality of human males to her kind) she looks out passively and forlorn from the scene of her dismemberment, only uttering a hideous scream at the moment her tail is separated from her upper body.* (2016: 2)

Responding to this scene (Figure 2), Hanan decides to save *hourriyat al-bahr* by hauling her mutilated body back to the shore, from where she drags herself into the sea (Figure 3). Ameen's tale is unlike the aforementioned episode of *Kan Yama Kan* in that it is no longer the poor fisherman who accidentally finds the creature in his net who is the focus of the narrative. Rather, the film is related from the perspective of a fisherman's daughter – a distinct presence in an otherwise all-male environment that restricts her from venturing into the sea. She is initially represented as peacefully acceding to her position because her confinement is made more palatable by her father's apparent love and care, but rebels as she becomes aware of her constraints.

Ameen emphasises her inspiration for the film with regard to using mythology to represent and reinterpret the present:

> *I always wanted to explore the Gulf region in its varied cultures and stories. I wanted to tell a story that is set in a fantasy world, yet deals with real issues. Stumbling on the story of the goddess Atargatis was the inspiration behind the idea of the strong mermaid that represents the wild woman, as I wanted to represent the strong women of the Arab world.* (Mattson 2014: online)

Ameen's perceptions reflect the manner in which ancient Middle East femininity was rendered as essentially inseparable from the natural, and the goddesses who were worshipped derived their power from different aspects of nature (e.g. Isis controlled the flood and bestowed fertility on land and Atargatis brought the land and sea together and

Figure 3 – Hanan and the hourriya, as she drags her mutilated body back to the sea (from *Houreya w 'Ein* [2013]).

endowed them with fertility as well). These images of the mother-goddess as the ultimate nourisher were effaced by subsequent patriarchal systems that aimed to destroy these paradigms in order to guarantee male dominance. When Hanan's presence is limited to the land/home she is disempowered because her femininity is denied its connection to nature. She realises the gravity of her situation in such an environment while witnessing the fishermen's brutal treatment of *hourriyat al-bahr* – with whom she instantly identifies despite her exotic appearance. By returning the dismembered and bloodied creature to the sea, she frees her from the fishermen's clutches and metaphorically releases her image from centuries of religiously-authoritarian and male-dominated (mis)representations. Hanan's total reconciliation with her female identity (and herself) is achieved only after her father dies when she sets out to return her pearl necklace to *the hourriya*. In a mesmerisingly beautiful image, a grown-up Hanan comes face to face with her marine double underwater and only then do we realise the striking similarity between the two (suggesting each as a *qareen* of the other), allowing the land and the sea to come together in harmony and resurrecting Atargatis in the process.

Besides deconstructing the conventional *hourriyat al-bahr* story, Ameen plays with the politics of the Other in presenting her narrative. Not only does she allow Hanan to become the protagonist but she gives her the narrator's voice since the events are presented as a memory that Hanan retrieves on the day of her father's funeral. Ameen wants to affirm how women in Saudi Arabia specifically, and the Arab world in general, are robbed of their own voices because they are always regarded as the Other. And the inescapable problem with representing the Other is that it has to be seen from the Self's perspective. Accordingly, Ameen eclipses the entire society and gives her female protagonist the voice to narrate her story. Hanan is not spoken for – she is the one who pieces herself together and redeems that part of her identity which she has been denied all her life. Even if we do not get to know anything about *hourriyat al-bahr* and see nothing of her world, her exoticism

is reflected in Hanan, who takes up the role of the exotic Other in the narrative. In other words, she becomes our *hourriya*. From the beginning of the film Hanan is singled out. She is the only girl among the fishermen, yet her dashing femininity overrides her situation. In an early scene, her father asks her before giving her a black pearl: "Will you give me your heart?" and she nods in agreement. In this manner – and subliminally referring to popular mermaid tropes – Hanan's heart is bound by love for her father and is not fully reclaimed until his death. Perhaps this is not our typical love story between a man and a mermaid, but the politics of the relationship are first established then destabilised to negotiate Hanan's position in the narrative as *hourriyat al-bahr*, whose exoticism and Otherness she fully assimilates in the end.

In its subversion of conventional roles in *hourriyat al-bahr* narratives, *Houreya w 'Ein* helps in redirecting the course of Middle Eastern adaptations of the myth, that have been previously limited to either building on the *One Thousand and One Nights'* tradition of using religious frameworks and elements of Western mythology, or directly borrowing from Andersen's famous fairy tale. While foregrounding questions of female dis/empowerment in Arab societies, Ameen's film also re-establishes the lost tie between the myth of the mermaid and the worship of goddesses in ancient Middle Eastern civilizations.

Conclusion

The progression of popular representations of *hourriyat al-bahr* manifested in the three audiovisual works examined above attests to the universality of the myth which has travelled far and wide across civilizations and cultures, acquiring traits and leaving traces in every place the story has been told. It has proved to be one of the most enduring and adaptable stories in human history. Despite its ancient roots, it is still the subject of various popular artistic representations. In the Middle East, the myth tacitly tells the history of a region that once cradled several great civilizations and assimilated diverse religions, and bears the marks of a rich culture caught between political and religious forces belonging to both the past and the present. Born from Isis/Atargatis, metamorphosing into the forms represented in *One Thousand and One Nights*, and more recently adapting to a turbulent culture, *Houreya w 'Ein* has successfully engaged with politics of assimilation and the complex interplay between myth and religion.

Notes

1. The area comprising Egypt, the Arabian Peninsula, Palestine, Jordan, Lebanon, Syria, Turkey, Iraq and Iran. (NB While Israel also falls within this region, Israeli/Jewish folklore and mythology are not addressed in this chapter as the mermaid is not a significant figure within Israeli culture.)

2. NB Since the term *al* in Arabic serves as a definite article for the noun following it, this chapter does not duplicate its function by placing the English definite article *the* before terms such as *hourriyat al-bahr* and *insan al-maa*.

3. Scholars have been unable to offer any precise date for the collation of the anthology within this period.

4. This couple and the narrative that involves them prefigure the Biblical creation story of Adam and Eve and have been interpreted as providing its inspiration.

5. Satis (Satet) is another water and fertility goddess that ancient Egyptians combined with Isis. However, she is often connected with war and is referred to as the archer-goddess because she was believed to protect the Egyptian frontiers from invaders.

6. See Elsner (2007: 19-22) for a discussion of representations of Atargatis in fully human form.

7. This power derived from its annual flooding of lowlands. These annual floods substantially diminished following the erection of the Aswan Dam in the 1960s.

8. Despite its title, the Egyptian film *A'roos El Nil* (Fatin Abdel Wahab, 1963) only has a tangential connection to the themes of Eber's novel.

9. Released with English-language subtitles under the title *Bride of the Nile*.

10. The translations of the Arabic text of the original stories in this section are the author's.

11. As previously noted, scholars have been unable to offer any precise date for the collation of the anthology within this period.

12. See Hayward (2017a: 15-16) for a discussion of this aspect with regard to Western mermaid imagery. While not entirely congruent, the public display of female hair is regarded as immodest in traditional Islamic cultures, and displays of long, luxuriant hair are regarded as particularly sensuous and/or provocative.

13. A variant spelling of the standard term.

Chapter Two

Matsya Fabulism: Hindu Mythologies, Mermaids and Syncretism in India and Thailand

Philip Hayward

Introduction

Over the last three decades, Western-style mermaid imagery has become more prominent in various aspects of Indian and Thai public culture. While this may be understood to reflect the manner in which audiovisual media culture has become increasingly internationalised in this period (in parallel with increases in Western tourism to South and South East Asia), it also represents the latest inflection (and/or an intensification) of earlier cultural assimilations into and blendings of indigenous and European traditions. In India, and in South East Asia more generally, Hindu mythology has provided a rich tradition of imagery and narratives that has been adapted and localised in various ways and has influenced artists, sculptors, authors and filmmakers (etc.). In terms of this chapter's focus, the two most significant aspects of Hindu mythology are the avatar (incarnation) of the god Vishnu in fish (*matsya*) form and the story in South East Asian versions of the epic *Ramayana* concerning the (monkey-human) Hanuman's encounter with a sea princess. This chapter introduces these mythological elements and

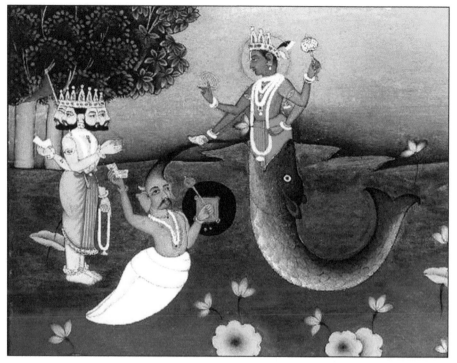

Figure 1 – Detail from painting of Matsya avatar from Jaipur (c1800), showing Vishnu emerging from a fish's mouth.

discusses them with regard to the subsequent development and circulation of mermaid images in India, as a country in which the Hindu religion is predominant,[1] and in Buddhist Thailand,[2] where Hinduism has been a significant influence on aspects of national and local folklore.[3] The chapter provides case studies of religious syncretism and various aspects of public and popular media culture that give insights into the processes behind the mermaid's circulation in contemporary Indian and Thai cultures.

I. Hindu Mythologies

The field of interconnected spiritual and mythological beliefs commonly referred to as Hinduism has its roots in the Vedic culture of northern India between c1700 BCE and 200 CE. As Banerjee identifies:

> *The entire body of the Vedas in the written form, as they came to us comprised of myths and legends which were unending, vast spaces full of self-contradictory discourses, relating a world of the divine, semi divine, incarnations, animals, half humans, humans with nature, and were fluid, self- contradictory and not always unified, without a fixed chronology.* (2017: 2)

Hinduism emerged out of Vedic culture, becoming distinct by blending Buddhist, Sramanic and other influences with Vedic traditions and creating a similarly complex tangle of legends and associations. In Hinduism there are three main gods: Brahma,

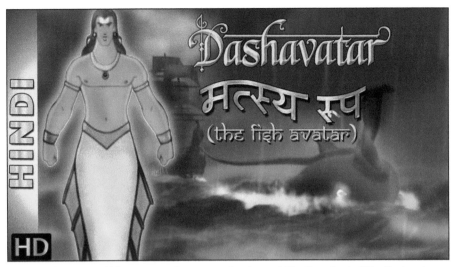

Figure 2 – Image of Matsya avatar from promotional material for the animated film *Dashavatar* (Bhavik Thakore, 2008).[8]

Vishnu and Shiva. Brahma is the creator, who created fishes as the first form of life and then animals and man. Vishnu sustains life on Earth and Shiva is the destroyer who transforms and renews. Vishnu is distinct in that he has been incarnated into living form on multiple occasions (ten in the tradition of the *Dashavatara* and 22 in the *Bhāgavata Purāṇa*). Vishnu's first incarnation in the *Dashavatara* is in *matsya* (fish) form. The literary texts of Hinduism are ambiguous as to how this fishly incarnation is physically articulated[4] and there are a variety of interpretations in visual arts and sculpture, and in temples devoted to the *Matsya* avatar.[5] One of the earliest conventions represented the avatar as a fish with human characteristics. A second form represented the avatar in human form emerging out of a fish's mouth, usually protruding erect, with two sets of arms (Figure 1). In many versions, the transition point between the human upper- and lower-piscine body is either obscured by fabric, leaving it ambiguous as to whether the entity is a physically integrated or compound one, and/or incorporates a v-shaped transition around the human figure's midriff that is suggestive of the fish's mouth motif of previous visual representations (Figure 2). The latter ambiguities have led to many characterisations of the *Matsya* avatar as a merman-like entity[6] within early Western scholarship and later pseudo-mythological and/or New Age discourses.[7]

Amongst the wide variety of female mythological entities in Hindu mythology the most direct parallel to the Western mermaid is the *Matysa Kanya* ('fish-woman') who occurs as a minor figure in some regional folklore traditions in India. One tradition of representing her in fish-tailed form is particularly significant for being produced by female artists in domestic contexts. This has principally manifested itself in the Mithila region of Bihar state, where women have decorated the walls of their houses with representations of folkloric themes. This practice achieved a degree of social visibility in the 1960s when the socio-economic impact of a severe famine in Bihar resulted in a number of women

23

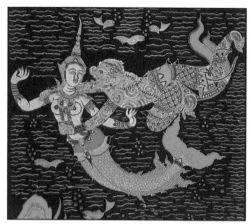

Figure 3 – Contemporary Thai silk print representing Hanuman (right) courting Suvannamaccha (left) (c2010, artist unknown).

producing similar representations for sale to tourists. These attracted the attention of art collectors and commercial galleries and have been actively promoted and exhibited in India and internationally in subsequent decades. Representations of the *Matsya Kanya* as fish-tailed feature in several of these works,[9] Despite this tradition – and, in all probability, because of its existence as a women's cultural practice – it has not been subsequently represented in public statuary and/or audiovisual media in the manner that other figures have.

Aside from the *Matysa Kanya* there is also a degree of affinity between aspects of Thai (and Khymer) Hindu mythology and Western mermaid traditions in the form of the narrative concerning the hero, Hanuman, who attempts to build a bridge between India and the island of Lanka[10] in order to rescue his wife from the clutches of the demon king Ravana. The legends have it that the construction of the bridge was continually thwarted by a group of fish with human characteristics led by Ravana's daughter, Suvannamaccha.[11] After falling in love with the prince, she ceased to oppose him and eventually bore him a child, named Macchanu. While Suvannamaccha is commonly translated/referred to in English as 'The Golden Mermaid', her name is less prescriptive in its original form, conjoining the terms 'gold' and 'fish'.[12] Despite this, renditions of her form in 20th and 21st Century Thai visual arts and statuary have overwhelming represented her in a form more akin to the standard international mermaid (Figure 3).

In addition to the figures discussed above, which involve the conjunction of human and piscine bodies, Hindu mythology also has *nāgas* and *nāgiṇīs*,[13] respectively male and female creatures who appear in the Sanskrit epic *Mahabharata* somewhat ambiguously as either snakes with human characteristics or else as compound entities with the upper halves of humans and lower halves of snakes. The snake is a complex symbol in Hindu culture. One aspect of particular relevance to the material analysed in this chapter is the snake's association with sexual desire and of the potentially transformative and/or disruptive effect of the preoccupation with and/or fulfilment of desire (which is represented as analogous to the suffering engendered by the snake's poisonous bite).[14] In such symbolism the snake is represented in its essential form, rather than being physically compounded with other figures. Despite this association, *nāgas* and *nāgiṇīs* are not commonly associated with sexuality or represented in overtly sexualised manners,[15] and often appear as the guardians of waterways or pools. Along with *nāgas* and *nāgiṇīs*, Hindu mythology also offers the *makara*. While the original Sanskrit term refers to a fabulous aquatic creature (without further prescription) it has come to be applied to various portmanteau or hybrid creatures, usually conjoining a fish or aquatic mammalian tail and the front body of either a singular

(and identifiable) mammal or else a collage of terrestrial creatures. The *makara* often serves as the *vahana* (material embodiment and/or vessel) of the river goddess Ganga and is frequently represented in Hindu (and Buddhist) temples in rows on walls or around archways. Ganga is usually represented as fully human, often riding a *makara* and pouring a jug of water. Alternative representations include her lower-body clothing rendered as fluid and water-like or else as more mermaid-like. One notable form of the latter occurs with regard to representations of the god Shiva as *Gangadhara* (bearer/protector of Ganga), in which Ganga appears in mermaid form clinging to Shiva's hair.

As the above discussions suggest, there are a variety of characters in Hindu mythology that have physical similarities to Western mermaids (and mermen) that originate from distinct cultural contexts and with distinct and often complex symbols. The introduction of Western-style mermaids into Indian and Thai culture discussed in the following sections involves their insertion alongside these indigenous figures and, on occasion, the cross-association and/or blending of the two in public culture.

II. The Introduction of Western Mermaids

The introduction of Western mermaid imagery and associated themes and narratives into areas as populous and culturally diverse as India and Thailand over an extended historical period is obviously complex and irrecoverable in terms of its totality. As such, the survey offered here relies on the discussion of particularly prominent instantiations.[16] Despite these caveats, a number of surviving artefacts and the history of their presentation and representation provide evidence of more general processes at work. Following sections explore these with regard to both specific geographic clusters of imagery and/or patterns of use in specific religious and secular contexts.

a. India

i. Catholicism, Syncretism and the *Sereia*

In all likelihood, mermaids first arrived in India in immaterial form as folkloric entities familiar to Western mariners, traders and religious missionaries. Their earliest manifestations in what can be regarded as Indian public culture appear to have occurred in Portuguese areas of influence in tandem with the promotion of Roman Catholicism.[17] While by no means a prominent motif in Portuguese Catholic religious iconography, fish-tailed *sereia* (literally, 'siren')[18] images featured in numerous medieval Portuguese churches,[19] as they did elsewhere across Western Europe. Their manifestation in Catholic religious iconography in India was not therefore an innovation but rather reflected European traditions, allowing them to be deployed in cross-cultural syncretic processes. Two notable occurrences of mermaid imagery in areas of Portuguese influence are found in Goa and on the southern and central coastal strip of the present-day state of Tamil Nadu.

Following initial contact with the region in the late 1490s, the Portuguese deployed forces to establish a permanent settlement in Goa in 1510 and maintained a colonial presence there until Indian occupation of the area in 1961. From its earliest stages, Portuguese colonialism proceeded to install Catholicism as the dominant religion, variously supplant-

ing, overlaying and/or syncretising its practices with pre-existent local religions. The establishment of Catholicism in Goa resulted – and manifested – in the form of churches that blended elements of European Mannerist (and, later, Baroque) architecture and Indian architectural styles.[20] Parts of the interiors of these churches were decorated with motifs that both drew on European traditions and resembled aspects of Hindu temple decoration. As upanov (2014/2015) identifies, a number of Goan churches (such as Saint Anne's church in Talaulim and the Church of Our Lady of Help in Ribandar) feature "splendidly crossbred creatures" that adorn the "baskets" (i.e. lower sections) of elevated pulpits:

> Carved as human from the waist up with bent fish (or snake?) tails of blue or dark green, or with golden foliage at the bottom, they appear in four types: females with bulging breasts, males with beards and sometimes wings, androgynous figures, and figures with grotesque or beastlike faces. (ibid: 299)

 upanov identifies these as intercultural figures that reflect the specific situation of priests preaching European religion from pulpits to predominantly Indian congregations steeped in their own cultural mythological traditions. In this spatial and discursive scenario the pulpits had a particular function. As in Europe, they served not only as the stage from which the divine word could be preached but also, via their undersides, manifested various "monstrous creatures" that were "tamed and immoblized when carved in wood and affixed beneath the feet of the preacher" (ibid: 304) (Figure 4). Focussing on the first of the types she identifies – and the ambiguity of their lower sections as snake- or fish-tail-like – it is notable that the mermaids frequently used as motifs in European churches were variously generic and/or expressive of aspects of local cultural beliefs that were incorporated in religious iconography to various ends.[21] With regard to the former, mermaids have often been interpreted as symbols of lust to be avoided (Berger 1985: 42–43), at the same time as they might be considered to (somewhat problematically) evoke the same impulse. The voluptuousness of the figures also invites comparison to traditional Indian entities such as *apsaras*, human-form water nymphs who appear in the Vedas and who later became closely associated with male sexual gratification (Banerjee 2017: 2) and of *yakshis*,[22] who bore similar associations. In contrast to earlier (and unambiguous) characterisations of the pulpit figures as *nāgas* and *nāgiṇīs*[23] upanov identifies them as "ambiguously" syncretised forms combining aspects of *nāgas*, *nāgiṇīs* and mermaids (2014/2015: 311) that reflect the manner in which Catholic missionaries and colonists invoked the latter as symbols of forces threatening to undermine their presence and success in establishing themselves in Goa (ibid: 304). Developing this characterisation, she contends that representations of *nāgiṇī*-mermaid figures in Goan churches can "be understood as a means of establishing ties of kinship between foreigners and autochthons" (ibid). Noting that the figures were "sculpted in wood and painted by local woodcarvers who may or may not have been Christian", she identifies that while they:

> appear at first sight to be bound, tamed creatures, staring quietly from below the pulpit basket as they emerge out of invisibility, carrying on their backs nothing less than the Word of [a European] God ... Staged institutional acts like preaching from pulpits created a kind of electric circulation of gazes among the preacher, the audience, and, in our case, the nāga. It was while looking at the nāgas that the Goan Christians – whose ancestors had destroyed their "idols"

and burned their "pagan" books a generation or two earlier – were able to reconstitute bits and pieces of their former non-Christian selves. (ibid)

Figure 4 – Pulpit features from Saint Anne's Church, Talaulim (photo: Lovell D'souza, 2016).

Figure 5 – Mermaid Figure on Golden Car (photo: Tuticorn: Our Lady of Snows, 2007).

The survival of the *nāgiṇī*/mermaid carvings to the present is striking in that they represent an enduring symbol of the cultural accommodations of indigenous and imported religions described above.[24] The manifestation of mermaids in religious contexts also occurred in the far south east of India, amongst coastal Paravar communities. The Paravar were heavily involved in pearling, fishing and, in some instances, piracy in the 15th and 16th centuries until their livelihoods were threatened by Arab intrusions into their traditional waters. Unable to repel the intruding fleets on their own, the community sought protection from the Portuguese. Keen to add a new region to their Indian sphere of influence, the Portuguese obliged and decisively defeated an Arab fleet in the area in 1538, leading to a period of sustained prosperity for the Paravan community. In tribute to their protectors, the Paravars responded positively to Catholic missionary activities and a form of Catholicism emerged in which elements of Hinduism and/or other nativistic beliefs remained prominent, including the veneration of the Virgin Mary in a manner akin to that of Hindu goddesses (Frykenberg 2008: 137–138). A variety of visual symbolism that drew on Christian and non-Christian traditions (and/or offered syncretic adaptations of these) was displayed in churches and in other sacred objects. One notable example of the latter was the carriage created for the Festival of the Golden Car, a major event held intermittently since the early 1700s that involves a crowd dragging a statue of the Virgin Mary on a huge carriage through the port of Tuticorn (Thoothukudi) on an extended procession that often lasted several days. In 1806 local traders and caste leaders funded the con-

struction of an ornately decorated, 23-metre-high carriage which continues to be used to the present. The bottom section of the carriage includes a striking detail of carved mermaids with clasped hands (Figure 5) located at each of the carriage's four corners, directly above the heads of the processioners. As Figure 5 indicates, the mermaid has distinctly syncretic aspects, particularly with regard to the junction of her upper and lower halves, that evoke both the traditional Western mermaid and the human figure emerging from a fish's mouth associated with the Matsya avatar (discussed above).

In both Goa and the Paravar communities of the Tamil Nadu coast the mermaids fixed in Indian Catholic religious imagery provide what might be understood as the roots of enduring cultural filaments that have manifested themselves in various ways. One of the clearest examples of this occurs in the form of the decorative gates that afford entry to a coastal park in Kanyakumari (formerly Cape Comorin). The twin gates are crowned by mermaids that resemble the Golden Car figures, with one particular modification: while the gateway figures also clasp their hands, as if in prayer, their use in a secular context is represented by the lower position of their hands and forearms; whereas the Golden Car mermaids' arms obscure their breasts from view, the beachside figures openly display theirs (Figure 6).

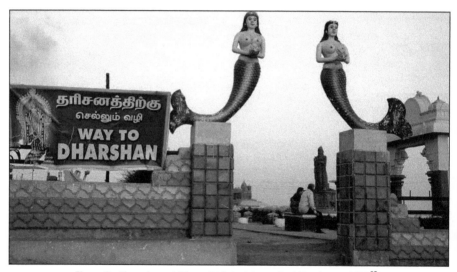

Figure 6 – Kanyakumari Mermaid Gate (photo: Paul Brockman, 2012[25]).

More modestly, the striking artwork that adorned the side of a coach that operated in Kanyakumari in the early–mid-2010s depicted a similar, long-haired mermaid whose upper body is enveloped in swirling layers of fabric that complement and merge with the clouds of her dark hair (Figure 7).

While not as directly tied to local Paravar traditions as the modern images discussed above, the Telugu-language film *Sahasa Veerudu Sagara Kanya* (K. Raghavendra Rao, 1996), which was shot on the Tamil Nadu coast, blends elements of regional folklore and imported cultural associations in what might be considered a contemporary syncretic

Figure 7 – Mermaid artwork on side of bus in Kanyakumari, Tamil Nadu
(photo by Jaap Bijnagte, 2013).

manner. The film (whose title can be translated as 'The Adventures of a Hero and an Ocean Maiden')[26] drew on elements of the Hollywood mermaid film *Splash* (Ron Howard, 1984)[27] but (unlike *Laal Paree*, 1991 – discussed below) added substantial novel inflections and characterisations. The film starred actress Shilpa Shetty as a mermaid (Figure 8) and Ravi Chandra as the male lead. In a typical Bollywood style, the production features action, romance and comedy elements together with song and dance numbers. The plot involves a villain who is intent on finding a sunken ship carrying treasure (including a famed diamond) who is aided by a witch who divines that a mermaid is necessary to locate the treasure. In parallel with this, a fisherman named Venkatesh (Chandra) inadvertently catches a mermaid in his nets only for her to transform to human form (as her tail dries in the sun) before he realises she is there. Appearing on the boat as a naked, young, mute female, Venkatesh takes her ashore and tries to establish her identity. The mermaid's character and behaviour closely resemble that of *Splash*'s Madison, projecting an innocent sexuality and falling in love with the film's hero. When the witch discovers the existence of the mermaid, she forces her to return to the sea, restore her mer-form and lead the villains to the sunken treasure while the hero is held hostage on shore. After escaping and killing the witch while the looting of the sunken ship is underway, Venkatesh then dives down and joins in an extended underwater combat sequence, survives a shark attack and then escapes together with the mermaid and the diamond. After presenting the diamond to authorities the couple are about to be married, with the mermaid in human form again, when she sees a leaping dolphin. Reminded of her true nature, she tearfully reverts to mermaid form and dives back into the sea. In this scenario she represents an ideal, open-hearted lover who is denied to the hero through her intractable other-worldliness.

Similar to the Golden Car parade in Tuticorn, religious syncretism has also manifested itself in Goa in the form of its annual pre-Lenten *Intruz* (Carnival), held each Shrove Tuesday. Initially introduced by the Portuguese as a religious celebration, *Intruz* has developed distinct Indian characteristics (including adopting some aspects of the local Hindu Shigmo Spring festival[28]) and has continued to the present (albeit with periods of prominence and decline). The street parade that forms its core encompasses a range of

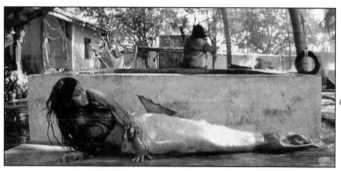

Figure 8 – Screen still from *Sahasa Veerudu Sagara Kanya* showing its mermaid heroine accidentally reverting to mermaid form after falling into a trough.

costumed participants and themed floats. Since the early–mid-1980s at least, traditional costumes and float tableaux drawing on Indian, European and Lusophone African traditions have been juxtaposed with Western characters such as Walt Disney figures (Sequeira 1986: 172). Mermaid and related imagery has frequently been deployed at the event. In 2015, for instance, a number of floats featured images that variously incorporated aspects of the traditional Indian *makara vahana* and the state's ornate Christian pulpits. One took the form of a vehicle adorned with a seahorse's head and scallop shells that carried the carnival's figurehead, King Momo, and another float carried a mermaid and merman in a giant clam shell, together with fish similar to those featured in Disney's film *Finding Nemo* (Andrew Stanton and Lee Unkrich, 2003) (Figure 9).[29]

Figure 9 – Float with a merman and mermaid, Goa Carnival (photo by Lovell D'souza, 2015).

In a point of connection with other contemporary local mermaid imagery, the *Intruz's* current route takes it past The Mermaid's Garden in Panjim. The garden (originally named the Jardim de Sereia) and the statue that gives it its name were created as part of beautification works conducted in the early 1940s under the mayoralty of Froilano de Mello. However, rather than drawing on Goa's tradition of pulpit iconography, the Jardim's statue has a more classical aspect, being a five-foot tall, bare-breasted porcelain mermaid, mounted in a shallow pond in a garden opposite the North Goa courthouse, close to the banks of the River Madovi. The statue has remained in place and was carefully restored in 2012, attracting wide coverage in the Indian Press.[30] Goa's association with *sereia* imagery was also invoked by the Goa ForGiving Trust in 2013. The organisation announced their plans to erect statues of a merman and a mermaid holding flaming torches on the banks of Goa's Rue de Ouvrem and Campal Creek as symbols of resistance to violence against women (following a high-profile gang rape attack in Delhi earlier in the year) (PTI 2013: online). While this project was not completed, it illustrates the polyvalence of merfolk as symbolic figures, deemed able to represent safety as well as the active sexuality they are often associated with. Derived from Portuguese colonialism and modified by various aspects of modernity and Goa's integration into India after 1961 the region's *sereia* imagery constitutes a distinct cultural tradition.[31]

ii. Mermaids, Narrative and Terminology in Modern Indian Culture

In addition to its introduction via the Portuguese, the mermaid also arrived via other cultural routes. The British Government formally declared its *raj* (i.e. rule) over India in 1858, following an extended period of de facto colonial administration of large areas of the sub-continent by the British East India Company in the early–mid-1800s. One result of incorporation into the British Empire was an expansion in mission schools teaching English language and associated cultural traditions to Indian students. As Das (1995) documents, the main texts used for English-language education in the mid–late 1800s were Western fairy tales and Sanskrit literary classics translated into English. As he also identifies (ibid: 46), these texts, in turn, formed the context and/or models for the development of subsequent English-language children's fiction in India. In this manner, the works of Andersen (via English-language translations from their original Danish) and authors such as Lewis Carroll were read alongside translations of Hindu epics such as *The Ramayana* and *Mahābhārata*. There are two significant aspects to this. First, the use of English-language fairytale literature in schools established this corpus as an enduring aspect of anglophone Indian culture and, second, the juxtaposition of the texts with translations of Sanskrit classics suggested a loose equivalence of status between them, leading Das to identify that "the beginning of children's literature in India emerged from cross-cultural sources" (ibid: 47). This process was complemented by the translation of various English-language works into Indian languages from the early 1800s on. One of the earliest translations of Andersen's 'Den lille Havfrue' was a Bengali version produced by Madhusudan Mukhopadhay in 1857 that was published with the alternate titles 'Marmet' and 'Matsya Narir Upakhyan'. The dual titling reflected the necessity of explaining the initial (phonetically modified) English-language loanword (i.e. 'marmet') by specifying it as 'The story of a fish/woman'. As a result of the educational factors referred to above, Andersen's descriptions of the Little Mermaid, together with various illustrations in

different published versions, have been disseminated since the mid-1800s, familiarising Indian audiences with her form and associations. While Andersen's Little Mermaid story may not have been as prominent a children's story in India as it was in China (see Chapter 7 of this volume), its publication in English and Indian languages over an extended duration established it as a familiar and acceptable motif.

While India's independence in 1947 led to a series of modifications in its educational systems that increased the prominence of local-language literature, the continuation of English as an officially recognised language after independence ensured that established works of children's fiction continued to be taught and circulated.[32] The longevity of Andersen's tale was extended through the success of the Disney film version (1989), which revived interest in Andersen's original work and was followed by the production of a number of postcolonial reinterpretations of the narrative. Rao, Wolf and Shyam's book 'The Flight of the Mermaid' (2009), for instance, freely interpreted Andersen's text with illustrations in the style of central Indian Gond tribal art. Sunandha Ragunathan pursued a different approach with her production of 'The Little Mermaid' for Theatre Nisha in Chennai in 2014. Setting out to subvert what she has referred to as the international "pervasiveness of Disney's Mermaid" (p.c. July 18th 2017) she alternated the mermaid role between six actors and had the titular character die of a broken heart within the context of a drama that addressed issues such as (so-called) 'honour' killings and racism.

In linguistic terms, a variety of Indian languages refer to the (Western-style) mermaid with broader, pre-existing compound terms, including: variants of *Matysa Kanya* (meaning 'Fish Girl') in Bengali, Telugu, Kannada, Malayam and Gujarti; *Matsyagana* ('Fish Body') and *Jal Pari* ('Water Angel') in Hindi; *Jala Kanyaka* ('Water Nymph') as an alternative term in Malayalam; and *Kadal Kanni* ('Ocean Angel') in Tamil. As these translations indicate, the terms *include* – rather than *prescribe* – fish-tailed female forms within general terms, indicating women associated with water. The only language that has incorporated mermaid as a loanword on a regular basis to specify a fish-tailed female is Gujurati, which uses the term *Marameida* alongside the less prescriptive traditional term *Jalastri* ('Water Lady').

It is notable in the above regards that the first mermaid-themed film produced in India eschewed any of the above terminology and was instead entitled *Laal Paree* (Hannif Chippa, 1991). The title, which can be translated as 'Red Angel,' refers to the exotic appearance of actress Jhanvi in role as a mermaid with dyed blonde hair and an orange-red tail. Like the examples of recent Indian mermaid-themed fiction referred to above, the film was based on a key Western referent (Ron Howard's 1984 film *Splash*) localised by being set in Bombay, with its opening scenes shot in and around the Fisherman's Wharf/Mazagon Docks area. One of the more striking aspects of the film (in the context of Indian cinema in the 1990s) is the adult mermaid's open passion for the male lead, Shankar (played by Aditya Pancholi). This is first demonstrated in the film's (fairly direct restaging of *Splash's*) beach scene where the mermaid appears naked (in human form) to Shankar on a beach and kisses him passionately before diving into the sea. While kissing became increasing common in Hindi cinema in the 1990s (following a 50-year hiatus [Dwyer 2014: online]), nudity (even when concealed behind long hair as in *Laal Paree*) was still unusual. Like Madison, the mermaid in *Splash*, both were, however, 'explicable' given

that the mermaid was represented as unaware of dominant social mores in her first interaction with humans.

iii. Mermaids, Statuary and Indian Material Culture

Along with religious material culture, literature and cinema, public statuary has been the most prominent avenue for the dissemination of mermaid imagery in India. This practice began before the formal colonisation of India and took the form of wealthy Indians commissioning works that represented various Western motifs as signs of their own modernity. Early examples of such practices involved the representation of mermaids as fountain features. The first example that my research has uncovered was that of the Marble Palace in Calcutta (now Kolkata) built by Raja Rajendra Mullick in 1835. The main building features three-storey-high neo-Corinthian pillars and its grounds and interior are liberally adorned by sculptures and Western artworks. One of the notable features of the palace's gardens is an elaborate fountain in the midst of a small pond. The fountain's water jets emanate from a large circular cup that is supported by mermaids who hold it erect over the heads of seated tritons. As such, it is a purely decorative work designed to evoke classical and neoclassical European grandeur. While the palace grounds are now open to the public on a limited basis, the fountain has been an essentially private feature since its inception and does not occupy any prominent role as a significant heritage item within the city.

The first public monument to include representations of Western-style mermaids was erected in 1864 in (what was then) Bombay. The monument is significant by virtue of facilitating a complex set of cross-cultural aspects through a more general local cosmopolitanisation that was related to Bombay's emergence as a modern international city. The mermaids appeared as fountain features at the base of a cast iron column supporting a bronze statue of Cursetjee Manockjee Shroff, a noted Parsee academic, anglophile and advocate of girls' education. The mermaids were represented with long, curling tails, were bare-breasted and held shells aloft with both hands (as if blowing them as instruments), with water spouting from them (Figure 10). The structure was commissioned by the academic's youngest son as a tribute to his father and represents a modification of the design of a statue of Ceres, the Roman goddess of agriculture, conceived by Chilean politician Pascual Binemelis Campos, manufactured in Liverpool and shipped out to Chile for installation in the city of Concepción in 1857 (Edmundson 2009: 126–127). After becoming familiar with the design of the statue while studying in England, Cursetjee Manockjee Shroff Junior commissioned a similar work from the same foundry, retaining the base and column but replacing Ceres with a statue of his father. The incorporation of mermaids as support features in the original conformed to the European Gothic Revival style of architecture and decorative design. This movement attempted to inject classic elements into the increasingly utilitarian styles that arose in Western Europe and North America during the Industrial Revolution and, through their transport elsewhere, distributed such features to a variety of other locations. While there are no records to illuminate the matter, it is improbable that Cursetjee Manockjee Shroff could have been unaware of the similarity of the mermaids to *nāgas/nāgiṇīs*,[33] the resemblance between the shells they blew and the similar, sacred Hindu *shankar* shell-trumpets[34] and of the association between *nāgas* and *shankas* in the *Ramayana*. In these regards the mermaid figures provided a

33

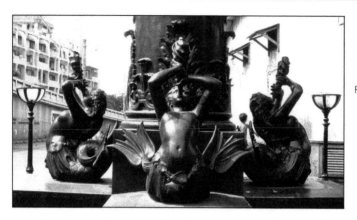

Figure 10 – Mermaid
features, Shroff
statue, Mumbai
(photo by Anand
Tharanay, 2017).

suitable ceremonial support for the column and for the individual represented at its summit.[35]

Like the Goa pulpit carvings, whose designs upanov described as "splendidly crossbred" (2014/2015: 299), the intercultural significance of the Bombay statue and its mermaids resides in its interpretation. The statue and its support figures appeared in the cityscape as an intertwining of cosmopolitan modernity and traditional Indian culture facilitated by an emergent, Western-educated Indian upper class.[36] As Chopra has detailed, in a richly nuanced study of the meanings of Victorian-era Anglo-Indian architecture in Bombay, the Gothic Revival style "was an unscripted script whose meaning was grasped in terms of experiences or concepts familiar or relevant to the local population" rather than by the specific meanings associated with the Western architectural style in its places of origin (2011: 61), allowing for various processes of incomprehension, indifference and/or affective engagement by various groups at various times.[37]

In addition to their ability to be perceived as related to Hindu mythology, the somewhat ambiguous significance of the mermaids was offset by the potential for their association with Andersen's Little Mermaid as mission school activity in Bombay increased and as Literature courses were introduced at the Elphinstone College of Higher Education (formally established in 1856), which was affiliated to the newly created University of Bombay in 1860. In this manner, the city offered materialisations of the figure of the mermaid that were open to cross-association. While these did not appear to have prompted any marked proliferation of mermaid imagery in the city, they can be understood to have provided both a precursor to and context for later cultural phenomena.

Along with a cluster of 19th Century fountain features, several more recent monuments that combine aspects of traditional Indian water/women figures and Western mermaids have been commissioned for areas frequented by tourists.[38] A number of these have been conceived and realised in monumental scale. Two of these occur in the south-western state of Kerala. The largest is the 35-metre-long statue, variously referred to as a Matsya Kanyaka and Jala Kanyaka,[39] by noted Kerala sculptor Kanayi Kunhiraman installed at Shankhumugham Beach, near Thiruvananthapuram city in 1981 (Figure 11).[40] The statue is a sister work to the sculptor's best-known work, a 5.5-metre-high statue of a nude female sitting with her legs wide apart completed in 1968 in Malampuzha Gardens park. The

Figure 11 – Kanayi Kunjiraman's statue at Shankhumugham Beach (photo: Kerala Tourism, nd).

statue is named the Yakshi, in reference to a figure in traditional Indian mythology.[41] Kunhiraman's Shankhumugham Beach sculpture has a similar voluptuousness of naked form, but represents its female in a similar manner to that of Eriksen's famous Little Mermaid statue in Copenhagen, with legs that morph into twin tails below the knees. Reclining in a giant shell, with her head thrown back, her body is fully and openly revealed to the spectator and has provided an enduring tourist attraction and photo opportunity since its construction.[42] The statue appears to have no obvious associations with local folklore and instead presents itself as a luxuriant celebration of physical experience of the sun and beachside leisure in a noted tourist destination.[43]

The second monumental mermaid statue on Kerala's coast is a 10-metre-high one located at Kollam Beach. Her form is similar to that of Kunhiraman's work, in having fins that commence below the figure's knees. This aspect was one facet of disagreements between Shanthanu, the sculptor originally commissioned to produce the work in 2000, and the Kollam Municipal Council that commissioned it. Following a dispute about funds in 2003–2005, Shanthanu was taken off the project, with one of the Council's stated reasons being (unspecified) "anatomical defects" in the work in progress. The sculptor countered this claim with the characterisation that "a mermaid was an imaginary creature and the anatomy of the beach mermaid was a distinctive creation of his imagination" (Unattributed 2005a: online). Shanthanu's remarks are significant in characterising his mermaid statue in progress as a creative representation of an imagined creature, rather than tying it to any specific tradition; however, despite his threatening a hunger strike rather than see his creation completed by another artist, the statue was eventually completed by Vijayan V. Chavara, after the Kollam tourism development corporation took over coordination of the project, and represents a kneeling, naked mermaid staring out to sea (Figure 12). Interviewed prior to the statue's ceremonial opening in August, Vijayan identified

Figure 12 – Kollam Beach statue (Photo: Rajeev Nair, Wikimedia Commons, 2007).

the mermaid's "melancholic look" as resulting from her being "cursed and sent to live on land for having fallen in love with a sailor" (Unattributed 2005b: online).

Whatever the monumental aspect of Kerala's two actual beachside mermaid sculptures, their conceptualisation was dwarfed by that of another project announced in January 2015 for the city of Kochi (Cochin). As part of the Kochi Development Authority's attempts to attain recognition as a major metropolitan city (similar to New Delhi, Kolkata and Mumbai) it announced plans to construct an artificial circular island of over 300 square metres, comprising a coastal fringe of luxury residential buildings and jetties surrounding a monumental statue of the Queen of the Arabian Sea, similar in scale to that of New York's Statue of Liberty and represented as a blue-tailed mermaid balancing erect on her tail (Figure 13).[44] Planned to be located off the shore of the city's popular Marine Drive promenade area, the announcement was met with both scepticism (about the likelihood of it actually being constructed) and complaints about the cost of such a project when the city still faced basic problems, such as quality of water supply and other infrastructural issues.[45] The statue was proposed as a realisation of the city's long-established nickname, 'Queen of the Arabian Sea', referring to its historical importance since the 1300s as a

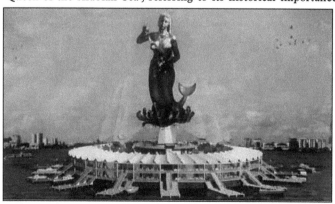

Figure 13 – (Unattributed) Artist's visualisation of proposed statute for Kochi Harbour (2015).

spice-trading port dealing with Arab and European merchants. As former head of the Greater Cochin Development Authority (GCDA), N. Venugopal, expressed it, the corporation aimed to create a landmark "similar to international cities like New York, which has the Statue of Liberty and Paris, the Eiffel Tower" (Shibu 2016: online). By October 2016 the plan was quietly dropped on economic grounds (ibid).

In addition to the tourist-orientated sculptures in Kerala discussed above, a number of other coastal locations have added such features as photogenic attractions. These include Visakhapatnam in the state of Andra Pradesh, which has opted for groups of mermaids rather than the gigantic individuals constructed in Kerala. The mermaids formed part of a municipal revival project announced in 2003 that also included interpretative theme parks. Emphasising the essential foreignness of the figure to the locale, a report on the installation of the first mermaids discussed their impact in the following terms:

> *According to Chinese philosophy, the presence of a mermaid on the east brings good luck to the place.*[46] *Let's hope that the mermaid installed on the eastern side of the town, would help it regain its past glory.* (Gopal 2003: online)

One set of mermaids was initially installed on rocks in shallow waters, with a further cluster of 10 cement models posed facing the sea on the land side of the beach road. While these have remained in place, their allure appears to have faded as they have fallen into disrepair and the town appears to have reaped little glory from their presence.[47]

iv. Mythological Motifs, Fabulism and Innovation

Whilst not achieving the public prominence or controversial profile of public statuary discussed above, the mermaid has emerged as a regular motif in Indian visual art in recent years. There have been several strands to this. In addition to a continuing range of folk-art figures from Hindu mythology rendered in conventional manners, a number of contemporary fine-arts practitioners have produced images that are more complex and ambiguous in nature and have often combined motifs. Such an approach is evident in the work of K.G. Subramanyan in paintings such as 'Summer' (1996) or 'Midnight Blues' (2013). Discussing such work, he has characterised that he is a "fabulist":

> *I transform images, change their character, make them float, fly, perform, tell a visual story. To that extent my pictures are playful and spontaneous. I do occasionally build round a well-known theme, and give it new implications. The* matsya avatar *motif, for example, generates the vision of a fish goddess. Symbolising elegance and grace or a conference of mermaids. It will be unproductive to explain each image as it will destroy the mystery of its birth.* (Kumar 2016: online)

Similar approaches are evident in the work of Jayasri Burman. Originally from Bengal, she was initially influenced by traditional Pattachitra scroll paintings from Odisha and folk art before studying print-making in Paris and becoming interested in Impressionism. Mermaids are frequently central motifs in her paintings, either in standard human/fish form, or else with added wings (evoking European classical imagery and other Indian traditions) or, in one of the artist's trademark details, blended with swan's heads (see, for instance Figure 14). This fabulist approach to the plasticity of such creatures' design extends to her addressing entities more central to Hindu mythology:

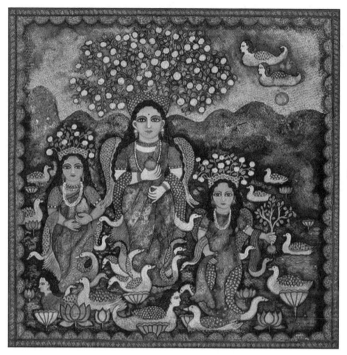

Figure 14 – Jayasri Burman 'Shankuntala, Anushyua and Priyamvada' (2017).

Sometimes you will see in my paintings that Ganeshas are flying, or they are like fish or mermaids, because I like to play with the subject. One day I was painting a Ganesha and he suddenly started flying. I was so thrilled once I got that form in my hands, once it was under my control. In this way, even a common subject or theme becomes a myth, even if it didn't start out as such. (Bajaj 2014: online)

In addition to Burman's and Subramanyan's fine-art practices there have also been innovations (and related debates) around aspects of the representation of mer-form entities in forms of vernacular religious culture. One such development occurred in Mumbai in conjunction with the annual Hindu Ganesh Chaturthi festival. The festival involves ten days of prayers and festivities followed by processions that carry figures of the god Ganesha to bodies of water, where they are submerged (allowing the god to return to his abode on Mount Kailasha). The event is a community-based one that blends standard religious imagery and figures, such as well-known actors and cricketers, who are temporarily 'deified' by their inclusion. The figures displayed and paraded include elaborately painted, animated Plaster of Paris and/or fibre-glass ones. These automata are animated by traditional mechanical techniques that allow for simple motions of limbs, torsos and/or heads and are presented in *chal-chitra* (*son et lumière*) tableaux during the festivities. In addition to the most prominent figure, Ganesha, and others such as the Matsya avatar, mermaids have also begun to be featured as minor figures in recent decades.[48] Rather than representing particular entities from Hindu mythology, they can be considered as essentially fabulist 'ornaments'. As Figure 15 reveals, their appearance draws on elements of

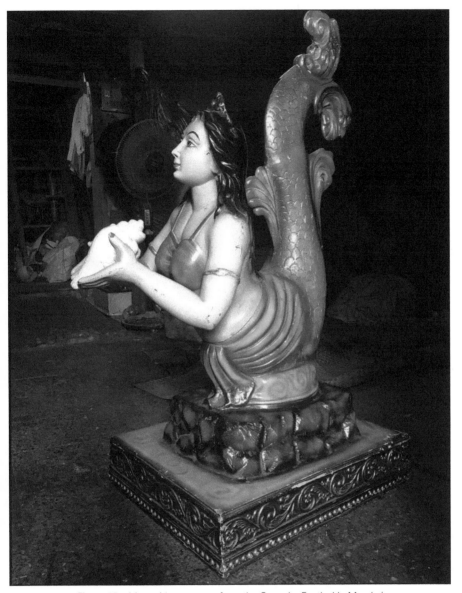

Figure 15 – Mermaid automaton from the Ganesha Festival in Mumbai
(photo: Anand Tharaney, 2017).

Hindu mythology and classic Western mermaid imagery (and thereby invites comparison to the conch-shell-blowing mermaids decorating the base of Mumbai's previously discussed Shroff statue – see Figure 10 above).

While further research needs to be undertaken on the history of representations of the

Figure 16 – Ankush Baikar's novel Matsya avatar (photograph by Sameer Tawde, 2017).

Matsya avatar at Mumbai's festival, in recent decades it has been rendered in classic Western mer-form – in conformity with its representation in 20th and 21St Century Indian visual and audiovisual media more generally (see Figure 15 for a representative example). Recent research conducted by Anand Tharaney[49] explores the increasing standardisation of Matsya Avatar automata through focusing on one designer, Ankush Baikar, who has recently broken with the established practice of rendering the Matsya in merman-like form. One of his recent avatars has a human body with two sets of arms and a fish's head, with fish-scaled arms, human hands and animated shoulder and back fins (Figure 16). While Baikar has characterised his innovation as one intended to refresh the figure for younger audiences, other automaton designers have repudiated his deviation from the standard styles. Responding to this, Tharaney has produced a filmic interpretation that moves from documentary into fantasy. Hemmed in by orthodoxy, he shows the avatar moving out into the secular space of Mumbai, implicitly shaking off traditionally defined contexts for his representation and circulation and making the figure a more contemporary one. As this suggests, the Matsya avatar is part of a living, developing folkloric and popular cultural tradition that is informed by complex threads and discourses of tradition, modernity, innovation and transgression that have been influenced by the arrival, assimilation and/or syncretism of exotic figures, such as the mermaid and merman.

b. Thailand

The Thai term for mermaid is *nang ngueak*.[50] While *nang* simply means female, the term *ngueak* is an archaic Thai Ahom word for crocodile that is only retained in contemporary Thai language in the compound term *nang ngueak*, now understood to refer to a mermaid (with a classic upper-half human and lower-half fish physique). While detailed research on the topic has not been undertaken, it seems likely that the compound term once designated a broader range of entities and that its tighter prescription resulted from a growing awareness of Western-style mermaid forms.[51] One of the most established uses of the term *nang ngueak* has been with regard to the aquatic female who features in the story of Hanuman and Suvannamatcha, discussed in the Introduction to this chapter. The

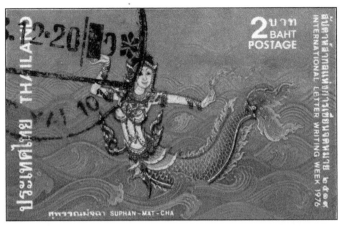

Figure 17 – Thai 1976 postage stamp.

couple's story has been a popular one in Thai folklore through its presence in the Thai national epic, the *Ramakien* (a variant of the Indian *Ramayana*), and in its inscription in various traditional media. In the Thai national epic, Suvannamatcha is referred to as *Nang Ngueak Thong* (the latter term meaning 'Golden') and is overwhelmingly represented as mermaid-like in form in the manner typified by her representation on a 2-baht postage stamp issued in 1976 to commemorate International Letter Writing week (Figure 17). In this, her upper body is stylised in pose and adornment in a traditional Thai style with the transition to her scaled tail and lower elaborate fin being marked by a belt and two frills that are also somewhat suggestive of the traditional fish's mouth motif of the Matsya avatar.

One of the most notable material representations of Suvannamatcha is a statue commissioned by the Songkhla municipality in the south of Thailand (Figure 18). The council wanted to find a device to promote Similla beach and took their inspiration from Eriksen's famous statue of The Little Mermaid in Copenhagen.[52] Cast by Thai sculptor Jitr Buabutr in bronze, like the Copenhagen statue, the figure more closely resembles Western mermaid imagery (and particularly the pose of the realist rendition of the mermaid in John William Waterhouse's famous 1901 painting 'The Mermaid') than the more ornately tailed and costumed figures in Thai art (such as Figure 17).[53] Since its installation in 1966 the statue (Figure 18) has continued to fulfil its function as a tourist attraction and photo opportu-

Figure 18 – Songkhla mermaid statue (photo: Jefferson Scher, 2017).

nity, and has also become something of a religious icon, with some visitors draping the statue with garlands and yellow scarves to elicit support for their prayers and/or acknowledge the success of these. Indeed, the local council was so concerned by the shift in the statue's social function that it issued an announcement in 2015 that the site should be regarded as a place of secular tourism rather than a religious site (Boonchote 2013: online).

While the Golden Mermaid's tale has not been the subject of a Thai feature film, it provides a reference point for a slow-paced, low-budget, romantic/erotic feature entitled *Wang Ngang Ngueak* ('The Wished-for Mermaid')[54], written and directed by Wichian Thain in 2007. The film features a young man living by the coast while researching a book on mermaids. The film opens by showing him repeatedly gazing at mermaid images in photos and on his laptop[55] and neglecting the attentions of a young woman who is seeking his affections. As if his desires are made flesh, a beautiful, ornately made-up mermaid with a glittering fabric tail and matching bikini top arrives onshore and then immediately transforms herself into a human. She then finds her way to his house where she waits, naked and mute, for him to find her. Puzzled by her identity and her inability to speak, he lets her stay and she sees his collection of mermaid images and understands his fascination. Warmed by this (and by his possession of a mermaid's tail scale) she begins to speak. The couple rapidly become romantically involved, culminating in a slow-paced, softcore sex scene. After this, the mermaid sees a picture he has of the Golden Mermaid and professes her identification with it and then, delightedly, watches a sequence from Disney's *The Little Mermaid* (Ron Clements and John Musker, 1989) that is showing silently on his TV set. When she touches the screen a thunderclap rings out, lightning flashes and she runs to the shore and faints. Bringing her back, he puts her to bed. Upon waking and explaining to her lover that she cannot continue to live on land, she departs for the sea, leaving him heartbroken. The film is notable for drawing on both traditional Thai mermaid imagery and international representations to reflect on the nature of obsessive longing and to insert a traditional mermaid figure into a contemporary environment within which mermaid media-lore intertwines with national traditions.

The second major Thai mermaid tale occurs in *Phra Aphai Mani*, an epic poem written by 19th Century royal poet Sunthorn Phu. The poem concerns the adventures of Prince Aphai Mani following his exile from the royal court where his devotion to music, and to playing the *khlui* flute in particular, has angered his father, who wishes him to devote his time to soberer administrative matters. As Pupaka (2015) identifies, Aphai's fictional wanderings are set on the fringes of the nation state in an unspecified marine region and the poem addresses issues concerning cross-cultural contact and processes of multicultural integration. Merfolk enter the narrative at the point at which Aphai is escaping the clutches of an ogress who seduced him in the form of a beautiful maiden and bore him a son, Sinsamut, before he realised the ogress's true identity. A mer-family assist him, at considerable cost, with the father and mother being killed by the ogress. Their daughter takes Aphai to a magical island where he fathers a son with her, called Sudsakorn, before he (like Hanuman in the Ramayana) moves on to fresh adventures. Later, as his son matures, his mother sends him to search for her lost love.

Various characters and episodes from the poem have been represented in Thai culture. Soon after the poem's publication aspects of it were dramatised in the dance-drama form

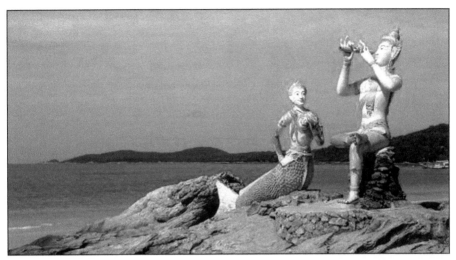

Figure 19 – Statue of Phra Aphai Mani and mermaid on rocks at Sai Kaew Beach, Ko Samet [original location] (Photo by Roy Kavanagh, 2012).

known as *Lakhon chatri* and were subsequently represented in visual art and statuary of various kinds. The island of Ko Samet has been identified as the paradise island where Sudsakorn was born and this connection was commemorated in a sculpture at Saikaew beach installed around 1970.[56] Drawing on Thai art traditions, the statue (Figure 19) shows the prince playing his flute for his mermaid lover. As is apparent from the number of photos uploaded to social media platforms, the statue and its scenic backdrop proved highly popular with visitors in subsequent decades but, despite this, the statue was relocated in 2016 to make way for a more recent work by Haritorn Akarapat (Figure 20). The new statue represents its mermaid in more realist form and shows her as a loving mother, standing aloft on her tail while holding an infant as if launching him into the

Figure 20 – Akarapat's mermaid and baby statue, Ko Samet (Photo: Coconuts Media, 2015).

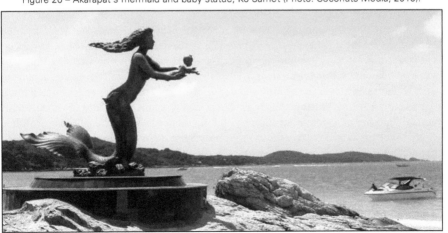

43

Figure 21 – Cover of an English-language version of the DVD *Legend of Sudsakorn.*

water. The statue was commissioned by the Thai petroleum company, PTT, which was responsible for a major oil-spill on the island in 2013 that resulted in it being sued by local tourism operators for compensation for lost earnings (English 2014: online). Akarapat responded to his commission by setting out to create an iconic attraction inspired by folklore that would also demonstrate "the strength and energy of love" in a more general sense (p.c. July 2017). Along with the installation of the new statue, PTT funded the repainting of the earlier statue and its relocation to a nearby hilltop. The two images now form a pair, contrasting impressions of traditional national imagery and narrative themes and a more generalistic, international image of the mermaid as a loving ocean mother (as an offset against its sponsoring company's actual care of marine resources).

In addition to statuary representations, the mermaid element of *Phra Aphai Mani* has been represented in three Thai feature films. The earliest of these was *Sudsakorn* (Payut Ngaokrachang, 1979), a low-budget production made as a labour-of-love by its director that was Thailand's first feature-length animated film.[57] The film focuses on the adventures of Sudsakorn as a precocious and resourceful boy, meeting various supernatural entities and battling creatures such as sharks and dragons. The film represented his mermaid mother as a glamorous figure with long tresses and an ornately finned tail in a design that evokes traditional renditions of both Suvannamaccha and *Phra Aphai Mani's* mermaid. Krisom Buramasing's identically titled live-action film (2006) represented Sudsakorn's mermaid mother in its early sequences in a manner more akin to Western realist representations of mermaids. As Figure 21 (a promotional image for the film) suggests, the film's representation was also a significant erotic one. Aside from her sexualised presence as an element of box-office appeal, such images serve to suggest the charms that detained Phra Aphai on the magical island of the story. More extended

Figure 22 – King Uros from *Apaimanee Saga* comic.

representations of mermaids occurred in *Phra Aphai Mani* (Chalart Sriwanda, 2002). The film condenses aspects of the original poem, specifically Phra Aphai's seduction by the ogress, his relationship with the merfolk who assist him in escaping her and his romance with a young mermaid. The merfolk are represented with silvery tails, frequent the shore and are friendly to humans. Phra Aphai's romance with a beautiful mermaid (played by well-known actress and singer Juraluk Krittiyarat[58]) is a particular feature in the latter part of the narrative and includes a sequence in which she uses a magic pearl to transport him under the sea in an extended sequence that recalls the similar scene at the end of *Splash*. In their opposition to the ogress and with regard to the assistance they offer to humans, merfolk are aligned more clearly to the latter than to the former and – despite her essentially human (giant) body – it is the ogress who appears other and inhuman rather than the merfolk. In this manner sea people and land-people are posed as complementary.

The mermaid/Sudsakorn element discussed above is also prominent in the Thai comic *Apaimanee Saga* (2001–2006), written and drawn by Supot Anawatkochakorn. Loosely based on *Phra Aphai Mani*, the extended narrative features a clan of merfolk, led by their king, Uros. Uros's daughter, Mira, plays a prominent role as coordinator of a dolphin pod who come to Apaimanee's rescue at a crucial point in the narrative. The representation of Uros is relatively unusual in 20th–21st Century international popular culture, as mermen are not commonly depicted (see Hayward 2017a: 151–166). Uros belongs to the only cluster of mermen that have a significant presence in popular culture, being a powerful royal patriarch akin to Andersen's sea king and Disney's King Triton. His visual depiction differs from these models by virtue of retaining the fish's mouth intersection of lower fishly form and upper human (Figure 22) prevalent in those representations of the Matsya avatar (discussed in Section I). His character thereby represents a direct insertion of traditional Hindu imagery into 21st Century popular culture in a manner that has not

occurred to date in India. Unwieldy as his body might appear to a Western viewer – on account of the ambiguity of its conjunction of fish and human – it is a highly coded one that adds significant depth to the fiction for national readers. Uros's daughter, by contrast, is styled in a more modern manner, akin to images in Japanese manga art, with a smooth transition between a simple, shiny fishtail, a human upper body and with her breasts highlighted by decorative swirls. The comic series' representation of a mer-clan, with such pronounced differences in appearance between the King and his daughter, highlights the different nature and symbolic role of powerful, patriarchal males and more conventional – and conventionally eroticised – females. This also provides the merfolk with a complexity that is more evocative of the nature of Hindu mythology, its avatars and *vahanas* (etc.) than any attempt to create a cohesive species of merfolk (such as that proffered by the US hoax documentary *Mermaids: The Body Found* (Sid Bennett, 2012).[59]

Departing from adaptations of traditional narratives, Thailand has also produced other mermaid-themed material with more generic, international mermaid themes. The earliest production of this type was *Ngueak saw chao sanae* ('Charming mermaid') (Chachai Kaewsawang, 2006), a low-budget feature that allowed Julaluk Krittiyarat to return to playing a mermaid (after her previous role in Chalart Sriwanda's *Phra Aphai Mani* [2002] as discussed above). The film features Krittiyarat as a university student who finds that she turns into a mermaid when immersed in water. Her father then comes to her aid by seeking a legendary pearl that can allow her to retain human form. This theme was echoed in a subsequent television series aimed at the teen and pre-teen market established by Australian TV series such as *H20: Just Add Water* (Jonathan M. Shiff, 2006–2010) and *Mako Mermaids* (Jonathan M. Shiff, 2013–2016) and followed up by the various Indonesian Sinetrons discussed in Chapter 5 of this volume. The 18-episode series *Rak Nee ... Hua Jai Mee Kreeb* ('Love this finned heart') (2012) was set in a coastal community and featured two young mermaids in human form who strike up a friendship with two researchers who (unaware of the girls' true identities) are trying to prove that mermaids exist – the mismatch providing ample opportunity for comedy, alongside the series' love angle between the older mermaid and younger researcher.[60] Replete with sequences showing graceful mermaids swimming over coral reefs with shoals of bright, tropical fish, the series combines locally nuanced elements (such as humour and courting practices) with a more generic international imagery and associations that do not engage with Thai folkloric heritage to any appreciable degree.

Another Thai film that incorporates foreign mermaid traditions in a markedly different manner is *Gancore Gud* (Apisit Opasaimlikit, 2011). The fast-moving and somewhat complicated film features a Thai hip hop group, named Gancore Club, stranded on a place called Mermaid Island where they are assailed by both cannibal islanders and aquatic zombies. The back-story to this situation draws on the Japanese *ningyo* folklore discussed in Chapter 3. It involves Japanese troops on the island during World War Two experimenting by feeding a local girl with *ningyo* flesh. While she gains the youthful longevity described in Japanese folklore she also develops a desire to bite humans, an action that causes her victims to become flesh-eating zombies that have to stay in water to avoid withering up and dying. The now 70-year-old (but still youthful-looking) girl has become the island's priestess, venerating a mummified *ningyo* (see discussions in Chapter 3).

Assailed on all sides, the band encounter a Japanese tourist who turns out to be a relative of the commander of the Japanese forces on the island and who is keen to return the mummified *ningyo* to Japan. At the end of the film the *ningyo* is accidentally dropped into the water, regenerates as a mermaid and swims away.

Conclusion

Unlike Japanese culture, in which we can observe a significant 'mermaidisation' of the folkloric fish/human figure of the *ningyo* over the last 150 years (see Chapter 3 of this volume), no such general process can be discerned in India with regard to contemporary representations of a range of Hindu mythological entities. The situation in Thailand is less complex with regard to there being a tradition of representing mermaid-like figures in Thai legend and epic narratives prior to the diffusion of mermaid imagery through various forms of Western cultural imperialism. In this regard, there is both a greater complementarity to local and imported mermaid figures and a notable revival of traditional Matsya avatar imagery in the form of King Uros in Thai comic books. With the exception of Goa and the Paravar Coast, which might be regarded as having local traditions of mermaid imagery on account of the early introduction of the figure into churches and its subsequent manifestation in other areas of public culture, in much of India the mermaid continues to have an exotic aspect. This has manifest itself in various ways, some of which are more complex than others. In the case of the Gothic Revival, mermaids feature at the base of Cursetjee's monument in Mumbai, where they signify Europeanness (and the socio-political capital that aspect had in the mid-1800s) and, through that, modernity (at the same time as those self-same aspects signify the Western classical traditions that the Gothic Revival consciously sought to evoke). In the case of the feature films discussed above, their mermaids represent particular packages of cultural-outsiderness that allow the films' heroines to flout various social and behavioural conventions. The prominence of mermaid statues as tourism attractors in both India and Thailand is also notable and appears to be (directly or indirectly) influenced by the continued effectiveness of Eriksen's Little Mermaid statue in Copenhagen as a brand mark for the city (and for Denmark as a whole) that continues to attract high numbers of tourists. In the case of Thailand, the Songkhla mermaid – envisaged purely as a secular tourist attraction – has been both highly effective in attracting visitors and has assumed the status of a religious icon. The success of several Indian statues as tourist attractors has relied more on the monumental scale and/or overt sexuality of the figures' forms than any recontextualisation of them as sacred by national visitors, but it is also notable that in Kanyakumari there are aggregations of mermaid imagery that cross-associate sacred and secular aspects, catering for tourists who both visit sacred sites and also enjoy the town's beaches and coastal waters. While Kochi's proposed icon for mermaid island might now be an item in an intangible archive of unbuilt architectural follies, its imagination reflects the manner in which the mermaid is a highly flexible symbol that works at various scales. Its polyvalence allows it to be credibly proposed as a symbol of municipal grandiosity at the same time as it works as a complex coded motif in such subtle contexts as the undersides of church pulpits in Goa.

Acknowledgements: Thanks to Roy Cavanagh, Channi Chaitali, Lovell D'souza, Philip Jepsen, Alison Rahn, Dan Sheffield and Anand Tharaney for their research assistance and to Supriya Banerjee, Swaminathan Ramanathan, Chalida Uabumrungjit and Ines upanov for their feedback on initial drafts of this chapter.

47

Notes

1. Around 80% of India's population identify as Hindu.

2. Around 90% of Thailand's population identifies as Buddhist and the King is required to be a follower of Theravada Buddhism.

3. There are also engagements between Hindu religious/folkloric traditions and imported mermaid folk- and media-lore in Sri Lanka, Myanmar and Cambodia that merit further research and analysis.

4. See Wilkins (1900: 134–141) for further discussion.

5. In Nagulapuram (Andhra Pradesh) and Mannarkoil (Kerala) – thanks to SupriyaBanerjee for this information.

6. See Hayward (2017a: 10 and 151–166) for discussion of the merman.

7. See, for example, Virtue (2005: 190) or the entry on *Matysa* in Mermaid Wiki (nd) http://mermaid.wikia.com/wiki/Mermaid_Wiki. However, in terms of the Freudian analyses of the merman as a distinctly demasculinised figure that I have advanced elsewhere with regard to the Western mermaid (Hayward, 2017a: 151-166) the *Matsya* avatar is less obviously problematic (in phallocentric terms) in that his representation implies a fully human form emerging from (and thereby partially concealed by) a fish's mouth *and* has the symbolism of a tail that can also be considered as a phallic symbol (ibid: 13–15).

8. Note that this figure has a single set of arms (as per a Western merman) rather than the double set more common in representations of the *Matsya* avatar.

9. See, for example, Hira Devi's 'Matsya Kanya' (undated), reproduced online at: http://www.exoticindiaart.com/product/paintings/matsya-kanya-mermaid-DM42/ – accessed 2nd November 2017.

10. This island is a mythical one but has at various times been proposed as either Sri Lanka or an area in the Maldives.

11. The Khymer version of her name is often transliterated as Sovann Maccha.

12. Thanks to Therephan Luangthonhkum for discussing this issue with me.

13. *Nāgiṇīs* are also represented and/or termed as *Vish Kanya* ('snake women') in some regional folklore traditions.

14. Another aspect of snake symbolism concerns *kundalini*, literally a 'coiled up' power within humans believed to be located at the base of their spines that can be liberated/activated by the pursuit of yoga and can rise within the body to cause enlightenment. The *kundalini* is often associated with and/or conceived as the divine female energy entity Shakti. In some of the esoteric traditions and practices of tantra – a system of beliefs and practices designed to achieve spiritual enlightenment – the activation of the *kundalini* is associated with sexuality and with intense sexual experience. While the latter aspect has been prominent in Western engagements with the tradition, such as various tantric sex practices (see Urban 2003), this is only one element of a complex body of tantra philosophy and practice in India (see White 2006).

15. There are exceptions to this, such as the representation of a *nāgiṇī* in overtly sexual motifs of the 13th-Century Ramappa Temple complex in Telangana (see Kumari 1988).

16. There are also a number of topics that would merit further research, such as the associated fish and mermaid imagery around Lucknow that derives from ancient Persian mythology and was elaborated in the 1800s in the royal court of Awadh (see Singh 2014: online).

17. Christianity arrived in India long before the arrival of the Portuguese, with Frykenberg (2008) identifying that it was present in several areas by the 6th Century.

18. While sirens took a variety of forms (including bird-like ones) in classical literature and medieval cultures, their representations in Portugal and elsewhere in Western Europe were standardised as more typical mermaid-like ones from the 1500s on. See Holford-Strevens (2006) for discussion.

19. *Sireias* have survived to the present as ornamental details in places such as the exteriors of the Igreja de São Cristóvão de Rio Mau in Vila do Conde and the Ingreja do Mosteiro do Salvador de Travanca in Amarante.

20. See Pereira, J (1995) and Noronha (1997) for discussions of Indian influences on Goan colonial architecture.

21. See Hayward (2017a: 22–23 and 113–115) for discussion of specific local associations.

22. *Yakshis* are attributed with varying degrees of benevolence or malevolence in various regional traditions, but are often characterised in the latter terms in Kerala (such as in Malayattoor Ramakrishnan's Malayam-language novel 'Yakshi' [1967], adapted into an eponymous film by K. S. Sethumadhavan in 1968). In these texts the *yakshi* resembles the siren of Western antiquity, using her charms to lure men to their doom. Kanayi's *Yakshi* statue was commissioned by Kerala's Irrigation Department to attract tourists to their new

park. The work drew on the artist's training in Western sculpture to create a monumental image of a naked woman sitting up with her legs wide apart. The statue attracted controversy, resulting in delays to its construction but continues to be perceived as bold in its sensuality; see, for example, Madathara (2017: online).

23. See upanov (2014/2015: 304).

24. Although it is also telling that the original 'brazen' imagery of bare-breasted female figures on some of the pulpits have been subject to subsequent modification/mutilation, as in the case of the pulpit at Saint Anne's, whose figures have had their breasts chiselled off by unknown agents.

25. From his website: https://somuchworldsolittletime.com – accessed 4th July 2017.

26. The film was subsequently dubbed into Hindi and released as *Sagar Kanya*.

27. See Hayward (2017a: 91–101) for further discussion.

28. See Haldankar (2015) for further discussion.

29. The 2016 event also featured a colourfully tailed mermaid reclining on blue waves on King Momo's float.

30. For a discussion of the restoration process and copies of Indian media reports, see Goa Jazz (2012: online).

31. It is also notable that in the last two decades the area has been served by businesses such as Rudy's Golden Mermaid Bar on Calangute Beach (which used the image of Ariel from Disney's *The Little Mermaid* as its logo) and the Mermaid Restaurant in Candolim.

32. See Superle (2011) for further discussion.

33. Nor, perhaps, of the similarity of the mermaids' appearances to representations of the Matsya avatar.

34. These trumpets were the shells of giant Indian Ocean sea snails (*Turbinella pyrum*), known in India as *chanks*.

35. *Shankas* were used in Hindu rituals to welcome the arrival of a deity and/or announce any auspicious event.

36. See Chopra (2011: 31–73) for detailed discussion.

37. While the Cursetjee monument occupied a prime location in 19th-Century Bombay, it (along with many other examples of Bombay's Gothic Revival architecture) was variously damaged and/or spatially recontextualised by subsequent city developments, particularly as motor transport increased and new roads were imposed over prior spatial structures. The metal surfaces of the monument deteriorated considerably in the years following its erection, particularly as a result of inner-city air pollution, and the mermaid fountain figures were also damaged by vandalism at various points. These aspects were finally addressed in the early 2010s as part of a concerted attempt to restore and re-emphasise the heritage of Mumbai's cityscape. Cursetjee's monument was extensively restored in 2012–2014, resulting in wide press coverage that cited it as an "iconic" example of the city's 19th-Century architectural heritage that merited conservation. See Deshpande (2013: online), for instance.

38. A similar idea led to the announcement of a resort development in the Gupuru River in Mangalore entitled Mermaid Island in 2010.

39. Kerala Tourism (nd) uses both names on its web page about the statue (which translates the former term as 'Mermaid'), leaving the latter untranslated.

40. Different dates appear for the completion of this work; 1981 appears the most likely.

41. See note 22 (above).

42. For an extended video representation of the statue by Ajar Kumar Ojha see: https://www.youtube.com/watch?v=44A7AXI_54g – accessed June 2nd 2017.

43. The Shankhumugham Beach statue also inspired a related work in the grounds of Cochin University of Science and Technology that attracted sustained (and decisive) protest about its blatant sensuality. The work in question was a smaller-scale, 5.5-metre long and 1.7-metre high topiary imitation that was made by gardener P.A. Varghese in 1992. In the mid-2000s the University's Women's Welfare Association mounted a campaign for its removal on the grounds that its "high[ly] suggestive torso is not in keeping with the decorum of a centre of learning" (Mary, 2010: online). After the university's registrar responded by proposing to conceal the mermaid behind palm trees, the Association pressed for more drastic action that was eventually undertaken by hacking off mermaid's breasts in 2005. The action led to considerable media coverage and online debate about the propriety of such representations and of the legitimacy of mutilating the topiary in such a manner; see, for instance, the posted items on the Judgment of Paris website (2005).

44. See Kochi Connect (2015) and Unattributed (2015) for information on the announcement.

45. See, for example, responses to Kochi Connect (2015).

46. I have been unable to ascertain what Chinese philosophical tradition the item refers to.

47. By 2011 *The Hindu* newspaper published a large colour photo of a group of statues under the heading 'Mermaids in Distress' and characterised them as an "eyesore" (Unattributed 2010).

48. These figures appear to have been around since the 1990s but it is uncertain whether they featured in earlier versions of the event. The mermaid depicted in Figure 15 is animated by means of an electric motor, enabling her upper body (above her midriff) to sway from side to side.

49. Research for his filmic work-in-progress *Gods and Robots*.

50. Since Thai phonology differs greatly from languages like English, the latter half of the term is also romanised as *nguak* or *ngurk*.

51. Thanks to Benjamin Baumann, Chintana Sandilands and Wiworn Kesavatana-Dohrs for discussing Thai mermaid terminology with me.

52. Unlike the former British colony of India, English (and other European-language) fiction has been far less prominent in Thailand over the last 200 years, and Andersen's 'The Little Mermaid' has largely become familiar via secondary representations such as the 1991 Disney film and/or by awareness of Copenhagen's iconic The Little Mermaid statue.

53. Also see the statue at Siam Park City amusement complex that closely resembles the Similla statue.

54. Also referred to in some publicity for the film with the English title 'The Mermaid of Paradise'.

55. The film often includes a small, framed image in its screen compositions showing a mermaid sitting on a crescent moon. This image exists in various versions and appears to date back to Victorian Europe. Its symbolism is unclear.

56. I have been unable to ascertain the sculptor's name, but he appears to have been a local artist without formal educational training.

57. There was also an animated TV series version of the tale broadcast in 2002 that was unavailable for viewing during the research for this volume; it is therefore not discussed in the chapter.

58. Also known as Juraluk Ismalone.

59. See Hayward (2017a: 167–185) for discussion of the series and its representation of merfolk.

60. The series was also notable for spawning both female and male aficionados. A number of the latter appeared in various cosplay photo shoots subsequent to the series, either imitating mermaids in (variously glamorous or grotesque) drag-style or else appearing as merman (for further discussion see Chow 2014: online).

Chapter Three

Japan: The 'Mermaidisation' of the Ningyo and related folkloric figures

Philip Hayward

Introduction

Early 2017 saw the release of a US independent film production entitled *The Ningyo*, directed by Miguel Ortega. Set in 1909, the film follows the adventures of a professor from a Californian University who sets out to track down the *ningyo*, a legendary Japanese creature, part human, part fish, whose flesh has magical properties in that anyone who consumes it becomes able to live healthily for centuries. The film chronicles the extremes to which the professor will go to prove his hunch that the *ningyo* are real rather than mythical creatures. The *ningyo* is a figure from Japanese folklore that features in a range of narratives and visual materials dating back to ancient times, and the legend of the beneficial effects of consuming its flesh are present in several accounts. While the term *ningyo* is often translated into English language as 'mermaid' (or 'merman', as the term is not gendered), this is misleading in that the creatures originally described and represented in Japan are not the familiar portmanteau form of the Western mermaid, with abrupt delineations between an upper, fully human half and a lower, fully piscine one, but are rather more varied (and often monstrous) piscine-humanoid beings. One well-known image (see Figure 1) essentially has a (horned) human head on a fish's body, whereas other early images have either monkey-like heads or fish-scaled humanoid faces on fish bodies. One of the most significant aspects of Ortega's film is that it represents

Figure 1 –
Representation of a
ningyo supposedly
caught in Toyama Bay
(1803).[6]

a partial reversal of a centuries-long process of the diffusion of mermaid imagery into Japanese culture from the West and, as will be discussed, a progressive 'mermaidisation' of the *ningyo* and related folkloric figures that has led to them increasingly being rendered in a Western standard form.[1] The nature of this standardisation, and of its re-interpretation within these parameters, is explored in the following sections with regard to a variety of popular cultural representations.

I. *Ningyo* Folklore

Discussion of the *ningyo* in its traditional Japanese context is complicated by the nature of the term itself. *Ningyo* – 人魚 in Kanji[2] – literally means 'human-fish' and historically has been applied to a wide range of creatures, ranging from fish with human aspects (such as faces and/or the capacity to speak) through to water nymphs who have human form (some or all of the time) despite being sea-dwellers (see Fraser 2017: 21 for further discussion). Prior to the mid–late 1800s the Western mermaid/merman form, with an upper-half entirely human and a lower-half entirely piscine, was uncommon in Japanese descriptions and/or visual representations of *ningyo*. However, despite this and occasional uses in *manga*, *anime*, theatre and live-action film titles,[3] the English-language term 'mermaid' has not entered Japanese language usage to any significant degree as a standard loanword[4] and, when used (usually in the modified phonetic form *māmeido*), is predominantly regarded as an exotic term referring to a distinctly Western-style of female-fish creature.[5]

The power of *ningyo* flesh to bestow extreme longevity for those who consume it, which is a central theme of Ortega's 2017 feature film, is derived from one of the earliest Japanese *ningyo* legends. This legend, often referred to as 'Yao Bikuni' (the '800 year [old] Buddhist priestess'), involves guests attending a feast at which *ningyo* flesh was served. Reluctant to consume it, the guests wrapped up their portions and took them home or otherwise disposed of them. However, one of the portions was found by a young girl who ate it, not knowing what it was. She then became fixed as permanently youthful and subsequently

lived to be 800 years old, initially becoming a Buddhist priestess wandering the world while all around her aged and died. A different account of the perils of consuming *ningyo* flesh has been associated with Togakushi, in Nagano prefecture. A local legend tells of a fisherman who caught a *ningyo* and killed it, despite its pleas for mercy, and took the meat home. There his children consumed it, only to grow scales and die.[7] Another region, Lake Biwa, also has a particular association with *ningyo* folklore. A tale concerning a (male) *ningyo* who seeks the assistance of a prince exists in two main variants. In one, a *ningyo* asks a prince to build a temple so that he can worship Kannon (the Buddhist goddess of mercy) to ensure good fortune. This legend is associated with the Kannonshô temple, which was supposedly built on the lake's shore in fulfilment of that request. A second tale tells the story of a prince who encounters a *ningyo* who tells him that he was once a fisherman but was transformed into monstrous form after fishing in forbidden waters and then asks the prince to exhibit his body after his death as a warning to others.

II. *Misemono* and the International Trade in Preserved *Ningyo* Carcasses

During the Edo period (1603–1868), a type of public exhibition known as *misemono* became highly popular in Japan. This form was akin to Western phenomena, such as the so-called 'freak shows' and 'cabinets of curiosity' popular in the 1800s in which various exotic objects were displayed for the public gaze. *Misemonos* occurred in various locations, including central city areas and/or the forecourts of religious shrines. Markus characterises them as "an inalienable part of the Japanese urban landscape" at this time, identifying that "their popularity extended to all strata of society" and that "their oddities and marvels were a favorite topic of scandal sheet and scholarly disquisition alike, and inspired the author and printmaker" (1985: 499). Manufactured bodies of various folkloric and/or crypto-zoological[8] species (presented as if authentic) were a common element of such exhibitions, and mummified *ningyo* bodies (known as *ningyo no miira*) were popular attractions of this kind. In this manner, the manufacture of preserved *ningyo*, and the skill sets required to produce them, were intertwined with the development of the *misemono* circuit and also resulted in *ningyo no miira* being available for sale to other purchasers, most notably foreign mariners and travellers who arrived in the South China Seas and Japanese waters with increasing frequency in the early–mid-1800s. Working within the somewhat broad parameters of the traditional form of the *ningyo*, early manufacturers of *ningyo no miira* basically combined mammalian heads (either genuine ones, such as monkey heads, or fabricated ones) and fish bodies (of various types). These were manufactured in two main varieties, both of which possessed human-like arms and hands: one being arranged horizontally, with the *ningyo* reclining on its belly, and one where it was displayed vertically, as if hanging in the water, with its hands clasped to its face and with its mouth open. The grotesque appearance of these artefacts was consistent with some folkloric accounts of the *ningyo* and fed into subsequent representations of the creature by writers and artists who, as Markus (ibid) identified, were inspired by aspects of the public exhibitions. Reflecting the previously identified association between *misemonos* and religious shrines, a number of *ningyo no miira* were introduced as features in shrines during the Edo period and some of these have survived to the present, albeit with varying degrees of prominence. One such relic, supposedly the corpse of the *ningyo* of the aforementioned

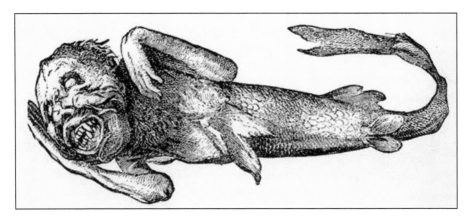

Figure 2 – Feejee Mermaid (contemporary engraving) (c1842).

Lake Biwa legend, is retained at Tensho-Kyosha at Fujinomiya in Yamanashi prefecture, and other examples exist at the Karukayado temple in Koyasan, the Myochi temple at Kashiwazaki in Nigata prefecture and in the Zuiryuji temple in Osaka.

In the early 1800s several *ningyo no miira* were acquired by Western mariners. Given the closed nature of Japan during the Edo period, when foreigners' access to the country was highly prescribed, Viscardi et al (2014: 103) contend that Westerners' first exposure to Japanese *ningyo* artefacts 'almost certainly' occurred at a *misemono* that was located on Dejima island in Nagasaki Bay (which was an authorised entrepôt for Dutch mariners at this time).[9] The *ningyo no miira* prepared in this period included the best-known example exhibited in Europe and North America during the 1800s, the so-called 'Feejee Mermaid', which was first acquired by an American mariner, Samuel Barrett Eades, around 1820 and was exhibited in England before being acquired by the showman P.T. Barnum in 1842. Along with affixing a South Pacific association (by specifying it as the 'Feejee' – that is the Fiji – Mermaid), Barnum's use of the term 'mermaid' to refer to an artefact with a shrivelled and somewhat hideous appearance reflected his trademark chutzpah, with promotional posters for its exhibition showing a far more recognisably appealing mermaid. As a result of this type of publicity, Barnum's initial exhibition of the Feejee Mermaid in New York was highly successful and much discussed (see Bondeson 1999: 36–63). The artefact was later destroyed by a fire but a contemporary engraving of it shows it to have had a typical fabricated *ningyo no miira* form (Figure 2).

III. Andersen and Japan

In 1837 Danish author Hans Christian Andersen published a short story entitled 'Den lille Havfrue' that became one of his best-known works. Known in English as 'The Little Mermaid', its titular character sought the services of a sea-witch to gain conventional human form in order to pursue an attachment to a human male. Her story did not end well. Despite her efforts, the man she desired wed another and she died, broken hearted. The story proved popular and was first translated into Japanese in the 1910s and 1920s under various titles before it acquired what is now its standard Japanese-language title of

Ningyo Hime ('Ningyo Princess'). As Fraser (2017: 70–183) discusses, the story struck a chord with a number of Japanese writers, particularly female ones, who have provided a series of "open-ended and nonlinear" (ibid: 13) engagements with Andersen's tale, including a number of works aimed at a young adolescent audience that use the mermaid and her accrued cultural meanings to explore female subjectivity and experience. Despite the frequent use of the term *ningyo* in their titles and texts, most of these works drew more heavily on Andersen's model than on traditional Japanese *ningyo* folklore and didn't attempt significant infusions and/or modifications of the latter. In addition to exploring Japanese versions of Andersen's tale, Fraser also identifies a number of Japanese engagements with English-language texts that had also adapted elements of Andersen's original tale. Her discussion of Tanizaki Jun'ichirô's adaptation of Oscar Wilde's story 'The Fisherman and His Soul' (1891) in his short story 'Ningyo no Nageki' ('The Ningyo's Lament') is particularly effective in emphasising how the voluptuous mermaid-form *ningyo* of the story is an exoticised representation of elements of traditional *ningyo* imagery synthesised with mermaid imagery drawn from Andersen's original story (ibid: 72–86).

IV. The *Ningyo* in *Manga* and Audiovisual Productions

Since the 1950s, two forms of visual-based narrative, the *manga* and the *anime*, have become highly popular in Japan. Similar to Western graphic novels, which have been substantially inspired by it, *manga* is a form based on arrangements of drawn images and text, often in black and white but also in colour. *Anime* is a style of audiovisual text that either animates *manga* texts or else is inspired by them. Commercially successful *manga* and *anime* are also sometimes adapted into live-action television or film narratives. *Manga* and *anime* derive from visual media traditions dating back to the Edo period, and often represent aspects of traditional and/or folkloric culture along with more modern representations and innovations. As a result, representations of *ningyo* occur in various contexts. Although many draw heavily on the Western figure of the mermaid (and, more specifically that of Andersen's short story and its subsequent screen and musical theatre adaptations)[10] there are also some that draw on and represent aspects of traditional *ningyo* folklore. The most notable example of the latter is Takahashi Rumiko's *Ningyo Shirîzu* ('Ningyo Saga') trilogy (1984–1994) and subsequent anime feature adaptations, such as *Ningyo no Mori* ('Ningyo Forest') in 1991. Takahashi's narrative draws on the aforementioned Yao Bikuni folktale as the basis for a story concerning a young man who accidentally acquires longevity by eating *ningyo* flesh and then searches for other *ningyo*, in the hope that they will be able to free him from his condition and enable him to age and die. When he finally finds a pod of *ningyo* he discovers that they are keeping a (human) girl to whom they have also fed *ningyo* flesh and are about to eat her in the hope of gaining aspects of her physical beauty for themselves. He succeeds in rescuing the girl and together they travel on in the hope of eventually ridding themselves of their condition. While the *ningyo* in Takahashi's tale have some degree of similarity to Western mermaid form, their hideous faces (Figure 3) recall early representations of *ningyo*.

Oda Eiichiro's manga series *Wan Pîsu* ('One Piece') (1997–present) and subsequent animated TV series and films are based around a young adventurer seeking treasure and aiming to become king of the pirates. The series is notable for having two sets of piscine human characters, a hybrid form with gills, fish-like faces and human-type bodies named

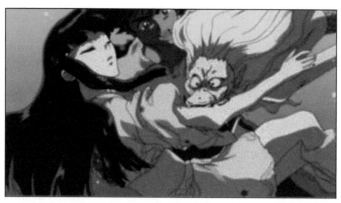

Figure 3 – A menacing *ningyo* from *Ningyo no Mori* anime (1991).

the *gyojin* ('fish-human') and merfolk (with human upper-halves and piscine lower ones) named *ningyo* (i.e. 'human-fish'). One of the most notable of the latter is Princess Shirahoshi, a gigantic, pink-haired and red- and pink-tailed mermaid who first appears as a cute infant but then grows into a monumentally statuesque and eroticised adult. Complicating the separate nature of *gyojin* and *ningyo* in the extended narrative, the two species can (and do) crossbreed, usually resulting in merfolk-style offspring.

Along with the *Ningyo Shirîzu* and *Wan Pîsu* franchises, there have also been a number of other screen representations of what the productions' titles indicate as *ningyo* in the post-War period,[11, 12] the majority of which appear as more typical Western mermaids. The first of these was a short, animated film by Tezuka Osamu made in 1964. Simply entitled *Ningyo*, the film is introduced by on-screen text as occurring in a faraway country. Following its introduction it progresses as a visual narrative accompanied by music without captions, narration or dialogue. The film shows a lonely boy finding a small fish on a sandy beach and fantasising it to be a young mermaid with whom he plays before returning home. Carrying the small fish back and putting it in a tank in his house, he continues to imagine it as a mermaid. Unfortunately for him he lives in a totalitarian state where such fantasies are prohibited and he is arrested and subjected to various aversion therapies to make him abandon his fantasising. Managing to escape, he returns home and takes the fish back to the ocean. Pursued by the police, he lets the fish free and then realises his fantasy by encountering a real mermaid, as beautiful as the one he had imagined. Despite the film's title, the figure represented is clearly a Western-style one similar to Andersen's mermaid and the film primarily uses her to emphasise the power of the imagination to overcome conformist repression.

Hino Hideshi's anime *Ningyo no Zan'ei* ('Remembrance/Traces of the *Ningyo*', published in English as 'Memories of the Mermaid'), also depicts its titular *ningyo* as a young mermaid with close resemblance to the protagonist of Andersen's story. Her form is all the more surprising since the young male protagonist of the narrative (who subsequently remembers her) first encounters her as one of the living exhibits in a touring tent show presenting living *yokai* (traditional Japanese folkloric creatures) to audiences. In this context (and others detailed below) we can effectively regard the Western mermaid as having been adopted into Japanese culture as (one potential version of) the *ningyo*. In this

regard, we can identify that the term *ningyo* has gained a particular – and particularly precise – semantic subset that is only made apparent through its literary or visual description. By the latter, I mean that the term continues to refer to a human-fish creature (in a broad sense) in Japanese language but also has a more specific meaning, referring to the Western-form mermaid. This specific interpretation of the term *ningyo* is also evident in a very different audiovisual text produced by Hino in 1988, the short feature film *Manhôru no Naka no Ningyo*.

Hino's 1988 film is more typical of his standard oeuvre than the gently nostalgic *manga* discussed above. Inspired by the combination of horror and *märchen* (i.e. supernaturally themed folktales) in Ray Bradbury's collection *The Illustrated Man* (1951) (Machimaya 2005: 35), Hino's oeuvre combines aspects of Japanese folklore with explicit and detailed depictions of violence (and a more general sense of almost all-embracing menace) in a series of works published in Japan and subsequently packaged and released in English-language versions in the early 2000s. Many of his *manga* depict physical mutilation and decay, and appear to revel in gore and the exposure of the body's innards and fluids.[13] Hino diversified into film production in the mid-1980s, producing a number of films related to his *manga* known as the *Ginî Piggu* series. This series, which commenced in 1985, attracted notoriety on account of its highly realist representations of various forms of bodily damage, causing a degree of moral panic and even police investigations to ascertain whether actual acts of violence had been committed as part of the films' productions (ibid: 36-38). Hino directed the sixth film in the series himself. Entitled *Manhôru no Naka no Ningyo* ('Ningyo in a Manhole') (1988), the film has a simple plotline: an artist whose wife has recently left him devotes himself to painting and to visiting an underground sewer that was once a river where he played as a child and where he recalls glimpsing a *ningyo* or, more accurately and as per his 2015 *manga*, a mermaid-form *ningyo*.[14] On one of his sorties he finds the *ningyo* he recalls from youth, only to discover that she has been trapped underground since that time, with her skin and scales progressively decaying in the sewer water. At her behest, he helps her out of the sewer and takes her to his apartment, placing her in his bath and painting a portrait of her. Despite her relocation to less polluted environs, her condition worsens, with sores and tissue mutations coming to cover her entire body, and she begs him to capture her decay on canvas. When his palette of paints proves inadequate to represent the vivid corruption of her flesh, she invites him to cut open her infections and use the pus and blood to complete her portrait as vividly as possible before she dies. The story invites interpretation as allegorical in a number of ways. In one sense, it concerns the impossibility of (visual and other) representation itself, as the painter's medium proves inadequate to convey the true horror and physical decay. In another, it represents a progressive sense of alienation, disenchantment and despair as the artist-protagonist, already alienated by being separated from his wife, finds it impossible to regain the sense of enchantment in his memory of a mermaid-*ningyo* recalled from a time of youthful innocence. Instead of being able to reconnect with those emotions, he is forced to confront the decaying nature of both dreams and corporeal bodies. Like the mermaid of Andersen's famous short story, who suffers pain as she transitions to a human form that brings her neither comfort nor the ability to realise her desires, the mermaid-*ningyo* of Hino's film suffers pain and despair as a result of her confinement within the human realm where her mer-body decays.[15]

Figure 4 – Promotional image for *Māmeido Merodî Pichi Pitchi* (2005).

The transformative mermaid – a major trope in Western literature and audiovisual media (see Hayward 2017a: 21–50 and 91–109) – is also present in contemporary Japanese popular culture. One example, which derives heavily from Andersen's original story, is Yokote Michiko's *Māmeido Merodî Pichi Pitchi* manga series, published between 2002–2005 in *Nakayoshii* magazine, produced as an anime series in 2003–2005 and as a series of video games in 2003–2004 (Figure 4). The series is modelled on Andersen's tale, in having a young mermaid transformed into a human pursuing the affections of a human prince, with the added novelty that her sisters also come to land and transform and become singing teen idols (allowing the series to release a number of spin-off music tracks and videos). Another well-known example is Kimura Tahiko's *manga* series (and subsequent anime adaptation of) *Seto no Hanayome* ('Inland Sea Bride') (2002–2009), which offers an original twist on both Andersen's and Disney's 'Little Mermaid' stories and the US film *Splash* (Ron Howard, 1984). The narrative commences with a mermaid saving a young boy from drowning in the Seto Sea. The local mer-folk have a law that any contact between them and humans must result in one of the parties being executed. In order to avoid this, the couple get married, much to the disgust of the mermaid's father who is head of a Seto Sea *yakuza* gang. The couple subsequently lives on land, with the mermaid transitioning to human form, while her father tries to kill off his unwanted son-in-law throughout the series. The trope of the transformative mermaid has also often been deployed in *hentai* (sexually explicit and/or perverse) *manga* series. Nagashima Chôsuke's *Ningyo Wo Kurau Shima* (2014–2015), for example – whose title can be loosely translated as 'The Island made

Figure 5 – Cover of 20th Anniversary DVD version of *Densetsu no Māmeido*.

to get Ningyo' – features a group of im-probably buxom young mermaids who en-counter various young island men, undergo transitions to fully human form and then proceed to have strenuous sex with them (to the apparent satisfaction of all concerned). Taking another slant, the title of Akebono Haru's *Momoiro Ningyo* ('Pink Ningyo') (2013) refers to both the colour of its central *ningyo*'s tail and the style of soft-core erotic cinema known as *pinku eiga*. Its plot involves a young *ningyo* finding some (human) erotic magazines in the ocean and resolving to come ashore and transform in order to participate in the activities she has seen depicted. In the *manga* both humour and pathos are gener-ated by her tendency to revert to mer-form once aroused, undermining the primary purpose of her entering human society.

Sexuality is also prominent in the feature-length live-action film *Densetsu no Māmeido* ('The Legendary Mermaid') (Nagashime, 1997) set in Okinawa and starring prominent Japanese porn actress Kazama Yumi. As illustrated on the cover of the 20th anniversary DVD version (Figure 5), which recalls the pose of Eriksen's Little Mermaid statue in Copenhagen Harbour, Kazama stars as a mermaid who comes ashore, in tailed form, periodically transforms to human form – initially with the intercession of a mysterious beach hermit – and subsequently spends time on land having sex with various men before resuming her mer-form and returning to the sea. Despite the somewhat low-budget nature of the production (with Kazama's tail clearly being a fabric wrapping that she can ease off when required) the film provides a representation of transformational mermaid media-lore that is congruent with an estab-lished Western tradition (see Hayward 2017a: 91–110). As the subsequent section dis-cusses, associations of mermaids, beaches and sexuality in Okinawa and the southern islands is not just confined to explicit sex films.

V. Mermaids and Southern Island Tourism

Since its reversion to Japanese administration following the post-war period of US administration (1945–1972), the lower Ryûkyû archipelago (comprising the Okinawa, Miyakojima and Yaeyama islands) has become a major national centre for tourism, lifestyle relocation and retirement, and has also experienced a significant increase in international visitation in recent decades. While the islands possess significant cultural heritage assets, the prime attractions that have been featured in marketing are their beaches, substantial areas of relatively unspoiled coastline and clear-water diving loca-tions. Reflecting these aspects, the region has been marketed with a combination of

standard Sun-Sea-Sand imagery and secondary references to local cuisine, culture and folklore. Within this promotional matrix, mermaid imagery has arisen as a minor but recurrent theme.

Historically the Ryûkyû archipelago has been a complex socio-cultural space with a profusion of local languages (and micro-local variations) and associated folkloric forms and traditions (see Kerr 2000). Prior to 1400, the islands of the region were largely autonomous from each other. This condition altered in the 15th Century with the Ryûkyû kingdom, based in Naha in southern Okinawa Island, progressively exerting control over the region. This tendency consolidated and continued until 1608, when the Shimazu clan from Kyushu invaded and made Ryûkyû a tributary state (albeit one with a considerable degree of socio-cultural autonomy). After 250 years of neo-colonial domination, the southern archipelago was included as a prefecture within the Japanese national state in 1879. As a result of the above factors, over the last 700 years traditional local languages have been increasingly marginalised, firstly with regard to an increasing hegemony of Okinawan language from the 1600s on and, even more significantly, the imposition of standard Japanese as the medium of school education from the 1880s on. Despite this, elements of local folklore and languages persist in remnant and/or modified form in the islands. The latter aspect is pertinent to discussions of Ryûkyûan coastal and maritime folklore. Discussions of the concept of the *ningyo* as a human-fish entity in Japanese national culture in earlier sections of this chapter are complicated in the southern Ryûkyû islands by the presence of another (actual) sea creature that has been interpreted in various folkloric contexts, the dugong (Latin name *dugong dugon*), an aquatic mammal belonging to the *sirenia* order.[16] The creatures have a particular mythological significance in the region, being regarded as both human-like entities in themselves and/or being representatives of marine deities and/or intermediaries between them and humans.

Linguist Daniel Long (2017) identifies that the Japanese-language term *jugon* is a loan-word acquired from English (rather than from the Malay-language term *duyung* from which the English term itself derives) (p.c. June 16th 2017). Long contends that acquisition of the English term was necessary since traditional Japanese language lacks a specific word for dugong, since these creatures only inhabit the Ryukyu islands (which, as discussed above, were only integrated into the Japanese nation state in the late 1800s). By contrast, he identifies a variety of words for the dugong in Ryûkyûan languages, a number of which suggest local perceptions of the dugong as possessing some human characteristics. Long gives two examples of the latter, including *akangwaaiyu* (a local compound term for dugong that means 'human-baby-fish'), and the term *yunaimata*, used in Miyakojima, and *yonatama* in Okinawa, to refer to *both* the dugong and a half-human, half-sea creature. The decline of the languages that these terms originate from, and circulated within, in favour of, first, a standard Okinawan term and, more latterly, a Japanese one, has had implications for contemporary versions and/or accounts of regional folklore. The adoption of terms such as *ningyo* or, more recently, *māmeido*, to refer to figures present in regional folklore significantly alters the specificities (and often basic sense) of the original tales and the creatures they involve. This tendency is present both in more studious attempts to collect, preserve and disseminate local folklore and in freer re-inscriptions within the largely unedited space of the Internet, which increasingly plays a prominent role in the public

representation and promotion of tourist locations. In the latter, the 'niceties' of specific terminology discussed above are sidelined in favour of easily recognisable standard terms that come with ready-made associations drawn from national and/or international popular culture.

In addition to the previously discussed traditional stories concerning *ningyo*, Japanese culture also has a substantial body of maritime folklore concerning other creatures that interact with and impact upon humans in various ways. One such creature is the *namazu*, a giant catfish restrained underwater by the god Kashima that occasionally thrashes around in attempts to escape and causes devastating tsunamis as a result (see Ouwehand 1964). This legend is also related to a more general perception of the common catfish (*Silurus asotus*) – also known as the *namazu* – as variously precipitating or warning humans about impending earthquakes and/or tsunamis (ibid). There is a convergence between this strand of folklore and that involving human-fish creatures in the Ryūkyū Islands. The region has been particularly prone to tsunami activity (most notably with regard to a devastating event in 1771) and a variety of stories abound that link them to (what are usually referred to today as) *ningyo*. One standard story diffused through the Ryūkyūs concerns *ningyo*-type creatures warning humans about impending tsunamis and thereby allowing them to escape.[17] A second, reverse, story involves them calling up tsunamis to rescue them when caught by humans.[18] The expression of these and related stories via the Internet creates another layer of what might be variously understood as distortion and/or innovation.

Over the last two decades the Internet has become a significant medium in both promoting tourism (through official sites, blogs and related social media) and in developing media-lore – a modern, media-based form of folklore (Russian Laboratory of Theoretical Folk-loristics 2014). As Hallerton characterises it:

> The Internet is a wonderfully sprawling repository of arcane fictions and crypto-everything. Its fragmentary and often inter-generative texts thrive and gain momentum with the slightest (and often most erroneous) of pretexts, generating threads of online mythology that variously intersect with older folkloric and mythological stories or else develop independently. (2016: 112)

With regard to southern Japan in particular, reference to mermaids and associated contemporary media-loric myths have flourished on the Internet, free of the necessity of being tied to actual historically documented folklore and/or any answerability to local sources. Internationalisation has also impacted on this space, resulting in: simplifications and/or inventions provided by Japanese tourism promoters to national and international tourists, national and international tourists' contributions to the virtual repository of accounts of regions online, and various highly creative and/or outright fictional embellishments of these.

Similar to the modern destination branding of Takarajima island (which has involved highly tendentious mishmashes of actual historical incidents, Robert Louis Stevenson's novel *Treasure Island* [1883] and a mistaken belief that Scottish pirate William Kidd had visited and buried treasure on the island [Hayward and Kuwahara 2014]), modern media-loric accounts of Okinawa and the southern islands draw on pre-Internet-era stories and associations and remix them in often florid manners. One manner in which this can

be ascertained is by tracing the relation between contemporary online media-lore and more entrenched local perceptions. In September 2016 I visited Miyakojima with my Japanese colleague Kuwahara Sueo to research the background to what has been represented in English-language online media as a significant local cluster of mermaid-themed folklore. During our visit we found minimal inscription of mermaid (or related) symbolism in the island's signage and other public visual culture.[19] Our investigations confirmed our prior hypothesis that what is discussed online as the story of a *mermaid* warning locals of an impending tsunami is actually a translation modification of the aforementioned *yunaimata* legends from the islands.[20] Our research also revealed very slight associations between a variety of online items and locally articulated folklore.

The online sources we took as our starting points had a number of commonalities. The *Stripes.Okinawa* website, for instance, an English-language amenity established to service US military personnel based in Okinawa, featured a news item written by an Okinawan journalist in 2016 that promoted the Miyakojima islands as a premium location for quiet holidays (Kudaka 2017: online). One of the sections of the article refers to a location in its subheading as "Mermaid Ponds" and goes on to describe the ponds in question in the following terms:

> *Toori Ike is a pair of ponds on Shimojijia* [sic] *an island right next to Irabujima. The two big holes in the rock are 246 feet and 181 feet in diameter and 148 feet and 82 feet in depth, respectively. These ponds, which are connected to one another and to the ocean by underwater caves, are a hard-to-miss spot for divers with adventurous minds. Even if you are not a diver, you can still experience the supernatural mood of this place, which is in fact known for its legends of mermaids.* (ibid)

There are a number of aspects of this account that merit comment. One concerns the section's subheading, which uses the term 'Mermaid' rather than any term from Miyakojiman folkore. The other is the free interpretation that posits a "supernatural mood" for the location and then the addition that the area is known for its "legends of mermaids" (ibid). The author has identified that this item derived from a visit to Miyakojima and research into previous online material (p.c. April 6th 2017). A previous item of this type appeared on the *Okinawa Clip* website (an English-language service that describes itself as being "a new style of Okinawa tourism information site where you can find the hidden charms of Okinawa in articles written independently by local writers" [nd]: online]). The website has a series of photographs and linking text about Shimojijima that includes the speculative comment that the ponds' "blue black color makes you feel like being absorbed into the water or even eerie, which might have created some legends including yunaimata (mermaid) legend" (2014: online). The language here is even more speculative: "which might have ..." A short item on the *Cityseeker* travel website[21] also offers a related account of the origin of the ponds, referring to a legend that the (singularly described) pond "became this way when a large wave came from the ocean and came crashing over the pond to save a mermaid who had been caught by humans" (nd: online). Even with a lack of reference to sources, this account of the ponds can be seen to evoke the general mythological connection between marine folkloric figures and tsunamis referred to above. As far as our collaborative research could ascertain, the earliest account of a local tale of this kind was written by Nishimura Sutezou in 1884.[22] In this account, a fisherman from a

small village on Shimojijima encountered a pod of *yunaimata* (dugongs) and caught one and took it home, where he divided it, keeping half for his family and distributing the rest to neighbours. That night the family was woken by a dialogue between the (somehow still sentient) portion of the *yunaimata* retained by him and a powerful marine entity in which the latter promised to send three big waves to float the fragmented *yunaimata* back to sea. These then came, destroying the village and leaving two big holes where the fisherman's house had been located. This tale can be understood as a prohibitionary/cautionary narrative associated with the *yunaimata's* particular importance in Miyakojiman folklore. Re-telling this story with the *yunaimatas* recast as mermaids obviously distorts the original tale to a considerable degree.

In discussing the above, it should be noted that association of mermaids and mermaid folklore with diving spots is not one that requires specific local folklore and/or place-name associations to be mobilised. Divers' names for particular dive locations and dive companies' and/or tourism agencies' promotions of these locations often include colourful terms that lend mystique to them. Corfu, for example has its Mermaid's Cave,[23] Belize has its Mermaid's Lair[24] and Aruba has a Mermaid Dive Center[25] (and there is even a 'Mermaid Grotto' section in the Electronic Arts 'Sims #3: Island Paradise' tourism-adventure video game[26]). Nearer, and more apposite to the topic under discussion, Okinawa has its own Mermaid Grotto dive site on the mid-north coast, which is widely promoted in online tourism literature without any attempt to justify its name by linking it to folklore (see Altimari 2016: online, for instance). But while Okinawa's Mermaid Grotto dive site may not have a local folkloric angle, another location distinguished by mermaid symbolism – Moon Beach – has a distinctly modern one. The area is the site of the Hotel Moon Beach, one of Okinawa's first post-War tourism facilities, which was originally mainly frequented by US officers and their families. Some time in the 1950s the beach became associated with a story that a group of tourists had got into difficulties while swimming and were rescued by a mermaid. The story provided the location and its hotel with an engaging association that was commemorated in a bronze statue made by sculptor Naka Bokunen, from Izena Island, in 1997.[27] The statue, named 'Shiosai' ('sound of the sea') is similar in size to Eriksen's Little Mermaid statue in Copenhagen Harbour and depicts a classic, Western-style mermaid (albeit with an oriental face). The mermaid's posture is more unusual, showing her hugging a conch shell to her ear, with her fin folded at mid-point (in a manner that suggests a knee bend) and with a pronounced rib running down the front centre of her fin (Figure 6). Despite the latter variations, the statue clearly represents a mermaid, and its location and associated story can be seen to mark the introduction of Western-style mermaid folklore into Okinawa. Indeed, the statue is closely similar in design to a number of depictions of mermaids in the artist's paintings, and he held a show dedicated to these, entitled 'Night Frolics with a Mermaid', at his Okinawa Gallery in 2003. Interviewed about his focus on such figures, he expressed a broader interest in mystic femininity in a New Age context inspired by aspects of traditional Okinawan culture:

I think that women are the spiritual heart of life. In Okinawa, they also have the special roles of kaminchu and yuta, priestess and shaman. To some this female power is known as Gaia, others call it Mother Nature. When I begin to draw or carve, the images just come naturally from my subconscious. (Travel 67 2009: online)

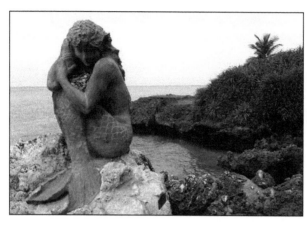

Figure 6 – Mermaid statue by Naka Bokunen at Moon Beach, Okinawa (photograph by Konishi Junko, 2017).

Another statue at Kabira Bay, one of Ishigaki island's most popular tourist spots and the centre of the local black pearl industry, combines the figure of a mermaid lying on her hip, her upper body held erect by her arm resting on a rock, with a young human child sitting on her tail and touching her nipple. While Naka's statue commemorates a recent legend, the Kabira work (sculptor unknown) draws on a minor strand of traditional Ryûkyûan folklore involving a fisherman and dugong/*ningyo*[28] forming a relationship and, in this case, having human progeny. The specific local version concerns a young fisherman who catches a female dugong/*ningyo*. Despite the creature's flesh being prized for bestowing longevity on those who consume it (as per the aforementioned 'Yao Bikuni' *ningyo* legend), the fisherman finds the female attractive, takes pity on her and releases her. As a result he is driven out of his village. Becoming aware of his plight, she invites him into the ocean and her chief rewards his kindness by allowing him to live with her and bestows a gift of black pearls upon them. The couple subsequently leave the sea, move to Kabira and raised human-form children. The statue was commissioned by the Ryûkyû Pearl Company, which has drawn on the particular version of the tale related above to give a supernatural 'back-story' and associations to its product.

Despite Naka's attempts to combine local folklore with more general New Age sensibilities, the most significant development of mermaid-themed tourism in the southern Ryûkyû Islands in recent years has drawn more on standard representations of young, attractive mermaids in Japanese popular culture (such as the high-profile 'Mermaid Love' campaign for Pocari Sweat's Ion Water drink featuring actress Fukada Kyôko in 2014[29]) and the more general international vogue for young women to dress in mermaid tails, swim with these and be photographed and/or filmed in this mode as a memento (see Hayward 2017a: 138–149). This has taken the form of mermaid tourist packages that have been offered in the southern Ryûkyû since 2016, when introduced by the Rising Asia company. These usually comprise small groups of young women participating in organised sessions held on Okinawa, Irabu and Ishigaki islands during summer seasons, where they wear mermaid tails and are photographed in various or poolside locations.[30, 31] In these, the specificity of place and cultural history is effaced in favour of an internationalised and essentially media-loric one.

Conclusion

Japanese culture is marked by an intense interaction between traditionalism and syncretism. This is nowhere so evident as in the relationship between the country's Indigenous religions, Shintoism and Buddhism over the past 1500 years. The two forms have coexisted separately, while also intertwining and modifying aspects of each other. From this perspective, there is nothing radically disjunctive about the introduction, adoption and/or adaptation of the mermaid into various aspects of Japanese culture. What is more significant, however, is the manner in which it has aggregated with older concepts of the *ningyo*, and similar regional figures at the same time as it has established its own identity as distinct from these. In this process, the original form and associations of the *ningyo* have been increasingly sidelined, largely functioning as a residual cultural trace. The nearest Japanese popular culture has come to a representation of a creature more akin to a traditional *ningyo* occurs in Miyazaki Hayao's 2008 animated film *Gake no Ue no Ponyo*, which features a tiny goldfish with human characteristics as a lead character. But even this film shows the influence of mermaid media-lore as the character, actually a miniature piscine princess, aspires to and then manages to transform to a human child despite parental opposition, as per Andersen's and Disney's Little Mermaid fictions (see Fraser 2017: 39–69 for further discussion). If anything, this confirms the dominance of mermaid media-lore over traditional *ningyo* folklore in the 20th and 21st centuries and confirms the manner in which the latter has been increasingly mermaidised from the 1980s onwards. Japanese culture has shown little resistance to this process and, indeed, continues to offer creative engagements with the figure. One of the most wry and artful engagements of this kind was produced by Nobeoka City Council as part of a promotional campaign to attract people to relocate to the city.[33] Using a documentary style, the council produced a video that shows a *kappa* (a green-skinned, turtle-backed river imp from traditional folklore) and a Western-style mermaid turning up to inquire about the city's advantages. Carrying the mermaid into the offices, the *kappa* and his partner are given a promotional talk and shown around the town and its beaches before deciding to relocate there and being warmly welcomed for their choice. The characters were also used in other promotions for the city (see Figure 7). Drawing on the fashion for Japanese places and organisations to have

Figure 7 – Nobeoka City promotional poster (2016).[32]

65

promotional mascots (known as *yuru-kyara*), the Noboeka campaign combined a rendition of a traditional *yokai* with a Western-style mermaid to create a novel image for a quiet regional town with a declining population.

The various aspects of the mermaidisation of the *ningyo* and related folkloric figures discussed in this chapter involve her recontextualisation in Japanese cultural scenarios where her alluring but enigmatic femininity is a key element. Her associations are thereby significantly different from those of the *ningyo*. She is not so much a substitute for the latter – in a less monstrous manner – but rather offers a different set of associations that allow for new types of interpretation. Her polyvalence, in being able to represent either innocent early/pre-adolescence or else a far more adult maturity and sexual demeanour, allows artists a variety of deployments. In this manner we might characterise the mermaid as an invasive species that has out-performed indigenous ones in various contexts and, in the process, been accepted and adopted by an indigenous culture that is less concerned with the nature and qualities of the displaced species than by the potential of the exogenous one to contribute to various aspects of national culture.

Acknowledgements: Research for this chapter was undertaken during a visiting professorship at Kagoshima University Research Centre for the Pacific Islands (KURCPI) in May–October 2016. Thanks to Kuwahara Sueo for collaborating with me on fieldwork in Miyakojima and in subsequent inquiries, and to Yamamoto Sôta, Konishi Junko, Danny Long and Alison Rahn for various other assistances during my time at KURCPI and in subsequent research. Felicity Greenland, Lucy Fraser, Danny Long and Suwa Jun'ichiro also gave valuable feedback on the initial draft of this chapter.

Notes

1. Another, more complex, reversal occurs in Gabriele Mainetti's 8-minute-long promotional film for the Renault Scénic car, made in 2016. Entitled *Ningyo*, and available in three sequences that users can combine in different orders, the material features a man eating in a Japanese restaurant, finding a typically young and attractive Caucasian mermaid next to a fountain, driving the mermaid in his car and interacting with her in the sea. The two most evident combinations of elements concern him either rescuing her from possible consumption as sashimi or else delivering her to the restaurant for that purpose. (Also see discussion of the Thai film *Gancore Gud* [Apisit Opasaimlikit, 2011] in Chapter 2.)

2. Long has identified that *ningyo* is a Chinese-language term that appears to have been imported into Japanese language around the 6th Century. The presence of previous terms for such creatures (including *amabie* and *amabiko*) indicates that the concept of such creatures predated the adoption of the Chinese term. With regard to the aforementioned translations, it is also notable that *Ama* is also one of the terms used to refer to free divers in Japan, most famously, female ones.

3. The term was, for instance, adopted for the *Māmeido Merodî Pichi Pitch* manga, anime and video game franchise (discussed in Section III), the porn film *Densetsu No Māmeido* (discussed in Section IV) and *Ritoru Māmeido* – the title of the long-running Japanese stage musical version of Disney's 1989 film *The Little Mermaid* (Ron Clements and John Musker, 1989), which opened in Tokyo in 2013.

4. In linguistics, a loanword is a foreign-language term introduced into another language. For a discussion of patterns of loanword usage in Japanese see Schmidt (2009: 545–574).

5. Thanks to Danny Long for his discussion of this issue.

6. The text refers to the *ningyo* as having been hunted after it capsized a fishing boat near Shikata, in Toyama Bay on the north coast of Honshu. The *ningyo* is described as having gold-coloured horns, a red belly, a body like a carp and three eyes on the side of its torso. (Thanks to Yamamoto Sota and Hamashima Miki for translating the old form of kanji in the text.)

7. See Davisson (2015: online) for an account of this legend, accompanied by photos of the three cedars the fisherman reputedly planted to atone and to save his children's souls.

8. Crypto-zoology being the study of folkloric creatures.

9. My qualification about this claim being a contention reflects the fact that Japanese *ningyo* figures could have been seen and/or acquired by Western mariners outside Japan, given that some Asian traders had greater access to Japan and may have traded *ningyo* on after acquiring them.

10. See for instance, the character of Pipi the *ningyo*, in Tezuka Osamu's manga *Umi no Triton* ('Umi the Triton') (1969–1971), and the eponymous *anime* TV series (1972), who closely resembles standard visual representations of Andersen's Little Mermaid.

11. There have also been a number of films that have use the term *ningyo* allusively in their titles (without featuring representations of aquatic humanoids), such as *Riku no Ningyo* (Abe Yutaka, 1926), *Oniroku Hanayome Ningyo* (Dan Oniroku, 1979), *Ningyo Densetsu* (Ikeda Toshiharu, 1984) and *Ningyo ni Aeru Hi* (Nakamura Ryûgo, 2016).

12. Research into Japanese films and television programs representing the *ningyo* conducted by Western researchers with limited conversance with the Japanese language is complicated by an issue concerning renditions of Japanese terms in Western characters. The Japanese term *ningyō* (with a macron on the concluding 'o' sound) does *not* refer to aquatic humanoid creatures. In literal usage the term can refer to a doll, puppet or mannequin, but can also be used figuratively to refer to someone or something controlled by another person or agency. The term features in the title of a number of Japanese audiovisual productions. When these are rendered in Western characters the concluding macron is often omitted, leading the term to be spelled identically to the *ningyo* and leading to confusion as to whether dolls or human-fish are being referred to. Examples of the latter include Yamato Michio's 1970 film *Chi O Sū Ningyō* (about a vampiric ghost) and Korçda Hirokazu's 2009 film *Kuki ningyō* (about a blow-up sex doll that comes to life).

13. See, for example, the *Hino Horror* series of anthologies published from 2004 on.

14. Somewhat confusingly, the cover of the DVD release version shows a more typically monstrous Japanese *ningyo* figure.

15. A somewhat different scenario occurs as a plot element in the 2004 comedy wrestling film *Ā! Ikkenya puroresu* ('Oh! House Wrestling') (Kudo Naoki, 2004), where the lead wrestler's wife has been infected with a virus that is slowly turning her into a *ningyo*. The film was released in Anglophone markets, somewhat misleadingly, as *Oh! My Zombie Mermaid*.

16. An order of aquatic mammals that include dugongs and manatees.

17. See, for instance, Spurrier (1989: 110) re Okinawa.

18. See IRCJS (2002: online) and the Miyakojima tale discussed below. See Fraser (2017: 50) for reference to this aspect in the film *Ponyo*.

19. The sole example being a generic mermaid photo prop outside a shell/craft shop on the main island.

20. Thanks to Oyadamari Soushu from the Miyakojima City Museum for assisting us in our inquiries on local *yontama* legends and related media-lore.

21. Cityseeker website: https://cityseeker.com/miyakojima/662070-tori-ike-pond – accessed April 3rd 2017

22. Nishimura's account is the basis for the tale as represented online at a local folklore website targeted at children: http://www.miyakojima-kids.net/R-Densetsu.html – accessed April 10th 2017.

23. See: https://www.scubahellas.com/places/ionian-islands/corfu/dive-centers-corfu/the-mermaids-cave/ – accessed April 3rd 2017.

24. See: http://www.diveboard.com/explore/spots/belize/ambergris-caye-L2TpzL0/mermaids-lair-S6Q7Yrj – accessed April 3rd 2017.

25. See: http://scubadivers-aruba.com/ – accessed April 3rd 2017.

26. See: https://www.youtube.com/watch?v=VPNcnahqLSw – accessed April 4th 2017.

27. Most online sources give the date as 1987 but the artist's website (http://www.bokunen.com/ – accessed April 3rd 2017) gives the date as 1997.

28. I use this term as I have been unable to ascertain the original Ishigakian term used to describe the creature.

29. See, for instance the Ion Water TV ad archived online at: https://mail.google.com/mail/u/0/#inbox/15b4b2d4c9b40691?projector=1 – accessed April 6th 2017.

30. See the Tabitatsu company's website for details of its packages and photographs of mermaid tourists: https://tabitatsu.jp/tour/2357 – accessed April 9th 2017.

31. Other operators have also trialled mermaid photo-session packages and/or sea swims in locations such as Tottori.

32. The caption translates as 'It's now so clear why I want to live here'.
33. See the video online at: https://www.youtube.com/watch?v=fwPRMJB1bmE – accessed April 9th 2017.

Chapter Four

Legend of the Blue Sea: Mermaids in South Korean folklore and popular culture

Sarah Keith and Sung-Ae Lee

Introduction

This chapter considers the mermaid in South Korean folklore and popular culture, focusing on its representation in the 2016–2017 television fantasy/romance series *Pureun Badaui Jeonseol* ('Legend of the Blue Sea'). Korean mermaid folklore is not well known internationally. Heidi Anne Heiner's extensive volume *Mermaid and Other Water Spirit Tales from Around the World* (2011), for example, includes 151 tales, including five from Japan and two from China but none from Korea. *Pureun Badaui Jeonseol*, according to the director Jin Hyeok,[1] tells Korea's "own ancient mermaid stories" (Park 2016: online) and is based on a folktale from Yu Mong-In's *Eou Yadam* ('Eou's Unofficial Histories') (1559–1623). *The series* adapts the *Eou Yadam* folktale in stories that take place in both the Joseon era (around 1600) and in the present-day, blending local elements with aspects of Andersen's seminal 1837 short story 'Den lille Havfrue', especially the mermaid's motive for attempting to become human. By situating *Pureun Badaui Jeonseol* in both historical and 21st Century Korea, the mermaid and human protagonists confront both tradition and modernity and relate fantastical themes to current social concerns, such as the endemic Korean hostility to those who are different. Interspecies love thus functions as a metaphor for other societal boundaries, such as class, economic privilege (or lack thereof) or otherness in general.

Pureun Badaui Jeonseol comprises 20 hour-long episodes that were broadcast by Seoul Broadcasting System (SBS) in 2016–2017. The series was written by Park Ji-Eun, a veteran television screenwriter whose previous project *Byeoleseo on Geudae* ('My Love from the Star') (2013–2014) proved a massive success, both domestically and abroad. Director Jin Hyeok was likewise associated with previous successful projects, including the 2011 drama *Siti Heonteo* ('City Hunter'). The popularity of the series' main actors, Jun Ji-Hyeon and Lee Min-Ho (who, respectively, starred in *Byeoleseo on Geudae* and *Siti Heonteo*) ensured that *Pureun Bada ui Jeonseol* was highly anticipated (Kil 2016). The series was filmed in Korea as well as in Palau and Spain, and was noted for its use of CGI for the lead character's mermaid sequences (Hong 2016: online). In terms of ratings, the series performed reasonably well, on average surpassing 20% viewership nationwide (Nielsen AGB 2017).

South Korean television dramas with supernatural themes, mythical and legendary characters, and historical settings have become increasingly popular in recent years. S-A. Lee (2016) identifies three broad currents in such material: the first deals with retellings of specifically Korean folktales and legends; the second, with Korean adaptations of Western fairy tales (such as Cinderella and Snow White); and the third – of which *Pureun Badaui Jeonseol* is an example – blends Korean and European folklore and fairy tales. Recent television dramas within the latter category have dealt with vampires (such as *Baempaieo Geomsa* – 'Vampire Prosecutor' [2011]), ghosts (*Arangsaddojeon* – 'Arang and the Magistrate' [2012]) and various spirits including *gumiho* (fox spirits) (*Nae Yeojachinguneun Gumiho* – 'My Girlfriend is a Gumiho' [2010]) and *dokkaebi* (goblins) (*Sseulseulhago Challanhashin: Dokkaebi* – 'Goblin: The Lonely and Great God' [2016–2017]). *Pureun Badaui Jeonseol* also mirrors the successful 2014 drama *Byeoleseo on Geudae* in that both series centre on the romance between a human and a mythical or fantastical being (in the case of *Byeoleseo on Geudae* an alien) and include both modern-day and Joseon-era settings. Other common dramatic tropes used in *Pureun Badaui Jeonseol* include repressed memories, hidden identities, trauma and justice. These themes are woven into the series' narrative and the characterisation of the mermaid protagonist, Shim Cheong.

[NB all translations of literary texts and TV drama dialogue in this chapter are the authors'.]

I. Historical Depictions and Legends

The traditional Korean word for sea-dwelling beings is *ineo*, which translates literally as 'fish person'. Today, the term *ineo* is broadly used to refer to both fish-tailed mermaids (of the classic Western type) and other types of aquatic humanoids (with legs). In English translation, *ineo* is typically rendered as 'mermaid' and, in their modern representations at least, Korean *ineo* have been blended with Western forms of mermaid. In the discussions that follow we use the term *ineo* to refer to aquatic humanoids with two lower limbs and 'mermaid' for those with fish tails.

Andersen's 'Den lille Havfrue' (1837) exerted a considerable influence on contemporary mermaid stories and images in South Korea. It was first published in Korean translation in 1935, when 14 of Andersen's tales were included in Jeon Yeong-Taek's *Teukseon Segye Donghwajip* ('Selected World Fairy Tales') (Hyun 2015: 25). The tale would previously have been known in Japanese, into which it had first been translated in 1904, with 33

further translations by 1925 (Fraser 2017: 31). In formulating his story, Andersen drew upon the common folktale convention that a non-human being who comes to live among humans can only remain under certain conditions. This convention also existed in Korean folktales about fox spirits and heavenly maidens but not in *ineo* stories, where there is no example of an *ineo* impelled to come onto the land because she has fallen in love with a human.

Several Korean folktales deal with *ineo*, although there is little consistent detail on their physical characteristics or other attributes. Although all are sea-dwelling, they are variously described as human-like in form, or more opaquely as 'human fish'. They are described in *Eou Yadam* as "swimming like turtles" (Yu 2006 [1621]: 765), which suggests they have four limbs or flippers. In other stories (such as the one discussed below) they are apparently capable of sexual intercourse, implying a fully human form. *Ineo* include both males and females, although most tales describe *ineo* as female, who are usually captured for various purposes. Most stories follow one of two scenarios. In the first, in which there is little narrative development, a female is kept as a sex slave, as mentioned in another entry in *Eou Yadam*:

> Ineo *look like men and women. People who live by the sea once captured a female and kept her in a pond. They pulled her out of the pond from time to time and had dealings with her, and it felt as if they were having dealings with a woman.* (ibid: 765)

Here the basis for the *ineo's* treatment is her inhumanity: being like a human but not human; like a woman, but not a woman; and kept in a pond like livestock.[2] Additionally, *ineo* – while aquatic and needing a pond in which to survive – are described as looking identical to humans. The second scenario is grounded in the international folktale motif of the grateful animal, also found in Korean folktales such as 'The Heavenly Maiden and the Woodcutter' (Zǒng 1982: 21–25), in which a poor woodcutter concealed a deer from a hunter and sent him off in the wrong direction; in return, the deer told him where and how to capture a maiden from heaven to be his wife. A similar theme appears in 'The Legend of Jangbong Island':

> *Fisherman Choe, of Jangbong Island, was facing destitution because his daily catch of fish was very poor. One day he thought he had at last caught a very large fish, but when he drew up his net he found instead a very beautiful* ineo. *She did not speak but gazed at him, imploring him to let her go. He took pity on the* ineo *and carefully returned it to the sea. On the following day, and subsequent days, his net was full of fish. He thought that this abundance was a gift from the* ineo *in return for her release.* (Nam nd: online)

Within folktale morality, the story enjoins its audience to show empathy for and compassion towards others. As indicated by other stories, an *ineo* is a commercially valuable catch, and the protagonist must be humane enough to forgo personal gain and not inflict suffering on another, even another who is somehow less than human. A second example, the story of 'Myeong and the Ineo', involves a more far-reaching reward. It begins:

> *Once upon a time there was a man whose family name was Myeong, who was unmarried even though he was over 50 years old. One day when he was passing a quay he encountered a crowd of people who had caught an* ineo *and were discussing whether they would sell her or eat her. The* ineo *was very distressed*

and Mr Myeong pitied her and bought her with his life savings. He took care of her for a few days, and when she was well again he released her into the sea. Some time later when Mr Myeong was passing the shore the ineo came out of the sea and put a baby boy in his arms and returned to the sea. Mr Myeong brought the baby home and raised him with devotion. The baby was very handsome and clever. (Kim 2009: 53–55)

In this tale, the baby is the reward for an unmarried man whose family line faces extinction. As the child grows, he magically defeats a powerful family that attempts to usurp his father's family burial site (and thereby threatens to extirpate the family) and eventually becomes Chief Royal Secretary, thereby positioning the family line at the highest social level. The *ineo* has not only rewarded Myeong with the immediate pleasure of having an outstanding son (a rich reward indeed in a patriarchal Confucian society) but has also founded a continuing heritage in an ancestor-venerating culture. That Myeong and the *ineo* had a sexual relationship while she was in his care is implied but not stated. In other words, his compassion does not preclude the requirement of sexual favours. There is some crossover with the first captured *ineo* scenario in the unspoken assumption that females of a lesser species, in whatever sense (non-human, lower class, or different race), do not merit the same sexual respect as women of one's own social group.

These scripts show the potency of mermaids as a metaphor, as Dinnerstein observes:

The images of the mermaid and the minotaur have bearing not only on human malaise in general (this they have in common with all the creatures of their ilk – harpies and centaurs, werewolves and sphinxes, winged nymphs, goat-eared fauns [and, we add, fox women and Asian ghosts] – who have haunted our species' imagination) but also on our sexual arrangements in particular. (1976: 5).

Dinnerstein suggests that such creatures not only connote the "uneasy, ambiguous position" of humans in the animal kingdom but also that human gender relations signify that creatures are only "semi-human, monstrous" (ibid: 5).

The epitome of the monstrous aquatic-woman in Korean tradition appears in the folktale 'The Tale of Nanggan the Buddhist Nun':

Nanggan's father was a fisherman who, for no particular reason, was taken to the Sea Dragon Palace. There he feasted for several days in the company of beautiful women. When he was returned to the land he was presented with a gift of ineo flesh, which for anyone who tastes it is a panacea against aging.[3] He hid the flesh, making no mention of it to his wife and daughter, but, as will happen in folktales, Nanggan found and ate it. She thus acquired some attributes of an ineo, becoming increasingly beautiful and ceasing to age; it was rumoured that if she married her husband would be doomed to a short life. Unable, therefore, to find a husband and fulfil the traditional female roles of sexual partner, wife and mother, she enacted a sexual voraciousness associated with ineo that embodies an extreme disruption of social (Confucian) order. Over time, 3000 men who had dealings with her withered physically and died, as she sucked out their vitality. At the age of 120, Nanggan recognised her wrong-doing, converted to Buddhism and became a Buddhist nun to expiate her sins. She remained young and beautiful, however, and was pursued by countless men. To escape these unwanted attentions she eventually wandered into the mountains and disappeared. (S-G. Lee, 2015: online)

Figure 1 – Portrait of 'Nanggan' (Juk-Hyang), and one of her flower paintings.

In contrast to most Korean *ineo* legends, in which *ineo* are princesses, benefactors of fishermen or local guardians, Nanggan is more like the dangerous seductress of Western tradition, an object of a forbidden desire, a desire to abandon oneself to sensuality regardless of consequences. This alternative, monstrous tradition persisted, in that a famous 18th Century *gisaeng* (courtesan), known as Juk-Hyang, was suspected of actually being Nanggan. An accomplished painter, she mesmerised people with her youthfulness and beauty and interacted with many celebrities of the era (see Figure 1); one of her poems has survived. Juk-Hyang was popularly known as Nanggan and as Yongganeobu ('fisher in a lotus lake'), names that connect her to the old tale (ibid).

Further legends represent the *ineo* as a dutiful wife, lover or daughter who helps others while sacrificing her own comfort and wellbeing. While not tragedies in the sense of Andersen's mermaid tale, they nonetheless convey the *ineo*'s otherworldliness. One such legend is based on the story of Queen Heo Hwang-Ok, recorded in the 13th Century text *Samguk Yusa* (Iryeon 2013 [1281]). Hwang-Ok travelled across the sea from a distant country to become the consort of King Suro around 48 CE. Grayson (2001: 115) proposes that the journey of Hwang-Ok constitutes a foundation myth, in which Hwang-Ok is a spirit of the water whose marriage to King Suro constitutes a union of Heaven and Earth. A variant of this story exists as a mermaid folktale, in which Princess Hwang-Ok ('Topaz') from Naranda married Eunhye, King of Mungungnara (now Dongbaek Island). Still functioning as a foundation myth, the story is now associated with the transmission of Buddhism from India to Korea. In this mermaid tale, Hwang-Ok undergoes two transformations. First, to effect her passage from sea to land, she dedicated the underskirt which she wore closest to her skin to the Mountain god. As the underskirt, carried by the wind, disappeared far into the sky she became completely human. Second, as time passed she suffered from homesickness for her undersea homeland of Naranda. Advised by a turtle companion to gaze at the full moon through an enchanted topaz given to her by her

grandmother, she saw her home country again and metamorphosed back into a mermaid, thus reclaiming her wellbeing (Ju 2012). This legend has the potential to be read as a cautionary tale, warning against the socially disruptive potential of exogamy and venturing beyond proscribed boundaries (Darwin 2015: 124).

Another tale in this mode concerns a mermaid named Sinjike from Geomun Island. Sinjike is said to have been a mortal queen from Kyushu, Japan, who followed her lover Seo-Bok (the Qin Dynasty courtier Xu Fu) on his travels but perished from unknown causes when they were stranded on Geomun Island (Yeosu Expo 2012). After her death she became a mermaid and continued to wait for Seo-Bok, while warning fishermen of impending storms by singing and throwing rocks into the sea. This story is alluded to in *Pureun Badaui Jeonseol*, where a young half mer-girl (the Joseon-era counterpart of Shim Cheong's friend Yu-Na) tells fishermen that a big storm is approaching and that they should not go to sea. In response, one fisherman urges the others to listen to her, saying, "Last time, she got it right, like a ghost!" Inhabitants of Geomun Island regarded Shinjike as a beneficent being who provided weather forecasts. She is thus ultimately a benevolent being, rather than a tragic figure who selflessly helps others despite her own misfortune.

As well as mermaid legends, human journeys to undersea realms, and especially the undersea palace of the Dragon King (Yongwang), are common in Korean folklore. The tale of Shim Cheong is cited explicitly in *Pureun Badaui Jeonseol*. While it is not a mermaid story it resonates with mermaid themes. Adapted as a traditional *pansori* (musical story) in the early 19th Century, it tells the tale of a girl who strives to restore her blind father's sight by means of making a large offering in a temple. To pay for this she sells herself to some sailors who wish to ensure a safe passage by throwing a maiden into the sea. Instead of drowning, she is taken to the palace of the Dragon King, where she stays for a while. The Dragon King, a figure in both Buddhism and folk shamanism, represents water and water beings, and is depicted in human form, although with coral-like facial hair and fish-like bulging eyes, and is usually depicted holding a pearl or coral sword (Mason 2014). Shim Cheong returns to land, is married to a prince and is reunited with her father, whose sight is then restored (Ha 1970: 40–46). The writer of *Pureun Badaui Jeonseol* evokes this story when, in Episode 4, the mermaid asks to be given a name. Jun-Jae, the object of her affection, jokingly proposes Shim Cheong, not for the folktale association but because its two components can be understood to mean 'really stupid' (shim*hage meong*cheong). She is pleased with the name, however, and keeps it, a decision that potentially adds narrative suspense. When and how will Shim Cheong sacrifice herself (since, being a mermaid, she cannot drown)? Will the story end like Andersen's, or will there be a twist?

II. Mermaids in Contemporary South Korean Culture

The mermaid assumes multiple forms in contemporary Korean culture. These are reflected in the live mermaid shows that have become popular attractions at aquaria, as in many other countries. Aqua Planet 63 in Seoul, for instance (see Figure 2) features daily mermaid shows and demonstrates the further influence of Andersen upon mermaid imaginary, at least as reinterpreted in Disney's film *The Little Mermaid* (Ron Clements and John Musker, 1989): fish or marine mammals are companions, treasure lies on the sea-bed and there is a pervasive linking of the mermaid with bubbles, the most common *Little*

Figures 2 and 3 – Mermaid performer at Aqua Planet 63 and Shim Cheong represented in the aquarium at Aqua Planet 63 in Episode 3 of *Pureun Badaui Jeonseol.*

Mermaid motif in Korea. Aqua Planet 63 is also a key location in *Pureun Badaui Jeonseol* when, in Episode 3, Shim Cheong, having travelled across the ocean to Seoul, enters a fish tank and reveals her true mermaid form, with spectators marvelling at the beautiful mermaid 'performance' (Figure 3). The scene makes gentle fun of the constructedness of mermaid performances, both because Cheong has upstaged the Aquarium's mermaid performer and because she breaks the frame of the illusion by snatching and eating a passing fish, to the horror of a child who witnesses her action.

The persistence of mermaids in everyday culture and the intermingling of Korean *ineo*

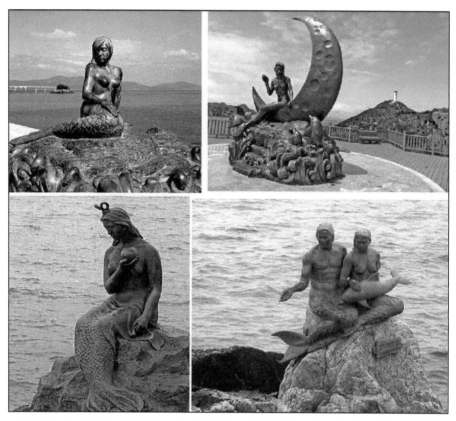

Figure 4 – Korean mermaid statues. Clockwise from top left: Mermaid at Jangbong Island, Ongjin Gun, Incheon; Sculpture of Shinjike in Noksan Lighthouse Park, Geomun Island; 'Mermaid Lovers' at Seorak Sunrise Park, Sokcho, Gangwon-Do; Princess Hwang-Ok at Dongbaek Island, Busan.

folklore with Western/global mermaid legends are also evident in the many mermaid statues which have been erected in coastal cities in various parts of South Korea (Figure 4). While these mainly feature fully fish-tailed mermaids – unlike Eriksen's famous Copenhagen statue (whose mermaid has legs with fins on her calves) – the influence of the Danish statue can be seen in the use of materials and/or poses. Notably, Seoul has a reduced-size copy of Eriksen's statue on the Han River, erected in 2016 to commemorate the artistic and cultural exchange between Copenhagen and Seoul (J. Lee 2016: online).

Despite the limited information about the physical characteristics of *ineo* in texts such as *Eou Yadam*, they are overwhelmingly represented in sculpture in classic mermaid form; that is, as half human, half fish. In Jeju, there are two smiling fish-tailed mermaid statues carved in basalt rock characteristic to the island, while in Busan, Hwang-Ok, the "mermaid princess" (Rowan 2017: online) is memorialised by a statue depicting her with the tail of a fish, holding an orb and gazing into the water (Figure 4). Like Copenhagen's Little Mermaid, the statue does not show her lower body as fully fish-like; from behind, her seated figure appears fully human, and draped fabric across her lap obscures the liminal

zone between human and fish. Sinjike is also shown as a half-fish, half-human mermaid in a statue on Geomun Island. Further mermaid statues exist in Incheon, depicting the mermaid of 'The Legend of Jangbong Island', and in Sokcho, showing a pair of lovers, a merman and a mermaid, who cradle a dolphin. The Sokcho sculpture reflects an influence from Andersen that goes beyond that of the Little Mermaid statue in Copenhagen. The Sokcho site, now Seorak Sunrise Park, was originally the village of Inner Humchi, which was destroyed by a storm in 1977. According to a plaque, a young woman's fiancé was shipwrecked and perished during the storm. The woman died three years later, having waited for her fiancé's return throughout that time, sitting on the rocks on the seashore. She became an emblem of enduring love, and a mermaid tale was developed around her, in which a dolphin helps a mermaid to recover her lost love. Locals commissioned the statue to suggest that, while the mermaid in Andersen's fairy tale could not realise her dream of love, this young woman and her beloved transformed into merfolk and remained together forever (see Figure 4). Stories in which a woman transforms into a mermaid are rare (in Korea and elsewhere) and in this example there appears to be a blending of Andersen's tale with the legend of Shinjike and the related popular song 'Ineo Iyagi' (discussed below). Inevitably, the sculpture is a tourist attraction which couples visit to pledge undying love and where, it is said, on still nights they can hear the mer-couple whispering to each other. Sokcho is also where Shim Cheong and her lover Jun-Jae are shown living happily ever after in the final episode of *Pureun Badaui Jeonseol* (although the 'mermaid lovers' statue is never shown or mentioned, it is doubtless part of the subtext of the ending).

Mermaids have also occasionally been referenced in Korean popular music. The melancholy 1974 ballad 'Ineo Iyagi' by the singer Heo Rim is a well-known example and is used multiple times in *Pureun Badaui Jeonseol* (in Episodes 2, 6, 7 and 8). The song, which blends the story of Shinjike with that of the siren featured in Heinrich Heine's famous poem 'Die Lorelei', begins:

> There is a sad story
> A girl who combed her golden hair became a mermaid
> She threw her tearful heart into the water
> Waiting for her beloved
> Her dream changed and she became a mermaid.

The second line derives from Heine, while the overall story related in the lyrics modifies Andersen's 'Den lille Havfrue' by ending with the mermaid's return to the sea and her death, showing her enduring association with faithful, unrequited love.

Fewer examples of mermaids exist in contemporary Korean pop music, although the 2014 hit song 'Catallena' by girl group Orange Caramel features mermaids prominently in its music video, which functions in a contrapuntal relationship with the lyrics. The lyrics concern an obsession with a girl, Catallena, despite her difficult personality. Mermaids are used here as the subjects of zany humour that accords with a global tendency to adapt folktales for comedic purposes. The group members imitate the waves of the sea as they dance and are also depicted as plastic-wrapped, 'farmed' mermaids on Styrofoam trays, for sale like fresh fish (Figure 5). They are beautiful and exquisitely costumed, but the supermarket packaging and their propensity to thrash about like netted fish cast on the

Figure 5 – Mermaids for sale in Orange Caramel's 'Catallena' video (2014).

land emphasises their non-human otherness and challenges the notion of the mysterious allure of that otherness. While the three singers are represented as mermaids, Catallena (played by cross-dressing male comedian Kim Dae-Seong) is represented as an octopus woman, similar in form to that of Ursula in Disney's *The Little Mermaid*.[4] The video's consumption theme parodies the otherness of K-pop stars (and the quest for yet another gimmick in a video clip) and playfully inverts East Asian traditions about the value and power of mermaid flesh in a contrast between the expensive Catallena (78,000 won) and the mermaids, who are left unsold and eventually heavily discounted (at 4,000 won each) before being prepared as sushi. The final sequence shows the group members as humans, consuming the mermaid-sushi and shedding tears as they remember their mermaid-selves, prompting the question of whether the group members are consuming mermaid flesh in order to become beautiful and desirable like Nanggan.

Pureun Badaui Jeonseol (Legend of the Blue Sea)

Pureun Badaui Jeonseol draws on many of the abovementioned Korean *ineo* folktales, as well as Andersen's short story and representations of mermaids in popular media, to create a distinctive mermaid character and narrative. The modern-day component of the drama mobilises the mermaid in new social and cultural contexts. The genres of *Pureun Badaui Jeonseol* include comedy, melodrama, tragedy and mystery, set in two time periods. The modern-day protagonists are Shim Cheong, a mermaid, and Heo Jun-Jae, a confidence trickster, and the Joseon-era protagonists are the mermaid Se-Hwa and magistrate Kim Dam-Ryeong. The series' core narrative device is one of repeating history: the modern-day protagonists, who are reincarnations of their Joseon-era counterparts (and thus played by the same actors), must avoid the tragic fate that befell their predecessors.

The Joseon-era narrative, which is slowly revealed throughout the series, retells and expands an *ineo* folktale recorded in *Eou Yadam*. The earlier text is quite brief but functions as an effective catalyst for the drama:

> *While on a spring outing, Kim Dam-Ryeong, magistrate of Heupgok-Hyeon, stayed overnight at a fisherman's house. When Kim Dam-Ryeong asked the*

fisherman which fish he caught, he replied, "When I went fishing I caught six ineo, two of whom were killed by being pierced with a spear and four of them remained alive."

Kim Dam-Ryeong had a look: all were the size of four-year-old children, and had beautiful faces and high noses. They had distinct earlobes, yellow beards, and black hair that covered their foreheads. They had shining black and white eyes, with yellow pupils. Some parts of the body were pale red, while other parts were all white, and they had a pale black pattern on the back. They had male and female genitals the same as humans, and had fingers and toes with patterns of wrinkles on them. When held and sat upon a lap so they face humans they appear no different from humans. They didn't make any noise, and shed white tears like rain. Kim Dam-Ryeong pitied them and ordered the fisherman to release them. The fisherman said with much regret:

"The oil extracted from ineo is very good in that it does not go bad for a very long time. It is far superior to whale oil which will decompose and stink if kept a long time." Kim Dam-Ryeong confiscated the ineo and returned them to the sea and they swam away as if they were turtles. In response to Kim Dam-Ryeong's curiosity, the fisherman said: "The size of a large ineo is the same size as a human, but these are only small babies." (Yu 2006 [1621]: 764–765)

The Joseon-era narrative in the opening episode of *Pureun Badaui Jeonseol* incorporates each of these details. The name of the magistrate is retained, along with his compassion for the *ineo* (now only one, a fish-tailed mermaid) (Figure 6) and his forceful action to release her. Her captor, now a venal town official, again plans to extract the mermaid's oil because of its superiority to whale oil and for its capacity to burn indefinitely. This motive establishes both his intention to slaughter the mermaid and the assumption that she possesses no personhood comparable to a human being.

In *Pureun Badaui Jeonseol*'s Joseon story, which is set around 1600 CE, villagers find the mermaid in a cave where she has washed up after a storm. The villagers are afraid to touch her, as mermaids are said to defend themselves by erasing human memories and souls if touched. This addition to mermaid lore becomes an important motif in the modern strand of the series, as it allows Cheong to continue to pass as human and to thwart threats against her safety. When Yang displays his catch to newly arrived magistrate Kim, the latter demands that the mermaid be released. It transpires that Kim and the mermaid were teenage sweethearts; however, after Kim's family forced him to marry, the mermaid realised the fruitlessness of their interspecies' love and erased his memories of her. Various other details of their previous time together and the mermaid's abilities emerge, including: that Kim bestowed the name Se-Hwa on the formerly nameless mermaid, in memory of his deceased sister; that mermaids cry pearls; that mermaids can communicate telepathically; and that mermaids, upon reaching adulthood, are able to grow legs on land. Following Se-Hwa's return to the ocean, the village head, Yang, resolves to catch her again. Se-Hwa is caught and kept captive by Yang's concubine, who beats her in order to extract pearls. When Kim discovers that Se-Hwa, now in human form, is being kept in captivity, he rescues her, and once again returns her to the sea. Shortly afterwards, he is arrested by a vengeful Yang on the pretext that Kim has been bewitched by Se-Hwa. Sentenced to exile, Kim is aboard a departing boat when he senses that Yang is making another attempt to capture Se-Hwa. Urging the boat to turn around, he discovers Yang and his allies

Figure 6 – The mermaid Se-Hwa in captivity.

hunting for Se-Hwa with harpoons and arrows. He dives into the water to save Se-Hwa and is pierced by a harpoon. Embracing the dying Kim underwater, Se-Hwa grips the harpoon and impales herself against him, ending her life. In their final moments, a jade bracelet given to Se-Hwa by Kim slips off her hand and sinks to the depths.

The contemporary storyline of *Pureun Badaui Jeonseol* follows two parallel strands. This is a common structure in long Korean television serials, where the two strands are imbricated by theme and by the involvement in both of at least two principal characters, and are elaborated by sub-plots featuring supporting characters. In *Pureun Badaui Jeonseol*, the two strands are the love story between Shim Cheong and Jun-Jae, and Jun-Jae's quest to find his lost mother – whereby he becomes reconciled with his family's past and rejoins mainstream society as an upright citizen.

The love story begins in Spain, where Jun-Jae encounters the mermaid in his hotel room, where she has strayed after being washed ashore. The opening sequence lays out the barriers between the two. The mermaid is initially mute, in an apparent citation of Andersen, and Jun-Jae assumes she has a mental disability as her social ineptitude provokes comedic 'fish out of water' scenes similar to those in *Splash* (Ron Howard, 1984). Jun-Jae's interest is piqued by an antique jade bracelet she wears, which is worth a fortune, and which he plans to take from her. The bracelet, which she found on the seafloor, is also a link to the Joseon-era narrative. After Jun-Jae returns to Seoul, with all memories of the

mermaid erased by a kiss, the mermaid realises she has fallen in love with him and swims from Spain to Seoul, whereupon the parallel stories begin to unfold as a romantic comedy and social critique. If Shim Cheong's love is not reciprocated, her heart will gradually harden, and she will die unless she returns to the ocean. However, her attempts to win Jun-Jae's love are confounded by her misunderstanding of social conventions and by her concealment of her mermaid identity. In the other strand, Jun-Jae's quest is being thwarted by the machinations of his evil stepmother, Seo-Hee, and stepbrother, Chi-Hyeon, who plan to murder Jun-Jae and his father in order to secure the family wealth for themselves. To get rid of Jun-Jae, Seo-Hee employs a psychopathic murderer, Ma Dae-Young. Ma is a reincarnation of the Joseon-era greedy town head Yang and becomes fixated with capturing Shim Cheong after he begins to recall fragments of his past life as Yang. As the two strands merge, Jun-Jae concurrently starts to recall his past life as Kim and realises he must prevent the old tragedy from being repeated.

III. Otherness and the Influence of Andersen

There are no extant mermaid stories in Korean folklore that conclude as tragedies of thwarted love and sacrifice. The innovation of the Joseon storyline of *Pureun Badaui Jeonseol* comes about through a blending of local folktales and Andersen's narrative. A primary aim of the reincarnated couple in the modern storyline is to avoid a replication of this ending, just as various evocations of Andersen's tale in Korean TV drama also seek to prevent this conclusion. In *Pureun Badaui Jeonseol*, the condition of finding true love has thus been grafted onto the folktale from *Eou Yadam*.

Andersen's scenario is also reproduced and parodied in the romantic comedy series *Ingyeo Gongju* (2014), which is an adaptation of the Danish story to contemporary Korean urban culture. The title plays with the theme of being 'surplus' because Aileen, the mermaid it features, is the youngest of 18 princesses (*gongju*), and the title plays with a resonance between *ingyeo* 'surplus' and *ineo* 'mermaid', suggesting she has little purpose in her own realm but may also find it hard to discover a purpose in the human realm.[5] The target audience for the series is young adults, an audience apt to respond well to the series' often zany humour and metacinematic citation of a large range of elements from other TV drama series, such as *Byeoleseo on Geudae*, and *Frozen* (Chris Buck and Jennifer Lee, 2013) or music videos by popular rapper G-Dragon.[6] At moments of high (mock) drama, comments, speech bubbles and images are superimposed on the screen, as when, for example, Aileen launches a successful surprise attack upon a former mermaid to steal the potion that will turn her into a human (Figure 7). The humorous appeal of superimposition, reminiscent of manga graphics, helps establish an audience for mermaid stories between childhood and adulthood.

Only after Aileen has become a human woman (renamed Ha-Ni), and is in pursuit of a love object who doesn't know she exists, does she learn the condition of her transformation: if she does not find true love within a hundred days, she will die and turn into bubbles. Thus, like *Pureun Badaui Jeonseol*, the series faces the challenge of overthrowing the ending to Andersen's tale. The series turns to social critique when Ha-Ni comes to live with several young people who have been unable to find jobs since graduation, and who consequently refer to themselves as 'surplus people' and name their residence 'surplus

Figure 7 – "It's here!!!"– Comedic superimpositions in *Ingyeo Gongju*.

house'. She thus concludes that her subjectivity and survival beyond a hundred days depend on the connection between finding a job and finding true love. However, she is naïve and does not comprehend human emotion and is not equipped to determine what true love even means, and her chances are diminished when she becomes enmeshed in a love triangle with two men. By her hundredth day she has found both a job and true love, but life is capricious and she turns into bubbles anyway. The series lost favour with viewers in the course of its run, and the writers and producers were asked to reduce the final four episodes to two. This sudden shift probably compromised the intention of the ending, so it is left ambiguous. It conforms to Andersen in representing Ha-Ni's dissolution, but then in an unsatisfactory close that seems to derive from the ending of *Nae Yeojachinguneun Gumiho* (2010) she makes a brief return a year later and announces that she will be back.

Andersen's tale was also invoked as a thematic analogy and cautionary tale in Korean television dramas prior to *Pureun Badaui Jeonseol* and *Ingyeo Gongju*, most notably in *Nae Yeojachinguneun Gumiho* and *Sikeurit Gadeun* ('Secret Garden'), both released in 2010. A fox spirit and a Cinderella story, respectively, these two series develop conceptual blends of Andersen's tale with other folk-/fairy-tales. 'Den lille Havfrue' conveys two edifying concepts that make it a useful reference in these dramas. First, the otherness of the female protagonist, who is non-human or of a much lower social class than the prince and, second, the short story situates the protagonist's struggle for acceptance within the 'innocent persecuted heroine' frame, familiar in the West but also employed in East Asia (Bui 2009). Common plot elements are that "the heroine is persecuted or threatened in her family home" and subsequently "attacked, interfered with, or otherwise abused in her attempt to be married" (Jones 1993: 17). The latter phase usually includes a rival. As Bacchilega (1993) summarises, the structure inscribes both variable and conflicting social norms, positions gender within the frameworks of class and social order, and ideologically

constructs the heroine's innocence and persecution (ibid: 2). The non-human heroine in that mermaid and *gumiho* tales has limited social experience, and is therefore perceived by other characters as a child or childlike, or even as cognitively impaired. Her otherness constitutes a state of lack that renders her an object of ridicule or persecution, and is an impediment to the realisation of her desire. The mermaid as 'persecuted innocent' is shown through Shim Cheong's cluelessness in early episodes of *Pureun Badaui Jeonseol*, while Aileen remains childlike throughout *Ingyeo Gongju*. In *Nae Yeojachinguneun Gumiho*, Dong-Ju, a demon guardian, uses a Korean picture book adaptation of 'Den lille Havfrue' to inform Mi-Ho, a nine-tailed fox in human form, that the difference between human and non-human is unbridgeable, and thus the tale is offered as a parable of insurmountable otherness (S-A. Lee 2011). A picture book is the chosen text because Mi-Ho is assumed only to have a small child's reading ability. The overall narrative of *Nae Yeojachinguneun Gumiho* is the overcoming of difference, in this case between fox and human. A crucial move at the close of this series, however, is that the erasure of the *gumiho* from the human world is temporary and is overcome by a miraculous disruption of the course of destiny which enables her to return to her human partner, even though she still inhabits a liminal space between human and non-human. This closure becomes a cornerstone of the drama series, and is replicated in both *Ingyeo Gongju* and *Pureun Badaui Jeonseol*. In both, the mermaid returns to the sea, but against the odds comes back to the land and the human she loves. The significance of these closures is that social otherness becomes accepted, and there is no longer the expectation that those who are different must conform.

Andersen's tale is once again used to address the challenge of difference in *Sikeurit Gadeun*, a production that alludes to and blends several European folktales. The main characters are Kim Ju-Won, a wealthy upper-class male, and Gil La-Im, an independent young woman who is an orphan. Their accidental meeting sets the scene for a 'Cinderella-type' scenario but the series constantly problematises whether the fairytale scenario they are following is 'Cinderella' or 'Den lille Havfrue'. 'Cinderella' is evoked by the repeated assertion that 'Den lille Havfrue' is the *second* best-known story in the history of human-kind (the first is presumably 'Cinderella' [S-A. Lee 2014: 277]). The recognition that the two stories involve innocent, persecuted heroines entails that a specific outcome for *Sikeurit Gadeun* cannot be assumed. When La-Im feels defeated by Ju-Won's mother, who threatens to strip him of all his assets if they marry, she resolves to disappear and leaves Ju-Won a farewell note in the form of a summary of the end of Andersen's tale as "the Little Mermaid turned into bubbles and disappeared". The close of the series oscillates between the outcomes of the two tales, settling for the 'Cinderella' version but then disclosing that the 'Cinderella' outcome is only a fantasy. For our purposes here, the two main fixations *Sikeurit Gadeun* illustrates is contemporary Korean culture's abiding interest in Andersen's short story and a constant struggle to transform its ending.

Similar tensions appear in *Pureun Badaui Jeonseol*, where 'Den lille Havfrue' foreshadows the potential tragic ending for the mermaid Shim Cheong. During a visit to a library (Episode 8), Shim Cheong sheds tears while she reads the sad ending of a picture book adaptation of Andersen's tale. Later (in Episode 11), Jun-Jae and his associates, Nam-Du and Tae-Ho, discuss the story. Nam-Du asks, "Aren't fairy stories all the same? The prince and the mermaid fall in love and get married, the end." Tae-Ho responds, "That's Disney's

version. She dies in the original version." Surprised, Jun-Jae asks, "Dies? Who? The prince? The mermaid?" On hearing the mermaid dies, he exclaims, "What kind of lame children's story is that?" Another notable moment occurs late in the series (Episode 19), where 'Den lille Havfrue' is weighed against Korean mermaid folklore. Shim Cheong, discussing Andersen's story with Mo Yu-Ran, Jun-Jae's mother, concludes that the mermaid's choice to end her own life – rather than that of the prince – was the right decision, as it all started because of the mermaid's greed. Mo Yu-Ran counters with the following story:

> Long ago, a young man went out to sea, but his ship was overturned. He met a mermaid and she saved his life. He married the mermaid and had babies. They lived happily. The children who were born through the human and the mermaid, some returned to the water, and some remained on land. One became the village people's benefactor. While communicating with the mermaids of the sea, when there was a storm, she was told in advance that people should not embark upon the sea. There's this mermaid story too. It's not greed that brought the mermaid onto the shore, but love.

This blend of Korean *ineo* and mermaid stories positions the mermaid not as a tragic character trapped by her otherness, but one with sufficient agency to transcend it. Within this context, Korean mermaid legends provide the 'happy ending' that Shim Cheong – and the drama itself – is seeking.

Societal imbalance and the restoration of social order underpin many of the key narrative points in *Pureun Badaui Jeonseol*. While mermaids are sometimes portrayed in popular culture as guardians of the environment (such as in Stephen Chow's 2016 Chinese film *Měirényú*), the mermaid Shim Cheong sets in motion events that restore a balanced *social ecology* – effectively restoring, or dispensing, social justice and order. Aside from Shim Cheong's own disordered status as a land-dwelling mermaid, many of the other key characters are similarly adrift from their proper social position at the story's outset. Jun-Jae is a son estranged from his family, engaging in criminal activity to make a living; his mother is likewise lost to her family and Seo-Hee (Jun-Jae's stepmother) and Chi-Hyeon (his stepbrother) are interlopers breaking up the family unit. Even the villains of the piece, Seo-Hee and Ma Dae-Young, are revealed to have transgressed their rightful social position – both of them were poor orphans – but Seo-Hee managed to ascend to elite society through various crimes, abetted by Ma. At the conclusion of *Pureun Badaui Jeonseol*, each character is returned to their rightful position through Shim Cheong's intervention. Seo-Hee and Chi-Hyeon are expelled from Jun-Jae's family, and Ma meets an ignoble end. Jun-Jae is reunited with his mother, mending the broken family unit, and redeems his criminal history by becoming a state prosecutor. The mermaid Shim Cheong, as the persecuted, innocent outsider, is the figure who sees and addresses these social imbalances.

Shim Cheong's otherness, and resulting naiveté, allow her to transcend social boundaries and forge bonds with other outcasts. She befriends a homeless woman and a socially isolated schoolgirl, beats up bullying schoolchildren and questions cultural values. A conversation with the schoolgirl, Yu-Na, touches on the social taboo against poverty. Shim Cheong asks why her mother works so hard to earn money, and Yu-Na responds, "You're helpless. She earns money so that we can be happy". This critique of materialism resonates with Korea's rapid modernisation and shift to affluence, and changing social and cultural

values. Similarly, when Shim Cheong looks enviously at commuters returning to their homes, her homeless friend bemoans society's materialism, commenting, "You're envious of them, right? But they are beggars with houses. Look at their slouching shoulders. It's because they have to pay back their debt to the bank". The outcast status of Shim Cheong and her homeless friend afford them a position where they can perceive societal imbalance. Her otherness therefore not only threatens to exclude her from society but also functions as the 'stranger in a strange land' motif familiar in science fiction and dystopian genres. Her growing conviction that intersubjective relationships are the proper basis of social life critiques the prevalent assumption that nothing is more important than material wealth. The mermaid's quest for acceptance and love hence stands in thematic contrast to the relentless and immoral quest for money pursued, especially, by Jun-Jae's stepfamily and the various investors whose 'dirty' money is siphoned off by Jun-Jae's scams. South Korea's social ecology is thus depicted as broken, marred by processes of exclusion that promote violence against those who are othered and militate against social justice, gender equality and moral economy, thus preventing people from flourishing.

IV. Memory, Self and Society

Perhaps the most unique mermaid attribute in *Pureun Badaui Jeonseol* is her ability to erase human memories.[7] In the Joseon era, Se-Hwa is passive, and is rescued by Kim on multiple occasions. She uses her memory-erasing ability once, to remove herself from Kim's memory. In contrast, Shim Cheong pursues Jun-Jae, makes inept romantic advances and possesses preternatural strength. Her ability to erase memory selectively is a key narrative device that is used several times in different ways. In *Pureun Badaui Jeonseol*, memory erasure – usually of memories pertaining to Cheong herself – is performed by a kiss or a handshake: the kiss is given only to Dam-Ryeong and Jun-Jae, and its main intention is to remove memories that might cause pain or regret. It is a motif that recurs throughout the series, encapsulated in an anachronistic image of Shim Cheong kissing Jun-Jae, which is dreamed by Kim and painted on a vase with the purpose of preserving Jun-Jae's memory in the future (see Figure 8). The parallel between time periods underlines the importance of memory, suggesting that both individual subjectivities and a stable social ecology depend on shared memory.

Much of *Pureun Badaui Jeonseol's* narrative involves the uncovering of memory. Shim Cheong, Jun-Jae and Ma Dae-Young struggle to remember their past lives, while Jun-Jae also strives to recall the memories that Shim Cheong has removed. Though she removes Jun-Jae's memories of her with good intentions, like Se-Hwa before her, this wilful erasure of memory is ultimately shown to be counterproductive. Shim Cheong's misunderstanding of the function of memory in human life is articulated when she is recovering in hospital after having been struck by a car while crossing a road. She encounters a woman who is picketing the hospital, demanding to know why her daughter died during surgery. Taken aback by the woman's grief, Shim Cheong asks whether she would like her sad memories to be removed, saying, "If you don't remember your daughter, then you won't be sad and hurting". The woman refuses, saying, "I would rather love and remember her, even if it hurts". This plot element is remarkable. While it ultimately has no relevance to the overall narrative, it underlines the significance of Shim Cheong's power by affirming the importance of memory, even painful memory, in honouring the past and moving

Figure 8 – The mermaid kiss that erases memory. A Joseon-era-style vase showing Jun-Jae in modern clothing from *Pureun Badaui Jeonseol.*

towards acceptance. This resonates with Korea's own traumatic history throughout the 20th Century, including the Japanese colonial period and military dictatorship. In fact, most of Korea's history has been marked by tumult, which has had profound effects on its culture. As Swanson contends:

> *political instability, geographical and climatic disadvantages, economic under-development and recurrent foreign invasions are basic factors which have shaped Korean history. One wonders how the Korean people have managed to maintain their cultural identity as a distinct ethnic group.* (1968: 130)

Korean identity is therefore contingent upon cultural memory and its preservation. This is apparent in Korean author Han Kang's 2015 novel '*Sonyeon-i Onda*' (published in English as 'Human Acts'), in which a central theme is the suppression of memory and "what happens when people are not allowed to remember" (Richardson 2016: online).

Shim Cheong's power to erase human memory is offered mercifully, but is also part of her monstrous aspect. This ambivalence is shown in the opening episode of *Pureun Badaui*

Jeonseol, where mermaids are rumoured to be dangerous, having the power to bewitch and erase human souls and memories. When Shim Cheong erases Nam-Du's memory of seeing her in mermaid form, he sits in a stupor for the rest of the day and his cognitive processes appear to be impaired. The most monstrous demonstration of Shim Cheong's power occurs during her encounters with fugitive Ma Dae-Young, the present-day reincarnation of Yang. Having abducted Shim Cheong and taken her to an abandoned hospital, Ma interrogates her, attempting to confirm that she is a mermaid. As he moves closer to touch her, Sim Cheong warns, "A mermaid doesn't leave a human who touches her unscathed. A mermaid can erase whatever memories she wishes". Reaching out her hand, she taunts: "Confirm it". Panicked, he flees. This foreshadows Shim Cheong's climactic meeting with Ma Dae-Young in Episode 17, where she apprehends him, and takes his hand. Before erasing his memory, she confides her hope that he gets "a taste of Hell, for a very long time". Continuing, she tells him "[I] will make your life into a blank page, so you cannot remember anything, so you cannot be forgiven". Afterwards, he stands in a daze, seemingly unaware of who or where he is, before bolting away. It is significant that Shim Cheong's idea of 'Hell' at this point in the narrative is the inability to remember. This episode shows her eventual reconciliation with the necessity of memories, even painful ones. Likewise, her own journey to uncover the tragic story of Se-Hwa and Dam-Ryeong yields the lesson (to paraphrase George Santayana's famous aphorism) that those who cannot remember the past are condemned to repeat it. In Shim Cheong's final act of memory erasure, she removes memories of herself from Jun-Jae before retreating to the sea to recover from a potentially mortal injury; however, Jun-Jae, anticipating this manoeuvre, has been documenting his memories by writing a diary, thus outwitting her.

The mermaid featured in *Pureun Badaui Jeonseol* is a memory talisman. She can trigger repressed memories, erase memories and finally compels Jun-Jae to externalise his memory by keeping written records. The moral imparted by the series, and eventually learned by Shim Cheong, is that preservation of memory is essential to both personal and interpersonal stability. At another level, the drama itself offers an opportunity for remembering: as series director Jin Hyeok (Park 2016) describes, it tells Korea's "own ancient mermaid stories", acknowledging its longstanding but little-known mermaid cultural heritage.

Conclusion

Pureun Badaui Jeonseol draws on Korean folklore, Andersen's 'Den lille Havfrue' and other dramatic conventions to present a series that comments on contemporary social concerns. Shim Cheong, othered by her mermaid identity as well as her ignorance of contemporary Korean society, allows the viewer to empathise with otherness and to see the absurdities of modern-day social conventions and materialism. Moreover, the mermaid in Korean folklore – whether benevolent and human-like or monstrous other – offers a counterpoint to the well-known, tragic figure of Andersen's tale. The dramatic trope of predestination takes on a new significance in light of these competing texts. Shim Cheong may either succumb to otherness, following Andersen's scenario by accepting the hopelessness of her love and returning to the sea, or somehow transcend her difference. Both 'Den lille Havfrue' and the Joseon storyline are invoked as tragic fates to be avoided. Ultimately, Shim Cheong's fate both follows and surpasses this ending. Recalling the Joseon-era

events, when Dam-Ryeong is killed by a harpoon, she has enough foresight to leap in front of Jun-Jae just before he is shot by an enraged Chi-Hyeon. Her memory, tragic though it is, saves the life of Jun-Jae. As he holds her, badly wounded, Shim Cheong telepathically tells him that, "the ending has changed – this time, I saved you" (Episode 19). At this moment, it seems as if the narrative will end – like 'Den lille Havfrue' – with an act of self-sacrifice for another. However, Shim Cheong's preternatural strength and strong constitution means that she will survive (although she needs to return to the sea to recover).

Notions of a society that is just and altruistic come together in the utopian dream sequence that closes the narrative. While Shim Cheong has spent three years back in the ocean recuperating, Jun-Jae has turned his life around and trained as a prosecutor, determined to implement social and political justice. After the suicide of his criminal step-brother and imprisonment of his murderous step-mother, the family wealth has passed to his mother, Mo Yu-Ran, who has allocated half of it to social causes – such as a refuge for runaway teens – strengthening the bond between the individual and society. Both are now able to act as what Bolton and Laaser define as "ethical, reflective and deeply social agent[s]" (2013: 509). Jun-Jae takes up a provincial appointment, and the series' coda, which unfolds after the revelation that Jun-Jae remembers Shim Cheong despite her efforts to erase his memory, shows them living together in an unassuming house by the beach in Sokcho. The ultimate overcoming of difference, foreshadowed in *Eou Yadam* and 'Myeong and the Ineo', is revealed; Shim Cheong is pregnant. The mermaid is thus released from existing only as a parable of otherness in the context of 'Den lille Havfrue', as has hitherto seemed the case. Instead, *Pureun Badaui Jeonseol* reclaims the mermaid within Korean folklore, restoring her to cultural memory.

Notes

1. Korean names in this chapter follow the standard national convention of surname first followed by given name. Revised Romanisation is used for Korean words and names.

2. A motif that reappears in *Pureun Badaui Jeonseol* and in the music video 'Catallena' (2014).

3. According to Lucy Fraser, this ancient belief originates in China, where mermaid flesh was thought to have various special powers, including the gift of eternal youth and incredible longevity for anyone who eats it, as seen most famously in the Japanese *Yaoya Bikuni* legend of a girl who unknowingly consumes mermaid meat and lives 800 years (2013: 181), which is an analogue of 'The Tale of Nanggan'.

4. See Hayward (2017a: 45–49) for a discussion of the origins and nature of the octopus-woman figure and its relationship to mermaids.

5. This linguistic punning is reflected in the two English-language titles for subtitled DVD releases of the series – *The Surplus Princess* and *The Idle Mermaid*.

6. Especially the character Do Ji-Yong's parody of G-Dragon's *Crooked* music video in Episode 4 of the series (with the in-joke that G-Dragon's given name is Ji-Yong [Kwon Ji-Yong]).

7. While the power to erase memory is an innovation for mermaids, amnesia and repressed memory are established tropes in science fiction, for example in *Men in Black* (Barry Sonnenfeld, 1997). These tropes are also commonly used in Korean drama. The immensely popular Korean romantic drama series *Gyeoul Yeonga* ('Winter Sonata', 2002), for instance, centres on a protagonist who suffers amnesia and then rediscovers his forgotten first love anew.

Chapter Five

From Dugongs to Sinetrons: Syncretic Mermaids in Indonesian Culture

Philip Hayward

Introduction

Contemporary Indonesian language has a number of compound terms that describe mermaid-like creatures. Four of these are modifications of the term *duyung*, denoting a dugong.[1] The literal meaning of the modified terms are as follows: *putri duyung* (girl/dugong), *ikan duyung* (fish/dugong) and *ikan duyung betina* and *ikan duyung perempuan* (fish/dugong/woman). Two further terms that are broader in their designation are *putri laut* (sea woman) and the (Arabic language) *bintu'l-bahar* (daughter of the sea). While several of these terms specify mixed (human) female, dugong and/or fish identities, none specifies the standard portmanteau female/fish form of the Western mermaid. Another term, *naga*, merits mention at this point. *Naga* refers to a variety of reptilian creatures, including dragons, but also includes creatures with human components, usually heads, or heads and upper torsos, and creatures that can switch between reptilian and human forms. The term originates in Hindu mythology and, similar to its original Indian circulation (discussed in Chapter 2), there are distinct similarities and blurrings of form and role between *nagas* and fish/human figures. Despite its history of Dutch colonisation and a significant number of Dutch terms being acquired and/or modified in the Indonesian language,[2] the Dutch term *meermin* (and its male variant *meerman*) have not been adopted, although (as discussed in Section II), the Dutch intro-

duced the European form of the fish-tailed mermaid in the early stages of their intrusion into the archipelago.

I. Hindu Cultural Traditions

As detailed in Chapter 2, Hindu mythology has a wide range of human/fish figures and a number of these are present in Indonesian culture, either in forms close to their original ones or else as ones that have been syncretised with more recently introduced ones. Hinduism flourished across the Indonesian archipelago from the 4th to 15th centuries before Islam largely displaced it. But while Bali remains the only island that has retained Hinduism as its dominant culture, traces of its mythology have been retained elsewhere in smaller Hindu communities,[3] in material culture that has survived to the present and in the form of cultural practices that persist in Muslim culture despite their Hindu origins. The versions of the Hindu Ramayana that were established in the archipelago prior to the proliferation of Islam were largely based on southern Indian versions of the tale and included the episode where the monkey-king Hanuman meets and forms a relationship with a *putri mina* (literally 'fish princess') after she initially resists his attempts to build a causeway to move troops across (discussed in Chapter 2). This incident, and the overall narrative, has been reproduced in a number of material forms, such as bas reliefs at the 9th Century Prambanan temple complex in central Java. In addition to surviving pre-Islamic temple reliefs, episodes from the Ramayana continue to be represented in both Balinese and Javan forms of *wayang* (shadow puppet) theatre, in which the figure of the *putri mina*

Figure 1 – Wayang-style mermaid figure (Bali, c1990s).

often features in representations of the causeway sequence (occasionally, in recognisably mermaid-like form).[4]

As researchers such as Nyoman Sedana (2015) have elaborated, Balinese culture is the result of a particularly intense syncretisation of earlier local animist beliefs and aspects of Hindu religious mythology (which, in itself, contains elements of pre-Hindu mythologies and folklore). In recent decades the mermaid has also risen in prominence as a motif that appeals to tourists in a manner that complements the island's tourist branding in terms of spiritual and/or eco/sustainable values. This is evident in the production of various artefacts. The popularity of *wayang*-style figures as souvenirs has, for instance, resulted in mermaids being featured as one design (Figure 1). Another example is *widyadhari* souvenirs. *Widyadhari* are minor mythological entities that have modified human form and are believed to possess valuable wisdom. They are consid-

ered as benevolent, and small carvings of them are traditionally hung over infants' cradles to ward off evil spirits. These take various forms, including chimeric combinations of various actual and fabulous creatures and are often associated with the rainbow (hence the multiple colours which representations of them frequently feature). They are also perceived to have associations with various *dewi* (goddesses) such as Nyi Roro Kidul (discussed further below) and the rice goddess, Dewi Sri.[5] As a result of the two aspects of the *widyadhari* – being represented as chimeric figures and as ones associated with goddesses – representations of them in mermaid form (often with wings) have become prominent in Balinese folk art forms (such as wooden carvings and paintings) and have become popular with tourists visiting Bali who find the mermaid form appealing. Some of the *widyadhari* artefacts have also incorporated aspects of standard Western mermaid imagery, such as deploying mirrors and combs (Figure 2).

Figure 2 – Mermaid form *widyadhari* (produced in Bali c1990 – author's collection).

Other mermaid imagery around the island has either drawn on aspects of existing traditions or else represents the direct importation of the foreign entity.[6] The clearest example of the latter is the statue of a mermaid with a traditional Balinese headdress together with a dolphin on a rock on the seafloor off the coast of Jemeluk Bay. The origins of the sculpture are (literally) inscribed in its base, prominently showing its sponsor's name in large letters – The Body Shop (a British cosmetics company known for its organic products and environmental awareness). The statue was conceived by Celia Gregory, founder of the Marine Foundation, designed by Balinese sculptor Wayan Winten[7] and has become a popular dive and photo opportunity site. In the 2010s these aspects have been complemented by the sale of fabric and polyurethane mermaid-tail outfits for visiting tourists and by so-called 'mermaid schools', which cater for mermaid aficionados by providing tails, accessories and beachside photo-shoots.[8] As discussed in Section IV, these associations have also been reflected in video production on the island.

II. Dutch Models

With regard to the introduction of the Western mermaid to the islands of (present day) Indonesia, it is significant that the Dutch term *meermin* (and its male variant *meerman*) are

Figure 3 – VOC coat of arms – Jeronimus Becx The Younger (1651).

also broad, denoting a 'sea woman' (and 'sea man') without specifying whether their forms are fully human or compound human/fish.[9] The ambiguities of this linguistic aspect are rendered apparent in a significant visual image: the coat of arms of the Vereenigde Oost-Indische Compagnie (VOC) (commonly referred to in English as the Dutch East Indies Company). The VOC exploited and increasingly administered the Indonesian archipelago between 1603 and 1800.[10] In 1651 the Dutch painter Jeronimus Becx the Younger commemorated the VOC's achievements by designing a coat of arms for the company (Figure 3). His design stressed the organisation's maritime aspects with a man-of-war ship at sea occupying the entirety of the shield under an array of navigational aids and weaponry and resting on a bed of tropical seashells. Supporting the shield on either side are a *meerman* (left) and a *meermin* (right). The previously discussed indeterminacy of the two terms is manifest. The *meerman* appears as a classical triton, in the form of a bearded, patriarchal merman holding a trident. In a manner common in heraldry, he is garlanded with a belt of leaves around the junction of his human and lower parts. Below this are two components that suggest a merman's tail. On his left side two curling drapes cover the area where his genitals would be (if he had human form in that area), while on the right a scatter of shells cover an area that the curvature of his body suggests marks the junction with the short green tail that curves under the left-hand side of the shield. He is depicted gazing right, across the top of the shield, towards a young, naked *meermin*. Her upper body is represented in standard mermaid style, with long flowing locks of hair, and she is depicted holding a small hand-mirror in which she gazes intently.[11] Concealing the anatomical feature that fish-tailed mermaids lack, a leafy garland lies draped around her pubic area. While her upper thighs are clearly human, closer examination of the coat of arms' design complicates matters in that her lower legs blur in form around (what would be) the knee area. The presence of a disembodied green tail lying at right angles to her at this point – and the scatter of shells that conceals and/or suggests a junction point of her anatomy – suggests the tail as hers. Reinforcing this, the

couple's tails are entwined, suggesting their fundamental connection and compatibility. Heraldry can be a subtle and often cryptic signifying system, and it is at least possible to interpret the armed and patriarchal *meerman* as representing Holland (and the masculine power and resources of the VOC), whereas the *meermin* represents the islands and resources of the VOC's archipelagic sphere of influence.

Unlike Goa, and other areas dominated by the Portuguese from the 1600s onwards, where the promotion of Roman Catholicism led to a dissemination of religious imagery that blended Western mermaids with figures such as the Hindu *naga* (see Chapter 2 for discussion), the Dutch were predominantly protestants (following a religion that had been premised on the rejection of various aspects of Catholicism, including its reverence for visual icons). As a consequence, no comparable representations of syncretised mythological figures appear to have been promulgated in Christian religious contexts in the archipelago.

The earliest recorded account of European perceptions of there being mermaids in the waters around the Dutch East Indies occurred sometime between 1706–1712 when a VOC employee named Samuel Fallours produced a striking illustration and accompanying description of what he described as *sirenne* (see the engraved and hand-coloured version of his image by Louis Renard in Figure 4). The description and illustration attracted much interest in Europe (see Pietsch 1991) on account of its combination of a seemingly sober account of a 1.5-metre-long creature that he reports as having been kept in a tub of water for four days before it died, and the fabulous appearance of the creature he represented. Despite the disjuncture between his account of ascertaining the *sirenne's* resemblance to a woman by lifting its front and back fins (ibid) and the lack of any such concealing features on the creature he represented in his illustration, his account and image were subsequently amended and circulated by authors such as Louis Renard (ibid: 5-6). By the mid-1700s there was increased scepticism about the plausibility of Fallours' mermaid, with it being asserted as a fanciful representation of a dugong (a view that is now the predominant[12]). But this explanation is clearly insufficient to explain the form and detail of the image. Whether secondary accounts and/or his observation of dugongs were the inspiration for his inclusion of the creature in his volume, the image Fallours produced is more readily interpretable as a blending of Western folkloric, artistic and heraldic symbolism and aspects of local mythology. While Fallours' image had none of the ambiguities of the *meermin* featured in the VOC's coat of arms it also shared common aspects with both Becx's design and one common strand of representation of *meermin* in Dutch and Western European visual arts, in featuring a garlanded intersection of human and piscine forms. The length of his mermaid's tail is, however, relatively unusual and invites interpretation in other contexts. While Fallours' mermaid is firmly associated with Ambon through its inclusion in the book he produced depicting many of the region's tropical fish while stationed on the island (and through *subsequent* local folklore[13]), the mermaid he depicted more closely resembles aspects of folklore from other islands, particularly those concerning *naga* snake goddesses. While the latter were not elements associated with Ambonese culture, it is significant that Fallours' initial VOC posting was at Batavia (present-day Jakarta) on Java, where he resided from 1703–1705, before being posted to Ambon.

As Andaya has identified, along with representations of the Ramayana mermaid, there is

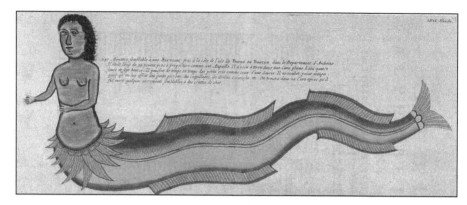

Figure 4 – The so-called 'Mermaid of Amboina' (Renard 1719, after Fallours).

pronounced variety and variability of water-related spirits across Indonesia and South East Asia more generally, with the result that:

> Anyone seeking to understand Southeast Asia's shifting spirit-scape will encounter a virtual army of indigenous water spirits, all of whom have their own domains of authority and whose personalities can range from kindly guardians to mischievous pranksters and jealous waterlords. (2016: 244)

Two such figures amongst that 'virtual army' that had substantial currency in Java at the time of Fallours' sojourn in Batavia were Nyi Roro Kidul, the sea goddess,[14] and the snake goddess, Nyi Blorong. Nyi Rorol Kidul has both a general aspect in Javanese and Sundanese mythology and a variety of regional interpretations and instantiations that render her as a more local folkloric entity.[15] In general terms, she is regarded as a sea queen or princess who was once human but now lives in an ornate undersea palace that she occasionally ventures from in a coach, either pulled by *nagas* (serpent-dragons) or else decorated with *naga* motifs and drawn by horses. She is strongly associated with the Mataram Sultanate of Central Java in a legend that saw her seduce the late 16th Century Sultan Agung, educate him in statecraft and go on to consort with a number of his successors. In more local folkloric instantiations she is believed to lurk along the shore, ready to seduce young men and is also an entity who can bring good fortune to fisherman and birds' nest harvesters. Wessing has identified her as an essentially liminal entity:

> located between the (physical world) bawono lahiriah, the bawono lenggeng (realm of the gods) and the bawono rohaniah (the place of the ancestral spirits). She is the boundary, which is why she is located on the border ... She stands between the sea and the land ... and this is, of course, precisely the source of her ambiguity. (ibid: 113–114)

Fittingly in this regard, she is commonly represented in various forms of visual arts as dressing in flowing green garments that often trail into the sea in a manner that blurs their edges and the water and, in some instances, she is represented in fish-tailed form. Nyi Blorong is often associated with Nyi Roro Kidul, increasingly as her daughter,[16] and is represented as having a woman's upper torso complemented by a lengthy snake tail. Fallours' image suggests a combination of these elements and Western mermaid traditions

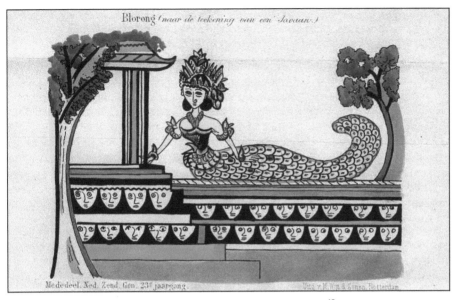

Figure 5 – Nyi Blorong (1879 – artist unknown).[18]

(perhaps inspired, in part, by reports of dugong sightings) that were added to his catalogue of actual fishes in a manner similar to Swedish taxonomist Carl Linnaeus's addition of mermaids to the second edition of his (otherwise overwhelmingly sober and scientific) *System Naturae* (1768).[17]

Fallours' image also has similarities to a later illustration painted by an unknown artist that accompanied an article by Dutch writer J. Kreemer published in 1879 (Figure 5) discussing Nyi Blorong as a Javanese goddess associated with financial good fortune. While the figure's upper-body garb and ornamentation gives her a distinctly courtly appearance, her long tail resembles that of Fallours' *sirenne* and signifies – in the perspective and rendition of Dutch artists at least – a continuing syncretic approach to representing local mythological figures through Western folkloric prisms. Such perspectives developed as one aspect of the (associated) Dutch émigré and Eurasian society in Batavia (and, to a lesser extent other locations) in the 18th Century (see Taylor 1983) and created various cultural filaments that have persisted through to the present.

III. Cinema and Popular Culture

Wessing (2007) explores a topic that intersects with the concerns of this chapter in various ways. His study set out to analyse representations of Javanese goddesses in Indonesian cinema and television. Focusing on representations of the aforementioned Nyi Roro Kidul and the snake goddess Nyi Blorong, he commences with the pertinent characterisation that:

> *In spite of the increasing influence of Islam in daily life in Java, mythological themes and ideas about magical powers remain important ... These ideas find expression in beliefs about spirits and supernatural forces, both local and*

supra-local, even though there is an ongoing discussion between various adherents of Islam and proponents of modernity about how these phenomena should be regarded. (ibid: 530)

His essay then examines the "effects of placing the stories about these entities in 'media-space'" (ibid: 529) – where they are displaced from the local contexts that provided senses of connectedness to specific cultural heritages – before concluding that these representations "have little to do with the role that these figures played locally" (ibid: 546), raising questions about "the position of these myths and religion in the nation's system of values as well as the system of values itself" (ibid: 547). The concerns of this chapter interweave with Wessing's by examining the manner in which the Western figure of the mermaid has variously been used to express and represent aspects of local mythology, been inserted into these or else has operated a locally nuanced instantiation of international media-lore.

One of the most tantalising aspects of researching Indonesian cinema is that many of the productions made in the pre-independence era have been lost and are only represented today by publicity materials. Archival records show that over 100 feature films were produced between 1926 and 1949. The first feature film produced in the Dutch East Indies was *Loetoeng Kasaroeng* (L. Heuveldorp, 1926), which set a precedent for a substantial strand of feature production through to the present by adapting a traditional folk story (about a girl falling in love with a magic *lutung*).[19] Two subsequent films – *Ouw Peh Tjoa* (1934) and *Anaknja Siloeman Oeler Poeti* (1936), both directed by Chinese-trained director The Teng Chun – were adaptations of Chinese folktales about snake women. These films emerged from the cultural context of a Chinese community that had been present in Batavia since the earliest days of the VOC's construction of the port city and had developed both a local identity in itself and through intermarriage with the Indigenous population in a mixed-race *Peranakan* community. Despite restrictions on the community after the Dutch Government took control of the region in 1799, the Chinese/*Peranakan* community continued to profit from entrepreneurial operations and also to produce individuals who achieved prominence in public affairs and the arts. They also developed a distinct localised syncretic culture, blending Chinese, Dutch and Indigenous elements.[20] Informed by this context, in 1941 Chinese Indonesian film-maker Lie Tek Swie directed (and probably wrote) an original film entitled *Ikan Doejeng*.[21]

Surviving marketing materials for *Ikan Doejeng* present an interesting dichotomy. While plot summaries printed in various newspapers[22] referred exclusively to the initial part of the narrative, in which a daughter is torn between her parents' wish for her to be married and her wish to avoid the suitor chosen for her, photographs used to promote it emphasise the latter part of the film's narrative, when the film's youthful heroine decides to escape to the sea and become a mermaid in order to avoid the marriage. The photographs show several mermaids (two in one shot, four in the other – possibly including the heroine in Mer-form).[23] The mermaids have scale-patterned tails stretching to above their bust-lines and with waist fins at the side of each hip. One shot also shows a small, older male holding a trident whilst talking to two mermaids sitting at the edge of the water. Even on this skeletal evidence, the film appears unusual within the corpus of international mermaid-themed cinema[24] by way of having a scenario that is the reverse of the paradigmatic

mermaid media-lore established by Andersen and the 1984 film *Splash* (Ron Howard), in that it features a human female aspiring and managing to turn into a mermaid to avoid a relationship with a human male. In this regard the film is more akin to the substantial contemporary body of Western pre-teen and early adult aficionado mermaid videos that I have discussed elsewhere (Hayward 2017a: 129–150), in which young girls explore the potential of becoming "mermaid-like a while" (ibid) as a way of escaping their transition to adulthood and their implication into the world of adult sexual activity. While the theme of (terrestrial) women being transformed into either dugongs or (more ambiguously) *putri laut* (women of the sea) as a result of various social factors (such as failing to obey their husbands) is common in various areas of Indonesia,[25] Swie's film appears to offer a distinct twist on traditional tales.

While mermaids had a low profile in Indonesian national culture in the immediate post-independence period, they re-appeared in the 1980s in various popular cultural contexts. Echoing aspects of *Ikan Doejeng's* incorporation of folkloric aspects into contemporary scenarios, *Duyung Ajaib* ('Magical Mermaid') (1978), directed by and starring popular singer and comic Benjamin Sueb, was a knockabout comedy concerning a hapless fisherman who hooks a mermaid, is pulled into the sea and ends up on a beach where local custom impels him to marry his catch. Unlike conventional Western mermaids, his is large and somewhat unattractive. The fisherman turns the situation to his advantage by keeping her in a pool and charging customers to see her. Miraculously the mermaid then transforms into a slender young woman and wins his heart. Later she sees the sea again, reverts to her previous form and disappears into the waves, leaving him heartbroken. The film is notable for *not* being influenced by or modelled on Hollywood films (there being somewhat of a dearth of Hollywood mermaid-themed productions in the 1970s).

A subsequent production, *Putri Duyung* (Atok Suharto, 1985), blended aspects of Indonesian folklore with themes derived from *Splash* and references to other aspects of popular United States' (US) cinema of the period. The film opens with a small boat out at sea when Tintus, one of the crew (played by leading 1980s actor Barry Prima) glimpses a mermaid swimming in the water (played by Eva Arnez).[26] Returning home, Tintus is shocked to discover that his girlfriend has been killed by a rival and he subsequently decides to join a disco band to escape from his previous life and memories. Meanwhile, the mermaid he has glimpsed has become infatuated with him and, despite being forbidden by an undersea queen in a grotto, comes ashore and transforms into human form. After repelling the unwanted attentions of two thugs (and revealing her alternate form to them in the process) she finds Tintus, explores the human world and initiates a sexual relationship with him while struggling to hide her tail, which (like Madison the mermaid's in *Splash*) regenerates on contact with water. The relationship is interrupted when a gang working for Tintus's spurned lover kidnaps the mermaid. After Tintus comes to the rescue and saves her he realises her true identity and, despite his deep love for her, accedes to her wish to be returned to the sea. Arnez's mermaid alternates powerful physicality and confidence in the oceanic world with a naïve and bumbling innocence on shore. Her tail is carp-like in appearance and her long black hair covers her breasts in all scenes, in the manner established in *Splash*. There is little, if anything, in the film that refers to Indonesian folkloric traditions and the film's title might, in this regard, be understood to represent a

Figure 6 – Front cover of
Misteri Air Mata Duyung
(1984).

translation of the English-language term and concept of a mermaid, rather than being a distinct Indonesian folkloric entity.

Mermaids were also represented in different contexts during the 1980s, including in the comics that began to be published in the mid-1950s, and underwent a surge in sales and popularity in the 1960s and 1970s despite (and, perhaps, due to) criticism and confiscation by police acting under the direction of President Soekarno (who dismissed them as being of low cultural value and as being redolent of decadent Western values). Despite this, Berman has identified that:

> During the 1970s, the theory of comics as a reincarnation of past oral traditions met its modern economic reality where Chinese silat stories[27] eventually led to a revival of local legends in comic book form. (2001: 19-20)

The local legends referred to above were often illustrated in ways that differed from their traditional representation and variously elaborated, sexualised and/or sensationalised the narratives being retold in the comic medium. They also freely cross-associated Indonesian themes with imagery and associations drawn from Western magazines, comics and cinema. While mermaids were not prominent characters in 1970s' and 1980s' Indonesian

comics, one was featured in the Bumi Langit series chronicling the adventures of the superhero Mandala. Written by leading Indonesian comic artist Ganes TH,[28] the lead character was a human raised by Nyi Nara Sati, the "Queen of the White Crocodile Demon" (Bumi Langit nd: online). A martial-arts and sword-fighting expert with super-powers, Mandala was often represented on magazine covers rescuing females of various types (often carrying them over his shoulder) (e.g. Figure 6). The 1984 comic *Misteri Air Mata Duyung* ('Mystery of the Mermaid's Tears') drew on the folkloric attribution of *putri duyung's* tears as possessing various magical properties[29] and depicts the hero's quest to rescue one from her captors. The magazine's cover (Figure 6) shows an interesting combination of images. Together with Mandala, with his customary long hair, headband and crocodile skin garb, the mermaid has a standard international form and the fish monsters appear like blends of elements of Indonesian folklore and the aquatic humanoids from Jack Arnold's 1954 US film *The Creature from the Black Lagoon*.

The vivid imagination and dramatic narrative of Indonesian comics in the 1980s were echoed in cinema during the decade, as commercial film-making expanded considerably during the middle period of President Suharto's New Order regime. Like the comics, a particular strain of filmmaking was marked by greater concentrations on action, violence, supernatural themes and/or sexuality that pushed the boundaries of established social propriety. One typical film of this type was *Bangunnya Nyi Roro Kidul* (Muryadi, 1985). The film inserted the sea goddess into the late 20th Century through her awakening (*bangunnya*) after a group of adventurers locate her comatose body on the seafloor and bring her to land. Reviving, the goddess (played by regular 1980s' horror film actress Suzzana) shows her supernatural powers by blasting any men who attempt to cross her with lethal rays that emanate from her face.

A subsequent exploration of the Nyi Roro Kidul legend, *Pembasalan ratu pantai selatan* (H. Tjut Djalil, 1989), proved one of the most controversial films of its type (and attracted a short-lived ban in the process). The film (whose title translates as 'Revenge of the Queen of the South Seas') provided a modern day twist on the Nyi Roro Kidul legend by representing her as a particularly violent and malevolent entity that possesses the body of a Western anthropologist.[30] The model for her behaviour in possessed mode (and of the film's subsequent representation of her) was ably summarised in the title of the English-dubbed release version – *Lady Terminator* – representing her as a relentless adversary immune to usual force, like that of the cyborg assassin played by Arnold Schwarzenegger in James Cameron's 1984 film *Terminator*.

Arwah Kuntilanak Duyung (Yoyo Subagyo, 2011), made two decades after the peak of Indonesian exploitation cinema, has many points of resemblance to the films discussed above (Figure 7). The film (whose title loosely translates as 'The Spirit Mermaid'[31]) features a mix of slapstick comedy, supernatural horror and violence in a story concerning a couple of young lovers who are plagued by the arrival of a menacing mermaid with a scaled gold tail and matching bikini top. The narrative strand concerning her winds somewhat unevenly through the film but basically represents her as the reincarnation of a young woman killed by a psychopathic businessman a decade earlier who has come to haunt the community she once lived in. She is indicated as dangerous in the film's opening, which shows her swimming underwater and killing a young man after he urinates

into the sea. After this graphic opening she principally appears as an unwelcome (and clearly unhinged) intruder in the lovers' coastal house, appearing in various rooms manically tittering and flexing her tail. Eventually confronting and revenging herself on her killer after he also murders her sister and dumps her corpse in the sea, the film concludes with a far more peaceful image of the two sisters reunited as mermaids, relaxing in shallow waters.[32]

A number of the strands discussed above were drawn together by controversial singer, actress and political activist Julia Perez (popularly known as 'Jupe'). Perez attracted wide media attention in Indonesia in the 2000s and 2010s (until her death in 2017) for her opposition to conservative Muslim clerics who sought to regulate women's dress and behaviour, and attracted their ire in 2013 by promoting the use of

Figure 7 – Promotional poster for *Arwah Kuntilanak Duyung.*[33]

condoms to combat the spread of HIV. Throughout her career she experimented with various types of imagery and roles, including many that were provocatively sexual in a manner that recalled American stars Madonna (in the late 1980s and 1990s) and Lady

Figure 8 – Julia Perez in mermaid costume (2016, Instagram post).

100

Gaga (in the 2000s–2010s).[34] In various videos and photo shoots she played with mythological personas, including angels (in her 2012 music video *Please Call Me*) and as Nyi Roro Kidul in a 2015 photo shoot. Moret has identified his photographic portrait of Perez floating underwater as Nyi Roro Kidul as the "masterpiece" of his oeuvre (Unattributed 2017: online) and documented the production of the image in a short video documentary entitled *Aliksah* ('Anxiety') (2016).[35] In her final year of battling cervical cancer, Perez took to swimming in a mermaid tail and posted shots of her wearing it on her Instagram page (see Figure 8), together with a message about how she donned the tail and swam with it as an attempt to promote her inner health and to defeat her disease through becoming a "duyung cijantung[36] ... supergirl" (2016: online).[37] Poignantly, she died less than a year later.

II. *Sinetrons*

While the films discussed above established the presence of mermaids in Indonesian cinema and in popular culture more generally, it was television, in the form of *sinetrons*,[38] which led to a profusion of audiovisual representations of mermaids. *Sinetrons* (low-budget, quickly produced TV series) have become massively popular in Indonesia since the 1990s, following both a marked decline in the Indonesian cinema industry and the introduction of national commercial television channels shortly after (Loven 2008: 48). The mass of *sinetron* productions that have been made for Indonesian television over the last two decades share a number of aspects, including the frequent copying and blending of plot elements of Indonesian and international films and television series and the copying of other *sinetrons* themselves. Fittingly, in this regard, the first mermaid-themed *sinetron* made in Indonesia was Atok Suharto's eponymous 2001 adaptation of his earlier feature film *Putryi Dyung* (discussed above), a light comedy starring Aya Azhari as a charming mermaid who transforms to human form to live on land (but reverts to tailed form when wet). This was followed by *Sissy Si Putri Dyung* (MD Entertainment, 2007), a series that revamped aspects of Andersen's 'The Little Mermaid' (as adapted by Disney) by focusing on the travails of Sissy the teenage mermaid as she comes to land, temporarily transitions to human form and attempts to win the affections of a boy (and thereby retain her human form). Genta Buana Paramita's 2010 series *Putri Duyung Marina* was based on a different model, being an adaptation of a Filipino television series entitled *Marina* that drew heavily on the long-running series of Filipino *Dysebel* films and television series (discussed in detail in Chapter 6 of this volume). One of the more novel productions of the 2000s was Rukmana's 2008 series *Putri Duyung & 100 kebaikan*, ('The Mermaid and the 100 Blessings'), which features a young female child in a Cinderella-like scenario (with a wicked stepmother and cruel stepsister) who escapes her drudgery when she is transformed into a mermaid and engages with other mermaids. Unlike the aforementioned series, this *sinetron* features frequent use of visual effects sequences showing mermaids and other sea creatures in an undersea realm

Building on these early series, the major impetus behind the increase in mermaid-themed material in the 2010s was the success of two series made by the Australian company Jonathan M. Shiff Productions, *H20: Just Add Water* (2006–2010) and *Mako Mermaids* (2013–2016) in Indonesia (and in South East Asia generally) and by the large body of young aficionado video productions that mimicked aspects of the two series (see Hayward, 2017a:

Figure 9 – Loyd Christina as the mermaid in *Gara-Gara Duying* (2016).

129-150). These productions established the appeal of narratives in which characters could be represented as mermaids (through wearing fairly basic costumery) and could then retain their mermaid identities as flexible alter egos in human form, providing opportunities to explore their lack of familiarity with social norms (often to charming and/or comic effect). MD Entertainment's *Putri Duyung* (2013) exemplified this, following the *H20* model by featuring three girls accidentally transformed into mermaids (with the ability to switch between human and mermaid form and with individual special powers). Similarly, the same company's 2015 series *Duyung* copied the basic premise of *Mako Mermaids* by having three mermaids transform to humans in order to repossess the magical abilities acquired by boys who accidentally stumbled into a mermaid full-moon ceremony. Lunar Maya Films' 2016 series *Gara Duyung* similarly has multiple mer-characters and commences with video effects footage of an undersea court ruled over by a mermaid queen with both golden-tailed mermaids and mermen in her retinue. One of the mermaids (played by Loyd Christina) (Figure 9) rescues a trapped human diver and follows him onshore to be with him (with inevitable complications ensuing) and the plot is complicated by the arrival of two squabbling mermen, transformed into human form, and a group of villains who have ascertained the mermaid's identity and want to trap her to exploit her magical powers. Mega Creations' 2016 *Mermaid in Love* and its loose sequel *Mermaid in Love 2: The World* also draw on Disney's version of Andersen's tale (such as for the lead characters' names, Ariel and Eric) and mix depictions of teenage scenarios similar to *H20: Just Add Water* and *Mako Mermaids* with explorations of themes that reference Indonesian folklore and Disney's version of Andersen.[39]

Like Disney's adaptation of Andersen's short story and the two Australian series discussed above, the success of mermaid-themed *sinetrons* can be seen to result from a number of factors. One concerns the polyvalence of the mermaid as a symbolic character (Hayward 2017a: 188), whereby the mermaid's distinct anatomy can be used to variously symbolise lust (ibid: 9, 51–74 and 91–128), fatal seduction (ibid: 82–89) and/or innocence/pre-sexuality (ibid: 21–50 and 129–150). As suggested in the opening of this section, the lost 1941 East Indies film appears to have embodied the latter quality, while subsequent films have emphasised the former two. This polyvalence has proved useful in the particular situation that enfolds, characterises and is expressed by Indonesian popular culture in the 2010s.

Essentially, there are two competing forces in play. One is a growing liberalisation of values concerning socio-sexual mores and appropriate forms of female dress and behaviour. This, in some ways at least, represents a negotiated form of Westernisation that reflects facets of internationally distributed audiovisual, audio-musical, print and online media materials and the values they are perceived to represent. The other is a growing tendency for conservative Islamists to seek to reverse such liberalisation and return to earlier (and implicitly pre-1970s') standards of public propriety. Unlike the Suharto and Sukarno years, the state has played a far weaker and/or erratic role in balancing these competing impulses. Complicating the situation, there is also a growing volume of media outlets that provide a platform for the dissemination of modern Islamic media texts that provide less traditional role models and discourses and that intersect with the aforementioned forces in various ways. Within this situation, issues around the representation of women – and particularly young women – and their interactions with men are intense and often highly contested. The mermaid swims into this space with a number of highly attractive features. Firstly, her polyvalence is complemented by her nature as a fantasy figure. Mermaids exist outside of established social logics and rationales, and thus are not over-determined by particular moral or religious codes or legal strictures. Secondly, the mermaid's tangential relation to Indonesian cultural history makes her essentially an exotic entity, something that is both from 'somewhere else' and is 'something else', rather than being (fully) human. Similarly, mermen arrive in *sinetrons* with ambiguities about their sexual identities (ibid: 151–166), without prescribed roles and the expectations that accrue from these and, indeed, with very limited representation in popular culture as a whole (ibid).

Like *H20: Just Add Water* and *Mako Mermaids*, the Indonesian *sinetrons* have prompted local mermaid aficionados to make their own amateur video productions, showing young girls becoming magically transformed into mermaids and learning how to adapt to their new form. Like the US pre-teens who have been responsible for a major body of video production (see ibid: 129–150), examples of this work have achieved surprising large viewing figures. One example is a five-minute-long video entitled *Putri Duyung Terdampar di Pantai Sanur Bali* ('A Mermaid Cast Ashore at Sanur Beach Bali') (2017). The video presents six-year-old Lifia Niala in a simple narrative involving her at the beach with her younger sister when she suddenly acquires a purple mermaid tail, which she wears together with a turquoise rash shirt. After flapping her tail and swimming in the shallows, screen captions state "Sebenarnya Lifia pengen jadi Mermaid beneran loh … Bisa bernafas di air" ('Actually Lifia wants to become a real-life mermaid … who can breathe in water) she swims around some more and gives a thumbs-up to the camera. As of August 3rd 2017, the video had been accessed 2,280.462 times. A second example features Indonesian pre-teen Instagram and You Tube star Peachy Liv. Her six-minute-long video *Real Mermaid Returns to the Ocean* (2016)[40] features her waking up, dreaming about going to the sea, magically transforming into a mermaid (via a full-length, pink mermaid outfit) and then swimming in a pool before pausing and thinking (via a thought-bubble shown on-screen) "I miss the ocean." After an intertitle linking the scene to the next day, she is shown visiting the beach and sitting with her feet in the edge of the water before suddenly acquiring the pink suit again and then swimming underwater before blowing a joyful farewell kiss to the camera. As of August 3rd 2017, this had accrued 748,000 views. As with the aforementioned Western aficionado videos, high production standards and/or narra-

tive originality are less important than the representation of predictable scenarios for the pre-teen viewers who appear to make up a sizeable proportion of the videos' online audiences.[41] Participant and viewer comments indicate that the special powers that donning a mermaid outfit appear to bring are key attractions for pre-teen girls and that the role offers a sense of empowerment that may be hard for them to come by in Indonesian everyday life.[42] This aspect is similar to the dominant strand of Western, pre-teen mermaid aficionado videos and, indeed, one of the only noticeable differences between the two corpuses is the more covered-up upper bodies of Indonesian pre-teens, reflecting the different prevailing standards of modesty in the country that the aforementioned Julia Perez sought to question in her career.

Conclusion

A number of the texts discussed in this chapter use mermaids to engage with traditional Indonesian cultural themes. Perceptions of cultural heritage as a stable field that requires preservation might perceive the mermaid's presence to distort or dilute that heritage. Alternatively, those who regard cultural heritage as a highly dynamic field might view the development of aspects of traditional culture in a modern media-loric space as having the capacity to refresh and/or innovate it. Similarly, the elaboration of international media-loric tropes in locally made mermaid *sinetrons* can either be considered as unwelcome instances of Western cultural imperialism being facilitated by national collaborators or else as national 'makeovers' of imported products to suit and reflect national sensibilities. There is, of course, no single correct reading of the phenomenon discussed in this chapter, but rather a set of positions and rationales that produce different perspectives. In all of these it is the mermaid's polyvalence that allows her to serve various functions in comedy, horror and *sinetron* contexts. Most recently, we can perceive the mermaid's function in a significant number of *sinetrons* and aficionado videos as allowing the exploration of pre-teen and teen female roles by making these strange in various ways as they are performed by mermaids learning what it is to be a young human female in contemporary Indonesia. In this manner the recent popularity of the mermaid as such (i.e. rather than as a representation of traditional Indonesian figures) can be seen to represent a moment of localisation/nationalisation of an international media-loric entity that might lead to more original local interpretations of its form.

Acknowledgements: Thanks to Roy Jordaan and Robert Wessing for their correspondence with me on matters discussed in the chapter and for their feedback on earlier drafts. Also thanks to Linda Burrman-Hall and Revency Vania Rugebregt for further research assistance.

Notes

1. As the similarity of the two terms suggests, the English-language word is derived from the original Malay term.
2. See J. W. DeVries (1988) and Giesbers (1997) for discussion.
3. Such as the Osings and Tenggerese of eastern Java and small communities in central Kalimantan. There is also a discernible Hindu influence on the culture of Lombok (and a sizeable Hindu community on the western side of the island).
4. Dewi Urangayu, daughter of Hyang Mintuna (god of freshwater fish) is also occasionally represented in fish-tailed form, as in Cirebonese wayang sets dating from 1900–1930 (thanks to Matthew Cohen for this information).

5. My thanks to Robert Wessing for his clarification of aspects of *widyadhari* symbolism.

6. International-style mermaid imagery has been used in various tourism contexts on Java. See for instance the three mermaid fountains at Putri Island jetty and the fountain figure, naming and logo of northern Jakarta's luxury Putri Duyung Resort (for detail on the latter see: https://www.ancol.com/id/resort/putri-duyung-ancol – accessed August 19th 2017).

7. See Marine Foundation (nd) online for further information about and photos of the sculpture.

8. Such as the Island Mermaids company – Facebook: https://www.facebook.com/islandmermaidsid/

9. The term *meer* actually refers to insular bodies of water (such as lakes) in the Dutch language but is used to refer to mermaids and merman as sea-dwellers in its common usage. In the latter case, the word *zee* (sea) is also added, becoming *zeemeermin*.

10. When the archipelago became officially the *Nederlands(ch)-Indië* colony - usually referred to in English as the Dutch East Indies.

11. See Hayward (2017a: 14–16) for discussion of this symbolism in Western traditions.

12. Indeed, the 2009 Indonesian Dugong Strategy Report slated this as the explanation for mermaid sightings in the archipelago.

13. My inquiries to Ambonese researchers as to whether there may have been mermaid-like folklore in Ambon around the early 1700s were responded to affirmatively – but only by identification of Fallours' account as evidence of this. I have yet to identify any accounts or representations that pre-date Fallours and there is no evidence that Fallours' account has been subject to serial reinterpretation and/or localisation in Ambon since.

14. See Jordaan (1984) for a discussion of Nyi Roro Kidul (referred to as Nyai Lara Kidul) as a chthonian deity.

15. See, for instance, Wessing (1997) for a study of beliefs concerning her in Puger (in eastern Java).

16. See Wessing (2007: 537).

17. See Hayward (2017a: 169) for further discussion.

18. Image from Kreemer (1879: unpaginated).

19. Literally a monkey but actually a god in animal form.

20. This was so well-established by the early 1900s that it prompted the formation of a local association (the Tiong Hoa Hwee Koan) dedicated to re-instilling traditional Chinese Confucianism in the community.

21. An alternative spelling of the term *ikan duyung*, discussed above.

22. See, for instance, the brief press advert archived online at: https://commons.wikimedia.org/wiki/File:Ikan_Doejoeng_ad.jpg – accessed July 30th 2017.

23. See the blurry copies of the stills archived online at: https://id.wikipedia.org/wiki/Berkas:Ikan_Doejoeng_film_still.jpg and - https://commons.wikimedia.org/wiki/File:Poetri_Doejoeng_Pertjatoeran_Doenia_June_1941_p9.jpg - accessed 30th July 2017.

24. See Hayward (2017) and chapters 3, 6 and 7 of this volume for discussion of this corpus.

25. See, for example, Forth (1988: 192–199) for an account of Subamese folklore on this topic. The theme has also been reiterated in more recent fiction. Dian's novella (2017) *Legenda Putri Duyung* (2017), for instance, reinterprets a story from Central Sulawesi folklore concerning a mother who angers her husband by not giving him enough to eat. Distraught, she walks to the sea, enters it and transforms into a *putri duyung* to escape her shame.

26. This glimpse is given dramatic (if incongruous) emphasis by accompanying it with a musical pastiche of John Williams' distinctive theme from George Lucas's *Star Wars* (1977).

27. Stories concerning accomplished martial arts practitioners.

28. The professional moniker of Ganes Thiar Santosa (1935–1995), who created the first popular Indonesian martial arts publication *Si Buta Dari Gua Hantu* ('The Blind Man from Ghost Cave') in 1967.

29. The folklore concerning these has continued into the early 21st Century with a product named (and supposedly made of) *Airmata* [sic] *Duyung* ('Duyung's tears') being retailed over the Internet as a magical potion contained in small glass bottles bearing the product name and the image of a mermaid with a long fish's tail (see Airmata Duyung nd: online).

30. There is a fleeting reference to mermaids in *Pembasalan ratu pantai selatan* that occurs when the anthropologist is shown consulting books for references to Nyi Roro Kidul before her possession. The camera shows her

looking at a page in a book that shows the goddess in fish-tailed form. Despite this, the goddess doesn't manifest in mermaid form in the film.

31. The term *kuntilanak* refers to the ghost of a woman who died giving birth. Unlike the mermaid *kuntilanak* depicted in the film, she is usually represented as hideous and/or disfigured.

32. While having a fatally seductive snake-girl (evoking Nyi Blorong) – rather than mermaid – as its central character, Gobind Punjabi's 2013 film *Pantai Selatan* ('The Southern Beach') invites comparison to the mermaid-/Nyi Roro Kidul-themed horror films described above due to its sea-snake theme and coastal setting.

33. The poster is an impressionistic rendition of the film's themes. The hideous mermaid figure on the right of the image does not appear in the film, but rather represents the golden mermaid's vengeful impulses. The mermaid's midriff is also scaled in the poster (unlike in the film).

34. NB both US stars also explored mer-imagery, Lady Gaga having an occasional alter-ego as Yüyi the mermaid (as in her 2010 music video *You and I*) and Madonna having appeared with mermen in her 1989 music video *Cherish*.

35. Video online at: https://www.youtube.com/watch?v=1yasMOJMUD0 – accessed August 8th 2017.

36. Cijantung being her hometown in Java.

37. Also see footage of her swimming in her mermaid costume at: https://www.youtube.com/watch?v=_V4AdHPotaUhttps://www.youtube.com/watch?v=_V4AdHPotaU – accessed August 6th 2017.

38. The term is an abbreviation of *sinema elektronis* (meaning specifically made for TV production). See Loven (2008) for discussion of the form.

39. See, for instance, Episode 86 (2016), with its (infra-diegetic) stage version of the 'Little Mermaid' tale online at: https://www.youtube.com/watch?v=GEM_3Cwbbo4 – accessed August 15th 2017.

40. Online at: https://www.youtube.com/watch?v=werFfoIq_-M – accessed August 3rd 2017.

41. One of the precursors of these videos was a short series starring an infant school-age girl entitled *Mermaids of Bali* (completed in 2016). Unlike the videos discussed above, this secured miniscule viewing figures – only 739 in the case of Episode 1, online at: https://www.youtube.com/watch?v=YuZZhKHDSpg–accessed July 4th 2017.

42. Illustrating the extent of the popularity of the mermaid with young viewers, another video that attracted surprisingly high viewing figures (1,036,877 as of August 3rd 2017) was entitled *Buang Squishy Mermaid Ke Pantai de Lombok* (2017). The 2:30-minute-long video features teenage Video Blogger star Ria Ricis unwrapping two squishy mermaid toys, arranging them on a beach in Lombok next to a starfish and then letting them float away on the tide. Online at: https://www.youtube.com/watch?v=o44V2hoAdh8 – accessed July 4th 2017.

Changelings, Conformity and Difference: Dyesebel and the Sirena in Filipino Popular Culture

Philip Hayward

Introduction

The Philippines consists of a group of over 7500 islands located north of central Indonesia and south of Taiwan. Positioned at the northern apex of the so-called 'Coral Triangle' – a hotspot for marine diversity that holds some of the world's richest fishing stocks – the communities of many small islands and the coastal areas of larger ones exemplify the integration of marine and terrestrial spaces for livelihood purposes that has been identified as *aquapelagic*.[1] As I discussed in the introduction to a previous study of the representations of mermaids (Hayward 2017a), this orientation also extends to the cultures of such societies, with regard to there being elements of an "aquapelagic imaginary" (ibid: 7) that manifests itself in folklore in the form of various aquatic entities and narratives concerning humans' interactions with them. In locations such as the Philippines, that also include substantial lakes and major river systems, there are also related sensibilities and folklore concerning lacustrine and riverine locales. The archipelago's folklore combines strands of indigenous customs and beliefs with aspects of

religions such as Hinduism, Taoism and Islam introduced by early traders. These elements were overlaid and/or partially displaced by Roman Catholicism and related Spanish culture following the islands' colonisation by the European power in the mid-1500s, with Catholicism now established as the majority religion (being followed by 80+% of the population - Gripaldo 2013: 6). This combination of elements was further diversified with the introduction of both Protestantism and United States' (US) popular culture following the American takeover of the islands in 1898. US administration continued until the Japanese invasion in 1942 and the country finally achieved independence in 1946. As a result of these successive waves of cultural influence, Filipino culture is a highly syncretised one that draws on both long-established cultural tropes and more recent introductions and innovations. Filipino folklore is notable for having a range of mythical entities, including several types of aquatic humanoids and the enduring figure of the *sirena*, who blends aspects of local, pre-Christian folklore with the fish-tailed female introduced by Spanish colonists. Following a discussion of aquatic humanoids in Filipino folklore, the chapter goes on to consider various aspects of the *sirena* and her representation in 20th and 21st Century popular culture, with particular regard to the nature and prominence of Dyesebel, the mermaid character created by Filipino comic book artist Mars Ravelo in the early 1950s who went on to appear in a series of films and television programs and became a national popular cultural icon.[2]

I. Filipino Folklore

As Ramos (2000) identifies, there are a profusion of folkloric entities across the Philippines, many of which have regional variations.[3] Contemporary Tagalog (the *lingua franca* of the Philippines) utilises the Spanish loanword *sirena* to denote the fish-tailed aquatic females of the type commonly referred to in English-language cultures as mermaids; and the term *catao/kataw* has an essentially similar meaning in Cebuano and Hiligayon languages. The *magindara*, known in the Bikolano culture of south-eastern Luzon, is also *sirena*-like but is often characterised as having an eel- or snake-tail (similar to the *nāgiṇīs* of Indian mythology). Beyer-Bagatsing (2017) also identifies a particular concentration of aquatic humanoid folklore in the Ilokano regions of central and northern Luzon that includes modern examples of seductive *sirenas* with the ability to transition to human form. While there are no fish-tailed male figures of the type known in the West as mermen in Filipino folklore, the *siyokoy*, a scaled male with either a fish-tail or legs with webbed feet, is known in various areas and is the nearest equivalent.

While Filipino society has become increasingly urbanised and modernised over the last seven decades, traditional beliefs in and acknowledgement of the presence and role of supernatural entities has persisted in various locales. With regard to fishing communities, for instance, Polo (1985) provided a detailed account of the invocation of the *kataw* in fish-corral rituals in Maripipi island that identified that fishermen "strongly felt" *kataws'* presence in their aquapelagic context "as a real authority influencing and controlling the fishermen's livelihood" (ibid: 54). Commenting on the significance of the *kataw* to Maripipi fishing communities, Polo identifies it as a symbol that condenses "several ... frequently incompatible meanings" – such as benevolence, hostility, power and aquatic otherness – that are dependent on "specific and situational contexts" (ibid). *Sirenas* are

often believed to possess special powers, such as the ability to manipulate water levels and/or create whirlpools to swamp their prey (Ramos 2000: 102).[4] The latter belief has led to particular areas, such as the Pinacanawan tributary of the Cagayan River, being avoided by local inhabitants on account of the belief that they are home to hostile pods of *sirenas* (ibid: 259). In addition to their fish-tailed manifestations, essentially similar characteristics have been attributed to a fully-human form of *sirenas* believed to inhabit various areas.[5] In their inland form at least, *sirena* are also associated with riches and treasure, such as the one believed to live around the Caliraya waterfall in Laguna (ibid: 100).

Modernisation, internal migration (voluntary or otherwise) and rural–urban drift has broken many patterns of close relation within and between communities,[6] their subsistence livelihoods and specific locales and, in such circumstances, aspects of folklore have been refigured in various ways. In locations such as Angono, on the shores of Laguna de Bay, for instance, local folklore concerning a *sirena* living in a palace beneath the waters of the lake has come to be celebrated in annual festivities, a lakeside statue (Chapter 6, Figure 1) and a number of *sirena*-themed public artworks.[7] Several broader beliefs about mermaids and sirens common to various cultures have also

Figure 1 – Sirena statue near Angono on Laguna de Bay (2008) (photo by Travel-on-Foot).[8]

been reported from the Philippines. One of these concerns the capacity of *sirenas* who have been trapped and confined by humans to generate storms to draw attention to their plight. Cordero-Fernando (2011) details a number of early 21st Century instances of such beliefs, including that of an angry crowd who marched on the Silliman Marine Science Laboratory in Dumaguete after the city was flooded by rains in the mistaken belief that the scientists were keeping *sirenas* in their water tanks. *Sirena* folklore has also been incorporated into tourism marketing, particularly that targeted at international visitors. In the course of an article promoting eco-tourism, Valdez cites the so-called 'Enchanted River of Hinatuan' in north-eastern Mindanao as a recently discovered "picturesque" "gem" "believed to be inhabited by mermaids, spirits and fairies" and adds that "folklore has it that these unseen inhabitants protect the river from outsiders" (2017: online).

Since the mid-20th Century, the recontextualisation of the *sirena* and related aquatic folklore in Filipino society has been reflected and inflected by the prominence of particular figures, associations and motifs in popular culture such as, most notably, *komik* (i.e. combined text and graphic) narratives, cinema and, more latterly, television. In these contexts many of the subtleties of local association have been collapsed in favour of more commonly recognised stereotypes, many of which have been deployed in supernatural/horror narratives. This aspect was recently acknowledged by comedian Mikey Bustos, whose parodic 'Filipino Mythical Creatures Rap',[9] in which he dresses up in costume to

impersonate the best-known ones (including a *sirena*), has secured over 5.6 million views and over 6000 comments on YouTube to date.

Subsequent sections of this chapter identify the manner in which Mars Ravelo's creation of the Dyesebel character, and the narrative of her engagement with human and mer-communities represented in *komiks*, film and television, set a particular template for Filipino representations of the *sirena* that has been nuanced in a slew of subsequent audiovisual texts.

II. Dyesebel

Mars Ravelo's Dyesebel character emerged from a particular cultural niche in the newly independent Philippines, the country's emergent *komik* (comic) book sector. This drew on American comic books and newspaper and magazine strips of the type that were accessible in the pre-World War Two (WW2) era and the super-hero-themed DC and Marvel comics that were introduced after WW2 with the American transitional forces. *Komik* narratives began to be published in *Bulaklak* magazine in early 1947 and the *Pilipino Komiks* series commenced later in the same year and became rapidly popular by featuring characters that were both comparable to, but distinct from, their US models. In the early stages of the *komik* industry there were two distinct types of narrative. The first drew on themes from Filipino folklore and, in particular, literary adaptations of them. The most notable group of these were the stories that appeared in the *Tagalog Klasiks* series in 1949–1950 (Figure 2), many of which were adapted from the Lola Basyang stories written by Severino Reyes in the early–mid-1920s. Showing influence from the work of Hans Christian Andersen and the Brothers Grimm, Reyes' stories combined European fairytale themes and elements of Filipino folklore. This aspect was evident in his 1925 short story 'Ang Sirena sa Uli-Uli ng Ilog Pasig' ('The Mermaid in Pasig River's Whirlpool'). The story, set in a stretch of the river that connects Laguna de Bay to Manila Bay, concerns a *sirena* (named Ena) who has transformative abilities. After she has initiated a relationship with a human male named Siso, who she has sucked into her realm via a whirlpool, the couple attempts to understand each other's worlds and appreciate what is distinct to each. The story represents the underwater realm as a sacred space to the *sirena* and her family, and her invitation for Siso to become immortal through loving her and living under the sea is a profound one.

Gutierrez has identified Reyes' *sirena* story as an example of "glocal otherness" based around the adventures of a "blended" heroine who combines aspects of Andersen's Little Mermaid character and local *sirena* folk tales in a story that focuses on "the transcultural relationship" between the siren and the human in order to "expose the impact of colonizing forces on local cultures" (2017: 159–164). She contends that Reyes constructs the *sirena* as one of a number of his characters who are "empowering figures representative of concepts in opposition to patriarchal hegemony" (ibid: 159–160) and who is particularly empowered as a result of her "surfacing from the intersection of femininity, nature and the underclass" (ibid: 160). But whatever her symbolic function in this regard, her persona and related narrative did not succeed in transitioning from literary and graphic narrative form to cinema and, later, television in the manner that Dyesebel, another *komik* heroine, did.

From the earliest stages, the post-War Filipino *komik* sector featured female lead characters, one of the best-known examples being Darna, created by Mars Ravelo in 1950 as a female localisation of DC Comics' Superman character.[10] *Dyesebel*, conceived and written by Ravelo and illustrated by Elpidio Torres, followed this and was published by *Pilipino Komiks* in 1952–1953. The series drew on Ravelo's early inspiration by American animation artists such as Max Fleischer,[11] DC and Marvel comic narratives and his interpretation of elements of Filipino folklore.[12] Ravelo's original 'Dyesebel' narrative has two distinct stages and a marked difference in tone and orientation between them. The first part, concerning the early life of the series' titular protagonist, is set on a remote island location and beneath the sea. The second part, concerning the adventures of an adult Dyesebel, is predominantly set in urban locations before an ending that returns the narrative and its

Figure 2 – Front cover of 'Ang Sirena sa Uli-Uli ng Ilog Pasig' issue of *Tagalog Klasiks* (1949).

heroine to the ocean. While the term 'Dyesebel' nowadays conjures up the image of a beautiful mermaid, romance and maritime adventures for Filipino audiences, the first issues of the comic were very different in tone and subject matter. With regard to the series' title, its protagonist's name is – in pronunciation if not spelling – similar to and evocative of the Biblical character, Jezebel, who appears in the Old Testament *Book of Kings*. Her name serves to associate Ravelo's character with one of the Bible's least pious women, the Phoenician wife of King Ahab who advocated the worship of the Sumerian female deity Asherah (who is associated with the later goddess Atargatis, commonly perceived as the first proto-mermaid)[13] and the male Baal. Killed by members of her husband's court for her pagan convictions, her name has subsequently become associated with female harlotry and general untrustworthiness. The weight of these allusions is notable with regard to Dyesebel in that she is first presented as a newborn baby when she might, otherwise, be assumed to have a fairly open and undetermined identity. Instead, even without an assumption of the audience's ability to grasp her name's associations, the cover of the first issue of the magazine (Figure 3) featured a child's dismayed face (crowned by Medusa-like locks of hair) accompanied by an intense image of a male standing with his fist raised above a supine woman while an older female attempts to intervene. Not only did the image and its cover caption (translating as 'See how you were born') provide a dark and bleak introduction to the narrative, it also gives no suggestion of the mermaid narrative that would unfold in later episodes, nor of the figure of the glamorous Filipino female that the name 'Dyesebel' would come to signify in subsequent decades.

Figure 3 – Front cover of 1st
issue of *Dyesebel* (1952)
(courtesy of Video 48 website).

The themes, images and narrative inside the issue's covers were similarly intense, concerning an anxious wait for a mother to give birth in a village house. The final panels show the shocked reactions of the woman's husband and mother as they see the child she has given birth to. The image of the child is, however, held over to the following issue (in typical 'cliff-hanger' style) and is shown in the first panel, revealing that the mother has given birth to a *sirena*. There are a number of novel aspects to this. The first is that there is no folklore concerning human couples producing *sirena* offspring in the Philippines. The infant's condition is therefore problematic on a number of levels that merit comment. Firstly, it raises questions as to whether the presumed father *is* the father. If he *is*, the issue is whether his offspring's form is the result of some kind of magical intervention (such as a curse). Alternatively, if he is not the father, who/what is? Given the absence of male *sirenas* one possible culprit might be a *siyokoy* (although there is no tradition of such interspecies relations in the Philippines). Alternatively, the newborn may instead be a supernatural creature manifesting as an infant *sirena*.[14] In all these cases the arrival of a *sirena* is problematic and traumatic for the family concerned.

The situation represented by Ravelo in the opening three issues involves a permutation of an international vein of changeling folklore. This involves supernatural entities swap-

ping either a new or recently born child for a less-human and/or ailing one.[15] Viewed through this prism, any newborn with non-standard appearance or infirmity could be construed as a supernaturally induced changeling, and the offspring could be shunned or even disposed of. One such physical defect that has been associated with folkloric accounts of mermaids is *sirenomelia*, which, as its name suggests, is a deformity involving the fusing of a baby's legs so as to produce a single lower limb with two protruding feet that bears a superficial resemblance to a classic mermaid tail. In the majority of cases this malformation is associated with an absence of visible genitalia.[16] The *sirenomelic* infant is therefore doubly aberrant, not only can it be construed as inhuman it is also gender-ambiguous. In the early instalments of Ravelo's narrative we only know that the couple's offspring is female by virtue of knowing her name and by her having curled hair and facial prettiness that suggest her as female. As I have argued elsewhere, this anatomical aspect is crucial to understanding the sexual/symbolic *polyvalence* of the mermaid in contemporary Western culture, and in the audiovisual-signifying system of cinema in particular (Hayward 2017a).

The gender/sexual polyvalencies I refer to have an additional dimension in the Philippines in that Garcia (2014) has identified that "gender transitivity" was "very much an archipelagic phenomenon" in the early colonial era, with archival evidence suggesting that:

> a number of pre-Hispanic cultures in the Philippines recognized the existence of "mixed," "liminal," and/or "alternative" bodies. From all available accounts, it would appear that, even during early colonial times, the male/female dualism did not exhaust all the possible somatizations of the gendered self that the various Philippine indios could assume. (ibid: 165-166)

Garcia also contends that situation was superseded by a "dichotomizing of the gendered body into practically anatomically immutable and mutually exclusive male and female normative 'types'" (ibid: 165) by "the gender norms of Hispanization" and a cult of machismo that ridiculed related behaviours such as male–female cross-dressing and transitivity (ibid: 164). This saw the more neutrally descriptive Tagalog term *bayoguin* (meaning 'feminine male') being replaced by *bakla*, a term whose original meaning included senses of being confused and/or cowardly (ibid: 164). Garcia has identified that this cultural resignification involved the inflection of a particular Tagalog discourse, that of *kabaklaan,* which "entails the discursive movement from the genitally sexed 'external body' (*labas*) to the realm of the psyche and interior selfhood (*loob*)" (ibid: 165). He has also emphasised that this:

> did not completely negate or eliminate the importance of the former, but merely cast both in a reverse and mutually exclusive relationship. This binarism effectively absolutized their difference from one another, effectively recasting the bakla's identity into a perversion (... a "self-contradiction") (ibid)

While Ravelo conceived Dyesebel in a modern cultural context that lacked the acceptance and acknowledgement of alternative liminal bodies and identities that Garcia characterises, it is possible to discern remnants and resonances of earlier perceptions and beliefs and their diminution by colonial heteronormative culture. Dyesebel's otherness – as not human – is only an issue for her when it is the cause of confusion, shame or fear on the part of the humans she interacts with and when she internalises these responses as part of her formation and perception of identity (her *loob*).

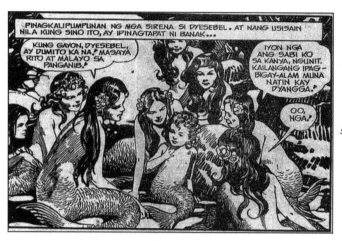

Figure 4 – Dyesebel meeting the pod of *sirenas* for the first time (issue 7).

Having delivered a figure who expresses such dense complexities, the narrative soon poses a solution to the situation, namely that the mother's pregnancy may have been subliminally influenced by her fascination with *sirena* images, resulting in the fetus growing as a *sirena* rather than a human. This is, however, a relatively under-developed element of the story (which could have been given greater credulity through some more complex explication) and fails to mollify the child's father, who departs in a state of shock. His anger and confusion are vividly represented at the end of the second issue, which shows him creeping back into the house at night. Unable to tolerate the monstrous creature that has usurped the infant he had anticipated, the final panel shows his hands locked around the child's neck, about to strangle her as she sleeps. But, as the first panel of Issue 3 makes clear, he does not follow through on his intent and instead relents as Dyesebel opens her eyes and smiles. Her father subsequently resolves to let her live. In order to provide some semblance of normality for the family, who are keeping their daughter's condition a secret, they have her baptised. This element recalls aspects of folklore from the Asturia region of Spain concerning the Xana, a type of water nymph who lived around streams and lakes who tried to swap their babies with human ones so that theirs could be baptised (Barrangaño 1995). Whereas Asturian folklore refers to parents being duped into having infant Xanas baptised, Dyesebel's parents' deliberate arrangement of a baptism for an entity that does not possess a soul (at least in terms of Catholicism) is a highly transgressive act.

Following the baptism, her parents are faced with the issue of how to bring up their *sirena* in a manner that conceals her true identity. This issue is, however, sidelined in issue 5, as the infant slips away from the house and swims delightedly in the sea. As shown on the first page of issue 6, she revels in her element, free of any awareness of the identity issues that surround and await her on land. This idyll is, however, short-lived. Discovered by villagers, she is shunned and driven away from the shore with a hail of stones and, seeking shelter in a canoe, she drifts away. Issue 7 brings in a new narrative element, washing ashore on an island at night, she meets an adult siren, learns that she is not a unique creature and is introduced to a welcoming pod of young adult *sirenas* living in lagoon (Figure 4). The mermaids' appearance and location invite comparison to the mermaid

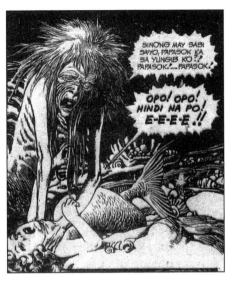

Figure 5 – Dyangga throttling Dyesebel, detail
from opening panel of Issue 9.[17]

lagoon scene featured in J.M Barrie's play 'Peter Pan' (1904) and vividly represented in Disney's adaptation of the story in the company's eponymous 1953 film, and the locale provides a safe and accepting culture that contrasts dramatically to the human society that has driven Dyesebel away. In this context, her body and identity are neither aberrational nor transgressive.

In order to get permission for Dyesebel to stay in the *sirena* community she is taken to meet Dyangga, an aged and authoritative *sirena* witch. While she obtains the necessary permission, Dyesebel's curiosity and precociousness almost undoes her as she stumbles across Dyangga's secret golden clam shell, leading the witch to turn on her and – in an image that echoes that of her father with his hands around her neck in issue 2 – commences throttling her (Figure 5) until another *sirena* intervenes. After temporarily transforming Dyesebel into a fish, to show the infant her power, Dyangga lets her go, cautioning her to avoid her cave for ever after. This sequence provides a rapid lesson for Dyesebel that while the *sirenas'* realm may be free from the problematic issues of her previous co-existence with humans, it has its own prohibitions, power structures and hierarchies that mirror those of the terrestrial world.

The narrative jumps after issue 9, with issue 10 opening with an adult Dyesebel and her *sirena* daughter sitting in a grotto. This scene introduces an extended flashback showing Dyesebel falling for a handsome young man named Fredo and the trials and tribulations that follow from her romance with him. Fredo's response to her *sirena* form is significant, as he accepts her for what she is and, initially, manages to conceal her identity from his parents and friends. Her anonymity (her 'passing for' human) is eventually breached by Betty, another woman who covets Fredo's affections. Keen to capitalise on the inhuman nature of her rival, Betty conspires to have Dyesebel kidnapped and she is taken and exhibited in a cage in a tawdry freak-show where her tail is grabbed by gawping onlookers. As her fame spreads she is exhibited in higher-profile contexts, with news of her appear-

Figure 6 – Dyesebel in performance tableau (issue 23).

ance in one – in the amusement zone at an international fair in Manila – coming to Fredo's attention. Angry at her kidnapping, rejecting Betty and keen to regain his *sirena* lover, he sets out to secure her again. In contrast to her appearance at the freak-show, she is given a glamorous showcase at the fair. Carried on-stage concealed in a giant clam shell by four men, the shell is opened to display her sitting up and looking out at the audience from behind a pool of water (Figure 6), in a manner evocative of the central image of Botticelli's painting 'The Birth of Venus' (1486), as a group of musicians play lap-steel guitars and bongos to accompany a group of hula dancers arranged in front of the shell. Suddenly, a percussive clap rings out. The dancers flee and Dyesebel dives from her shell into the pool. A single spotlight then shines on the pool as a water-tank rises to show her swimming underwater (and thereby confirming her as a real *sirena*). While Dyesebel has been coerced into participating, the staging is notable for representing her physical form – and her tail in particular – as a graceful and attractive object of the gaze rather than as an element that causes revulsion and/or aggression (as in earlier scenes of her interaction with humans). In this situation she is represented as an impossible object of (phallic/penetrative) desire. While glamourised on-stage, her tail clearly signals her difference and her exclusion from conventional genital-sexual and procreative activity. The narrative shuts down such spectacularisations of her trans-species femininity shortly after, as Fredo confronts her captors and rescues her. Convinced that she cannot live on land he reluctantly returns her to the sea and the couple part broken-hearted.

The final section of the narrative commences in issue 25. Arriving back at the *sirenas'* lagoon, Dyesebel is fondly greeted. However, she cannot settle or be happy there as she longs for Fredo and, implicitly, for sexual gratification and/or the possibility of procreation that her form denies her. Moved by her plight, her surrogate *sirena* mother tells her of a magical procedure using the witch's sacred clam shell that will allow her to lose her tail and gain a completely human body. The opportunity to wrest the pearl from Dyangga's cave comes about when a series of tremors disturb the island and Dyesebel escapes with the clam just as an explosion wracks the island. Coming ashore on another island she immediately activates the charm and her body is instantly transformed. Delighted, she retains the clam shell and her newfound capacity to transfer between human and *sirena*

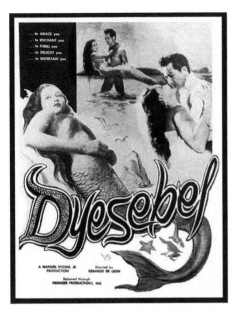

Figure 7 – Promotional poster for *Dyesebel* (1953).

forms. Reverting back to *sirena* form, she dives into the sea and swims off to find Fredo and recommence their relationship using her alternate human body and identity.

The comic series was highly popular and was rapidly adapted for the cinema in a version written by Ravelo and directed by Gerardo de Leon in 1953, starring Edna Luna in the title role, Jaime de la Rosa as Fredo and Carol Varag as Betty. Despite being highly successful and one of the early Filipino cinema's most noted productions, there is no longer an extant copy and – at the time of writing – efforts were underway to attempt to restore the film using copies located overseas. Discussion of the film is therefore limited to a number of silent and degraded film extracts that are available online,[18] surviving production stills, publicity materials, reviews written around the time of the film's release and more contemporary commentary based on fragmentary versions of the film. As the promotional poster (Figure 7) suggests, the romance angle and representation of Dyesebel's bodily difference were central to the marketing of the film, but surviving footage also indicates that the production team made efforts to show credible *sirenas* swimming in the sea and other footage also shows groups of mermaids around the shore of their island. Commenting on the overall tone of the film, and illustrating his characterisations with screen grabs, Stadtman (2013) identifies that the film's lighting, sinister and tawdry sideshow scenes, tough-guy abductors and combat scenes were reminiscent of film noir and that the *sirenas* were shown as "disturbingly abject and debased" when they ventured on land. The latter characterisation is not excessive and is shared in a number of subsequent adaptations of the story, which regularly show Dyesebel and/or groups of other *sirenas* painfully dragging themselves across sandy beaches, emphasising their innate otherness and helplessness out of their own element.

Ravelo and Torres revisited the characters from their original graphic narrative in 1963, writing a new narrative for Liwayway publications entitled *Anak ni Dyesebel* ('Dyesebel's Daughter'). The story involves Dyesebel and Alona, her (human-form) daughter, dealing with the aftermath of Fredo's rejection of his alternative suitor, Betty, in the 1952–1953 narrative. The vengeful Betty, who has been transformed into a *sirena* herself, first causes Fredo's death in a car crash and later finds Alona swimming in the sea with a group of friendly *sirenas* and kidnaps her, taking her to the lair of Ubangga, the octopus king. While Alona escapes her imprisonment, Ubangga places a curse on her that sees her transform into a mermaid every full moon. After surviving another attack by Betty while swimming, Alona encounters a human male and falls in love with him. Shortly after she discovers

117

that Dyesebel has disappeared and eventually traces her to Ubangga's cave. In a climactic final fight sequence, Alona, her human lover and mother succeed in killing both Betty and the octopus king. One notable element of the scenario of Ravelo's second *sirena* narrative is that Alona is born in human form (to Dyesebel, in human form) and she is cursed with periodic transformations to *sirena* form. In this context, her alternative *sirena* incarnation is a problematic interruption of her human identity that she has to negotiate, rather than the central, defining aspect it is for her mother. In 1964 Ravelo and de Leon reunited to produce an eponymous screen adaptation of the graphic narrative, again starring Edna Luna as Dyesebel and with Eva Montes in the role of Alona. While the film is not recognised as being lost (like its predecessor), it does not appear to be available for online or archive access and has not been analysed or discussed by film critics in any detail (suggesting that it has been unobtainable for some time).

Following the graphic narratives and screen adaptations discussed above, a series of further films adapted elements of Ravelo's original story, including two directed by Emmanuel Borlaza. His 1973 production, variously known as *Dyesebel* or *Si Dyesebel at ang Mahiwagang Kabibe* ('Dyesebel and the Magic Clam'), starred Vilma Santos as Dyesebel and Romeo Mitranda as Fredo. Fortunately, unlike its predecessors, copies of this film are still available. Skipping the back-story of Dyesebel's birth and infancy, the 1974 feature opens with a pre-credit sequence set in the *sirenas'* underwater cave. Departing from previous versions, there are a variety of male characters present, including an overweight merman[19] who provides a comic foil for the *sirenas* throughout the film, and male, human-form guards (with aquamarine trunks, shoulder coverings and finned hats) henceforth referred to as sea-men. After some discussion between the assembled *sirenas*, Dyesebel tries out the magic, finds that it works, then uses it to revert back to mermaid form and swims off. The remainder of the film (whose editing is somewhat puzzling with regard to temporal continuities and cross-cutting), interweaves a similar strand about Dyesebel to that featured in the mid-section of the original graphic story (her forming a relationship with Fredo, being abducted by men tipped off by Betty, being exhibited as a fairground freak and then being rescued by Fredo) with a narrative set in the mermaid cave involving Dyesebel's initially thwarted and then successful attempt to access the magic clam after a volcano disturbs the island.

Borlaza's principal innovations occur in the form of: diegetic musical sequences that nuance the narrative; a fight sequence between *sirenas*, sea-men and humans; and the appearance of a giant, tame seahorse. The musical sequences work to enhance the atmosphere and emphasise narrative themes. The first takes the form of a song that is sung in loose unison by a group of *sirenas* and the merman early in the film to an up-tempo waltz rhythm, affirming their communal identity. This is followed by a very different performance by Fredo, accompanied by a friend on guitar. Joking with each other, Fredo sings (English-language) lyrics that reflect on his melancholy at being parted from Dyesebel to a flamenco-like accompaniment, comparing Dyesebel to a "devil without horns" and "a fallen angel" for deserting him (while, unbeknownst to him, she listens). The combat scene between the *sirenas*, their accompanying sea-men and humans on a beach has little narrative significance and appears to principally serve as an action feature, representing hand-to-hand (and, in some, instances, hand-to-tail) combat and the sea-men's use of their

tridents to impale angry villagers. Unlike the two earlier films, in which interactions between humans and Dyesebel involve hostile actions of the former against the latter, Borlaza's 1973 film shows stiff resistance to aggression by the aquatic group, empowering their collective identity. The large seahorse has even less plot function, serving mainly to give Dyesebel and Fredo an exhilarating ride around the bay to a location where Fredo repels an attempt by sea-men to kidnap Dyesebel. The film's narrative reprises the ending of the 1954 film by having Betty accidentally transform into a *sirena* by touching the magic shell and being driven from shore by villagers throwing rocks, leaving Dyesebel to surprise Fredo on a beach by appearing in human form and dancing in his arms before they embrace to close the film.

Borlaza returned to Ravelo's tale in 1996 with another eponymous production that starred Charlene Gonzales in the title role. Lacking the musical set-pieces of his first production, the second version is principally notable for a modification of the role of the sea-men of the 1973 film. Whereas in his earlier feature they were simple functionaries, the scene in which Dyesebel visits the *sirenas'* grotto for the first time shows the (uniformly young and attractive) sea-men interacting with the *sirenas* in a flirtatious manner that suggest them more as suitors than soldiers. Their interest in the *sirenas* results in one seeking to assist Dyesebel by trying to steal the magic shell from the sea witch – represented in this version as a giant octopus-woman. While unsuccessful on his first attempt, he is more successful later in the narrative when fishermen involved in illegal dynamite fishing damage the grotto and allow Dyesebel to secure the shell and return to land to assume human form to pursue her relationship with Fredo.

The two other film adaptations both retained key elements of their source material and introduced noteworthy innovations. In the case of *Sisid, Dyesebel, Sisid* ('Dive, Dyesebel, Dive'; Anthony Taylor, 1978), starring Alma Moreno in the title role, this concerned the narrative's ending. Now only available in low-quality pirated copies, the film retained the premise of Ravelo's original story by having the *sirena* born to a human couple under mysterious circumstances, but unfolds differently from that point since her parents are rich and use their resources to raise her in secrecy to adulthood. After falling in love with the family gardener (named Fredo, like her love interest in the original story) she marries him. The narrative and Dyesebel's trajectory to happiness is then disrupted when, first, her parents die in an accident and then, second, she finds out that Fredo is enjoying the company of other women (presumably seeking the sexual congress that he cannot achieve with his bride). Distraught, she feels compelled to return to the ocean, and there obtains a magical pearl that can transform her physique. Using this, she assumes human form and returns to land but when she is reunited with Fredo she breaks up with him and returns to the sea, re-assumes mermaid form and pledges to live under the sea forever. Dyesebel's decision to embrace the *sirena* life and community is a notable positive affirmation of the latter that deviates from previous versions of the story and reflects her recognition of her essential nature and of the compromised nature of having to live an assumed identity onshore.

Ravelo's character re-appeared on cinema screens in another eponymously titled production directed by Mel Chionglo in 1990 starring Filipino-American actress Alice Dixson in the title role. Released six years after the US feature *Splash* (Ron Howard, 1984),

Chionglo's film drew heavily on aspects of the former and also featured a significant innovation to the Dyesebel formula. Rather than having its heroine born to a human mother, the film's credit sequence shows fishermen harpooning what they believe to be a large fish. Escaping injured, the creature turns out to be a pregnant mermaid who washes ashore in a storm and is found and taken in by a kindly couple. Soon after, she gives birth, delivering a large oval pod (from some part of her anatomy) that breaks open to reveal a squealing baby *sirena* with an orange-red, carp-like tail (similar to that of Madison's in *Splash*). This eschewal of the changeling scenario positions the Dyesebel character less ambiguously between the human and *sirena* worlds and, like the majority of Western mermaid films and Andersen's seminal 1837 fairytale, has her wishing to convert her form to become 'other', in terms of the human she has never been and which her parentage never promised.

III. Other Sirena Films

The success of Ravelo's graphic narratives and films inspired other creators to explore the topic. One of the first was Pablo Gomez, whose graphic novella *Miranda: Ang Lagalag na Sirena* ('Miranda: The Wandering Sirena') was serialised by Universal Komiks in 1966. The plot involved a young *sirena* being injured and swept ashore during a storm and being cared for by a kindly woman who lost her own child in infancy. After recovering, she returns to the sea. Returning some years later to revisit the woman, she becomes embroiled in conflicts involving gangsters and also has to contend with the arrival of menacing *siyokoys*. The narrative was adapted for the screen in an eponymous production in the same year directed by Richard Abelardo, starring teenage actress Marifi in the title role.[20] The film premiered later in the year at screenings that were promoted with the promise that the cast would be on-hand to give all children attending colourful tropical fish, and with balcony tickets including copies of comics. Hedging their bets, the producers publicised the film with posters that variously sought to stress the thriller angle, showing Miranda being menaced by *siyokoys* who have come onshore[21] or more creatively inclusive representations of Miranda as sexual, maternal and menaced by lurking *siyokoys* (as in Figure 8). Despite these gimmicks, the film was only a modest success with audiences, with its

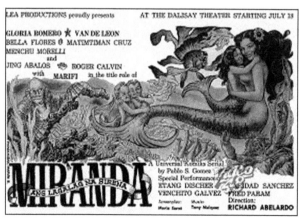

Figure 8 – *Miranda* (1966) (reproduced from Video 48 blogspot).

low-budget text appearing to fall somewhat short of its marketing hype and is no longer in distribution in any format. Similar hype accompanied the production and release of Celso Ad. Castillo's eponymous screen adaptation of Francisco Coching's 1954 graphic narrative *Ang Mahiwagang Daigdig ni Pedro Penduko* ('The Magical World of Pedro Penduko') in 1973. Like the graphic narrative, the film featured a variety of fantastic entities (such as dragons and giant spiders) and a *sirena* named Marina (played by Lotis Key). First encountered by Pedro while combing her locks on the shore, he later comes to her aid when she is driven ashore by a menacing *siyokoy*. Impressed by her rescuer, she transforms into a human in the light of the full moon and befriends him.

A number of other late 20th and early 21st Century films also featured *sirenas* in different roles. *Si Baleleng at ang gintong sirena* (Chito Roño, 1988) featured its golden (*gintong*) *sirena* (played by Bale Melisa Perez Rubio) in a fantasy-horror feature. The *sirena* acts as a guardian for an orphan in a narrative in which zombies serving Gungadina, the Queen of Darkness, menace the local community and orphan heroine before being saved by the *sirena*. While less original in genre terms, *Halik na sirena* ('Kiss of the Sirena') (Joven Tan, 2001), starring Isabel Granada in the title role, offers the most overtly erotic representation of the *sirena* in Filipino cinema to date. Beginning with a sequence of a topless *sirena* and human male kissing and encircling each other underwater to an up-tempo house music track, the film adapts elements of *Splash* to a Filipino fishing community. Assuming human form, as she is able to every ten years, the *sirena* comes ashore and embarks upon a passionate affair with a local Lothario who becomes enraptured by her. The romance is not without complications, however, as his dalliance with the *sirena* causes a series of misfortunes to befall his community, eventually separating them.

Whatever the distinguishing aspects of the films referred to above, the most original *sirena*-themed film produced in the Philippines to date outside of the *Dyesebel* cycle is Danilo Santiago's 1975 film *Lorelei*. Often (mis)characterised as a simple action-comedy,[22] on account of the presence of popular comedian Chiquito and Johanna Raunio, Finland's representative in Manila's 1974 Miss Universe pageant as a lead actor, the film offers a complex representation and discussion of *sirenas* that draws on Western imagery and associations to a far greater extent than previous (or subsequent) Filipino cinema. As such, the film largely operates outside of the national folkloric traditions discussed in this chapter and is the subject of discussion elsewhere (Hayward and Hill, forthcoming 2018), drawing on Western psychoanalytic theory to a greater degree than other analyses featured in this volume. While elements of Santiago's film were reprised in the narrative of Mike Relon Makiling's film *Manolo en Michelle Hapi Together* (1994), starring comic actor Ogie Alcasid and Australia's representative in the Manila's 1994 Miss Universe pageant, Michelle Van Eimeren, the complex discourse of the earlier film was replaced by simpler themes. Unlike the more passive and winsome *sirena* of Santiago's film, *Manolo en Michelle Hapi Together* featured a more robust performance from Van Eimeren, whose tail colour closely resembles that of Madison, the mermaid featured in *Splash*. Angered by fishermen tossing dynamite into the sea, Eimeren's character attacks the fishing boats until she is rendered unconscious by a second blast, rescued by Manolo and brought ashore. As her tail dries out she assumes fully human form, much to Manolo's delight, wakes up and, in accented English, identifies herself as "a mermaid from Australian waters" and gives her

rescuer a necklace that will guarantee him good fishing. Naming her Michelle – after she reveals that mermaids don't have names – he later serenades her, singing a version of The Beatles 1965 hit 'Michelle',[23] mixing the original English-language lyrics and Tagalog phrases referring to *Dyesebel*. Continuing this inter-textual theme, the film – like both *Lorelei* and *Splash* – features an eccentric scientist intent on proving the existence of mermaids.[24] Suspicious of the real identity of Manolo's new amour, the scientist arranges for salt to be thrown on Michelle's legs, causing her to revert to mermaid form. Taking her to a laboratory he threatens to dissect her. Reading about her capture in the press, Manolo comes to her aid, rescues her and decides to reject the terrestrial world and follow her to live under the sea.

IV. The *Sirena* in 21st Century *Fantaseryes*

The stream of *sirena*-themed films discussed above dried up in the early 2000s as the national film industry experienced a more general decline, but the figure soon re-emerged in television, which flourished as a number of new channels and production companies were established. Content developed for the new outlets drew on a number of sources, including national cinema and popular cultural heritage, and the *Dyesebel* films provided an appealing model for producers.[25] The first deployments of these themes occurred in *Marina* (2004), a 188-episode narrative developed by ABS-CBN and announced in the program's credits as the Philippines' "very first *fantaserye*" (i.e. TV fantasy series).[26]

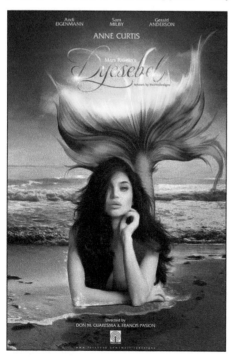

Starring Claudine Barretto in the title role, the narrative centres around the adventures of Marina, a human girl who is transformed into a mermaid on her 7th birthday by a female sea spirit in human form. After having been driven away from land and her family as a changeling, she has a period living with a community of *sirenas*, *siyokoys* and other aquatic entities before she manages to regain her human form. Over the course of a complicated narrative, Marina switches between human and *sirena* forms, suffering various indignities, such as being exhibited in a circus, before finally reconciling herself to being a *sirena* and departing to live under the sea forever. The *fantaserye* series' combination of dramatic plot lines, comedy and striking CGI effects (such as gigantic sea serpents) proved popular with audiences and was rapidly followed by the GMA Network's 75-episode series *Marinara* (2004). The GMA series was conceived and publicised as a *kwelanovela* (spoof) of its predecessor but deviated from its model by featuring three

Figure 9 – Poster for Dyesebel (2014), featuring Anne Curtis in title role.

Figure 10 – Akirang from *Mars Ravelo's Dyesebel* (2008).　　Figure 11 – Butete from *Mars Ravelo's Dyesebel* (2008).

sisters, Dophina, Marie and Aira (all played by Rufa Mae Quinto), who are the offspring of a man and a *sirena*. Featuring a similar array of undersea entities to its predecessor, the narrative revolves around a prophecy that one of the daughters is destined to become the ruler of the undersea realm of Laot Daot. While Marie and Aira are human in form, Dophina is fish-tailed. Echoing *Dyesebel* and *Marina*, she is captured and exhibited as a fairground attraction before being liberated and continuing her adventures in her quest to reunite with her sisters.

Following the two 2004 series that drew on elements of Ravelo's original narrative without acknowledging the connections in their titles, two further series provided contemporary reinterpretations of Dyesebel.[27] GMA Productions premiered the first episode of a 126-episode series entitled *Mars Ravelo's Dyesebel*, starring Marian Rivera in the title role in 2008, and Dreamscape Entertainment produced an identically titled 87-episode series in 2014 starring Anne Curtis (Figure 9). Both took key elements of Ravelo's original scenario and adapted them to form the basis of elongated narratives, keeping key themes from the original, such as Dyesebel's alterity and movement between aquatic and terrestrial realms. The former, in particular, allowed ample scope for the addition of new aquatic creatures, such as Akirang, the evil seahorse humanoid and Butete, a cute green pufferfish child (Figures 10 and 11). The 2014 adaptation departed more freely from Ravelo's original, identifying its heroine as the offspring of a princely merman and human mother, and has the former killed by hostile villagers before the familiar *Dyesebel* narrative commences. In a further deviation from its model, the series features open conflict between humans and *sirena*/merfolk that ends with Dyesebel bringing peace and understanding between the human and mer-realms and moving freely between them.

While not publicised as being associated with *Dyesebel*, the 68-episode ABS-CBN series *Mutya* (2011), starring Mutya Orquia in the title role, has a notable re-inflection of the opening of Ravelo's graphic narrative. As discussed above, the story of a *sirena* being born to a human couple invites interpretation as being an attempt to comprehend and represent the foetal abnormality known as *sirenomelia*. *Mutya* takes this aspect one stage further by opening with the birth of a baby showing this condition (without the fish-scaled attributes of Dyesebel's lower body in Ravelo's original). As the series progresses this vexing condition is revealed to be the result of the infant being the offspring of a human mother and an aquatic humanoid prince, and resolves itself as Mutya's fused legs gradually morph into a scaled fish-tail and as Mutya embraces and explores her identity as a *sirena*, interacting with other sirenas, mermen and *siyokoys* under the sea. The GMA Network's 78-episode series *Kambal Sirena* (2014) approached the tensions between human and *sirena* form somewhat differently by virtue of having actress Louise delos Reyes play twin sisters Alona[28] and Perla, born to human parents but each with a different abnormality: the former with a fish-tail and the latter with gills. As in *Dyesebel*, the parents seek seclusion to rear their offspring. The sisters are later separated, Alona going into the sea to live in the realm of Sirenadia, while Perla goes to work in a marine park. The two are bought together – and into competition with each other – when they both fall for the young man who runs the marine park, with much of the narrative concerning this rivalry. Another *sirena*-themed series, ABS-CBN's 189-episode *Aryana* (2012–2013) takes its inspiration from foreign sources in the form of the two Australian series, *H20: Just Add Water* (2006–2010) and *Mako Mermaids* (2013–2016), which represent the plight of transformative teenage mermaids living between terrestrial and marine worlds.[29] ABS-CBN's production starred Ella Cruz in the lead role and centred around the tension between the character's destiny to become a mermaid on her 14th birthday and her experiences and identification as an adolescent girl.

Of all the *fantaseryes* featuring sirenas made to date, ABS-CBN's 115-episode *Dyosa* (2008–2009) stands out by virtue of engaging with *Dyesebel* and its creator via a plot strand. The series concerns the adventures of its titular heroine (played by Anne Curtis), a goddess who grows up on Earth, masquerading as a mere mortal, and meets a *komik* author named Mars who – unaware of her true identity – creates narratives about her supernatural self that include various incarnations, including a sirena named Dyosa Agua who has magical powers to command the movement of water. The inscription of a character based on Ravelo into the narrative emphasises the author's crucial position in Filipino *sirena* fiction – in a manner analogous to Andersen's in Western mermaid fiction.[30]

V. The Sirena, Gender Fluidity and Contemporary Gay Culture

While the reasons for the continuing success of serially revised cultural products such as *Dyesebel* are difficult to isolate,[31] the theme of identity acceptance and belonging (and of their reverse: alienation and rejection) are key to all the Dyesebel-related narratives discussed above. Since (of necessity …) none of the films' or television series' audiences are actual *sirenas* who have experienced the events and attitudes represented on-screen, it is apparent that audience engagement has been based on degrees of empathy for the various

sirenas' plights and senses of analogies between the *sirenas'* experiences and those of viewers who have experienced similar forms of conflicted identity, rejection and/or persecution. It is not surprising then that the figure of the *sirena* has come to have another association in Filipino culture, where the term has been adopted by gay culture as an emblem of their difference, and of heteronormative prejudice and discrimination against them. The highest profile manifestation of this usage has been in the song 'Sirena', written and recorded by rapper Gloc-9 in 2012, and promoted in a video directed by Jay Pacena II.

The song's lyrics do not refer to any aspects of the folk- and media-lore narratives discussed above, but rather depict the life of a young gay male and his troubled relationship with his father. The song's video makes explicit the nature of the harsh treatment meted out to the young gay male in its lyrics. A short narrative prelude shows the young man's father forcing his son's head into a water barrel, demanding to know whether his son is a man or woman. When he replies that he is the latter, his father forces his son's head under water again. The screen then shows the son in a white shirt floating underwater as the song's music track begins, to a descending stepwise chord progression evocative of Latin American and Flamenco music that composer Jonas Baes has identified as *barriotic*, seeming to evoke poor, urban culture (p.c. January 11th 2018). The opening chorus declares (in translation):

> *I'm a sirena*
> *Whatever they say, I'm beautiful*
> *I'm a sirena*
> *Whatever they do, my flag will not fall*
> *Diving into a water barrel*
> *Gigantic arms are pushing me down*
> *Diving into a water barrel*
> *You'll be amazed how long I can hold my breath*

The water barrel serves as both a means of torturing the son and, allusively, as a portal to an oceanic realm where he floats free of hetero-normative repression.

This image of the body floating underwater recurs, interspersed with shots of Gloc-9 rapping the lyrics in a nightclub and of the young man growing up and experimenting with make-up and non-traditional male roles (such as being a cheerleader), while looking after his abusive father as his health declines. As the song reaches its conclusion the screen shows images of successful gay professionals before ending on a blurry image of the young man floating away underwater.

Conclusion

Writers such as Garcia have argued that the gay community's contestation of their marginalisation from contemporary Filipino society is a form of postcolonial resistance in that "one of American neo/colonialism's most invidious and enduring effects is the socialization of Filipinos into Western modes of gender and sexual identity formation" (2014: 161). Referring to the extended historical frame discussed in the Introduction to this chapter, Garcia contends that the Western "sexological" discourse of homosexuality (regarded as a "psychosexual inversion") was easily grafted on to the traditional concept of *kabaklaan*,[32] "because of the equivalency or 'comparability' that exists between the Western concept of the gendered inner self, and the capaciously generative concept of

loob"[33] (Ibid: 165–166). Garcia asserts that this complex combination of indigenous and colonial discourses has produced a situation whereby "transgenderal characteristics" (such as "effeminacy, 'femininity,' and/or transvestism") locate gay men "somewhere along the continuum of gender-variant performativities within the Philippines' much-riven history" (Ibid: 166), but prescribe a distinct role for them as they are "burdened" not only by their "gender self-presentation but also, and more tragically" by their "sexual orientation" – "a biomedical ascription capable of defining who [they are] as a matter of deep psychological being, as an innermost question of self" (ibid).

The latter characterisation is also apposite for the plight and perception of (various incarnations of) Dyesebel and associated *sirenas* in Filipino *komiks*, cinema and television. Their "innermost questions of self" are largely determined by external apprehensions of their physical form that see them as confrontingly other to normal human form and abilities. They are "burdened" by these perceptions in all their attempts to engage with the human world, which they variously reject or flee from (if they choose to accept and acknowledge their statuses as *sirenas*) or else embrace in transformed bodies – suspending and repressing their experiences and perceptions as *sirenas* in order to imitate humans physically and mentally as a way of securing emotional, sexual and parental associations with the men they desire. In this regard, they are – if anything – even more inconveniently positioned than gay humans, in that the absence of male *sirenas* from Filipino media-lore leave them awkwardly positioned with regard to both the sub-human *siyokoys* and sea-men who co-populate the marine realm in several of the films and television series. Without directly comparable mates, the *sirenas* always have to accommodate difference (never, in any production to date, seeking solace in each other in anything other than a sororal fashion). The always-unresolved nature of the *sirena's* existence is perhaps her most enduring aspect, allowing multiple scenarios to circle round her central enigma and provide ready material for serial adaptations that show no signs of abating.

Acknowledgements: Thanks to Video 48 Blog for access to their digitised complete run of the *Dyesebel* comics, to Jonas Baes for his comments on Filipino folklore, to Jon Fitzgerald for comments on musical matters and to Katrina Gutierrez for her feedback on an earlier draft of this chapter.

Notes

1. The concept of the aquapelago and a number of articles debating it are archived online at the *Shima* journal website: http://shimajournal.org/anthologies.php#aquapelago – accessed December 9th 2017.

2. It should be noted that research for this chapter has been substantially hampered by the lack of availability of several key film texts (identified in subsequent sections) and that aspects of the analysis I offer might require modification if and/or when these are variously rediscovered and made publicly accessible.

3. Despite this, one of the most significant national works in theoretical folkloristics, Herminia Menez's *Explorations in Philippine Folklore* (1996)does not refer to the topic.

4. Another aspect noted with regard to Filipino *sirenas* is their strong fish smell (which is cited as a disincentive to human males associating with otherwise attractive *sirena* in various tales. See, for instance, Bayar-Bagatsing's account of 'The American and the Sirena of Amburayan' (2017: online).

5. With regard to the latter, Ramos cites accounts that they often stalked their male prey by following religious processions and tried to lure men into the water (2000: 97).

6. Currently around 44% of the national population of around 104 million reside in urban areas, with around 13 million residing in the metropolitan Manila area (see Statistics Portal, 2017: online).

7. Such as murals at Nemiranda Art House.

8. Original photo, other images and discussion at: https://traveleronfoot.wordpress.com/2008/04/18/the-mermaid-queen-of-angono/ – accessed December 9th 2017).

9. Online at: https://www.youtube.com/watch?v=giCK8Sou3HU – accessed January 3rd 2017.

10. Based upon an earlier prototype named Varga (Ernee 2012: online).

11. This is significant in that Fleischer featured mermaids in his works, most notably in *Time On My Hands* (1932), where his well-known Betty Boop character appears as a mermaid, topless and erect on her tail, wiggling her hips suggestively to a mid-tempo dance music track before being pursued across the screen by a large octopus. While there is no evidence that Ravelo saw *Time On My Hands*, commentators such as Ernee (2012: online) have identified Ravelo's engagements with the Boop cartoons in other aspects of his work, and there is at least a possibility that Fleischer's mermaid-themed animations were in some manner influential on Ravelo's approach to Dyesebel and her undersea adventures.

12. Although various press articles and online items have identified that *Dyesebel* was influenced by Andersen's 'Den lille Havfrue' (see, for instance FilipiKnow 2014), Ravelo never acknowledged an explicit connection between the two. English-language translations of Andersen's work were introduced to Filipino children in the early–mid-1900s as part of their education following the US takeover of the islands (Parayno 1997: 199). Since Ravelo was born in 1916 and was educated in the 1920s and early 1930s, it is likely that he had some degree of direct or indirect exposure to Andersen's story in his youth.

13. While I have no evidence that Ravelo was aware of this connection it is a notably complementary one. (See Chapter 2 of this volume for discussion of Middle Eastern mermaid mythology.)

14. In Filipino folklore there are figures with the capacity to imitate infants, such as the vampiric *tiyanak*, which assumes the form of a crying newborn baby to attract its human victims.

15. See, for instance, Munro (1997).

16. See de Jonge, Los, Knipscheer and Frensdorf (1984) and Morfaw and Nana (2012) for further discussion.

17. Dialogue bubbles in translation: "Who told you that you could come into my cave? Trespasser! Trespasser!" and "Opo! Opo! Yes/no… eee!"

18. See, for instance, footage archived online at: https://www.youtube.com/watch?v=qLgiBuoxpbw – accessed December 13th 2017.

19. I use this term rather than 'male sirena' since – as identified in the Introduction – there is no tradition of the latter in the Philippines and since the *siyokoy* is generally *not* represented in the upper-half human, lower-half fish form.

20. The production was notable for a series of measures calculated to attract attention. One of the first was a poster and press advertisement calling for applicants to play the role of the infant Miranda (who were required to be able to swim and to have "beautiful long curly hair" and giving context to the role by showing a swimming infant mermaid surrounded by aggressive looking *siyokoys* swimming towards her and with a non-too-friendly shark opening its jaws at the bottom right of the image. Archived online at: https://4.bp.blogspot.com/-5DHNEUAS_aM/VVg0T8R6gHI/AAAAAAAAvF4/dL-12pasIWg/s1600/Miranda-66-1.JPG – accessed December 21st 2017.

21. See, for instance, the poster archived online at: https://4.bp.blogspot.com/-tNo1_v0uXZ4/WTJLGPYHsMI/AAAAAAAASgw/VPNKqT99cSkVXZ62r2PepezE1m_Fp55rQCEw/s1600/Miranda%252C%2BAng%2BLagalag%2BNa%2BSirena%2B%2528Release%2BDate%2B-%2BSeptember%2B26%252C%2B1966%252C%2BDalisay%2BTheater%2529.jpg – accessed December 21st 2017.

22. See, for instance the description at: http://videodw.comnl.videodw.com/view/Vn9jIE7P4Oo/ang-unang-sirena-chiquito-and-lorelei-1975-tagalog-action-comedy.html – accessed March 10th 2017.

23. The film itself takes its title from the Turtles' 1967 single 'So Happy Together', which is rendered in a Tagalog-language version that refers to *sirenas* to accompany a comic sequence of the film's love duo in paddy fields around the mid-point of the film.

24. In this film supposedly associated with and demonstrative of the existence of Atlantis.

25. The 2006 TV ABS/CBN series *Da Adventures of Pedro Penduko* – adapted from Francisco Coching's eponymous 1950s *komik* narrative – also featured a *sirena* in several episodes.

26. A debatable claim since the fairy-themed TV series *Okay Ka, Fairy Ko!* debuted in 1987–1989.

27. The GMA Network series *Darna* (2005) also featured Dyesebel (played by Ara Mina) in several episodes.

28. The name of Dyesebel's daughter in *Anak ni Dyesebel* (1964).

29. See Hayward (2017a: 135–138 and 156–158) for further discussion.

30. Reference to Andersen is pertinent since his influence on Filipino *sirena* fiction is significantly less marked than in other Asian cultures (see, for example, Fraser's [2017] discussion of Andersen's influence on Japanese *ningyo* stories).

31. Capino (2005) includes a brief discussion of some of the Dyesebel films and argues that (what he identifies as) the *hybridity* of a number of fantasy characters (such as Dyesebel and Darna) is key to their enduring appeal and their appearance in multiple films. While his general argument – and its cross-reference to broader notions of the hybridity of Philippine identity – is credible, I am less convinced that the *sirena* actually represents/manifests hybridity and rather perceive her as a portmanteau creature better discussed within the tropes of liminality and alterity I focus on in this chapter.

32. Which, as previously discussed, entails "the discursive movement from the genitally sexed 'external body' (*labas*) to the realm of the psyche and interior selfhood (loob)" (Garcia 2014: 165).

33. See fn 30 above.

Millennial Měirényú: Mermaids in 21ˢᵗ Century Chinese culture

Philip Hayward and Pan Wang

Introduction

As the following sections elaborate, the mermaid (in its standard Western form) has become prominent in various aspects of Chinese popular culture in the early 21ˢᵗ Century. This phenomenon is closely linked to the loosening of the state controls over cultural production established during the Mao Zedong era (1949–1976). The loosening occurred in protracted form in the 1980s and 1990s as the state shifted towards a form of socialism that embraced aspects of free-market principles. The embrace of the mermaid can be seen to be aligned to a general internationalisation of the Chinese economy and society in that period. This chapter examines the mermaid's rise in Chinese culture in the early 21ˢᵗ Century within these contexts. As several of the creators whose work is discussed below have elaborated, the mermaid has been imported into Chinese culture as a Western figure with a pre-established set of associations formulated and manifested in several key referent texts. The mermaid's innately portmanteau form and related instability – as half human, half fish – and the Western tradition of its transformativity (whereby it can switch between mer- and fully human forms) makes it an appropriate and malleable figure for complex negotiations of role and identity, such as those that have manifest during China's ongoing period of socio-economic readjustment. Following an introduction to Chinese folkloric traditions of similar entities, the chapter examines the manner in which the mermaid has been rendered and transformed in various contexts in contemporary China.

I. Chinese Folklore

China has a host of legends concerning various aspects of human interaction with marine, lacustrine and riverine environments and various folkloric creatures believed to exist within them. The term commonly used to refer to a mermaid in contemporary Mandarin is *měirényú*. This is derived from the traditional term *rényú*, (literally 'person-fish') used to refer to dugongs (which have often been attributed with human-like characteristics) and, by extension, to other aquatic creatures with some human characteristics. *Měi* means beautiful and the term serves to identify its described entity as (what is now known as) a mermaid (although the Chinese term does not specify the abruptly divided human/piscine form that typifies contemporary mermaids). Descriptions of aquatic humanoids date back to ancient times. One of the earliest to appear in various folktales is the male Yangtze River god, variously known as He Bo or Feng Yi, who had a half-human, half-fish body (of an unspecified kind). The 4th Century text, 'Shān Hǎi Jīng', also includes reference to a similar figure inhabiting the river. More archetypal mermaid-type creatures first appear in the 'Sōu Shén Jì' compilation of Chinese legends written by Gan Bao during the Eastern Jin Dynasty (317–420 CE), which refers to a type of mermaid living in the South China Seas as *jiāorén*.[1] These creatures were reputedly industrious, weaving miraculous, intricate cloth and, when sad, they cried tears that turned into pearls. Nie Huang, a naturalist working during the early Qing Dynasty, also depicted and described a type of aquatic humanoid with dark skin, yellow hair and webbed hands and feet in a survey of aquatic creatures entitled 'Hai Cuò Tú' (1698). However, despite Huang's account, belief in aquatic humanoids was not a prominent aspect of Qing Dynasty culture.

II. Hans Christian Andersen and the Popularity of Western Fairytales in 20th Century China

As Wenje (2014) has documented, Andersen's short stories have had a sustained popularity in China since the earliest translations were published in the 1910s. Indeed, she has argued that their translated forms have become canonised, becoming "archetypes for creating children's literature in China since they were introduced to the country" and have been acknowledged as inspirations for many 20th and 21st Century Chinese authors (ibid: 1). As Wenje documents, Andersen's short story 'Den lille Havfrue', known in English as 'The Little Mermaid', has been one of the most popular of his stories in China in terms of the number of translations that have appeared (ibid: 12) and has retained its position through various phases of Chinese cultural history. She has identified that Andersen's stories were widely circulated from the 1910s to late 1940s and were also deemed to be acceptable during the initial period of Communist party rule (from 1949–1966), only being marginalised during the ideologically intense period of the Cultural Revolution (1966–1976), when cultural activist Jiang Qing oversaw the abandonment of the majority of fictional texts in circulation in favour of the so-called 'Eight Model Plays'[2] that represented the struggles between the proletariat and representatives of the oppressive, conservative hegemony in simple terms. During the Cultural Revolution, almost all previous cultural works were marginalised, creating a highly restrictive space that was gradually expanded by cultural producers in the 1980s and 1990s, preparing the ground for the increased liberalism and pluralism that has characterised Chinese culture in the early 21st Century. As a result of

the latter, the number of translations of Andersen's works has "soared" (ibid: 20), re-consolidating the canonical status of Andersen's stories and opening them up for serial reinterpretation. Through these various stages, Andersen's class position as the son of a poor cobbler and his representations of characters faced with adversity and disappointment were frequently seen as pivotal elements of his works. Ye Yunjian, who translated and commented on Andersen's works extensively in between 1949 and 1979, for instance, identified Andersen's work as encouraging people from various social classes to adopt a critical worldview, and even managed to characterise the Little Mermaid's desire to escape the restrictions of her father, the Sea King, and to try and win the affections of a terrestrial prince as the actions of a "rebellious nobility" seeking "to abandon their corrupt, shallow aristocratic society and seek a virtuous way of life" (ibid: 18).

Zhu Jianjun contends that the use of the term *měirényú* in the title of translations of Andersen's story is particularly evocative in the Chinese context. She argues that it activates memories of traditional legends and combines them with Andersen's representation of the physical and spiritual beauty of his heroine in a story that emphasises morals and virtues. In this way, she argues:

> The image of the little mermaid has become so deeply engrained that nowadays it jumps into the minds of most Chinese when hearing the term *měirényú* ... conveying mixed feelings of exotica, beauty, love, and virtue. In this manner, the image of the *měirényú* in China reflects the increasing cultural contact and exchange between China and the West from the early 20th Century onwards. (p.c. September 7th 2017)

Reflecting the above, the prominence of Andersen's stories in 20th Century Chinese culture has created themes and motifs that have been mined and activated by recent Chinese cultural producers and have led the figure of the mermaid to assume a new prominence in Chinese popular culture.

III. The Deployment of Mermaids

a. Two Perspectives: Shanghai 2000 and 2010

With a population of around 25 million, Shanghai is one of the world's largest cities. Originally founded as a fishing village on the Suzhou River, which flows into the estuary of the Yangtze River, the city's Chinese name, *Shànghǎi*, literally means 'upon the sea' and its alternative colloquial name, *Hù*, derives from the name of a type of fish-trap gully used in the area in the 4th Century. The area began to develop as a major centre in the early 18th Century, when it became a regional trade port, and boomed in the mid-19th Century when it became an *entrepôt* servicing the various international concessions nearby awarded by the Chinese Government. The city recovered from Japanese occupation in 1941–1945 to become China's major centre for economic activity – a position it has retained to the present. After maintaining a relatively stable population of around 6 million between 1960 and 1982 the city underwent major growth as a result of loosening restrictions on economic activity and freedom of relocation in the 1980s, rising to around 14 million in 2000.[3]

Sûzhôuhé ('Suzhou River')[4] (Lou Ye 2000) is a significant film with regard to the various

perspectives sketched above. In terms of the modelling of phases of Chinese filmmaking, it represents a moment when what Fleming (2014) characterises as the "urban realist impulse" that dominated filmmaking in the 1990s was *détourned* (i.e. internally subverted and/or re-routed) and opened to embrace more complex symbolism and fragmented narrative forms. It is no accident in this regard that *Sūzhōuhé* was also the first Chinese film to feature a mermaid (or, rather, a human female represented as performing as a mermaid).[5] The film involves its lead character, an anonymous documentary video-maker who is never shown on-screen, becoming entangled in a complex web of uncertain female identities. The latter arise from his encounter with Meimei (Zhou Xun) who works as a mermaid performer in a tank at a nightclub, wearing a blonde wig and clad in a shimmering orange tail like Daryl Hannah's mermaid character in *Splash* (Ron Howard, 1984). Her glamorous presence, on display under water, is in direct contrast to the grim, polluted stretches of the titular river throughout the film, suggesting her role-play as an imaginative line of escape from the city. Struck by Meimei's glamour (both in her role as a mermaid and as a performer who appears as one), the video-maker meets and forms a relationship with her. As Ye has emphasised, the mermaid is a self-consciously exotic aspect of his drama:

> *Mermaids don't exist in China; the whole idea is a Western import, like Coca-Cola and McDonald's – everything Fifth Generation filmmakers refused to admit as Chinese ... But how can you draw this line? As a child, I can remember my parents telling me Andersen's 'The Little Mermaid.' And when did my parents first hear it? It's impossible to say. This, I think, is a very important difference with filmmakers of my generation. We're not interested in being cultural immigration officials saying, this is Chinese, this is not Chinese.* (Rosenbaum 2000: online)

In terms of the generational model Law refers to, Ye is one of the 'Sixth Generation' of Chinese film-makers, distinguished by being independent, rather than state-funded, and by their determination to address negative aspects of modernisation, such as social alienation.[6] As his comments suggest, unlike many of his predecessors, he was less concerned with respectfully representing and promoting elements of Chinese culture (as the 'Fifth Generation', established in the mid-1980s, had been) than to problematise aspects of the present through using novel approaches. *Sūzhōuhé's* narrative is complex and fragmented, first through Meimei's regular unexplained disappearances and then by switching to narration guided by two other characters, Madar, a crook and motorcycle rider, and Moudan, daughter of a prominent local alcohol dealer, who is also played by Zhou Xun, inviting comparison between her and Meimei. The latter aspect is amplified when Madar gives Moudan a mermaid doll (that resembles Meimei in her mermaid role) as a birthday present. Despite his affection for her, he colludes in her subsequent kidnapping, which she escapes from by diving into the river and predicting that she will return to life as a mermaid. The final sequence involves Madar returning to Shanghai several years later. Encountering Meimei he initially believes her to be Moudan, and forms a relationship with her, before finding the actual Moudan working in the suburbs. The film ends with Meimei and the video-maker sleeping together one last time before she leaves and she invites him to find her if her really loves her. In this context, the figure of the mermaid recurs as a motif of glamorous female otherness associated with aquatic spaces

that exist outside of the grim cityscape and offer the promise of escape. The film, however, offers no happy ending. Unlike *Splash*, the film's mermaid does not escort her human lover out of the city, but rather disappears from it, like a phantom. This ending serves to mystify love and to ask its spectators to consider the nature of love in the real social world.

The awareness of 'The Little Mermaid' story in China, as noted by Law above, was expanded and diversified by a number of factors in the early 2000s. Along with increased availability of Western film and television material through legitimate and illegitimate channels, the mermaid's prominence in contemporary Chinese culture was significantly boosted by the arrival of Edvard Eriksen's famous statue of Andersen's Little Mermaid, which had remained in Copenhagen since its original installation on a rock in the harbour in 1913. The statue was temporarily relocated to Shanghai in 2010, despite considerable controversy in Denmark.[7] The occasion of its relocation was the 2010 World Expo, the largest ever international exposition held since their introduction in 1928[8] in terms of its area (5.3 square kilometres) and attendance (with over 73 million people visiting between June and October). The event aimed to establish Shanghai as a major modern metropolis, akin to New York, Paris and London (Jing and Ron 2010) and, by implication, to establish China as a modern nation that could support such a metropolitan centre. The Little Mermaid statue was installed in the Danish pavilion in a pool with curving viewing platforms around it (Figure 1), as a feature in the pavilion's overall representation of an eco-friendly city space that contrasted the image of Shanghai presented in Law's *Sûzhôuhé*. It proved popular, receiving 5.6 million visitors and with 72% of those surveyed identifying the statue as the pavilion's "most interesting" feature (Danish Enterprise and Construction Authority 2010: 10). There was also extensive coverage of the mermaid statue on national television, including coverage of its arrival, installation and removal that added to the mermaid's national profile.

b. Mermaids in Chinese Cinema and Television

While the presence of the Little Mermaid statue at the Shanghai exposition represented the delivery of a material icon into the physical space of China, another event of a different kind that capitalised on the boom in interest in Andersen's story followed in 2015. This took the form of the production of an animated 3D feature film that drew on aspects of Disney franchise materials over the preceding two decades[9] in what was (and what was extensively advertised as) the debut of a new product specifically geared at the Chinese market. The film, entitled *Měirényú zhī hǎidào láixí* ('The Little Mermaid – Attack of the Pirates') (Figure 62), was produced by the US-based Golden Hill company, a specialist in 3D productions, and was directed by Qiu Haoqiang. The animated 3D film directly engaged with Disney's *The Little Mermaid* franchise of films and TV series, presenting a Chinese version of aspects of Disney's Little Mermaid character along with elements that recalled two other Disney products, the *Pirates of the Caribbean* franchise and the massively popular film *Frozen* (Chris Buck and Jennifer Lee, 2013). The film's promotional materials featured a clever combination of Chinese characters and a similarly coloured mermaid shape that serve to insert the latter into the cultural space of the former (see right side of Figure 63). As the poster indicates, the Chinese version of The Little Mermaid is more demurely clad than the seashell bra-wearing, tousle-haired, distinctly sexualised young

Figure 1 – Visitors viewing Little Mermaid pool area in Danish Pavilion at 2010 Expo (from cover of Danish Enterprise and Construction Authority [2010]).

Figure 2 – Promotional poster for *Mei rén yú zhi hai dao lai xi* (2015).

adolescent in the original Disney film (Hayward 2017a: 35–36). By contrast, the Chinese mermaid wears a sparkly pale-blue top (similar to that worn by Princess Elsa in *Frozen*) that matches her blue-scaled tail. Her hair, while red like Ariel's, is also tied back in manner like Elsa's. The film's plot involves the little mermaid helping a sea captain's daughter, coming onto land, battling a giant and becoming embroiled in human society. While the film is little known in the West – even among Disney aficionados – its release

Figure 3 – Promotional poster for *Zhuǐyú chuánqí* (2013).

in China (as a Chinese production) helped disseminate the figure of (a young, wholesome) mermaid to young Chinese audiences.[10] In terms of the values it promotes, it can be seen to operate as a moral tale in a manner akin to that of Andersen's original story during Mao's years (referred to above), allowing younger Chinese the opportunity to appreciate, reflect and gauge themselves against the virtues displayed by the heroine (arguably a useful exercise in an increasingly modernised, materialist and egotistic Chinese society).

Along with the Disney-associated animation discussed above, live-action, mermaid-themed productions commenced in 2013 with a television series entitled *Zhuīyú chuánqí* ('The Legend of Chasing Fish'). The series represents a famous southern Chinese folktale concerning the relationship between a 'carp fairy' and a poor intellectual that had previously been the subject of a Shaoxing opera and of the film *Zhuīyú* (Ying Yunwei, 1959). As the English-language title of the TV series – *Legend of the Mermaids* – suggests, it evoked *The Little Mermaid* by having its carp fairy heroine able to switch between mermaid and human form.[11] Similar to Andersen's mermaid story and Disney's film, the series glorifies the braveness of the carp fairy, the beauty of true love and self-sacrifice. Unlike Both Andersen's and Disney's *Little Mermaid*, it had minimal focus on underwater aspects and instead used its female lead's alternative identity as a 'back story' element (an aspect proportionately represented in its DVD release, which shows her in mermaid form in a small bubble below substantially larger images of her in human form with fellow cast members – Figure 3).

Ming's film *Rényú xiàohuā* ('Mermaid Prom Queen')[12] followed in 2016, combining elements from two US films, *Splash* and *Aquamarine* (Elizabeth Arden, 2006). The latter film provides the scenario of a young adult mermaid coming to land, transforming to human form, being befriended by two similarly aged human girls, falling in love with a boy, having her real identity discovered and eventually escaping and returning to the sea. The main element derived from *Splash* is the character of a deranged marine biologist intent on capturing a real mermaid at any cost. As in *Aquamarine* (and other audiovisual productions, such as the Australian TV series *H20 Just Add Water* [Jonathan M. Shiff, 2006–2010]) the focus is on friendship and support between young women and the mermaid is complementary to their concerns and preoccupations (see Hayward 2017a: 129–149). While there are no obvious Chinese inflections of either the story or its themes,

Figure 4 – Promotional poster for *Rényú xiàohuā* (2016).

the film has a distinct novelty by virtue of having its mermaid heroine depart at the end of the film astride a blue whale, an image that (despite its brief appearance at the end of the film) was used as one of the film's promotional images (Figure 4). Another mermaid-themed film released in the same year, *Zàijiàn měirényú* ('Goodbye Mermaid'), directed by Gao Weilun, also paralleled *Aquamarine*, featuring two young women who form a bond with a mermaid named Zixiao, whose appearance suggests her to be a similar age. The mermaid's experiences as she attempts to win the affections of a human male form a key narrative element. A more novel aspect of the film is that its core narrative is presented as part of an epic fantasy. The film opens with a narration over drawn images that relate the origins of merfolk in an alien species that came to Earth 3 billion years ago and established itself under the sea before bifurcating when a number of merfolk made the transition to land and became terrestrial bipeds. Two adversarial groups arose, the mermaid and dragon factions, who have been implacably opposed each to other ever since. After this introduction, the film alternates between occasional sequences identified as taking place in 1934 and more extended ones set in 2034. The 1934 sequences set up the latter ones, representing a young Zixiao and her mother being imprisoned in a tank ready to be killed and eaten by opposing clan members who are aware that mermaid flesh can impart longevity on those who eat it. While Zixiao is rescued, her mother is killed and consumed. The main narrative element occurs in a high-tech near-future, at a time when human cities are threatened by rising sea levels and major storm surge events that are growing in intensity. After various trials and tribulations, the mermaid and her human lover finally save the day. As they acknowledge the intensity of their love for each other and kiss on the shore, magic energy beams rise up and spread across the planet. A final narrated sequence explains that these have altered human DNA so that humans can live underwater (again), an attribute that proves vital given that the final images show the city fully submerged by the rising seas. While the major part of the film comprises Zixiao's fledgling romance, plotting and violent interactions between the mermaid and dragon factions, the film offers some interesting deployments of mermaid media-lore, including the references to the magical power of mermaid flesh, which is derived from Japanese folklore concerning an aquatic/humanoid creature called the *ningyo* (see Chapter 3 of this volume for further discussion) and the original notion of humans having evolved from merfolk.

c. Měirényú (2016): Stephen Chow's Environmental Morality Tale
Whatever the above films' accomplishments, another film released in the same year proved substantially more popular with Chinese cinema audiences and also engaged with its American referent texts in a more original manner. Stephen Chow's 2016 film *Měirényú* (released in anglophone markets as *The Mermaid*) was made on a production budget of US $60 million,[13] and went on to gross just under US$ 555 million internationally on cinema release (with the major proportion of that comprising Chinese revenue).[14] In economic terms, it is by far the most successful mermaid-themed film released to date.[15] In press interviews during the lead-up to the release of his film Chow reiterated the influence of the Western Little Mermaid story on his ideas for the project and his more general interest in fairy stories as models for his films, particularly the characteristic he describes as the standard pattern, whereby "the evil are punished and the good see a happy ending" (Fan 2016: online). This characterisation of fairytales is notable since it more accurately describes standard Disney versions of fairytales, where sad endings are routinely sweetened, than a substantial corpus of both traditional Chinese and Western folktales (such as those re-told in literary form by the Brothers Grimm and by Andersen himself). In this regard, it is Disney's version of *The Little Mermaid*, rather than Andersen's original short story, that Chow's film most resembles. Initially acclaimed as an actor and then as a director in Hong Kong cinema in the 1980–1990s, Chow went on to direct commercially successful Hong Kong/Chinese co-productions, such as the comedy martial-arts feature *Kung Fu Hustle* (2002) and the science-fiction comedy *CJ7* (2008). As Kraicer has asserted in a perceptive essay on *Měirényú*, Chow has forged "an ambivalent path through the politically treacherous waters of national and local identities" as Hong Kong and its cultural products have engaged with and been increasingly subsumed within a Chinese media industry and broader cultural establishment, attempting to maintain a sense of "cultural responsibility" along the way (2016: online). Like his previous productions, *Měirényú* relates its tale with Chow's trademark Mandarin/Hong Kongese *mou lei tau* orientation, combining comic – and often highly exaggerated – word play with slapstick action and various allusions to Chinese popular culture. In the film Chow uses *mou lei tau* style to particular didactic purposes, utilising its comic and allusive attributes in order to both entertain and illuminate, freely drawing on aspects of previous Western mermaid texts including – most obviously – both Andersen's and Disney's version of The Little Mermaid narrative, *Splash* and the US fake documentary *Mermaids: The Body Found* (Sid Bennett, 2012).[16] This Mandarin/Hong Kong modality is not simply present in verbal interactions but also works as a broader visual and thematic aesthetic that 'riffs' around mermaid media-lore in ways that are variously subtle and inventive and crudely – and/or pathetically – comical.

Born and raised in Hong Kong, Chow's upbringing in a coastal area gave him an awareness of the impact of coastal developments on marine environments. The most notable examples of the latter were the development of Hong Kong's airport on Lantau Island in the 1990s[17] and the current construction of major bridge links across the Pearl River Delta between Macau, Zhuhai and Hong Kong that are disrupting the habitat of Hong Kong's iconic white dolphins.[18] These local events informed his development of *Měirényú*, as what one critic described as an "environmental morality tale" (Sin 2016: online). Fittingly for the latter description, *Měirényú* opens in an unusual manner for a commercial fiction film,

showing stock images of deforestation, water pollution and the mass slaughter of dolphins at Japan's Taiji Cove before segueing into a sequence of a bathysphere being lowered into the sea, spinning and emitting sound and light waves that disturb the environment. Juxtaposed with the opening stock footage, the bathysphere sequence is signalled as disruptive in the manner of the previous acts. The serious tone of this sequence is then contrasted with another prelude to the film's main action via a sequence representing a tawdry local museum of 'exotic animals' in which bored-looking and increasingly aggravated patrons are presented with a range of unconvincing exhibits, including an approximation of the *ningyo no miira* style of artificial mermaid developed in Japan and around the South China Seas in the 1700s and 1800s,[19] made from the upper half of a plastic doll and the body of a dried fish.[20] Attempting to assuage the patrons, the owner then reveals what he perceives to be his museum's prize exhibit, a middle-aged man wearing a wig, glasses, fake breasts and a fabric fish tail, reclining in a bath. Underwhelmed by the pretence, the patrons eject the imposter from the museum and drive him away. These two sequences set up polarities of the catastrophic-grotesque (of the environmental footage) and comic-grotesque (of the museum) between which the subsequent narrative inserts itself. These are then returned to at the film's denouement in ways that inflect its closure.

The main narrative of the film begins when a rich businessman named Liu Xuan (Deng Chao) buys an island in a location called Green Gulf at auction, intending to develop it despite its status as a conservation area for dolphins. In order to remove the dolphins and, thereby, the necessity of conserving them and their habitat, he funds the development of a sonar device to drive them away. One thing his research has not revealed is that the area is also home to a pod of merfolk (and an associated octopus-man) living around a wrecked ship in the bay that has learned of Xuan's scheme and are intent on disrupting it. The pod dispatches a mermaid named Shanshan (Lin Yun), who has had her tail modified and has learned to walk upright, to set up a 'honey trap' that will allow the pod to murder Xuan. She attempts this by sneaking into a lavish party held to celebrate his acquisition at which models are impersonating mermaids. In one of the film's multiple layered jokes she disguises herself as a woman dressed as a mermaid (squeezing her tail into a fabric mermaid tail). Although she is ejected from the gathering she succeeds in giving Xuan her mobile phone number. The next day Xuan is seen rejecting proposals to develop a marine park in the area and, instead, engaging with a (Caucasian) scientist named George (Ivan Kotik) who has both devised a way of killing sea creatures through sonic waves and has identified a previously unknown intelligent species who are communicating with each other in the Gulf. These two aspects appear directly derived from the hoax documentary *Mermaids: The Body Found*, in which US military sonar experiments kill whales and merfolk, and in which investigators discover mermaid pods through analysing sound recordings made in the vicinities of the weapon test sites. The function of these two elements within Chow's narrative appears to be to ground the film's fantastic aspects in the pseudo/hoax science theme that predominated in the US program and to give this aspect some credibility. Following the scenes with the scientist, the film cuts back to the Gulf, showing a pod of merfolk swimming underwater and communicating with each other. Providing a back-story to the merfolk's existence, the film then shows them surfacing and listening to an aged mermaid relating a story of merfolk's evolution from humans and of humans' subsequent hostility to them, causing their retreat from contact with their ancestral race.

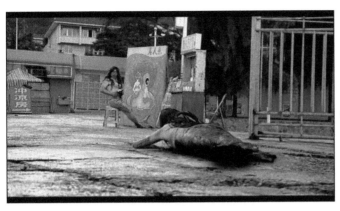

Figure 5 – Shanshan's
bloodied body blown
onto the quay adjacent
to the museum.

Xuan eventually calls Shanshan, after an argument with Ruolan (Kitty Zhang), a rich partner who aspires to having a relationship with him. After several comically unsuccessful attempts to kill him, Shanshan begins to develop a relationship with Xuan that prompts him to review his course of action. After experiencing the impacts of sound waves on his own body, he orders his staff to turn off the sonic weapon being deployed in the Gulf. This precipitates another narrative turn when George is revealed to have long been seeking to capture mermaids to harvest their DNA in order to exploit its commercial potential. Aided by Ruolan, who principally seems motivated to enact revenge on Shanshan, her love rival, the scientist organises a team of armed thugs to capture or kill all the merfolk in the Gulf.

The sequence that follows is very different in tone from the preceding ones, showing a vicious and unprovoked attack on a group of creatures seeking to live peaceably in their native environment. Finding the merfolk underwater in the bay, Ruolan's henchmen fire into the water, hitting various individuals and turning the water red with their blood (like the sea in Taiji Cove during dolphin hunting). When the remaining merfolk jump ashore to try and fight the men, many are bludgeoned to death and others are wrapped in sacks to be taken to the laboratory. The aged mermaid then intervenes to direct bay water against the thugs, allowing Shanshan, the octopus man Bāgç (Shuo Luo) and others to escape. Shanshan is then pursued, her body punctured by harpoon darts and then blown out of the water onto a jetty by a rocket-propelled grenade (Figure 5). This moment of high drama is then abruptly punctured by comic grotesquery as the screen reveals her to be close to the museum featured in the opening of the film, where the middle-aged male mermaid impersonator is seen painting a crude image of a mermaid. Shanshan is then surrounded by her pursuers again, led by Roulan, who is intent on killing her, only to be rescued in the nick of time by Xuan, who arrives by jetpack, carries her to the sea and releases her. A final sequence to the film, set some years in the future, reveals Shanshan in human form living with Xuan, who is now funding environmental research. While Xuan tells a young marine biology student not to "believe in fairytales" when asked about mermaids, the film's final sequence evokes that of *Splash*, by showing him underwater with his mermaid mate, magically enabled to exist in and appreciate the undersea world.

While the pod of merfolk includes mermen, their roles are essentially subsidiary to the film's leading figures of Shanshan, as the archetypally beautiful mermaid, and Bāgç as an

octopus-human portmanteau creature. The gender aspects of this situation reflect a broad tendency within popular culture to valourise the mermaid and marginalise the merman. One interpretation of this situation is that the clear absence of external genitalia on the merman's tail renders him a problematic entity within phallocentric discourse. As discussed elsewhere (Hayward 2017a: 151–166), when mermen appear in Western audiovisual material they are usually relegated to particular positions, such as adolescent (implicitly pre-sexual), aged (implicitly post-sexual) and/or gay/effeminate. Bāgç, by contrast, occupies a significantly different symbolic position. While his lack of external genitalia is apparent, this is compensated for by his array of powerful tentacles. Similar to Ursula, the octopus-woman in Disney's *The Little Mermaid*, whose physique offers the most obvious model for Bāgç's form, the tentacled nature of his lower body can be seem as polyphallic (ibid: 37–38) and, thereby, hyper-masculine. His role in the film supports this interpretation as he is the alpha male of the pod (the mer*men* being minor players, only appearing in group scenes without dialogue). His physique – and ability to resist pain – is also the subject of extended comic play when he appears as a teppanyaki chef who ends up pulverising, dicing and grilling his own tentacles in order to maintain his disguise.

d. Mermaid Fantasies

During its pre-production, production and release stages, *Měirényú* had a shadowy counterpart in the form of a film entitled *Empires of The Deep*,[21] intended to launch a franchise including sequels, video games and major theme-parks, that was produced on a reputed budget of c$140 million (Moxley 2016: online) over an extended period and has not yet been released. In this regard, the story of the film's troubled production history, the release of trailers and production stills, press conferences and press articles has comprised an extended meta-text that merits attention in advance of any potential release of the film. One of the most significant aspects of the film's initial conceptualisation was of its mermaid theme as being able to sustain a narrative, characterisations and special effects that might enable the film to be a 'blockbuster' success in both the Chinese and Western markets in a similar manner to the *Lord of the Rings* trilogy (2001–2003) and *Pirates of the Caribbean* film series, initiated in 2003 (inspired by the eponymous theme ride in Disneyland California). To the latter end, four different Western directors worked on the film at various stages (including, briefly, industry veteran Irvin Kershner, who directed *The Empire Strikes Back* [1980]) and sequences shot to date have featured American male leads, Ukrainian actress Olga Kurylenko, and various Western extras along with the film's Chinese female lead, Shi Yanfei, and a number of Chinese actors in minor roles.

The most comprehensive analysis of the film's various scripts and overall production process has been provided by Moxley (ibid). The film was originally entitled *Mermaid Island* and its original script specified that location as a "strange and otherworldly ... archipelago" within which a city is located "above and below the water" (ibid). While it is impossible to summarise the narrative of a film that has yet to be completed, its early scripts were based around a "Greek hero's quest to rescue his father, who is abducted by soldiers from a mysterious mer-kingdom, imperilled by the rise of a demon warlord" (ibid). Complementing this, its 2012 trailer (entitled, somewhat cryptically "Empires of the Deep: An Untouched World an Unimagined Life") trumpeted its subject matter as

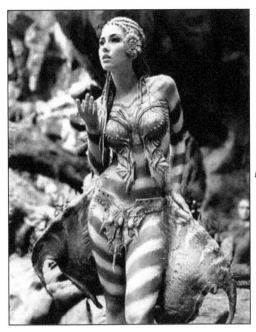

Figure 6 – Production shot of Olga Kurylenko as the mermaid queen in *Empires of the Deep* (source: Rodney 2010 online).

being 'The War between Good and Evil", while depicting alluring dancing water maidens and underwater battles involving militarised cetaceans. While mermaids were a key element in the film from its earliest phase, their traditional design was modified in the early production stages of the film. The film's initial director, Jonathan Lawrence intended the mermaids to have a compromise between fish-tailed form (which would have rendered them horizontal on land), and a more workably erect human one. Originally intending them to have "pliable fins that would delicately wrap around the actors' legs" (ibid), the costume designers instead opted to create rigid fins attached to the actors' waists and upper thighs that hang down to around knee level (Figure 6). Complicating this somewhat, the film's original two-minute-long trailer, released in 2012, shows large numbers of conventional (i.e. fish-tailed) warrior mermen in CGI-generated combat scenes (this variance being indicative of the generally confused nature of the film's production).

Whether *Empires of the Deep* is ever released or not, its high production costs make it unlikely that it will deliver a profit – let alone an extended mermaid-themed franchise – to its producer. It nevertheless remains significant for the scale of its imagination, of its choice of an undersea world populated by mer-creatures as potentially appealing to an international audience[22] and for the inscription of the "contradictions and chaos" of post-socialism (Zhang 2008: 15) within its production process.

While a group of Hollywood films may have provided substantial inspiration for *Empires of the Deep*, the concept also has substantial affinities to Guo Jingming's highly successful young adult novel *Huàn Chéng* ('City of Fantasy') (2003), which sold 1.5 million copies in China. The story involves members of three groups of supernatural beings, the Ice, Fire

141

and Mermaid tribes, who are temporarily living in the material world in human form. One of the two royal brothers of the Ice Tribe meets a mermaid princess in human form and falls in love with her, only for his brother to also declare his desire for her, resulting in conflict. The novel was adapted into a 78-part television series made by Shanghai Youhug Media in 2016 entitled *Huàn Chéng* ('Ice Fantasy'), with elaborate sets designed by New Zealander Dan Hennah (who had previously worked on the *Lord of the Rings* film series). Modifying its referent literary text, the TV series featured two prominent mermaid characters: a mermaid princess named Lan Shang and a treacherous older royal mermaid named Lian Ji. Like the novel, the series' narrative involves protracted and complex magical, romantic and combat scenarios. While the series does not follow *Empire of the Deep's* model in casting a European actress in the lead mermaid role, its lead mermaid character is played by Uyghur actress Madina Memet, whose distinctly non-Han facial features give her an exotic aspect within the narrative.

III. Mermaid Statuary and Place Association

Over the last decade, statues of mermaids have begun to appear in Chinese cities, usually – although not exclusively – as features associated with waterfronts or ornamental lakes. These have predominantly appeared in the context of modern built spaces in which the mermaid is incorporated as a decorative element signifying a diffuse bundle of associations (including, but not limited to, Western classicism, aquaticism and/or eroticism). The figure has also been represented in more ephemeral contexts, such as the Beijing Sand Festival, held at Tongzhou Canal Park in 2014, where works created by Zhang Weikang and Zhang Yongkang were exhibited, including a seven-metre representation of a mermaid with surrounding fish (Figure 7). In some cases, such as the statue erected in Qingdao 2015 (Figure 8), the standard Western form of the mermaid has been customised to give it a particular function, in this case associating it with the beer garden area in which it was located (seeming through a somewhat tenuous premise of an association between European mermaid legends such as the Rhine Lorelei and the city's Qingdao Brewery, originally established by the Anglo-German Brewery Company in 1903).[23] Western mermaid statues have also been directly copied in Chinese contexts. In the lead-up to the much-publicised arrival of Eriksen's Copenhagen mermaid statue in Shanghai, the Inner-Mongolian city of Ordos stole a march by manufacturing a copy of Danish artist Bjørn Nørgaard's radical configuration of The Little Mermaid. The work was originally one component in a group of Nørgaard's sculptures entitled 'The Genetically Modified Paradise' produced for Expo 2000 in Hanover (Germany) and subsequently installed in Copenhagen in 2006 (Figure 9). Nørgaard's group of statues comprised distorted versions of iconic figures (such as Christ, Adam and Eve), speculating on the impact of genetic engineering and of postmodern culture more generally. As documented by Ulfstjerne (2016), the manufacture and installation of Nørgaard's sculpture in Ordos was undertaken as part of the city's attempt to rapidly engineer itself as a new, internationally oriented metropolis (despite its somewhat remote position within China and its low population). Located in the International Friendship Park in Kangbashi, without any context for its re-imagination of its referent, Ulfstjerne characterises the work as essentially "weightless", in an art historical sense, functioning more as an abstract sign of modernisation and/or internationalisation than anything else (ibid: 92).

Figure 7 – Mermaid sand
sculpture by Zhang Weikang and
Zhang Yongkang
(photo by Beijing Sand Festival,
2014).

Figure 8 – Statue of mermaid raising a tankard of foaming beer in Qingdao Beer Gardens
(photo by Philip Hayward, 2016).

Given the absence of the mermaid in traditional Chinese folklore, it is unsurprising that there is no particular Chinese location associated with mermaids and that, in examples such as that of Ordos, there is no particular sense of local association between locale and

143

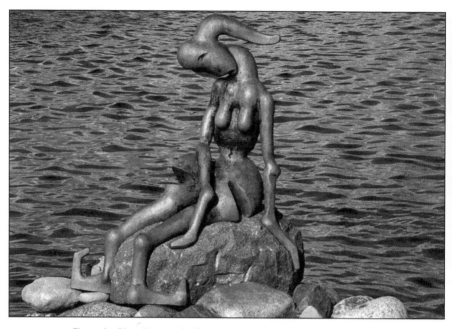

Figure 9 – Bjørn Nørgaard's 'Genetically Modified Little Mermaid' statue
(photo by Matthew Hart, 2013).

mermaid themes. There is, however, one minor exception in the case of Hainan Island, located in the South China Seas where (as previously discussed) Gan Bao identified that *jiāorén* lived, crying tears that turned into pearls. While Hainan continues to be associated with pearling it is now best-known as a tourism centre. Following its designation as a special economic zone in 1988, the island underwent major development as a centre for tourism, with the south-eastern fishing village of Sanya transforming into a city of over 650,000 people by the early 2010s. Along with beach and water activities and golfing, theme park entertainment and the participation of cultural minorities in these became major aspects of the island's marketing as China's equivalent to Hawai'i (Hayward and Li 2011). Aquatic traditions, such as the Li people's traditional water-splashing performances, have been packaged for tourist entertainment, often as components within specially designed aquatic spaces (ibid). Another subset of tourist attractions has involved mermaid performers, who have featured at several tourist attractions at various times over the last decade. These include regular performances at the Island's Romance Park, where they supply one component of an elaborate show about Hainan's multicultural history, to the subaqua-themed restaurant in Sanya, where young (predominantly Russian) women perform synchronised swimming routines while wearing mermaid costumes in a large water tank to entertain diners. In these contexts, the mermaids do not so much constitute a distinctive symbolism of place as one element within the "polychromatic exoticism" (ibid) of the island's tourism culture in which heterogeneous material is incorporated with local traditions to try and create maximum impact on tourists confronted by multiple choices of entertainment.

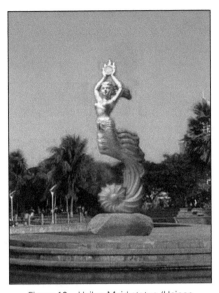

Figure 10 – Hailuo Maid statue (Hainan competition entry visualisation, 2013).

While there are no notable blendings of Indigenous traditions and Western mermaid imagery and associations in public art in Hainan, the provincial authority played an incidental role in the development of one figure that resembles and approximates aspects of the mermaid within a Chinese context. In 2012 a competition was held for designs for public statues for the island that embodied themes such as peace and harmony with nature. The competition attracted a wide national field of entrants, and prizes were awarded to four designs, one of which was an iconic condensation of the traditional story of the Hailuo Maid. The story involves a conch that falls in love with a young fisherman and transforms itself into a young woman to make herself attractive to him. She visits the fisherman's house in secret to prepare meals for him but is spotted by him one day, with the result that he falls in love with her. The Queen of the Sea finds out about the conch's actions, which she has not authorised, and takes her back to the sea. Undeterred, the fisherman follows her and, realising their true love, the Queen relents and allows the conch to retain human form and live with her human love. The prize-winning design (Figure 10) showed her upper half as fully human with her lower half morphing into finned legs, riding a wave that curled into a shell formation at the statue's base. In this manner, the design represents a traditional Chinese story with close affinities to Andersen's 'The Little Mermaid' by combining aspects of the physical form of the latter with elements of the former. While the design secured a prize, it was not eventually constructed on the island. Instead, the design was adapted, in slightly modified form, for the eco-themed Cangan Houchi Conch resort located on the coast south of Shanghai (Figure 11). In this setting, the conch maid's

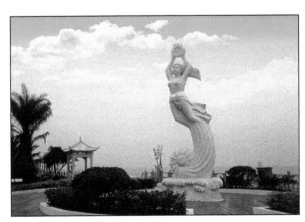

Figure 11 – Hailuo Maid statue at Cangan Houchi Conch Resort (2016).

145

story provided an appropriate theme for an area whose marketing hook is the more pristine nature of its coastline and waterways (compared to those around Shanghai and the Yangtze Delta discussed in Section II above). Together with a similar statue in Xingfu Park in Weihai,[24] these renditions of the Hailuo maid offer a distinctly Chinese inflection of standard mer-imagery.

Conclusion

As Hayward (2017a) identifies, the mermaid has been represented in a wide variety of ways in recent Western audiovisual media productions, including ones in which she is variously hyper-sexualised and/or represented as a dangerous predator. By contrast, the *měirényú* has been represented within a narrower 'bandwidth' in recent Chinese cinema and popular culture and in a manner that has strong affinities to – if not direct descendence from – the perception of Andersen's little mermaid in the 1950s–1960s as a virtuous individual seeking to escape repression and pursue a virtuous way of life. In contrast to the more earnest moral and propagandist culture of mid–late 20th Century China, the millennial *měirényú* communicates this through allusive, comic and/or *mou lei tau* modes of a type best positioned to resonate with a young audience today. However, despite being represented as heroines who often have superpowers and who are able to combat the evil they encounter, contemporary Chinese constructions of *měirényú* overwhelmingly reinforce traditional gender stereotypes by providing females who are willing to sacrifice themselves for the men they love and/or for their families (with the reverse scenario being almost entirely absent). It might be argued in this regard that, despite the dazzling appearances and magical abilities that Chinese *měirényú* possess on-screen or in statuary, their roles further reinforce women's vulnerability to male hegemony and the limit of being a woman in a modern, patriarchal China.

Acknowledgements: Thanks to Zhu Jianjun, Ou Zan and John Fanjun Li for their help with research for this chapter.

Notes

1. The term literally means 'shark-person' in contemporary Mandarin, but the term *jiāo* may have had a broader usage to refer to other types of fish and/or cetaceans in ancient times.

2. Actually five operas, two plays and a symphony.

3. In 1966–1976 Shanghai was also the centre for the radical faction known as 'The Gang of Four' led by Mao's fourth wife, Jiang Qing, who was active in promoting the Cultural Revolution (referred to above).

4. A tributary of the Yangste.

5. There was, however, a previous comedy feature produced in Hong Kong entitled *Rényú chuánshua* (released with English subtitles as 'Mermaid Got Married') (Norman Law, 1994). The film borrows plot elements and themes from *Splash* (Ron Howard, 1984) and features a young boy saved from drowning by a young mermaid and later re-encountering her when she saves him again, as an adult. In a twist on its US model, the mermaid has to use her magical pearl to revive the boy, who accidentally swallows it, causing a problem when she finds that she cannot return to the sea without it. The pearl element represents a distinct Chinese inflection of Western mermaid 'media-lore', in that pearls do not play a significant role in Western mermaid fiction but are – as discussed in the Introduction – associated with *jiāorén* mermaids.

6. See Xiaoping Lin (2002) for a discussion of the various generations of Chinese filmmakers.

7. For further discussion of the statue's relocation see Hayward (2012c).

8. Under the terms of the Convention Relating to International Exhibitions concluded in 1928, under which expositions could be proposed, registered and publicised as such.

9. It is also notable that Disneyland Hong Kong opened in 2005 on Hong Kong's Lantau Island. Its opening was commemorated with the release of a double pack CD of Cantonese and Mandarin versions of songs from Disney films (including Jolin Tsai's pop-dance music rendition of 'Under the Sea', from the score of *The Little Mermaid*) and a DVD of accompanying music videos. Ariel's character from *The Little Mermaid* has also featured prominently in parades and in a live musical version of the film staged at the park.

10. See the online trailer for the film: https://www.youtube.com/watch?v=cbF10LDbinw – accessed June 20th 2017.

11. While the carp fairy appears in mermaid form at various times she is still clad in traditional clothes coloured red like the carp.

12. A version of the film with English-language subtitles was promoted as *She's From Another Planet*.

13. A higher-end production budget for a Chinese film, but significantly less than that of films such as Zhang Yimou's World War Two drama, *Jīnlíng Shísān Chāi*, made in 2011 on a budget of US $80 million.

14. Source: http://www.boxofficemojo.com/movies/?id=mermaid2016.htm – accessed June 17th 2017.

15. With Disney's *The Little Mermaid* (1989) 'only' totalling US $211,343,479 internationally – http://www.boxofficemojo.com/movies/?id=littlemermaid.htm - accessed 17th June 2017.

16. See Hayward (2017a: 167–185).

17. See Lai et al (in press) for discussion.

18. See Hayward (2017b) for discussion of this issue and its effects on coastal settlements.

19. Best known in the West through P.T Barnum's famous 'Feejee Mermaid'. See Bondeson (1999: 36-63). See Chapter 3 of this volume for further discussion.

20. Kraicer identifies this as "a lovingly satirical and nostalgic tribute to Chow's Hong Kong cinema period, when pre-CGI, modest budget films were once enough to charm audiences" (2016: online).

21. NB the film has been generally publicised and referred to by its English-language title, reflecting its producer's aspirations to access an international market.

22. It is significant in this regard that, for all its profitability, Chow's *Měirényú*, took over 90% of its income from Chinese box offices and only received a highly limited release in Western markets due, in principal part, to the aspects of local humour that made it such a success in China.

23. It was removed from the gardens in 2017 and is currently not on public display.

24. See image online at: http://p1.meituan.net/320.0.a/deal/16181bd2d8b31013b923270ee7b83bec346478.jpg – accessed January 11th 2017.

Chapter Eight

Song of the Sirenas: Mermaids in Latin America and the Caribbean

Persephone Braham

Introduction

European explorers brought with them to the New World the tradition of the mermaid (half woman, half fish) known in Spanish as *la sirena*, and many Latin American cultures indeed include something called *la sirena*. This chapter traces *sirena* traditions in some Indigenous South American cultures, as described by Western interlocutors and, in the final section, a different group of traditions in the Hispanic and Francophone Caribbean. The *sirena* is a syncretic, trans-Atlantic figure, and her significance in a given culture must never be considered as purely autochthonous, but rather shaped first by the encounter of Western and non-Western traditions, and then again by modern Western interpretations.

Western sirens and mermaids represent a kind of power that is overtly phallic in the shape of the tail (Hayward 2017a: 9–16 and 51–73), and subversively transcendent, as they are able to control men through their enchanting song. Sirens are associated with the sea, and with the ubiquitous and elemental serpent. Not all cultures insist on attaching the serpent to Woman, but their complicity is unambiguous in Western myth, as seen in woman-snake hybrids, such as the Hydra, Echidne, Lamia, Medusa and Lilith. Odysseus's sirens promised him knowledge of "all things that happen on the many-nurturing earth"

('Odyssey' - 12.191); but, having been forewarned by Circe, Ulysses escaped their clutches. The siren recurred rather more successfully in the confederacy of Eve and the serpent (often depicted with the face of Lilith), who induced Adam to eat of the tree of knowledge, bringing sex and death to paradise.

The persistence of sirens (and monsters and monstrosities generally) in the compendia of religion, history and natural philosophy reveals their underlying importance to ordered speculation on the nature of humanity. All monsters are matrices of possibility; they are the matter that filters, organises and disrupts the transcendence of form. Sirens are fluid and liminal and, as such, disquieting to the taxonomic mind. The siren's hybridity signals the transgression of boundaries between air, earth and water, and they represent the primordial chaos that preceded the Word. The West's most durable monsters arise in epistemologies derived from Aristotle's conception of matter and form, in which immanent matter awaits the transcendent spark of form. This binary paradigm engenders and justifies the most basic (if not necessarily legitimate) Western principles concerning race, gender and subjectivity. Such principles in turn provide the axes of disciplinary thinking from metaphysics to ethnography.

The siren or mermaid[1] traditions identified by Westerners in Latin American cultures almost universally lack the principal moral attributes of the European mermaid: the enticements of forbidden knowledge and sexual enchantment, and the simultaneous threat of castration and oblivion. Like Western mermaids, Latin American *sirenas* are connected to telluric forces. Some have fish tails, and some have golden hair. They sometimes have difficult relations with fishermen, and may fall in love with them. Many carry conches, and some have supernatural musical powers. However, it is not at all clear how much the semantic charge of the European siren was ever absorbed into popular traditions of the same name. From Patagonia to the Caribbean, the social and moral function of Latin American mermaids is fundamentally different from that of their European counterparts.[2]

I. Spanish *Sirenas*

What did sirens look like to the Europeans who transported them across the Atlantic to the Indies, and what did they mean? The prevailing image of sirens was part bird and part woman until roughly the 8th Century C.E. (Mustard 1908: 22), after which the fish-tailed tritons, and female fish and snake hybrids, such as Nereids, were increasingly described as maidens (or virgins) above the waist and fish below. Bestiary narratives about the sirens generally included the episode from Homer's 'Odyssey', in which Odysseus and his men must pass by the sirens' rocky island, littered with the bones of ships and sailors shipwrecked by forbidden songs of knowledge. Medieval Christians easily mapped Odysseus's passage to the Christian passage through life's trials and temptations, and his ships of salvation as the reward for Christian virtue (Jones 1999: 107) – as shown in a 14th Century image of a Christ-like Odysseus resisting the sirens (Figure 1). The 7th Century Iberian cleric and encyclopedist Isidore of Seville identified sirens as *meretrices* or prostitutes (Isidore 2006: 245). Sirens were rumoured to eat men who didn't satisfy them sexually, and Spanish fishermen and sailors had to swear an oath against coupling with them. Brunetto Lattini's *Trésors* (ca. 1265), containing a bestiary, was translated into Castillian

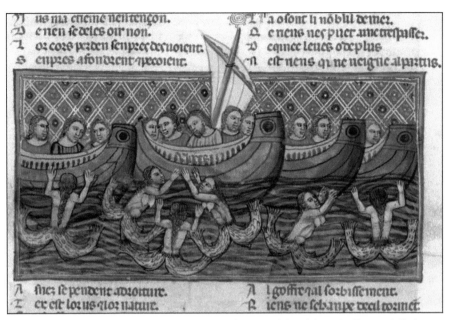

Figure 1 – Benoît de Sainte-Maure, 'Ulysse séduit par les sirènes', from the Roman de Troie (Venice or Padua ca. 1340–1350).[3]

in the late 13th Century; it spoke of sirens who "with their sweet songs made perish the men of little wisdom who wandered the sea" (Salvador Miguel 1998: 90).

Images of *sirenas* were common in medieval Castile, Navarre and Catalonia (Leclercq-Marx 1997), and the monastery of Santo Domingo in Silos, Spain (built slightly after Isidore's time), has reliefs of sirens of various forms carved into the capitals of its columns. There are many allusions to the *sirena* in the Spanish oral tradition, for example in this riddle centred on the *sirena's* hybridity:

> *It is fish and has teats,*
> *It is woman and has gills;*
> *It is not fish, nor is it woman...*
> *So, what thing is it?* (Gella Iturriaga 1968: 118.)

The *sirena* appears in numerous children's songs, poems and popular romances, and there is a well-known legend of a Galician (or Catalan) family descended from one. Both the bird-woman and fish-woman in this tradition are consistently associated with fertility, courtship, mating, and the dangers of the sexual encounter. The siren in medieval Spanish lyric poetry generally serves as a metaphor for flattery and the treachery of the senses, as in Juan de Mena's *Coplas de los siete pecados mortales*: "run away or be silent, sirens / who in my youth / such sweet poison / poured into my veins" (1989: 305). In other texts, *sirenas* symbolise hope in hardship (they sing in the storm) and the transience of good fortune (they cry and lament in good weather). A popular Spanish translation (1489) of the French text *Mélusine* by Jean d'Arras (1478) tells of the beautiful Melusina, tragically transformed each Saturday into a serpent below the waist. Melusina has many sons, all of whom have

some bizarre disfiguration (a missing or extra eye, a protruding fang, asymmetrical ears or eyes), betraying their monstrous origin. The 14th and 15th Century images of Odysseus's encounter with sirens depicted them in mermaid form, swimming around the ship instead of beckoning him from their island (though some artists hedged their bets by adding bird-heads or wings). By the 15th Century, sirens were firmly ensconced in the European imagination as bare-breasted, long-haired maidens with fishy tails, and golden-haired *sirenas* inhabit the lore of Spanish coastal towns to this day (Gómez López 2002).

II. Marvellous Manatees

In January 1493, near the 'Rio del Oro' on what is present-day Haiti, Christopher Columbus encountered three sirens (or *serenas*, as he referred to them). He described them, rather deflatedly, as "not so beautiful as they are painted, though to some extent they have the form of a human face" (1893: 154). He had seen similar creatures off what was called the Grain Coast of Guinea, where a coveted spice was harvested; his mention of which suggests that the *serenas* might be harbingers of gold in the Río Yaqui (near present-day Santiago, Dominican Republic). Following Columbus's disappointing encounter, *sirenas* periodically resurfaced in accounts of New World fauna, perhaps, as some scholars suggest, as evidence of "chroniclers' duplicitous positioning between the past and their present" (Garay and Vélez 2004: 33). However, it is not at all clear in such texts that the word *sirena* refers to mermaids; in fact, *sirena* had been used interchangeably with *vaca marina*, *dugongo* and *manatí* – the sea mammals eventually gathered into the taxonomic order *Sirenia* by Illiger in 1811 – from well before the conquest. The 13th Century *Trésors* described "a kind of white serpent that they call *serenas*" (Miguel 1998: 116). In the 15th Century, the Marqués de Villena included *sirenas* in the category of "larger fish", though he said that they were "not taken" (1766: 122) and the Castilian traveller Pero Tafur wrote dismissively of "the sea where the poets pretend there are Sirens" (1874: 297). Covarrubias's 1611 *Tesoro de la lengua castallana o Española* also defined *sirenas* as a poets' hoax: "the poets feigned seeing some nymphs of the sea, from the waist up like very beautiful women, and from the middle down fish, and with the charm of their song they would put sailors to sleep" (1611: Part II f31v).

Despite the common observation among scholars that Spanish explorers expected to find in the New World all the marvellous creatures of the bestiaries and classical lore, the textual evidence that this included *sirenas* is rather thin. Two miscellanies from the 16th Century give us a pretty clear idea of the popular opinion on *sirenas* at the time of the conquest. Miscellanies were gossipy, colloquial collections of the 'curiosities' of world cultures, history, natural philosophy and folktales. Based on the number of editions they ran to, they were enormously popular and widely read. Pedro Mejía, in *Silva de varia lección* (1540/1643), gives us some context for the semantic confusion attached to the *sirena*; the sea abounds in such a diversity of wonderful creatures that some confusion is inevitable even for one who has consulted the authorities:

> *I know perfectly well that rational man does not live anywhere but on the land, and that they do not inhabit the water, nor live in it, but even so, according to what I have read, there are some fishes, that have the shape and size of men, and among them are males and females, and the female has the same shape as*

a woman, and they (male) are called Tritons, and they (females) are called Nereids. (ibid: 61)

He goes on to explain that there are other sea-creatures who resemble elephants and sheep, and that even Alexander the Great spotted a Nereid off the coast of Greece, who had the face of a "perfectly human" beautiful woman and the tail of a lobster (ibid). If, as he concludes, so many experts write of these creatures, and "the people take it for true" it must be so (ibid: 63). His co-miscellanist Antonio de Torquemada (1570/2012) quite plainly described *sirenas* as *pescados* or fishes and, in passing, took the opportunity to distance himself from Mejía's account:

> To tell the truth, I haven't seen written by any serious author anything about these sirens, only Pero Mejía says that ... one was seen that came out in a net among other fishes that were taken, and it showed such sadness in its face that it moved the fishermen who saw it to compassion, and, moving it, they turned it around in such a manner that it could return to the water, and it submerged itself, and they never saw it again. And even if this type of fish should be in the sea, I take for superstition the thing about their song, and everything else they say about them. (ibid: 671)

Martín del Barco Centenera's *Argentina y Conquista del Río de la Plata*, notes the presence in the Rio Plate region of "fishes very like a human" (1602: 11v). However, his third chapter or *canto*, titled 'In which are treated the quality of the land, reptilian animals, horrifying snakes, and serpents, of the *sirena*, the Carbuncle, of some butterflies, which turn into worms, and then of rats, and other marvels' (ibid: 17r), clearly places the *sirena* within a general description of local flora and fauna. His use of the words "marvels" and "marvelous" throughout the text alludes, not to any magical or supernatural qualities, but to the wonder of God's creation.

In 1950, the renowned Peruvian scholar José Durand wrote a curious book, *Ocaso de sirenas, esplendor de manatíes* ('Twilight of the *Sirenas*, Splendor of the Manatees'), in which he argued that, rather than fomenting a discourse of the marvellous, Spanish explorers and historians of the 16th and 17th centuries were actively trying to bring the New World into the known scientific framework of the period. The phrase "esplendor de manatíes" suggests that the sense of marvel experienced by explorers after Columbus was not diminished by their comprehension of the manatees' un-sirenly nature. Columbus's sighting was the beginning of the end for *sirenas* in the wild. The majority of subsequent accounts from the Americas of that period (Pedro Mártir, López de Gómara, Fernández de Oviedo) were of sea-cows, manatees and dolphins; in short, *bestias*, with some suggestive characteristics of the *sirena*, but marvellous for their own nature rather than any moral or magical attributes, or domesticated.[4] One manatee captured by indigenous Taínos in the Caribbean was named 'Mato' by his captors. The story of Mato was first published by Pedro Mártir de Anglería in 1516, presumably after he heard it from returning soldiers. Pedro Mártir invented a Latin version of the name, Matum, and glossed it as 'noble' or 'generous' (ibid: 44). Subsequent chronicles referred to the tame manatee as Mato, which led to a new coinage, Jerónimo Gómez de Huerta's *manato* (1599: 217r).

Official Spanish nomenclature for the manatee changed over the decades, strengthening the conflation of mermaids and manatees. The first edition of the Spanish *Diccionario de autoridades* (1726–1739) unexpectedly introduced *pexemuller* (fish-woman or fish-wife) and

Figure 2 – Detail of sirens from *Americae* by Diego Gutiérrez and Hieronymus Cock, 1562.

manato [sic]. The modernised fish-woman, *pez-mujer* appeared with *manatí* in the 1817 edition. Popular philology connected *manatí* with *mano* ('hand') and *amamantar* ('to nurse'). The possibilities for etymological adventure multiplied with the addition of the French word for manatee, *lamantin*, absorbed into Spanish as *lamantin* or *lamentin*, suggesting that they howled in lamentation (as subsequently reported by several observers). The Real Academia's lexicographers combined all these attributes in the *pexe-muller*:

> *Fish thus named for the likeness that it has from the waist up with human features and limbs, especially of the woman: which it looks much like in the breasts, and to them it nurtures its children. It has arms, though not hands, but fins that start at the elbow. The face is flat, round and malformed: and the mouth like that of a ray, full of teeth, like that of a dog, with four long tusks like those of a wild boar: very large nostrils, like those of a bullock ... From the belly down it has a very long tail ... When they kill it, it groans like a person.* (Real Academia Española 1737)

In a karmic turning of the tables, the accounts collected by Durand demonstrate a growing enthusiasm for the food value of these marine creatures, especially as no one could (or wished to) determine whether they were meat – they tasted like veal – or fish, safe to eat in times of abstention. Fernández de Oviedo wrote casually that their fat was the best for frying eggs, and Las Casas advised marinating them for Good Friday (Durand 1983: 62–63). As it happens, the manatee has been commercially exploited for food and hides since the early 16th Century and is now an endangered species.

It seems clear from what we know of the terminology used to describe *sirenas* and like

sea-creatures, as well as contemporary descriptions, that there was an ongoing effort among lexicographers and historians to keep scientific knowledge in the foreground. The European public in both the Iberian Peninsula and the Americas were not being regaled with tales of mermaids from the New World, although they were most definitely barraged with illustrated accounts of Amazons and cannibals (Braham 2015). The mermaids and tritons of contemporary illustrations and maps (such as Diego Gutiérrez's 1562 masterpiece, see Figure 2) were rhetorical, or ceremonial, in nature; they broadcast the grandeur of the New World endeavour and signified that it was equal in magnitude to the heroic exploits of Odysseus, Alexander and Caesar Augustus.

III. Wives and Mothers, Never Lovers

As the *pexemuller* suggests, *sirenas* from Patagonia to Nicaragua are usually perceived as domestic or maternal, far from the *femmes fatales* of the bestiaries. A 17th Century *Historia General de Chile* relates the following incident:

> In the year 1632 many Indians and Spaniards in the sea of Chiloé saw that a beast approached the beach, showing against the water near the anterior part of the head, the face and breasts of a woman, well developed, with hair or a mane, fair and flowing; [she] carried a child in [her] arms. And as [she] dove they saw that [she] had the tail and back of a fish, covered with thick scales, like little conches. (Rosales 1877: 309)

The author adds that the Spanish call these creatures 'Sirena' and the Indians call them 'Pincoy.' While he is aware that "no real humans" live in the ocean, he is rather disappointed when a local Indian woman informs him that the creatures never sing (ibid.).

Sirena stories, whatever local flavour they may partake of, also comment on sexual and matrimonial friction between men and women. Well before Odysseus traversed the Strait of Messina, writes Pedrosa:

> It is well known, in any case, that, before [sirenas] were documented in Greece, the Babylonians worshipped a fish-god called Oanes, who was represented as a deity – benevolent – with a human body and fish's tail; and the Phoenicians worshipped the goddess Atargatis, of similar type, but intimately related, like the sirens, to sexual attraction, perversity, and death. (2015: 241)

Ethnographers and art historians have documented a significant *sirena* tradition in Andean cultures, noting the presence of *sirenas* in church art as well as textiles from the 16th through the 18th centuries. Classical imagery such as *sirenas* appears with some frequency in colonial Latin American art and architecture (Gutiérrez de Ángelis 2010: 70). As almost all art of the period was Church-related, the *sirena* became part of Christian iconography and was incorporated into the popular imaginary. Colonial Peruvian depictions of the Virgin Mary with *sirenas* would be seen by the Church to represent the evangelical message of her triumph over sin (represented by the *sirenas*). However, there appears to be a consensus that European mermaids became the syncretic face of Andean "water spirits" (Stobart 2006: 108). The mermaids that figure in altar carvings in Central Mexico and the Andes do not appear to represent evil, as they are sometimes winged (Kelemen 1967: 168), suggesting that their creators simply preferred them to cherubim.

Scholars have also documented a connection between *sirenas* and musical instruments. As

Figure 3 – Noah's Ark, *Cologne Bible*, 1478–1479, 6v. [6]

Stobart explains, the *sirenas* of Bolivian culture do not resemble mermaids, but regular people, "whose gender is ambiguous and sexual appetite insatiable [and whose music] may lure men or women away to drown in the river" (2006: 116). These *sirenas* give musical instruments their beautiful, alluring voices, but may demand a sacrifice in return. Turino (1983) notes that the *sirena* in southern Peruvian tradition is exclusively associated with stringed instruments, specifically the *charango*, unknown in the region before the Spanish arrived. The *charango* may even be shaped as, or decorated with, the image of a *sirena*. Images of the siren with *charango* have been found as well in textiles, coca boxes and other household items from the colonial period. Representations of *sirenas* playing guitar can be seen in other regions of Latin America, for example an 18th Century stone fountain in the Museum of the City of Mexico, and the Mexican popular art of today.

Although it is frequently asserted that mermaids were a common sight as ships' figure-heads, there is little concrete evidence of them to be found in maritime history, and it is doubtful that Indigenous people from the highlands would have been exposed to them. The Spanish and Portuguese used mainly images of the saints for which their ships were named, or heraldic figures such as the Lion Rampant (which eventually became a favourite of European navies generally). The Spanish and Portuguese held a formal monopoly on trade with their colonies until the early 19th Century, and despite the ongoing activity of pirates, privateers and buccaneers (notably Roberts and Morgan in the Caribbean and Drake in the Pacific) the percentage of non-Iberian to Iberian shipping in the Colonial period was relatively small. Any mermaids or other bare-breasted female figureheads would likely have belonged to French, British and Dutch privateers but, again, such ships were quite often captured enemy vessels under a Letter of Marque. It is evident, however,

that printed images of mermaids were available to Indigenous artisans along with Christian iconography. One possible source of sanctioned *sirena* iconography in colonial Latin America (anywhere that print culture could reach) is an emblem book, Alciati's *Emblemata* (1531), which circulated widely in Latin and was translated into Castilian in 1549.[5] At least seven different engravers illustrated the book over its 100-plus editions, and the representation of the *sirenas* changed considerably from the bold, double-tailed fish-maidens of the 1531 Latin edition to the virtually invisible musical trio of the supposedly 'definitive' 1549 edition. Another source of printed images was contraband. The art historian Pál Kelemen notes the wide distribution of images by Flemish en-

Figure 4 – Juan Gerson, Noah's Ark, c1552. Painted canvas on wood. Tecamachalco, Puebla, Mexico.

gravers in books, playing cards and reproductions of famous works of art (1967: 202). An illustrated bible printed at Nüremberg (1483) contained images combining Christian and pagan figures, including one showing mermaids swimming alongside Noah's Ark (Figure 3).

Images were an important tool for converting the conquered peoples, and the Church recruited indigenous artists and artisans to reproduce scenes from the Bible, the lives of the saints and the history of the Church. The *tlacuilos* were Indigenous Mexicans trained by the various mendicant orders to paint church murals and codices (Gruzinski 2001: 189). *Tlacuilo* artist Juan Gerson included mermaids in his painting of Noah's Ark in the Franciscan church at Tecamachalco, Puebla, Mexico (c1562), which share some similarities with the Nüremberg image (Figure 4). Mermaids may have been a natural fit for indigenous cultural expression as a syncretic face of Chalchiutlicue, an Aztec goddess of water, tempests and fishermen. She was thought to be the virgin mother of the other gods. According to 16th Century priest and historian Diego Durán, she was "universally revered" (1971: 261). Mexican artist Baltazar de Echave Ibía's *La Inmaculata* ('Immaculate Virgin')

157

Figure 5 – Baltasar de Echave Ibía (Mexico), *Tota pulchra* [La Inmaculada/The Immaculate Conception], 1620.

(c1620) shows the Virgin ascending above a mermaid (Figure 5). This iconography relates his image to the Virgin of the Apocalypse, persecuted by Satan in the form of a dragon who "cast out of his mouth water as a flood after the woman, that he might cause her to be carried away of the flood" (King James Version, Revelation 12: 15). The Apocalypse Virgin is usually depicted with a snake beneath her feet representing the vanquishment

of lust. This Immaculate Virgin is an atypical representation for Mexican art of the period, and directly contradicts the symbology recommended by Francisco Pacheco, an influential artist and iconographer who trained the great painters Bartolomé Murillo and Diego Velázquez (Pacheco's son-in-law). Pacheco deplored the representation of monsters and serpents as unworthy of the Virgin's perfection (Gilmore 1947: 447–448). The fact that Gerson and Echave Ibía went against iconographic norms in such a visible way would seem to indicate that mermaids had a special meaning for Mexicans. Today, Mexican folk art contains many mermaids, for example 'folk creches' or nativity scenes (Esau and Boeck 1981), Christmas ornaments and the like.

Modern artists in Chiloé have claimed the *sirena* and related figures, the *pincoya* and *sumpall*, as "symbolic guardian[s] of Chilote culture and environment," and use their images to protest the depredations of the salmon fishing industry (Hayward 2011: 91). Indigenous artisans in Perú have also claimed the *sirena* as part of their economy, and many make *retablos* (altarpieces) of musical mermaids along with saints and other religious imagery to sell in an international market (Figures 6 and 7).

As the above suggests, pinning down the origins and meaning of syncretic images is tricky. As at least one historian suggests, presumptively Quechua myths compiled by contempo-

Figure 6 – Claudio Jiménez Quispé (Peru), *Bajo el Mar* (Under the Sea) retablo, 2016/2017. Painted plaster sculpture in painted wooden box.

159

Figure 7 – Pedro González (Peru), *Sirena* retablo, 2007. Painted carved maguey wood sculpture in painted wooden box.

rary *cronistas* are not always Christianised Quechua stories, but may be Quechua-ised Christian ones (Mujica Pinilla 1999: 12). It is not unlikely that Indigenous and *mestizo* (i.e. 'mixed-race') interlocutors historically adopted the *sirena* as a rhetorical device for explaining themselves (or not) to Europeans. An image in the chapter on songs and music in Guamán Poma de Ayala's 'Nueva Corónica y Buen Gobierno' (1615) depicts two Quechua flute-players on a hill, harmonising with two apparent *sirenas* singing from the water. On closer inspection, the *sirenas* have feet but their hair, posture and gesture match European siren iconography in all other particulars (ibid: 318). Confirming his familiarity with European graphic convention, Guamán Poma includes a conventional *sirena* in his *Mapa Mundi* (ibid: 1000). As he was trying to convince the Spanish emperor Felipe III of the merits of Inca civilization, one might suppose he chose to couch his argument in terms he thought a European would understand.

Oral traditions regarding *sirenas* are more elusive to trace. Western interpretations of non-Western cultures are complicated by the European dependence on monstrosity as a mediating principle between self and other, and its conceptual extensions to Western/non-Western, Christian/pagan, culture/nature and other dichotomies by which Westerners have successfully ordered reality. Claude Lévy-Strauss acknowledged this dilemma in *Le Cru et le Cuit* (1964). His critique of ethnocentrism was prompted by his perception that the incest-prohibition, purportedly a spontaneous, 'natural' and universal element of myth (or sacred tradition), was in fact the very definition of a cultural norm. Structural ethnocentrism was exposed to more general scrutiny in Jacques Derrida's 1966 lecture 'Structure, Sign, and Play in the Discourse of the Human Sciences'.[7] Derrida argued that the notion of social structure itself betrays the metaphysical assumptions that precede it; therefore, 'objective' interpretations of religious, spiritual or cultural systems are not possible. Derrida's critique launched a movement that seriously destabilised ethnography and adjacent disciplines in the latter decades of the 20th Century. Whether or not one formally adopts a deconstructivist approach to ethnographic literature, scrutiny of its underlying metaphysical assumptions is now inevitable.

Some mid-20th Century ethnographers treated *sirena* myths as universal, on the order of the incest-prohibition and attendant matrimonial strictures. In Argentina the folklorist Bertha E. Vidal de Battini (1900–1984) collected approximately 30 *sirena* stories from informants throughout Argentina in the mid-20th Century. Sorting them according to the Aarne-Thompson Tale Type Index (the folklorists' taxonomy), she concludes that the *sirena* stories generally fall into the 'Lost Bride' or 'Animal Bride' category. Furthermore, she argues that *sirena* traditions are a universal feature of the popular imagination:

> *The millennial legend of the Sirena is conserved in the oral tradition of the whole country, ties to lakes, lagoons and rivers; the popular imagination sees her and fears her. We have documented her in twenty-eight versions. The Sirena is the Mother of the Water, associated with the ancestral spirits of nature. At times the archaic term Serena is used. [The legend] belongs to Group III of the International Classification.* (Vidal de Battini 1984: 450)

US academics applauded the rigor of Argentinean ethnography as conforming to the structural approach that they would soon find so burdensome. Chertudi's 'Cuentos Folkloricos de la Argentina: Introducción, Clasificación y Notas' (1960) was received with unanimous approval among folklorists in US academia, chiefly because it adhered so closely to European classification models; one even suggested that some of the indigenous tales were "clearly derived from Aesop" (Regnoni-Macera 1963: 59). Numerous ethnographers have collected *sirena* stories from Indigenous groups in Patagonia. But studying *sirena* lore among Indigenous populations in Patagonia presents a problem. On one hand, European print culture was virtually non-existent in the region for much of its history. On the other, the researchers may be unconsciously guiding their stories into a pre-existent pattern. A case in point is a group of stories the ethnographers called the 'Elal Cycle'.

In the 1960s, Bórmida and Siffredi collected stories from the Tehuelche, a now-remnant Indigenous group, including the Elal Cycle or story of the founding hero. The Tehuelche told the story of the Daughter of the Sun and the Moon, and the unfortunate decision on her parents' part to put Elal, her suitor, to a series of challenges as a condition of marriage. When Elal returns successful, they try to pass off a servant as his bride, which enrages him and he leads the unhappy daughter into the water, where she is condemned to stay. This is the nucleus of the story. Some variations include Elal's banishment of the Sun and the Moon to the ether, and the birth of a son whom Elal refuses to name. Bórmida and Siffredi understood that the conditions of their research were not ideal. The Tehuelche were not a coherent society, but rather the remains of several groups that had been decimated by Araucanian migrations, the so-called *Conquista del desierto* (a campaign of extermination) of the late 19th Century, and the concentrated misery of reservation life. The Tehuelche informants were, in the researchers' words, a handful of old women, one senile. Indeed, the ethnographers allude more than once to their subjects' "confusión apreciable" or "evident confusion" (1969: 201). Subsequent fieldwork reveals a dawning sense of resistance on the part of their subjects:

> *In our field-work, communication was very fluid, although there were numerous deliberate silences: for instance, whenever we made a reference to the Elal Cycle, Doña Luisa Mercerat would become mute, then taking refuge in forgetfulness. However, the repetition of this kind of behavior on the part of different interlocutors allowed us to recognize this kind of silence as a strategy of*

161

resistance to preserve their beliefs and practices from the interaction with outsiders. (Siffredi 1995: 172)

The fact that the ethnographers themselves recognised both confusion and hostility in their subjects does not elicit confidence in either the authenticity or authority of the Elal Cycle, especially as, when reading in sequence versions of the story from interviews completed in 1963, 1965 and 1967, it is impossible to overlook the fact that they become substantially more elaborate and coherent over the years.

More recently, Hernández (2002) compared the *sirena* stories collected by Bórmida and Siffredi from the Tehuelches, and those collected by Vidal de Battini and Chertudi from the Mapuches. Several Mapuche stories centre on a young girl kidnapped by a sea-man and taken to live under the sea forever, never seeing her family again. Hernández concludes that all these regional *sirena* stories are meant to reinforce prohibition against incest, exogamy and the fulfilment of the terms of the bride-price or marital exchange. However, there is a far more interesting (if currently unprovable) case to be made for comparing these stories to a literary tale (not folktale): Hans Christian Andersen's 'Den lille Havfrue' (1837). Tragic, vengeful water women also appear in Norse sagas, German opera and ballet, Scots and Irish folklore, and other art forms. In another popular mermaid tradition, a fisherman takes from the mermaid a sacred object, compelling her to marry him, and she suffers on dry land until she recovers the object, returning immediately to the sea. The theme of the mermaid abandoned by a faithless lover was well-known in 19th Century European culture: Andersen's mermaid and Fouquét's 'Undine' (1811) share this plot, and its underlying message that only matrimony will allow their female protagonists to acquire an immortal soul and enter the kingdom of heaven.

'Den lille Havfrue' is a tale about the perils of social ambition. The littlest mermaid, wishing to leave her natural place in the sea for the mysterious and glamorous one of the Prince's court, submits to having her tongue cut out and losing her tail. In exchange for the privilege of moving in the world of humans, she must dance on hot knives, and instead of winning the Prince's love with her lovely song, she must suffer mutely as the Prince falls in love with another who can sing. As a cautionary tale about social mobility, the story's moral is unequivocal: foolish ambition must be followed by extreme isolation and suffering in a strange land which will neither know nor truly accept the newcomer. As the little mermaid's grandmother states, "Pride must suffer pain" (Andersen 1974: 71). Not only the mermaid, but all her sisters and her grandmother, suffer humiliation and mutilation – the loss of their beautiful hair – because of the mermaid's ambition. Offered the chance to kill the Prince in exchange for returning to the sea, the mermaid refuses. She is rewarded by being taken in among the daughters of the air. Her salvation is perversely linked to the behaviour of the little boys and girls who are presumably hearing the story. In her blind pursuit of the prince and his world, the mermaid has given up the marks of her race (her tail), her power (her voice) and her happiness.

'Den lille Havfrue' is one of the inspirations for Oscar Wilde's (1891) short story 'The Fisherman and His Soul' about a fisherman who, seduced by a mermaid's beautiful song, sends away his soul so that he might go to his beloved. He goes first to the priest and then to a beautiful red-haired witch to learn how to accomplish this, and later meets the Devil, dressed as a jaded Spanish dandy. Rather than cutting off his feet, he takes a knife and

cuts around them to lose his soul. The soul pleads to take the fisherman's heart as well, but the fisherman needs his heart to love the mermaid. Each year the soul comes back to tell of his travels and tempt the fisherman to come away with him, offering him (siren-like) first wisdom, then riches. The fisherman succumbs on the third visit, when his soul offers to take him to see a dancing girl with beautiful feet. Along the way the soul, having grown heartless through having no heart, forces the fisherman to commit cruel deeds. The fisherman can't get rid of his evil, all-powerful soul, and so can never be with his mermaid, although he calls to her every day. One night she washes up on the shore, dead of longing. As the fisherman holds her in the waves, the soul enters his broken heart, and all are one again.

These two fairytales have several important points in common with what we know about Indigenous Patagonian siren stories, at least as codified by ethnographers. In the Mapuche stories, the inverse of Andersen's tale, maidens are taken to live in the sea with creatures of another race. If all goes well, the integrated maiden may prove to be a source of wealth to her human family in the form of fair tides and plentiful fish. If the maiden is unable or unwilling to fit in, her unhappiness may lead to floods or other misfortune. Like Andersen's mermaid, the daughter in the Tehuelche story has no name. In the Tehuelche story, the Sun and Moon put the hero Elal to a series of trials in order to win the daughter's hand. Of course they don't think he will be able to complete them all (they ask him to eradicate all evil, and anything that can kill people). When he returns triumphant, the Sun and Moon try to go back on their promise, hiding their daughter and covering her with filth. Elal sees through their ruse and, stripping the daughter of her necklace, declares that he will not marry her, but will take her away and "put her in the sea" (Bórmida and Siffredi 1969: 208). In another version he abandons her. She follows him to the sea, he casts a curse to trap her there forever and she becomes the *sirena*. With the new Moon, the ocean stirs, as the *sirena* stretches up to see her mother. In another variant, Elal has a son with the daughter (now called a woman). He forbids her from naming the child and, when she disobeys, throws the child into the sea. He follows by throwing the woman into the sea, where she becomes a sea-cow. Both Andersen's mermaid and the woman suffer mutilation as a part of their failed union. The daughter is stripped of her necklace and, in some versions, raped, and then abandoned. After failing to marry (and being stripped of their barter value), neither the mermaid nor the woman is allowed a place in society, and their failure leads to family ruin. Both are condemned to a state of limbo that mirrors their social displacement: the sea-dwelling mermaid adrift in the air, and the daughter of the Sun and Moon alone in the water. As a final injustice, neither woman is more than a footnote in the lives of the men they would marry. Given the essentially tragic nature of these fish-wives tales (for the women involved, at any rate), the fantasy of the glittering siren, possessor of unattainable wisdom and seducer of brave men, begins to look like a cruel hoax. In Afro-Caribbean cultures, where the *sirena* is a goddess in her own right, the *sirena* recovers her power and sexuality.

IV. Sirens of the Caribbean

The importance of water in the cultures of the African diaspora – as a medium of transit and livelihood, and as a symbol of enslavement, death, liberation and rebirth – cannot be overstated. The vitality and diversity of mermaids and mermaid-adjacent spirits, god-

desses, sprites and cults is a reflection of the historical and economic processes by which contemporary Caribbean cultures came into existence. The development of these syncretic entities is never linear; nor is their nature fixed. Afro-Latin *sirenas* belong to two interrelated traditions: one, mostly in English, which names the West African Mami Wata spirit as the inspiration for Caribbean mermaids; and another, mainly in Spanish, that traces them to the Orishas of the Yoruba religion. Although the two traditions may share some iconographical and semantic elements, they are attached to different values in Anglophone, Hispanophone and Francophone diasporic cultures.

Enslaved Africans came to the Americas in large numbers from the Yoruba, Dahomey and Bantú cultures of Nigeria, Congo and Angola (Carvajal Godoy 1992: 85). Orisha, also known as Santería or Regla de Ocha, comes from the Yoruba tradition. The saints or spirits of Orisha (the Orishas) rule the forces of nature. The Orisha Yemayá or Yemanjá is the mother of the oceans in Yoruba religion, and is often visualised as a *sirena* holding a conch. While terrible when provoked, she has also acquired the nurturing qualities of the Virgin and is worshipped as a protector of women and children and a force for justice. In Yoruba-derived religions in Cuba and Brazil, Yemayá is known as the mother of all the gods and humans. She is the goddess of water; but there is far greater specialisation among the Orishas than the South American spirits. Yemayá governs the ocean's surface but Olokun rules the underwater world, "surrounded by men, fish, and sirens with whom he copulates" (ibid: 86). Olosa inhabits the lagoons and Ochún minds rivers and other bodies of fresh water.

The Orishas are syncretically bound to Catholic saints. Cubans worship Yemayá in the form of the Virgen de Regla, a dark-skinned Virgin dressed in blue, Yemayá's elemental colour. The Virgin's voluminous robes hide her body, and she holds a pale-skinned baby Jesus in her arms (Figure 8).

The Regla neighbourhood of Havana was the first landing place for slave ships from Africa, and is known as the oldest centre for Afro-Cuban religion on the Island. The church of Nuestra Señora de Regla (established in 1690) is the site of an annual pilgrimage to the water, where crowds honour the Virgin with flowers, coins, decapitated doves and other objects. The folklorist Lydia Cabrera describes this annual ceremony as a ritual transformation of the Catholic Virgin to the Orisha Yemayá:

> They took the image of the Virgin from the house or cabildo of a santera to the doors of the church, where she was received by a catholic priest, and from there to the shores of the sea ... the Virgin of Regla is transformed in the course of this festivity into a Yoruba divinity, into Yemayá, and everyone calls her that. (1980: 17)

The history of the Our Lady of Regla ('the Rule') has been traced back to Saint Augustine of Hippo (354–430 C.E.), the great North African theologian and author of the Rule governing monastic life. An unpublished work by the Spanish cleric Diego de Carmona Bohórquez (1590–1653) tells the story of Augustine's miraculous discovery of the Virgin of Regla. Augustine's mother Saint Monica had seen herself in a dream, standing on "a sort of wooden rule" and was told by an angel that her wayward son would one day join her there, on the "Rule of Faith" (Lazcano 2012: 256). This information only came to light in 1630, when officers of the Inquisition questioned an accused witch, Francisca de la

Figure 8 – Virgin of Regla /
Yemayá. Templo Yemalla,
Trinidad, Cuba, 2015. Photo:
Ji-Elle.

Rocha, who told the story of an image of the "divine African" that Augustine ordered to be made for the city of Tagaste (in present-day Algeria). After his death, Augustinian clerics transported the image to Cadiz, where according to Carmona, King Rodrigo himself ordered the image buried after his defeat by the Moorish invaders at Gaudalete in 711. Carmona documented the Virgin's 100 miracles between 1338 (shortly after she was dug up) and 1636, the year of his writing. The majority involve the protection of mariners, and in one miracle she saved a ship from wrecking on an "island of Indians called Caribs, inhuman people who eat men" (ibid: 280).

The Virgin of Regla's skin colour caused Carmona some unease. He described her as "black, not because she is a black woman, but because that is what everyone calls her ... 'our black woman'" and rather lamely concluded that her darkness could be due to antiquity (ibid: 264). This conflicts with Cuban popular belief that the Virgin of Regla was not originally black, but "she turned that way on crossing the sea" (San Martín 1961: 153). The Cuban narrative clearly refers to the Atlantic slave passage, and allows the Virgin to have shared in the Afro-Cuban experience, but also, having different origins, to be a powerful force for their liberation. The Regla Virgin was stolen by anti-Batista rebels in 1958, with the intent to disrupt the annual celebration and taunt the regime. Four of the rebels were shot, along with two women who served as messengers, but the Virgin was not

returned until some days later. Since the economic crisis of the 1990s, the Virgin of Regla has taken on the role of protector of those who wish to leave the Island.

Given the sometimes polemical variations in the skin colour of different *sirena* images, it seems opportune to mention the Trinidad-born Rosa Guy's 1985 novel 'My Love, My Love', which recasts Andersen's 'Den lille Havfrue' (1937) as a Haitian romance in which a poor, dark-skinned maiden is rejected by her lover's lighter-skinned, upper-class family. Whereas in the original the barriers of social class were represented by species (fish/human) and the elements (water/air), in Guy's novel, colour and its attendant attributes of language, education and wealth constitute the barrier of social class. Skin colour is of enormous importance in Caribbean cultures, and underlies almost all social relations and interactions. A black mermaid, siren, Orisha or Virgin contains multitudes: her dominion of the sea encapsulates Atlantic history from the Middle Passage to post-colonial awakenings. She is definitively feminine, unlike some Orishas and *lwas* (Haitian deities) who may be represented as male or female.

Whereas Yemayá is still attached to chthonic forces, Mami Wata seems to be a more modern deity, associated with money and social mobility. The West African cult of the Mami Wata is largely a 20[th]Century phenomenon, and represents a consolidation of numerous local water deities (van Stipriaan 2003: 326). Beyond Africa, Mami Wata traditions have been documented in Suriname, Haiti and Martinique, sometimes under the name of La Sirène or some variation thereof.[8] Mami Wata is recognised by her West African followers as a combination of "exotic" (non-African) female images – European mermaids and Hindu snake-charmers or goddesses (Drewal 1988a: 102). These images combine with the serpent, which is an important figure associated with water in West African religions. The Mami Wata is a symbol of wealth and fecundity but, like other sirens, might exact a sacrifice in return for her favours. In West Africa, Mami Wata's devotees see her as a source of female empowerment (Drewal 2008a: 62; van Stipriaan 1996). Mami Wata is almost invariably represented with a snake, often two-headed. One of the most influential images of the Mami Wata is a 19th Century German print entitled 'The Snake Charmer,' which was widely circulated in Africa throughout the 20th Century (Figure 9).

Some representations of the Mami Wata are more clearly drawn from European mermaid imagery, for example those seen in the naieve paintings by the Grenadian artist Canute Caliste (1914–2005, Figure 10). Caribbean mermaids associated with the Mami Wata are often fair. Caliste said he was given his talent by a light-skinned mermaid:

> Caliste's mermaid is a light-skinned woman with a finned tail, which sometimes has a zipper. He once said that when unzipped the tail opens up into two normal legs and feet. She is usually in the lagoon where he first spotted her. Her hands may be in a waving position, at her side, or carrying a cross. (Hill 2013: 155)

Some other figures related to Mami Wata are the Haitian Lasirèn (associated with another *lwa* or spirit, Erzulie), the Martinican Lamanté and the Dominican figure Santa Marta la Dominadora (Saint Marta the Dominator or Snake-Tamer), which is represented by the Mami Wata image of Figure 81. The Haitian mermaid-spirit Lasirèn (from the French *la sirène*) or Maîtresse La Sirène is summoned by the blowing of a conch. When she is angry she seizes those who have angered her. She may bestow wealth and is associated with the

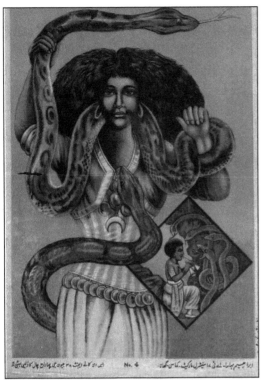

Figure 9 – Mami Wata, Adolph Friedlander Company (possibly Christian Bettels) 'Der Schlangenbandiger' ('The Snake Charmer') (1887).
Photo: Henry John Drewal.[9]

Figure 10 – Canute Caliste, *The Mermaid Resting in her Garden* (1998).

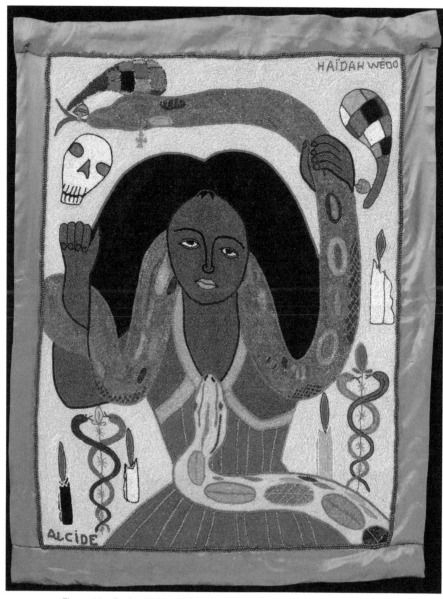

Figure 11 – Evelyn Alcide, *Haidah Wedo* (Mami Wata) Vodou Flag (c. 2010).
Image courtesy of Indigo Arts, Philadelphia.

cooling properties of water. Her consort, La Balen (from the French *la baleine*), is a whale. (Today, popular etymology associates the Martinican siren Lamanté with *amant* 'lover' or *amanté* 'beloved,' but it is far more likely derived from the French *lamantin* 'manatee' as the existence of La Balen would suggest.)

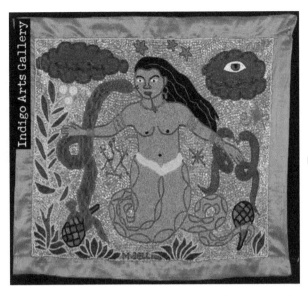

Figure 12 –
Mireille Delice (Delisme), *La Sirene and Damballa* (2009). Image courtesy of Indigo Arts, Philadelphia.

Images of Lasirèn are very common in Haitian *drapo Vodou* or Vodou banners, which are densely embroidered, ornamented textile creations that show *lwas* and other religious symbols. The genre became very popular in the late 20th Century, and the textiles are reaching a wide audience outside of Haiti. Myrlande Constant, among the best-known of these artists, has created images of La Sirène in a variety of guises and colours, and depicts her with a mirror, a golden comb and sometimes Agwé, her husband). Evelyn Alcide shows her as Mami Wata (Figure 11). According to Houlberg, a copy of the original Mami Wata image brought to Jacmel, Haiti in 1974 caused "an artistic explosion" in the local Vodou community, who focused not on the maiden, but on the snake, which they clearly took for the Vodou python spirit Damballah Wedo (1996: 34). Another banner, by Mireille Delice, shows La Sirène with Damballah (Figure 12).

Haitians know Lasirèn as a symbol of wealth and seduction, able to manifest both 'hot' (Petwo) and 'cool' (Rada) attributes. She might beckon from just below the water's surface, luring a passing traveler with the promise of a return to Africa. Those who emerge from her underwater realm (after three or more days) are possessed of sacred knowledge, lighter of skin, and have longer, straighter hair. Lasirèn is shown in many colors, occasionally with blonde hair, but these color variations seem to be attached to the values of fluidity, hybridity and mobility with which they associate her. Her vanity and mutability, her sensuality, and her power of attraction, are the same attributes that the medieval Church fathers denounced so vehemently in *sirenas*. But Lasirèn, like the other Caribbean *sirenas*, is a subversive and rebellious deity, and a beacon to marginalised women of color everywhere.

As is evident in the discussion above, the meaning of the *sirena* or mermaid in the cultures of Latin America and the Caribbean is flexible and varied, but virtually never coincides semantically with European folklore or religion. The fact that certain elements of the Patagonian oral tradition seem comparable to a Danish fairy tale only reinforces this

169

argument, as the oldest Spanish translation of 'The Little Mermaid' (*La sirenita*) seems to date to 1925 (García Méndez), suggesting that it could have influenced the ethnographers in question, but is unlikely to have reached the far less literate, isolated indigenous population. All the other *sirenas* discussed in this chapter represent rather subversive amendments to religious iconography (in the colonial are of Mexico and the Andes), or appropriations of the mermaid as an assertion of ethnic value and regional identity. As a source of income for folk artists, this appropriation becomes even more poignant, as we recognize that the market for these pieces is largely in Europe and the United States, and the market certainly drives creative production of such images. In the proliferation of Afro-Latin *sirenas*, however, we find a living expression of popular religious belief and cultural identity that circulates continually among Africa and Europe, Latin America and the Caribbean, renewing itself with each generation.

Notes

1. The Spanish *serena/sirena* refers to both classical sirens and mermaids.

2. NB All translations of Spanish language texts in subsequent sections are the author's, unless otherwise specified.

3. BnF, Manuscripts, French 782 fol. 197. © Bibliothèque nationale de France. Licensed under CC BY 3.0.

4. As in the legend of 'Mato' of Santo Domingo, a manatee raised by the Taino *cacique* Caramatex to eat from its captors' hands and ferry them from place to place (Durand 1983: 33–50).

5. The order of the text, as well as its content, changed over the many editions (Vistarini and Sajó 2012). Vistarini and Sajó have compiled all the versions of this text and published the first edition on their Studiolum website. Numerous editions are available in facsimile online at The Internet Archive, archive.org.

6. ©2013 Bodleian Libraries and Biblioteca Apostolica Vaticana.

7. Published in English as chapter 4 in his 1978 anthology *Writing and Difference*.

8. This profusion has led some scholars to suggest that her origins are Caribbean, rather than African (Paxson 1983: 418).

9. Originally commissioned in 1887 and reprinted in 1955 from the original by the Shree Ram Calendar Company, Bombay, India.

Chapter Nine

Swimming Ashore: Mermaids in Australian public culture

Philip Hayward

Introduction

The British colonisation of Australia began around Sydney in 1788. The early settlers relocated from their homeland at a time when rural–urban drift and major changes in rural land exploitation were breaking long-established patterns of regional culture. Migrants were widely scattered across Australia and many aspects of their traditional customs and folklore dissipated in the process. Since British settlement was premised on the dispossession, marginalisation and decimation of Indigenous peoples, few aspects of Indigenous folklore were adopted by European settler communities. Indeed of all the entities that feature in Indigenous ancestral stories only the hairy hominid now generally known as the *yowie* and the carnivorous, swamp-dwelling *bunyip* gained any foothold in Australian settler folklore and related popular culture. Similarly, while there are aquatic humanoid entities in the Indigenous beliefs of various Aboriginal communities, such as the *yawkyawk* of Arnhem Land (discussed in Section IV[1]), these were not assimilated within settler folklore. As a result, the establishment of the mermaid in Australia – and its association with a number of locations on Australia's eastern seaboard – occurred through the cultural processes that are analysed in the following sections.

I. Mermaids, Modernity and Anti-Modernity

While the folkloric figure of the mermaid was familiar to many Australians of European ancestry, she rose in prominence in Australia, as in the anglophone world in general, through translations of Hans Christian Andersen's short story 'Den lille Havfrue' that were published from the mid–late 1840s on. However, despite this diffusion there is little evidence of local interpretation and representation of Andersen's story in Australia during the 19th Century. Instead, the mermaid rose in prominence through the interrelation of social recreation, changing social attitudes to bodily display and cultural responses to these.

In Australia in the late 1800s and early 1900s, as in much of the Western world, women's roles, behavioural norms and dress codes were increasingly contested. This situation was most clearly apparent in the polarised nature of public debate about the campaign to recognise women's rights to vote, which gathered momentum in the 1890s and resulted in the *Australian Commonwealth Franchise Act* of 1902, which enshrined that right in law. As Dunn (nd) identifies, in line with changes in women's social positions, the predominant dress code of affluent society, in which women were frequently corseted and contorted into narrow-waisted 'S' silhouettes, gave way to less constrained garments. In the early 1900s further changes ensued, particularly with regard to women's more active participation in sport and a fashion for everyday clothes that mimicked aspects of sportswear. Changes in attitudes to public swimming – and requirements for modesty in that pursuit – also resulted in a vanguard of women choosing more practical garments than had previously been deemed appropriate for them. As Craik identifies, the changing designs of swimsuits "articulated conflicts in moral and gender codes associated with sexuality" (1994: 131) and were the subject of much debate, proscription and intervention.

Outdoor bathing and swimming gained popularity in the mid-1800s as activities deemed to aid the health of the individuals who participated in them. Around the 1850s women's bathing wear was complex, voluminous and cumbersome (Schmidt 2012: 62) making actual swimming awkward. Women's growing interest in competitive swimming in Australia led them to adopt tighter and less complicated swimsuits for training and racing (ibid: 64). By the early 1900s women's competitive swimming became increasingly popular and led to talented young performers, such as Beatrice Kerr and Annette Kellerman, gaining high public profiles. Kerr's and Kellerman's earlier careers unfolded in similar manners. Both became famous in Australia as competitive swimmers and divers in the early 1900s and toured Australia before relocating to the United Kingdom in the mid-1900s to further their careers. Kerr usually performed in one of two one-piece bathing suits. One was emblazoned with the image of a kangaroo above the word 'Australia' and the other was decorated with a silver threaded, fish-scale pattern in allusion to her fish-like abilities in the water[2] and/or to her status as a 'real-life mermaid'.[3] Kerr returned from England in 1911, withdrew from public swimming and largely disappeared from the public eye. Kellerman, by contrast, went on to appear in a string of successful feature films.

Kellerman moved to the United States (US) in 1907. Establishing herself as a versatile performer on the vaudeville circuit, she achieved further fame in films that both showcased her diving and swimming skills and frequently represented her as (various forms of) mermaid. The latter included two films made in 1911, *Siren of the Sea* (director unknown)

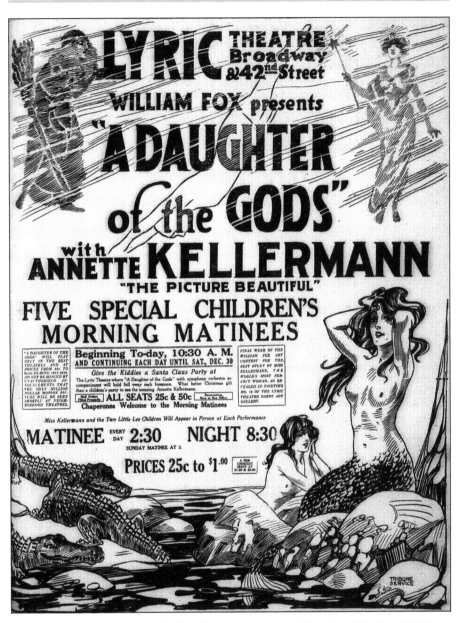

Figure 1 – Promotional poster for New York premier season of *Daughter of The Gods* (1916).

and *The Mermaid* (ditto), *Neptune's Daughter* (Herbert Brenon, 1914), *A Daughter of the Gods* (Herbert Brenon, 1916), *Queen of the Sea* (John Adolfi, 1918) and a final, lower-profile and lower-budget feature shot in New Zealand, *Venus of the South Seas* (James Sullivan, 1924). Her 1910s films were particularly successful and were marketed in ways that used mermaid

173

imagery to emphasise the film's erotic aspects (Figure 1). Her 1914, 1916 and 1918 films were widely exhibited in Australia, and she maintained a high profile in Australian media until the mid-1920s, boosted by a season of live performances at Sydney's Tivoli Theatre in 1921 and an east-coast tour in 1921–1922. Her films promoted a particular distillation of European-derived mythic/folkloric themes, and large-scale Hollywood spectacle that Woolacott has characterised as being a "modernist pastiche of the primitive and the exotic" (2011: online). When her performing career waned in the mid-1920s, Kellerman published a book of children's stories entitled *Fairy Tales of the South Seas* (1926) and visited Australia frequently before returning to live on Australia's Gold Cost in 1970 until her death in 1975.

Kerr's and Kellerman's association with mermaid imagery suggests that mainstream patriarchal society and its media needed a feminising context for the promotion and digestion of the new phenomenon of female aquatic performers. The mermaid, as a graceful and alluring figure, gave such an association. However, in Kellerman's case, this also resulted in a significant spectacularisation of her body in various fictional scenarios that constructed her as an impossible object of desire within the signifying systems of commercial cinema and within the promotional discourses that extended it (Figure 1). She thereby occupied a paradoxical position with regard to modernity. Changing social patterns allowed and enabled her to become famous for her physical accomplishments in spheres usually reserved for male performances. But, at the same time, her various appearances as a mermaid also served to represent her as essentially pre-modern and elemental. Whilst never a passive object of desire within cinema narratives, she was often marginalised from modernity and only enabled within fantastic, timeless spaces.

Kerr's and Kellerman's careers flourished during a period in which a number of Australian men also produced significant representations of mermaids. The two most notable of these were the artist and novelist Norman Lindsay and the poet Kenneth Slessor. As discussed below, their work can be seen to have embodied a set of responses to the growing emancipation of women and the modernisation of their agency, roles and related appearance.

Lindsay was a prolific artist, sculptor and novelist whose professional career extended from the 1890s until the 1960s. His work attracted controversy on account of its unashamedly sexual aspects and his lack of respect for a morally conservative society dominated by an Anglican Christian establishment.[4] His engagement with the emancipation of women and the agency exercised by prominent individuals such as Kellerman was essentially reactive and, in many ways, regressive. Tsokhas (1996) has characterised that Lindsay used images of women and various female mythological chimeras:

> to deny and escape from modernism and modernity. In this regard, women entered his paintings and narratives not as bearers of contemporary possibilities and meanings but primarily as neoclassical nudes or bodies through which sexual understanding could lead to male self-discovery and liberation from the modern world. (ibid: 222)

Drawing on European mythology, Lindsay produced a series of artworks that depicted nymphs, satyrs, mermaids and related figures in often unabashedly erotic scenarios. While there is no evidence of direct influence, the fantastic/mythological content and scenarios

of films starring Kellerman and similar US features of the period were closely similar to those of Lindsay's more florid paintings, such as 'The Festival' (1923) and 'The Orgy' (1932). Lindsay's interests were shared by a group of other young, Sydney-based writers and artists, including the poets Kenneth Slessor and Hugh McCrae, who founded a (short-lived) quarterly journal entitled *Vision* in 1923 that consciously sought to distance itself from the celebrations of parochial Australian rural and pioneer life central to popular Australian magazines such as *The Bulletin*. As Kirkpatrick characterises:

> *All bush ballads were to be banished, along with any mention of shearers, drovers or gumtrees. In their place the Visionaries substituted a delirious costume party of satyrs and centaurs, pierrots and pirates, mermaids and magnificos: supposedly 'universal' figures representing Life-with-a-capital-L and Art-with-a-capital-A unbounded by history or nationality.* (2015: online)

In the 1910s–1930s Lindsay produced a series of representations of mermaids as primitive entities tempting and suggesting accessible realms of otherness to human (and implicitly male) subjects. There are many examples of such work in *Vision* and in a number of subsequent collaborations Lindsay undertook with Slessor.[5] The majority of Lindsay's surviving paintings represent the mermaid similarly to that of Edvard Eriksen's statue of the Little Mermaid erected in Copenhagen in 1913; that is, with legs that are finned below the knee.[6] This aspect allowed Lindsay to represent his subjects in the erotic manner that typified much of his work. The eroticisation of mermaids whose physiology implied conventional female genitals (in contrast to their apparent absence in the fully fish-tailed variety), was particularly apparent in a complex image he produced in 1934 (Figure 2). As the image's title indicates, on one level this etching appears to be a re-imagining of Eriksen's statue. The mermaid's wide-eyed, direct look to the viewer, her exposed breasts and pubic area, and the surging wall of surf behind her are markedly more sexual than Eriksen's mermaid statue, with the latter's discrete hand across her lower waist and her downwards, sideways look. The image's suggestion of truncated arms also invites comparison to the Venus de Milo, the ancient Greek statue discovered on Milos island in the Aegean in 1820 and shipped to France where it became feted as the epitome of classical female beauty and artistic accomplishment. In this regard, Lindsay's image also invites reading in terms of Kellerman. One of the best-known publicity tags appended to Kellerman during the peak of her career was that her bodily proportions were those of the 'perfect woman'. This assessment was attributed to Dr Dudley Allen Sergeant, director of Harvard University's Gymnasium, who measured Kellerman's body in 1910 and asserted that her proportions were almost identical to those of the Venus de Milo (Woolacott 2011: online), In addition to becoming a news story in its own right, the characterisation provided a highbrow legitimation and point of interest for Kellerman's aquatic cabarets and film performances. Lindsay's artwork (whose central figure retains similar proportions to both the Venus de Milo and Kellerman) provides a very different image to Kellerman's various screen personae. With her lower arms transitioning to dark fish-like appendages that blend into the background, Lindsay's little mermaid is vulnerable, exposed and threatened by the wall of surf that rises behind her and principally appears as a fragile voluptuary positioned for male appraisal.

Slessor's interest in mermaids appears to have developed in parallel with Lindsay's and during the period in which Kellerman's career as a mermaid-themed performer in

Figure 2 – Norman Lindsay 'The Little Mermaid' (1934).

American cinema was at its peak. As Haft (2014) has detailed (after Jaffa 1971: 15), the references to mermaids in Slessor's early poems, published shortly after the end of the First World War, can be regarded as elements of sensual abundance presented as both a corrective to and distraction from the traumas experienced by Australia's young men (and society more generally) during the conflict. His interest in the mermaid led to his most concentrated engagement with her form, function and symbolism in his poem, 'Mermaids,' included in 'Atlas' (1932), a five-poem cycle inspired by medieval maps and their illustrations. The poem laments a loss of aspects of mystical romance in modern existence, contrasting the experiences of early mariners and their belief in mermaids and other fabulous sea creatures with modern cruise passengers' experiences in a world of scientific rationalism, where mermaids are lightly dismissed as mistaken manatees.

While Lindsay's adherence to the legged and finned mermaid design was shared by William Leslie Bowles, the creator of Australia's only significant work of mermaid statuary in the inter-War period,[7] it was somewhat out of fit with the more standard representation of the mermaid as fully fish-tailed in the early–mid 20th Century. The work produced by popular children's writer/illustrator Connie Christie and Sydney-based sand sculptor John Suchomlin (discussed in Section III below) was more in accord with global trends. Christie provided a striking rendition of a fish-tailed mermaid in Australia's first original mermaid-themed children's book, 'The Adventures of Pinkishell' (1939). This short volume reworked elements of Andersen's 'Den lille Havfrue' by having its character visit the human world at the prompting of an older mermaid. Encountering a ship's crew, she helps them retrieve sunken treasure and is taken to the boat captain's home where she stays with his sick daughter before being returned to the sea. Free of the markedly Freudian elements of Andersen's original (see Hayward 2017a: 21–50) and lacking the masculinist objectification central to Lindsay's aesthetic, the story is an amiable narrative whose most distinct element of modernism occurs in its final twist. In appreciation of her assistance, the captain gifts her a "seaproof wireless set" to enjoy in her marine world (Figure 3). As the image suggests, the young fish-tailed mermaid lacks the sexualised

Figure 3 – Pinkishell dancing to her "seaproof wireless set" on the final page of Connie Christie's 'Adventures of Pinkishell' (1939).

physique and demeanour of Lindsay's creations and instead appears as an innocent figure closely akin to those featured in Disney cartoons, such as *Merbabies* (Rudolph Isling and Vernon Stallings, 1938). The volume was highly successful, and Christie became one of Australia's most popular young children's authors over the next 15 years, also publishing a further mermaid-themed volume, 'The Fairy Mermaid', in 1946.

II. Place/Mythology

As discussed in the introduction to this chapter, the nature of initial British settlement of Australia did not facilitate the association of particular Australian places with traditional Anglo-Irish folkloric beliefs. There are, however, a number of Australian locations that have become associated with mermaids through the production of images, statuary, performances and, more latterly, audiovisual and Internet media representations. The most significant of these locations are situated on Australia's eastern seaboard.

a. Manly

Located around an isthmus on the north-eastern tip of Sydney Harbour, Manly became a major centre for swimming, lifesaving and surfing in the late 1800s. While bathing in swimming pools was a common practice in the mid–late 1800s, the New South Wales Government banned swimming in Sydney Harbour in daylight hours in 1833 and extended the prohibition to several ocean beaches in 1838. Increased flouting of the restriction led to its abandonment in 1902–1903, creating a boom in aquatic activities in Manly and other city beaches. Similar to the association of female swimming celebrities with mermaids and aquatic mythologies identified above, the early stages of Manly's development as a beachside aquatic centre were marked by deployments of traditional imagery aimed to celebrate and legitimise activities that were still regarded as risqué on account of the tight and/or abbreviated clothing worn by swimmers (of both sexes). In 1908, for instance, what was billed as the world's first 'Surf Carnival' was held at Manly. The event opened with a woman dressed as Venus coming ashore and being greeted by "Father Neptune and a crowd of mermaids, octopuses, and a '40-legged sea-serpent'" (MacRitchie 2004: 1). While this performance wasn't repeated at subsequent surf carnivals, the mermaid resurfaced in the 1920s in the work of Ukrainian migrant artist John Suchomlin. Suchomlin began working in Manly in 1927, creating sand sculptures stabilised with whitewash (to harden their surfaces and to allow him to paint them). His work became popular with locals and visitors, and in 1929 a small pavilion was erected at the south end of Manly's surf beach to showcase his works and retail picture postcards of them. Along with Biblical and mythological themes, Suchomlin reflected the nature of his environment by producing representations of agile young women in fashionably abbreviated bathing costumes. He commonly referred to such swimming belles as 'sea nymphs' and also sculpted (fish-tailed) mermaids in similar mode, with his vision suggesting a continuum between the two as archetypes of femininity associated with water. This interest was underlined by his choice of a mermaid to accompany him in his farewell self-portrait to Manly on the occasion of his departure to the US on an extended tour in 1931 (Figure 4). One notable aspect of the latter is that if the mermaid in the tableau is considered to symbolise Manly, it represents one of the earliest uses of a mermaid to signify a specific Australian location.

Despite these early uses of mermaid imagery, the figure was not actively promoted as a symbol of the area in the post-war period. Indeed, local businessman Jim Frecklington's public campaign to get Manly Council to accept and install a bronze mermaid statue on the central Corso in 1992 was unsuccessful. Despite a publicity campaign promoting the mermaid as a potential iconic image for the area, and a petition signed by over 5,000 people,

Figure 4 – Postcard of Suchomlin's farewell sand sculpture (1931).

Council rejected the proposal on grounds of insufficient artistic merit. By contrast, the mermaid has flourished as a symbol of Manly's principal Sydney rival as a surfside swimming centre, Bondi Beach.

b. Bondi

Located in Sydney's eastern suburbs, Bondi is one of Sydney's (and Australia's) best-known beach locations. As Sanders (1982) identifies, the area has had a complex history with regard to the various counter-cultural communities that have lived and/or congregated there at various times since the 1880s. The area experienced a peak period of contestation in the late 1950s and in 1960 concerning public use of the foreshore, beach and the surf zone (ibid: 14). One aspect of this involved the regulation and policing of women's swimwear by Waverly Council, which administers Bondi Beach. In 1935 the Council passed the *Local Government Act Ordinance #52*, which specified that women's bathing costumes should cover their entire trunk and the top three inches of their legs. Despite the arrival of the two-piece bikini as an item of fashionable beachwear in the mid–late 1940s, Council beach inspectors rigorously enforced the rule, escorting any woman brave enough to contest the ordinance from the beach and, on occasion, having them charged and fined. As the 1950s progressed, the number of women flouting the prohibition grew and the period 1960–1961 saw what has been described as 'the bikini war', when women ignored the ban in large enough numbers to force the Council to rescind the ordinance. Mermaids entered into Bondi's historical narrative at this point as an element promoted by eccentric sculptor, occasional vaudeville artist and inventor Lyall Randolph (Williams).[8] Inspired by Eriksen's Copenhagen statue, Randolph proposed the construction of two mermaid statues on a large rock near at the northern end of Bondi Beach. While Waverley Council expressed initial interest in the proposal, they neither offered financial support for the project nor gave it official approval. When the latter was not forthcoming, Randolph self-financed the sculptures and mounted them on the rock, claiming that since it was located offshore it was not under Waverley Council's jurisdiction anyway.[9]

Two local women acted as models for the statues: Jan Carmody, who was winner of the Miss Australia Surf competition in 1959, and Lynette Whillier, a champion swimmer and runner-up in the same competition. Randolph's design for the mermaids was notable for

179

Figure 5 – Close shot of the Bondi Mermaids c1960 (photographer unknown).

eschewing Eriksen's and Lindsay's finned lower-leg form in favour of figures with full fish-tails. The statues were made of cement, infused with polymer resin, and were painted gold (leading them to sparkle in sunlight) (Figures 5 and 6). In a public statement about his work, Randolph characterised them as manifestations of "a rational person's love of the beauty of clear line and form" (Unattributed 1960: 3). However, despite Lyall's emphasis on rationality and the abstracted aesthetics of his statues, the highly erotic nature of their bare upper bodies attracted most attention. Echoing the Anglican Church's earlier condemnation of Lindsay's artworks, Roman Catholic spokesman and broadcaster Leslie Rumble warned of the statues' impact, commenting that, "we can hardly complain if young men, their passions inflamed, commit sex offences" (Cockingham 1999: 28). In a remark entirely in accordance with the history of the siren, a Bondi Beach inspector was also

Figure 6 – The Bondi Mermaid statues, Mermaid Rock and adjacent cliffs c1964 (photographer unknown). (Note the similarity to Lindsay's 'Little Mermaid' artwork – Figure 2 above – with regard to the presence of looming waves).

quoted as fearing that the mermaid statues "could lure people to their deaths" (Unattributed 1996: 4).

As if in confirmation of critics' assessments of their seductive and disruptive power, further media attention soon followed when the mermaid modelled on Carmody vanished overnight. An investigation revealed that the statue had been removed by Sydney University engineering students as a University Commemoration Day prank and had been badly damaged in the process. The local community raised funds for her restoration and the pair were reunited in the following year. Between 1961 and 1974 the mermaids became icons of Bondi and the pleasures of its beachside location. This situation was disrupted again in 1974 when storm-agitated waves swept the mermaid statue modelled on Whillier away and severely damaged its companion. In 1976 the damaged mermaid was moved to a more elevated position before being placed in storage. While she may have been out of sight, she was not forgotten. In addition to Mermaid Rock continuing to be known as such (despite the statues' absence since the early 1970s[10]) the mermaids and their history were rediscovered by a local artist named Lizmania, who found the crumbling remains of Carmody's mermaid in storage in 1995. Learning of their background, she successfully campaigned for the statue to be conserved (in its damaged form), with it being put on display at Waverley Public Library in 1997. Her second campaign was less successful. Adopting the persona of 'The Bondi Mermaid' in various publicity stunts and photos, she launched a project entitled 'Mermania 2000', aimed to raise funds to install replicas of the original statues on Mermaid Rock. The venture did not produce the desired result and, despite Lizmania's intermittent campaigning on the issue, the project stalled in the early 2000s.[11] Despite this, Lizmania has continued to perform in her mermaid persona and achieves occasional high-profile media coverage, typified by her appearance on Channel 7 TV's *The Morning Show* in 2016, where she reclined in role on a studio couch accompanied by her pet 'mer-dog' Tipseatoes while being interviewed (Figure 7).

Figure 7 – The Bondi Mermaid/Lizmania and Tipseatoes on *The Morning Show* October 27th 2016.

Inspired by Lizmania's activism and memories of the statues, local interest in the mermaids has persisted in various forms. One notable recent example was an interactive artwork produced by Jonas Allen and Steven Thompson from Bondi Advertising Australia in 2013. This was based on a computer app that allowed individuals to manifest various versions of the Bondi mermaid statues on smartphones or tablets by aiming them at digital markers placed in a large fiberglass bottle lying on its side.[12] The installation was created and exhibited as part of the annual Sculpture by the Sea event, exhibited along the coastal walk from Bondi to Tamarama.

One aspect of the continuing public awareness of the mermaids in the area has been the inscription of multiple – if often ephemeral – renditions of mermaids along Bondi's foreshore. These have taken various forms including:

- photographs of individuals on or around Mermaid Rock imitating the poses of the original statues either retained for private purposes or else posted on sites such as Instagram or Facebook

- mermaid-themed artworks produced for graffiti walls along Bondi Beach[13]

- mermaid–themed artworks created by local artists and exhibited around Bondi (such as the Blackman family of artists' 'Memories of Mermaids exhibition' at Bondi Pavilion Gallery in 2017)

- mermaid–themed performance or theatrical events around Bondi (such as Alli Wolf's play 'Mermaid's Teeth,' given a development staging at Bondi Pavilion in 2013)

- locally authored fiction referencing mermaids (such as Rubinstein 1999).

Illustrating the intensity of local identification with mermaids, there was even a high-profile (if somewhat exaggerated) dispute between Lizmania and local swimming instructor Eve White about rights to use the name 'The Bondi Mermaid'. Lizmania threatened legal action, regarding herself as having de facto ownership of the moniker as a result of her adoption of a mermaid persona around Bondi for several decades. While no actual legal action eventuated, the coverage served to publicise both individuals and to further inscribe connections between Bondi and mermaids in popular culture. The clash was also something of a generational one, with White identifying her initial connection to mer-culture through its media representation in texts such as Madonna's 1991 video 'Cherish' (p.c. July 17th 2017) rather than the local history in which Lizmania has been an active and colourful participant in.

White's citing of 'Cherish' on account of its convincing representation of mermen aligns with another aspect of Bondi Beach's contemporary public visual culture, namely the manner in which location presents a broader and more inclusive set of mer-images than those that occur elsewhere in Australia. An audit of visual images displayed around Bondi Beach's seafront by the author in May 2017 revealed a wide range of mer-themed material. This includes traditional mermaid imagery, such as that painted on the side of the beach's skate ramp and, on the waterfront graffiti wall,[14] a bearded hipster merman, mer-dogs and pseudo-Aboriginal gender-ambiguous mer-figures.[15] The appearance of mermen in such contexts emphasises the strong connection of men and the water through the beach's long association with both lifesaving and surfing culture, and the relative ease of male identi-

fication with mermen who, like those represented in Madonna's videos, are active, empowered individuals.

In the latter regard, it is appropriate that the most recent audiovisual work to address Bondi and the Mermaid Rock is Daniel Mudie Cunningham's video *No Ordinary Love, 2017*. Cunningham's work mimics the style of a karaoke video, using a predominantly instrumental version of Sade's 1992 hit single 'No Ordinary Love'. The video's images comprise shots of Mermaid Rock and adjacent cliffs with text captions of the lyrics running across the bottom of the screen. This video source is then projected over Cunningham, dancing to the music in swimming trunks. The work plays off another referent – Sophie Muller's original music video for the single. Her 1992 video combines a number of striking images – Sade as a mermaid sitting on a rock underwater, a young man falling into the sea and being rescued by the mermaid, and then the singer in human form running along a street in a bridal gown. As Cunningham has elaborated:

> No Ordinary Love, 2017 *is a requiem to two Bondi histories: iconic mermaid sculptures once mounted to a boulder at the northern headland cast in the same conceptual net as the scores of men murdered on the southern headland, a cliffside gay beat. Drawing on the glitch of VHS and the kitsch of karaoke lyric videos, Sade's* No Ordinary Love *is reinvented as an ode to those lost to sea …* As marriage equality debates rage in Australia,[16] *the video's visual cues are reimagined as a melancholy karaoke poem to Bondi Beach as a site of fantasy and trauma – a sea of love and loss …* (p.c. September 21st 2017).

c. The Gold Coast

The three Australian locations with the most explicit connection to mermaids in their place-names are Mermaid Beach and the nearby Mermaid Park and Mermaid Waters canal estate on Queensland's Gold Coast.[17] Today, Mermaid Beach is just one in the long line of coastal suburbs that constitute the Gold Coast. Aggregated with a variety of post-War suburbs, artificial islands and canal estate developments purposefully given glamorous titles, such as Surfers Paradise, Isle of Capri or Miami Keys, Mermaid Beach's name might be assumed to be another modern invention. Instead, its glamorous associations are a fortuitous aspect of its original designation, with the beach area being named after the British naval cutter the *HMS Mermaid*[18] that visited the area while surveying the southern Queensland coast in 1817–1820.[19] The area grew considerably in the post-War period and the Mermaid Waters estate was constructed in the early 1970s. The latter coincided with the establishment of the Merlina Mermaid statue and fountain in Mermaid Park, off the Gold Coast Highway. Despite the classicism of her pose, Merlina's bare upper torso and metallic sheen resonates with other aspects of the Gold Coast's public iconography and public performance culture at the time of her installation. In particular her appearance invites comparison to the 'Meter Maids' who were introduced by local businesses in 1964 to top up tourists' parking meters. By the mid-1970s they wore golden bikini uniforms that created a signature association for the destination with glamorous, scantily-clad femininity that Kalms (2016) characterises as an aspect of the conscious "hypersexualisation" of the area as a tourism destination. Indeed, this aspect was manifest in postcards of the Merlina fountain pool sold in the 1970s that featured young, curvaceous, bikini-clad

Figure 8 – Models and Merlina Mermaid statue and fountain, Mermaid Beach
(c1970s, photographer unknown).

women posing next to Merlina and on a rock in the pool, accompanied by a caption implicitly including them as elements within the 'Mermaid Park' itself (Figure 8).

The fountain and sculpture were dismantled around 2005 due to deterioration and have not been replaced. The image has, however, been celebrated in a subsequent statue in nearby Ken Mansbridge Park. The more recent statue offers a revised, more discrete version of Merlina's earlier form, with fish scales covering the mermaid's body to above her breasts and with her arms held aloft and head tilted back.

In recent years mermaids have also been associated with the area through the production of two internationally successful TV series shot in Village Roadshow's Oxenford studios and on location around the northern end of the Gold Coast.[20] Developed by the Australian producer Jonathan M. Shiff, the first, *H2O: Just Add Water* (2006–2010), centres on the adventures of three early–mid teenage girls who become mermaids by accident and represents its lead characters as capable and resourceful individuals, able to act decisively on land and, in finned form, under the sea. After three seasons, Shiff produced a follow-up series entitled *Mako Mermaids*[21] (2013–2016) that flipped the premise of its predecessor by having three mermaids transform into girls in the same locales. Similar to *H2O*, the mermaid/girls are inventive and enterprising, and negotiate various threats and predicaments. As discussed in detail elsewhere (Hayward 2017a: 135–138, 143–149 and 156–158) the series set a model for a stream of subsequent TV and amateur aficionado productions that used the mermaid identity to explore various role models for pre-teen and teen girls.

The production of both series attracted media attention for its representation and promo-

tion of the locale internationally and for the employment opportunities and expenditure generated by it in the region.[22] However, despite the series' popularity with audiences there has been little in the way of spin-off influence on the Gold Coast in terms of marketing and promotion. This point was acknowledged by the series' producer in 2014, when Shiff identified that despite his series "bringing 300 million people a week pictures of Queensland" (Bochenski 2014: online) it had very little presence in tourism branding of the Gold Coast (ibid). Citing the examples of tourism to South Island, New Zealand, based on the success of the *Hobbit* films (2012, 2013, 2014) shot there by director Peter Jackson, and to Northern Ireland, by fans of the TV series *Game of Thrones*,(2011–), Shiff identified that:

> it would be great to join the dots more so Tourism Queensland can ride that wave ... I don't necessarily need to see Qantas planes with Mako Mermaids on it ... but people often go through the gates at Seaworld [sic] saying 'Where are the Mako Mermaids?' (ibid)

The lack of local engagement with television material representing their region in this example is noteworthy, reflecting the far from automatic social reflection of media phenomena in locales without any 'organic' folkloric connection to the material concerned. Modernity is also a factor here. The Gold Coast is a recent (i.e. post-World War Two) urban development that has a limited number of multi-generational families, and has a variety of coastal landscapes and built environments that have been subject to serial modification. Shiff's TV series rely on an imagined, unspoiled tropical island some considerable distance offshore as the base and point of origin of the series' mermaids. Without such an actual location that could be subject to branding in terms of the series, the disparate cafes, shops, coastal spaces, canal estates and houses around the Gold Coast that both series represent are too dispersed to easily be branded and/or socially signified with reference to the shows.

Despite the above, the Gold Coast has produced a number of local engagements with mermaids. One such work is the children's book 'The Surfer and the Mermaid' (2011), produced by Gold Coast writer Tim Baker, weaving a narrative around photographic images of Byron Bay-based professional mermaid performer Hannah Fraser,[23] surfer David Rastovitch and a number of whales shot by photographer Ted Grambeau. Baker's text provides a linking story of a surfer being introduced to wary cetaceans by a mermaid and becoming inspired to protect them. The book was subsequently developed into a stage play that premiered at Surf World Gold Coast Museum in early 2012 before transferring to Arts Centre Gold Coast for further performances. More recently, the mermaid was a feature element of the annual Sand Safari Arts Festival, held at Surfers Paradise. Described as "a celebration of sand and sea-inspired art," the 2017 theme was 'Mermaids and Mythical Creatures'. While the event did not overtly acknowledge Shiff's series in any aspect of its marketing, the particular design of the mermaid featured as the event's signature image (see Figure 9, for one example) resembled the mermaids in both of Shiff's series by having areas of scales forming a bikini-top pattern on the mermaid's upper torso similar to that of their tails. The event included sand-art sculptures of various mermaids and sea creatures, appearances by professional mermaids, classes in wearing and swimming in mermaid tails and the launch of a promotional booklet entitled 'Sandy's Surfers

Figure 9 – Promotional poster for one of the events at the 2017 Sand Safari Arts Festival.

Paradise Adventure' (Gibbs, Gibbs and Wells, 2017). The booklet was aimed at school-aged children and used the character of Sandy the Mermaid to promote awareness of the Gold Coast's marine environment. The booklet was launched by professional mermaid performer Alyce Hill, in role as Sandy, providing a photo opportunity picked up on by a variety of regional media outlets.[24] Local schoolgirls also mounted a live performance of the narrative on the beach after the launch.[25]

d. The Whitsundays

Along with the Gold Coast, the other Queensland location with prominent mermaid imagery is Daydream Island. Located in the Whitsunday archipelago, close to the major tourism centre of Hamilton Island, the island has been subject to various aspects of destination branding since it was first developed as a tourism resort in the 1930s.[26] The island's resort facilities have been subject to various disruptions and reconfigurations since their inception, including a near total re-build after Cyclone Ada devastated the region in 1967. For much of its early phase the resort's design, décor and ornamentation was relatively generic, before a distinct design element was introduced in 2002 when three mermaid statues sculpted by Queensland artist David Joffee were installed at the northern end of the island (Figure 10). Since their installation – and, most particularly, their popularity as photo subjects for visitors – the island has introduced other smaller mermaid statues, such as those outside its premium restaurant (also named Mermaids), and has also adopted a mermaid-themed logo (Figure 11).[27] The latter merits comment. Its simplification of the mermaid to three graphic elements that stretch the mermaid's form, as if representing her turning upwards in the water after having dived into it, is a dynamic rendition that goes beyond the passivity of the island's rock-bound sculptures and is, instead, one that is more closely comparable to the shapes that Kellerman's body took in many of her films. In this manner the image merits reading against the statues. Its similarity of general proportions to the figures (and, indeed the similarity of its curved

Figure 10 – Daydream Island mermaid sculptures (photo by Tony Hodkiss, 2016).

Figure 11 – Mermaid design logo for Daydream Island Resort and Spa (2015).

back to the mermaid at the right of Figure 10) suggests the logo as representing the island's mermaids as diving free from their tethering and the passive captivity they endure.[28]

While there is no reference to it in any aspect of branding and publicity, Daydream Island's mermaid imagery also resonates with previous mermaid performers and media representations in the archipelago. Possibly the least known of these is Kellerman's association with the region. In 1933, after her career in commercial cinema had ended, Kellerman and her husband, cameraman and director James Sullivan, relocated to the Whitsundays for 15 months, mainly staying on Lindeman Island.[29] During their stay the couple made a number of short silent films that featured the actress swimming through areas of coral wearing a prosthetic mermaid tale. Produced as short films intended for cinema release, they never made it to the screen and appear to have been lost. But while Kellerman's location footage has vanished, one significant re-inscription of her and of her aquatic athleticism in the Whitsundays was made by media artist Grayson Cooke in June 2011 in Airlie Beach. His performance of a live audiovisual work, entitled *Kellerman: EXPANDED*,[30] used extracts from surviving fragments of her silent film work and footage from the later Hollywood 'biopic' about her, *Million Dollar Mermaid* (Mervyn Le Roy, 1952), together with a collage of snippets from vintage recordings of songs about the Whitsundays and material by guitarist and sound artist Mike Cooper.[31] As Cooke outlined in an essay accompanying the event:

For the purposes of 'Kellerman: EXPANDED,' the life of Annette Kellerman serves to locate a cluster of associations that exemplify the notions of tropicality, temporality and aquatic experience, notions that likewise encircle the Whitsundays and other island tourist destinations. Her use of the mermaid figure, in film as well as in her performances, presents the spectacle of a life lived in relation to and under the water ... I wanted to present the audience with a palpable sense

of this experience, so I limited the types of footage I used to sequences featuring people diving into, or swimming under, the water ... the result was a series of changing vignettes in which Kellerman's various characters appear permanently suspended underwater. Kellerman's prodigious abilities in holding her breath underwater while performing acrobatic or ballet routines, are here taken to an extreme, presenting the audience with the spectacle of the Australian Mermaid trapped, somewhat ironically, in her own persona. (2012: 150, 152)

Emphasising Kellerman's aquatic athleticism, Cooke's video performance serves to reinscribe her agency in the scenarios she appeared in, an aspect barely rendered in the stills that remain the primary traces of her lost feature films.[32]

III. The Elusive Anima

One of the most subtle and succinct engagements with the strand of male representations of and preoccupations with the mermaid that can be traced through Lindsay's and Slessor's work and into Randolph's Bondi sculptures was presented in Kaitlin Tinker's short film *The Man who Caught a Mermaid* (2015). Set in a coastal suburb of Melbourne, the film shows a male retiree, named Herb, who is obsessed with young, stereotypically beautiful mermaids and the possibility of being able to interact with them underwater. As a result of his obsession, he regularly tries to catch one, despite the scorn of fellow fishermen. One evening he returns, dragging the catch he appears to have desired and conceals it in a shed. However, unlike his fantasy, it is less human than usual renditions, with a scaled body, gills and sharp teeth (Figure 12). Incapable of conventional speech, the mermaid communicates her displeasure through inhuman noises. Despite this misfit with his expectations he tries to keep her ashore and develop a relationship with her. Suspicious of his activities, his wife sets out to find out what he is up to. When she opens the door to his shed she sees something very different from what the camera has previously shown the audience, namely a terrified young women, chained up, her legs bound together with cling-film in a children's inflatable paddling pool. The film neatly summarises one particular trajectory and imagination of male desire, creating the figure of the mermaid as a fantasy that conforms to patriarchal heterosexist impulses. But the monstrous 'other' the camera shows, however, goes beyond that and is unreachably alien and implacably hostile.

Approaching the mystical creatures that also populated Lindsay's artwork from an early 21st Century perspective, Tinker has identified her design of the creature as stemming from her engagement with hybridised females presented within popular culture:

I was a kid of the Disney generation, so Ariel, the mermaids of Peter Pan, even the female centaurs of Fantasia, all contributed to my inner altar of the mystic feminine. But I think I had an adverse reaction to these cartoonish effigies, it didn't make much sense in my mind that every creature should be so languidly beautiful, particularly when they were an animal hybrid. I identified with the villainesses ... with stories that centred around wild, hybrid women in fantastical settings. (p.c. May 8th 2017)

Reflecting this, she effectively inserted a 'third option' between the imagined stereotypically beautiful mermaid and the traumatised young woman forced into playing that role in her film's scenario. Drawing on Jungian theory and its notion of the anima as the

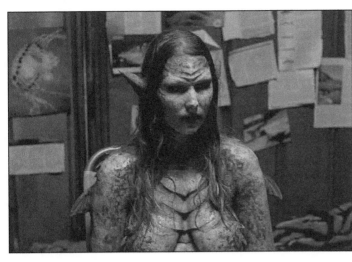

Figure 12 – The monstrous mermaid from Tinker's film *The Man who Caught a Mermaid* (2016).

archetype of the female in a mythic form, she evokes the type of mermaid anima identified by Relke (2007: 31) as a "terrifying" and confrontational figure:

> The story deals explicitly with male projection of anima, and while we, and Herb, perhaps have the expectation of the fantasy to be beautiful, it's more truthfully reflective of the darker aspects of our shadow self to discover a mermaid aligned more closely with the monstrous feminine, than 'divine'. The prominence of her hair and breasts were adapted into the design not only to be inclusive of the actress' body shape and ease SFX development, but to deliberately maintain the element of elusive sexuality so often associated with the mermaid myth. (ibid)

The story ends in a tragedy produced by male desire and fantasies of the unreachable anima. Perceiving the mermaid to be sickening due to her lack of access to salt water, Herb drags her heavily chained body to a pier, tips her into the sea and then dives in to be with her.

IV. Indigenous Engagements

As stated in the introduction, there are a number of aquatic humanoid entities in Aboriginal and Torres Strait Islander ancestral stories. A detailed study of their symbolism and variety is beyond the specific focus of this chapter, but an introduction is necessary in order to contextualise recent Indigenous engagements with the Western form of the mermaid. The Indigenous entities with most obvious similarity to the mermaid are the female water spirits that occur in the ancestral stories of Indigenous groups across northern Australia. One common name for these is *yawkyawk*, a word used in the Kundjeyhmi language of Western Arnhem Land that simply means 'young spirit woman'. There are also sub-types of this. In the Binij Gun-Wok community, for instance, there is a sub-type of *yawkyawk* known as *Ngalberddjenj* ('young girl with a tail like a fish') that is associated with rivers and rock pools (Green 2007: 20). Since the 1980s, *yawkyawk* figures depicted in mermaid-like form[33] have been represented in bark and canvas paintings and in woven pandanus fibre sculptures made by Indigenous artists from the Top End.[34] A number of striking paintings of *yawkyawks*, including ones of them being devoured by Ngalyod, the

189

Figure 13 – Edward Blitner 'Lightning Fisherman, The Mermaid and The Mimi Spirit' (2012).

Rainbow Serpent, were, for instance, produced by artist John Mawurndjul in the 1980s and early 1990s.[35] More recently, Edward Blitner, a member of the Marra/Alawa people from the Roper River region of Northern Territory, has painted a number of representations of what his community traditionally terms *gilijjirring* interacting with other mythological characters. His 2015 painting (Figure 13), for instance, represents the lightning spirit, who lives in a *billabong* (a small oxbow lake) and generates violent tropical storms in the wet season (centre of image), flanked by a net and a *Mimi* spirit[36] (to the left) and a figure (to the right) identified by the painting's title as a mermaid.

Blitner's use of the term 'mermaid' to refer to a figure in a group of Indigenous entities might be regarded as a translation of the local-language term for water-women spirits that is convenient for non-Aboriginal consumers of Indigenous art, but might also be perceived to suggest some degree of infusion of the traditional Marra/Alawa being with the Western figure that the painting's name refers to. Related issues occur in contexts where members of Indigenous communities may have limited familiarity with traditional languages and may use the term 'mermaid' in preference to the original name of aquatic humanoid

entities in their cultures. These and related tendencies can, even by default, be seen as syncretic activities that modernise traditional mythologies, borrowing aspects of Western mermaids (as the term and their images circulate in popular culture) and blending these with traditional mythologies in a manner that helps sustain them. Aspects of such processes are apparent in a project undertaken by the Wugularr (Beswick) community in central Arnhem Land. As part of the 'Sharing Stories' initiative,[37] the community collaborated on a short book, entitled 'The Mermaid and Serpent' (Wugularr Aboriginal Community with Liz Thompson 2010), and produced an associated video, entitled *Mermaid Stories by Wugularr Upper Primary with Sharing Stories* (Wugularr Aboriginal Community with Liz Thompson 2012), that drew on material from the book.[38] Both of the texts show active processes of characterising folkloric figures that shift between Indigenous and European frames of reference in a manner that shows them as active elements of lived belief/folklore rather than ossified legends.

'The Mermaid and Serpent' book weaves together a number of community voices, including those of Jimmy Balkbalk Wesan and Victor Hood, Wugularr community members who are *djungkayi* (guardians) of the stories related. Setting the scene for the book, they refer to the beings in their story as "mermaids" and identify that:

> They look like a human being, like us mob, but they're different. They've got a fish tail … good looking gills, white body, white tail – but if you pull off their tail they've got legs inside. (Wugularr Aboriginal Community with Liz Thompson 2010: 5)

Subsequent pages specify that the community uses two terms to refer to the figures discussed above, the commonly used *yawkyawk* and an alternative one, *ngalworreworre*. The book contains various elements of local beliefs and experiences concerning the aquatic females and representations of the *yawkyawk/ngalworreworre*/mermaids with either bare tops and a variety of coloured tails or else whole-body colour patterns.[39] The book and its accompanying audiovisual text provide particularly vivid examples of lived and negotiated mythological/folkloric beliefs and demonstrate an eschewal of definitive versions in favour of pluralities. In one passage in the book, community project facilitator Tango-Frankie Lane expresses a pessimistic view that, while the "spirits of the mermaids are still at Beswick Falls" they are "fading way a bit now" due to disruptive behaviour in their waterhole, linking this to the manner in which he perceives community culture to also be in decline. While these characterisations may be accurate, the lived nature of the storytelling and engagement with novel terms and visual styles of representation shown in the book and audiovisual text suggest that contemporary versions of oral folklore are actively evolving.[40]

Conclusion

The representations of the mermaid and consequent associations of her with particular places discussed in this chapter underline her polyvalence. Kellerman's work, in particular, represents a significant contribution to national and global media culture both in the early 20th Century, when she enjoyed her decades of fame, and in later years when her representations of mermaids were taken up in other contexts. With regard to Bondi, at least, we can perceive the mermaid to have become a motif in the socio-cultural identity

of place. Whether this is labelled 'postmodern folklore' (Warshaver 1991) or is viewed as the 'downloading' of media-lore into physical spaces, the materialisation of mermaids in local statuary and their subsequent dematerialisation by the elements has laid the ground for subsequent elaborations of meaning and significance. The more recent blendings and interrelations of Indigenous ancestral stories with the Western figure of the mermaid are, similarly, a sign of the latter's polyvalence and her ability to insinuate herself into various contexts. In these regards, Australia has a popular cultural, media-loric and increasingly syncretic history of mermaids that is part of its modern heritage.

Acknowledgements: Thanks to Cheryl Aubrey (Southport Public Library), John MacRitchie (Manly Public Library), Rob Wills (National Library of Australia) and Graeme Seal for various research assistances, to Alison Rahn for facilitating my research on Daydream Island, and to Marea Mitchell and Michael Pickering for their feedback on the earlier drafts of this chapter.

Notes

1. While fish-tailed humans are not an element in Torres Strait traditions, there are stories about humans transforming into dugongs from various islands.

2. This swimsuit was made for her by the community of Broken Hill in appreciation of her appearance there in 1906.

3. This connection was also made in a British newspaper cartoon entitled 'The Mermaid and the Angler' that represented her as tempted to try swimming across the English Channel. See a reproduction of the image at: http://collections.anmm.gov.au/objects/164836 – accessed October 4th 2017.

4. His drawings 'Pollice Verso' (1904) and 'The Crucified Venus' (1912) were deemed particularly scandalous and attracted criticism from the Church and conservative commentators. This aspect of his work and its reception was the inspiration for John Duigan's 1994 film *Sirens*. (NB While the film features a trio of actresses posing as alluring sirens, they are in fully human, rather than fish-tailed, form.)

5. Slessor's best-known poetic work, 'Five Bells', was published in 1939. The poem uses water imagery and markers of time passing to reflect on the finality of death. While there is no mention of mermaids in the poem itself, two appear on the publication's front cover as predatory creatures, with fully human, voluptuous bodies but webbed hands and fins for feet.

6. The statue was based on the appearance of Danish ballerina Ellen Price, who danced the role of the Little Mermaid in a ballet adaptation of the story staged in Copenhagen in 1909.

7. Bowles's statue of a mermaid reclining on a fish, sculpted in 1935, was one of three sandstone works commissioned from him for Melbourne's Fitzroy Gardens, where it remains on display.

8. The sculptor is usually known as Lyall Randolph. His other best-known work was his rendition of the Aboriginal legend of the Three Sisters as a feature fountain at the departure point for Katoomba's Scenic Skyway in the Blue Mountains. Installed in 1966, the sculpture was dismantled in 2004.

9. He also claimed that the rock was under the jurisdiction of the state's Department of Lands and that they had given their approval (Waverley Council nd: online) – although no evidence has ever come to light that such approval was ever sought or given.

10. Indeed, this continues to persist in social if not official place-name contexts. See, for example, the number of recent images of Bondi tagged as Mermaid Rock available online in social media postings on Facebook.

11. A second proposal was made by sculptor Alex Kolozsky in 1997 to create a new sculptural work featuring three mermaids and King Neptune on the rock. Waverley Council declined to support this and directed Kolozsky to discuss his plans with Lizmania; however, nothing eventuated from this (Waverley Council 1997: online).

12. See the short video documenting the application and users entitled 'The Bondi Mermaids at Sculpture By the Sea' online at: https://vimeo.com/65218663 – accessed 3rd May 2017.

13. See, for instance, those reproduced online at: http://www.alamy.com/stock-photo-bondi-beach-graffiti-art-mermaid-30228290.html – accessed May 3rd 2017.

14. Artwork on the wall is managed by Waverley Council with panels being displayed for six-month periods

after which they are replaced by new ones. For details see: http://www.waverley.nsw.gov.au/recreation/arts_and_culture/bondi_beach_sea_wall – accessed May 6th 2017.

15. Further from the seafront, two large panels on the side of the ANZ Bank on Hall Street on display in 2017 showed, respectively, a turquoise-haired mermaid and a triton-like figure with a trident.

16. The video was made and first screened in the month before a postal plebiscite on allowing same sex marriage that attracted polarised responses from various interest groups.

17. There are a number of other Australian place-names that feature mermaids, such as Mermaids Cave in the Blue Mountains and Mermaid Point in Western Australian. These are, however, locations rather than suburbs or tourist attractions.

18. The Mermaid was built in India in 1816. The name was a common one for British naval ships from the mid-1550s on.

19. The same expedition also resulted in the naming of a stretch of the Brisbane River as Mermaid Reach, a name that has not been adopted by subsequent residential developments nor become a motif in the area's promotion.

20. Prior to this an eponymous adaptation of Alice Hoffman's 2001 US novella 'Aquamarine' was shot on the Gold Coast in 2006. Directed by Elizabeth Arden, the Gold Coast stood in for the film's supposed location, Florida (exploiting the lower production costs of films in Australia than in the US). See Hayward (2017a: 133–135) for further discussion.

21. Released internationally as *Mako: Island of Secrets*.

22. See, for instance, Queensland Government (2014: online) and Simonot (2014: online).

23. Fraser also merits mention as a significant contributor to Australian mermaid culture through her work in public performances, photo shoots, and short films and videos in Australia in 1990s and 2000s (see Hayward 2017a: 87 and 139).

24. See, for example, Lyne (2017: online).

25. See Somerset College (2017: online).

26. Originally known as West Molle Island, its initial operators re-named it Daydream Island.

27. My attempts to identify the designer and to discuss the image with them have to date been unsuccessful.

28. A different kind of dislocation occurred in early 2017 when Cyclone Debbie caused high seas that washed away two of the statues and damaged the third (along with causing extensive damage to the resort's buildings and amenities in general). At time of writing (May 2017) the resort's management are looking to re-install mermaid statues on the rock and to retain mermaid branding for the island (Jane Hermann, Director of Sales and Marketing, Daydream Island Resort and Spa, p.c. May 3rd 2017.)

29. See Hayward (2001: 23-24) for further discussion.

30. Video footage of the performance is archived online at: www.youtube.com/watch?v=DK8Pdsa-nTY – accessed May 4th 2017.

31. Cooper had previously performed an improvised soundtrack to a screening of Kellerman's mermaid-themed film *Venus of The South Seas* (James Sullivan, 1924) at Queensland Conservatorium of Music in Brisbane in 2010. See Hayward (2011: online).

32. Mermaid performers appeared in Whitsunday waters again in 1998–1999 when a television film spin-off from the popular US 1990s teen-oriented show *Sabrina: The Teenage Witch* (starring Melissa Joan Hart in the title role) was shot on and around Hamilton Island. Entitled *Sabrina Down Under* (Daniel Berendsen, 1999), it features Sabrina, a teen with supernatural abilities, visiting the Whitsundays, encountering a pod of (mostly young) mermen and mermaids, bringing a young merman onshore for medical treatment and, eventually, rescuing the mer-pod when a scientist learns of their existence and tries to capture them.

33. *Yawkyawks* also manifest in other forms, such as turtles in bark paintings made by Robin Nganjmira in Western Arnhem Land in 1970, see: http://collectionsearch.nma.gov.au/ce/yawkyawk?object=45782 – accessed August 30th 2017.

34. See National Museum of Australia (nd: online) for images of woven pandanus fibre *yawkyawk* sculptures.

35. See Art Gallery of New South Wales (nd: online) for further information on Mawurndjul and images of some of his work.

36. In Arnhem Land ancestral stories, *Mimis* are thin, delicate spirit beings that represent the current form of humans who inhabited the continent before Aboriginal people arrived in Australia.

37. See the Sharing Stories website for further details and examples of the organisation's work, online at: http://sharingstories.org/ – accessed July 25th 2017

38. Currently online at: https://ictv.com.au/video/item/1134 – accessed July 26th 2017.

39. In addition to the Wugularr community book, there have also been children's books written by non-Indigenous authors that have represented Indigenous (or, at least, brown-skinned) mermaids, such as Heather King's 'Mimih: the Mindil Beach Mermaid' (2009) and Ian Coate's 'Aborigine and the Mermaid' (2012).

40. Outside of Arnhem Land, artists from the Pormpuraaw community, located on the mid-west coast of Cape York, have also produced a number of representations of traditional half-human, half-fish figures named *obalows*. Several representations of these have been rendered in manners that are similar to conventional Western mermaid form, and/or have been referred to using the term 'mermaids' in published statements by community members. An earlier draft of this chapter included discussion of these but has been deleted at the request of one of the artists concerned.

Chapter Ten

Mami Wata Remixed: The Mermaid in Contemporary African-American Culture

Nettrice R. Gaskins

Introduction

Female water spirits and deities are a common feature of many cultures. In the West, the best-known form is the mermaid and the most popular example in United States' (US) culture is Disney's *Little Mermaid* (Ron Clements and John Musker, 1989) character, with her European features and flowing red hair. Talking fish, singing lobsters and other mermaids – none of whom are Black – populate Ariel's underwater world. However, there are several other types of aquatic women in circulation. These include ones that have grown in popularity due to singer/performer Beyoncé's *Lemonade* film (Kahlil Joseph and Beyoncé Knowles, 2016) and have been explored in visual artist Romare Bearden's appropriation of the Greek goddess Circe, in multimedia artist/performer Jacolby Satterwhite's virtual 'ghetto diva' and in the electronic music 'wave jumpers' in the mythological underwater universe called Drexciya. These are modern examples of Mami Wata (literally, 'Mother Water') spirits that occur widely in Western and Central Africa and across the territories inhabited by members of the African diaspora. Mami Wata, often portrayed with the head and torso of a woman and the tail of a fish, has origins that lie on the African continent and she has been thoroughly incorporated into a number of local beliefs and practices in the Americas. This chapter explores the manner in which the Mami Wata phenomenon illustrates the invention or reinvention

Figure 1 – Darrell Ann Gane-McCalla 'Mermaid' (courtesy of the artist).

of these feminine deities, as an ongoing process of creating new realities, and explores the presence of Mami Wata.

Mami Wata has been extensively discussed and documented by academics over the last two decades, most notably by the contributors to Drewal's two edited anthologies (2008a and 2008b). As several contributors to the latter elaborate, she brings wealth and good fortune to those she favours. The earliest documented example of an African rendering of a mermaid juxtaposes her with reptiles, and early European travellers reported that Africans associated mermaids with the sea and water spirits (Drewal 1988a: 161). Travelling across the 'Middle Passage', enslaved Africans brought with them their beliefs and practices, including those honouring Mami Wata and other ancestral water deities, such as the Yoruba deity Yemọja. The latter's name is a contraction of the Yoruba words: *Yeye*, meaning 'mother'; *ọmọ*, meaning 'child'; and *ẹja*, meaning 'fish'. Roughly translated, the term means "mother whose children are like fish" (Canson 2017: online). Some people conflate Mami Wata with Yemọja but they are, more accurately, two of many water goddesses. Practices that invoke mermaids and water goddesses, widespread in West Africa and the African Atlantic diaspora, are explored in this chapter, especially with regard to how these visages are used in African American culture. Joseph Caputo writes:

> *Mami Wata is known for her beauty. But she is as seductive as she is dangerous. Those who pay tribute to her know her as a 'capitalist' deity because she can bring good (or bad) fortune in the form of money. This relationship between*

currency and water makes sense. Her persona developed between the 15th and 20th centuries, as Africa became more present in global trade. The fact that the name Mami Wata is in pidgen English, the language used to facilitate this trade, shows the influence on foreign cultures on the spirit's image and identity. (2009: online)

Figure 2 – Wangechi Mutu 'Killing you softly' (2014) (courtesy Victoria Miro, London).

Figure 3 – Doris Prouty 'Mermaid Quilt' (2012) (courtesy City Gallery, Charleston).

Mami Wata thereby represents a fully expressive system that draws inspiration from widely dispersed and diverse sources. Most mermaid versions have a similar physical appearance – half fish and half human (Figure 1) – but the intentions and actions of the African ones are often different than their European counterparts. Mami Wata devotees employ the term 'mermaid' or equivalent terms for mermaids in other languages, such as *sirène* in French and *sirena* in Spanish. In Haiti, she is called La Sirène Diament and she rules the ocean with her husband Met Agwe Tawoyo (Rakotomalala 2013). In Jamaica, she is *riba muma* or the 'river maid', representing a syncretism of the European mermaid and an African water deity (Payne-Jackson and Alleyne 2004: 112). Another embodiment of the mermaid is Oshun (spelled in various ways). Originally a Yoruba water goddess of female sensuality, love and fertility who inhabits the south-western region of Nigeria and the southern part of Benin, she is often depicted wearing yellow and surrounded by fresh water (Murphy and Sanford [eds] 2001). Other related figures include the Kenyan *nguva*, sea mammals whose mythology is often conflated with mermaids (Wainaina and Edwards 2014). Illustrating this, the short video *Nguva* (2014) and associated artworks by US-based Kenyan artist Wangechi Mutu explored the troubling spirit of mermaids and the abyssal mystery of the sea, where sailors are seduced and annihilated (Figure 2).

Beginning in the 16th Century with the arrival of enslaved Africans via the Atlantic slave trade, the traditions, beliefs and practices honouring their ancestral water deities were transplanted into the US. According to Ras Michael Brown (2012), African-descended enslaved people brought with them myriad ideas about nature spirits who champion the oppressed and avenge the enslaved. These South Carolinian 'low-country' sea spirits include a river mermaid as a surrogate mother and a captive mermaid who punishes the living for denying their freedom (ibid: 253). In 2012, an exhibition of fibre arts entitled

'Mermaids and Merwomen in Black Folklore' held at Charleston's City Gallery reflected on the West African traditions that inspired black mermaid folklore and symbolism in the Americas[1] (see Figure 3 for one example of the work exhibited). An accompanying event honouring the ocean goddess Yemaya explicitly reconnected Yoruba traditions, from present-day Nigeria to the Carolina Barrier Islands, in the form of a ceremony and feast.

In their works involving Mami Wata, artists and other practitioners make use of heritage artefacts or create new ones according to their local precepts, investing new meanings in them. They remix, present or perform as mermaids in new and dynamic ways to serve their diverse interests or needs. The Mami Wata, regarded by many devotees as foreign or 'other', came into being as a result of Africans' increasing awareness of European, East Indian or Mediterranean lore and imagery. People across West and Central Africa adapted the concept of the mermaid, whose most characteristic depictions show her emerging from the water combing her long luxurious hair as she gazes at her reflection in a mirror. Practitioners re-create the world of Mami Wata by using cultural information from a variety of sources, such as imported prints, foreign literature, trade goods and more. The mirror is significant as it represents the surface of the water, as well as the boundary between water and land, the present and the future. The mirror can be perceived as a 'virtual window' through which viewers communicate, such as the 'material' frames of computer and television screens, and other devices (Friedberg 2006). The virtual mirror/window creates openings for new representations of Mami Wata in the contemporary world.

In addition to their continually transforming histories of influence in Africa and its diasporas, Mami Wata and other African and African Atlantic water spirits have gained an even wider audience, as well as new meanings and import, by capturing the imaginations of a number of contemporary African American artists. Since 2001, artist Ellen Gallagher has worked on an ongoing series of mixed-media drawings entitled *Watery Ecstatic*. Gallagher's series is related to Drexciya, an origin myth created in 1997 by a Detroit electronic music duo of the same name (see Gaskins 2016). The musicians imagined an underwater world inhabited by the descendants of pregnant West African women forced from slave ships and lost at sea during the Middle Passage to America. Howardena Pindell's 'Autobiography: Water/Ancestors/Middle Passage/Family Ghosts' features a full-body mermaid – rendered as the artist, herself – who is positioned next to the white shape of a prototypical slave ship. Her arms are upraised and she is all but submerged under blue paint. Floating in between are fragments of faces, hands and written material.[2] Pindell and other US-based artists of African descent deploy the mermaid to evoke images of otherworldly creatures that engender identity, sexual liberation and power dynamics.

In considering how African diasporic people have constructed their associations of older African water spirits, such as Mami Wata, Oshun or Yemoja, and European-Atlantic mermaids, we gain insight into the many ways that African-descended people remain connected, and the diverse forms that mermaids take in their collective imaginations. This chapter offers a closer reading of mermaids in contemporary African American arts practices, specifically highlighting the diverse ways in which mermaid worlds are envi-

sioned and performed. The chapter explores heritage artefacts that include tangible culture such as art and crafts, intangible culture such as folklore, traditions and language, natural elements and technology. According to L. Taylor (2014: 350), Mami Wata epitomises the simultaneous fear of and attraction to Western technology. Reflecting this, many contemporary Mami Wata/mermaid images and objects throughout the African-Atlantic are adorned with artefacts of Western technology, including watches, jewellery, mirrors, automobile parts and sunglasses. New technologies have also been integrated into ritualised communications with Mami Wata, including computer screens, video projections, mobile devices and virtual reality.

I. Remixing Mami Wata and the Virtual Mirror

In visual art, textile design and music, artists take portions from one source and reuse it to create something new. One way to do this is through collage, assemblage or upcycling (i.e. the reuse of discarded objects or materials in such a way as to create a product of a different value to the original). Another is through sampling or taking a discreet unit of information (i.e., a sound, shape or motif) and re-creating or reproducing it in different ways. Rearranging and remixing artefacts facilitates the process of re-imagining heritage, allowing artists to mix or remix their own versions of culture. According to Alexander Weheliye, the "mix" provides us with a "model of modern black temporality and cultural practice" (2005: 73) that is rooted in sonic production but also extends to the visual image. Using remixing, Mami Wata and other water goddesses become embedded in tangible and intangible African diasporic artefacts. The mermaid's visage has been adopted from older cultures, as well as the items she carries, such as mirrors, combs and watches. A large snake representing divinity frequently accompanies Mami Wata, wrapping itself around her neck or arms. Traditions on both sides of the Atlantic Ocean tell of the spirit abducting her followers, bringing them down into her underwater or spiritual worlds.

The use of a mirror in mermaid art is also worth noting. Mermaids are often drawn with or portrayed as holding mirrors. According to Hayward (2017a: 14), the image of the mermaid looking at her reflection not only symbolises vanity, it also frames her humanity. In this chapter, the mirror is also envisaged as a virtual window or screen. As we spend more and more of our time looking at the screens of movies, televisions, computers and handheld devices – 'windows' full of moving images, texts and icons – how the different worlds or realities are framed is becoming as important as what is in the frame. The following examples show contemporary representations of mermaids in contemporary art through mobile devices, video projection screens and computer monitors. The mirror as a virtual window is a metaphor, or an opening to the dematerialised reality we see on screens. It is the virtual window that serves as an evolving method for viewing and interacting (rearranging and remixing) with Mami Wata. In this screen multiple mirrors or windows can coexist and overlap.

Several African-Atlantic artists and performers have sampled or taken artefacts from this domain, including collage painter Romare Bearden. The video *Romare Bearden: A Black Odyssey* (uncredited, 2013)[3] presents the artist's 1977 series of 20 collages based on episodes from Homer's epic tale 'The Odyssey'. Like DJs or jazz musicians who sample from and combine existing melodies, beats and rhythms to create something new, Bearden 'riffed'

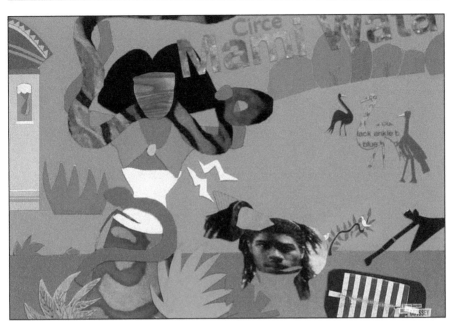

Figure 4 – Romare Bearden, collage from 'Black Odyssey Remixes' (courtesy of the author).

on the *Odyssey* and made it his own. All of the characters in his collages are African American. In 'Circe Turns a Companion of Odysseus into a Swine', Bearden replaced the witch-goddess Circe with the black mermaid Mami Wata. The virtual-window-as-mirror concept applies here, with the Smithsonian's *Romare Bearden Black Odyssey Remixes* mobile application or 'app' that allows users to create digital collages using Bearden's artwork. Users sample and remix Bearden's backgrounds and motifs, importing their own photos and use music or import their own sounds (Figure 4).

Wangechi Mutu's 2014 exhibition 'Nguva na Nyoka (Sirens and Serpents)', presented 13 collage paintings, a video and an undulating black vinyl mermaid sculpture. Mutu drew on such diverse references as East-African coastal mythologies of *nguvas*, gender and racial politics, Western popular culture, Eastern and ancient beliefs and autobiography. In her show Mutu created worlds within worlds, populated by warrior women, hybridised and symbolic mermaids. Although *nguvas* are not considered to be spirits (Wainaina and Edwards 2014: 9) Mami Wata inspired these characters and the exhibition continues the tradition of artists evoking the mermaid as the ultimate outcome of merging mythologies and realities. Mutu's artworks and performances incorporate diverse influences into transcultural art and ritual performances. Mutu expands on the material culture of Mami Wata in her collages by her use of tea, batik fabrics, synthetic hair, Kenyan soil, feathers and sand, amongst other media – many of which are imbued with their own cultural significations – and her video, entitled *Nguva* (2014,[4] features a mermaid who emerges from the sea onto land.

In the art world, the virtual window represents water and communications with Mami

Figure 5 – Salome Asega and Ayodamola Okunseinde, 'Artifact_012', *Iyapo Repository* (2016)
(photo: Kearra Amaya Gopee).

Wata. Because of outside influences, Mami Wata takes on new forms, from display and installation to virtual reality. The 2016 Aqualumina exhibit gathered artists, such as artist/illustrator Caitlin Ono, who digitised and layered traditional Mami Wata imagery then changed the colours and textures. Ono used ink, paint pens and coloured pencils to add artefacts to the work. MAMI, a 2016 group exhibition at New York's Knockdown Center, featured works by five woman-identified artists – Salome Asega, Nona Faustine, Doreen Garner, Aya Rodriguez-Izumi and Rodan Tekle – who related to Mami Wata in different, sometimes opposing, ways. The show included art such as a virtual reality bodysuit that recreates the sensation of being immersed in water and a new media installation that uses immersive technology to tackle online representation.

As a manifestation of centuries-old African religious traditions retooled for contemporary times, Mami Wata is the embodiment of multiplicity and hybridity as explored by Brooklyn-based artist Salome Asega, who researched the Orisha mounting (spirit) tradition, comparing this process to virtual reality. Orisha mounting comes from Santeria, an African American religion of Caribbean origin that developed in the Spanish Empire among West African descendants. The mounting activity of an Orisha refers to the medium's role as a "horse", whose performance is directed by an orisha/spirit rider (Murphy, 1993: 137). For MAMI, Asega presented a film and artefacts that explored the embodiment of Mami Wata (Figure 5). By contrast, Doreen Garner abandoned the oceanic iconography heavily associated with Mami Wata and instead offered sacrificial-like sculptures and installation. In *NEO(plasm)* she presented a collection of artefacts such as pearls, glitter, beads, Swarovski crystals, hair, condoms and petroleum jelly to investigate materialism and the sexuality within Mami Wata (Hernandez 2016: online).

Drewal notes that Mami Wata practitioners write notes to their spirit and receive messages in the same form (1988: 181). Writing and other forms of communication have become

part of the ritual act of performing Mami Wata. The blending of the old and new reflects the growing influence of the West as well as the new questions that emerge regarding technology's influence on traditional, non-Western cultures. This influence can be seen in projects such as Asega and Okunseinde's *Iyapo Repository* (established in 2016), a museum designed to mine a collection of digital and physical artefacts that affirm and project the futures of people of African descent. According to the artists, the artefacts address current concerns and forward-thinking possibilities of the black community (Sargent 2016: online). Artefacts created from crowd-sourced manuscripts rely heavily on technology and present a myriad of representations of what African-Atlantic culture could come to mean in both the near and the distant future.

Bearden Black Odyssey Remixes, NEO(plasm) and *Artifact:012* (all 2016) explore Mami Wata as a technology, using dynamic interfaces between the physical and virtual worlds. The artists are engaged in the process of invention and the creation of meaning that is at work when visual and written data are combined with the experience of 'otherness'. Mami Wata cannot be grasped singularly – even with the terms that describe the figure. Using modes of production, such as remixing or sampling, artists become part of an ongoing process of creating reality while re-creating representations of identity. The concept of the remix is a way to describe and demonstrate the evolving development of practices and performances that involve Mami Wata. Artists invent new ways of remixing by re-symbolising heritage artefacts and exploring technology. In addition to the ever-evolving concept of the virtual mirror in Mami Wata practice is the use of water (i.e., colour, texture, movement) and the connection to mermaid-like Orishas, such as Oshun, that are celebrated in the Yoruba tradition.

II. Oshun's Daughter: Beyoncé's *Lemonade* and the Moving Image

I'm always happy when I'm surrounded by water ... I think I'm a mermaid or I was a mermaid. The ocean makes me feel really small, and it puts my whole life into perspective ... It humbles you and it grounds you and it makes me feel almost like I've been baptised. (Beyoncé: Year of 4 documentary, 2011)

Oshun is a deity of the river, luxury and pleasure, sexuality and fertility, and beauty and love. She is one of many Orishas celebrated in the Yoruba tradition, which originated from West Africa, and African diasporic spiritual practices that survived the trans-Atlantic slave trade. She is often shown in gold/deep yellow, surrounded by fresh water and marine life. As a goddess of love, Oshun is often depicted as a mermaid, with a beautiful tail of a fish. She is also a goddess with great vanity and is often seen adorned with gold jewellery, mirrors, elaborate fans, brass bracelets and pottery filled with water. These artefacts and themes entered popular culture through *Lemonade*, a 2016 album by Beyoncé that was accompanied by a 60-minute film of the same name. In the 'Hold Up' video, Beyoncé appears as Oshun, wearing a flowing yellow Roberto Cavalli dress, gold jewellery and bare feet. While she does not appear as a mermaid in the video, she channels the Orisha by appearing in a dreamlike state underwater before emerging from two large golden doors with water rushing past her and down the stairs.

As Roberts and Downes (2016: online) have contended, *Lemonade* is grounded in African

tradition, spreading from Cuba to Louisiana, connecting women of the African Diaspora together. Through popular music and film, Beyoncé calls upon Oshun to reach women from across cultures. Folktales of Oshun describe her malevolent temper and sinister smile when she has been wronged. During the latter half of 'Hold Up', a smiling, laughing and dancing Beyoncé smashes store windows, cars and cameras with a baseball bat, representing Oshun's furious temper in a modern context. In the 'Love Drought' video sequence Beyoncé calls upon Yemoja and channels Julie Dash's 1991 film *Daughters of the Dust*, which is a meditation on black life, the passage of time and the search for home. A procession of African American women walks towards the ocean, raising their arms and holding hands to call upon Yemoja. The setting references the Igbo Landing at Dunbar Creek on St. Simons Island, Glynn County, Georgia, which is central to *Daughters of the Dust* and how the story chronicles an act of mass resistance amongst enslaved Igbos.

With *Lemonade*, Beyoncé reached out to African American women in need of positive reinforcement, deep healing and transformation. Her deepening involvement with West African religion, as seen in her films and videos, serves as an alternative model of womanhood that, according to Valdes (2014: 2), differs from those found in dominant Western culture. Beyoncé portrays herself as a warrior woman who, on one hand, resists conformity to one-dimensional stereotypes of womanhood and who, on the other hand, displays her vulnerability and emotional pain. Throughout the film we see the body art of Nigerian-bred, Brooklyn-based artist Laolu Senbanjo, which derives from a spiritual ritual in worship of Orishas, the gods in Yoruba religion. The painting we see by Senbanjo in *Lemonade* is called the *Sacred Art of the Ori*, showing white heritage symbols that are applied as "ancestral skin" on the body of the wearer (Klein 2016: online). The practice of creating and wearing a different 'skin' that is symbolic of a style or character stretches across West Africa to the Louisiana Bayou and the Caribbean. Imaginative and innovative uses of abstract patterns or depictions of figures such as Mami Wata are evident in traditional and contemporary art and crafts, including textiles and body painting.[5]

In addition to exploring the aesthetics and adornment of *Lemonade*, we can look at ways to interact with the film through its virtual window or screen. *Lemonade* is a cinematographic montage, with select artists and filmmakers remixing and sampling fragments from diverse sources and investing them with new meanings. Oshun imagery is reshaped and re-symbolised, and re-represented in order to transmit images that hold out hope of wealth and wellbeing, even as the apparatuses for viewing them are still controlled by external social, economic and political forces. Through the screen, various phenomena are presented in diverse dimensions from different points of view. Through collaboration with other artists and performers, the materiality of Oshun is changed by the shifting temporality of the film. The image of Oshun comes to life as Beyoncé enters the first scene, and the flowing water that emerges from the doors symbolises the way in which the deity functions in the lives of her followers.

III. The Virtual Avatar and the Mermaid as a Ghetto Diva

Historically, one of the main portrayals of Mami Wata has been with a woman's head and torso and with a fish as hindquarters. This characterisation was the result of Western

Figure 6 – Rodan Tekle 'Data + Feels' (screen grab) (courtesy the artist).

images that made their way to West Africa and, because of trade routes, circulated to the Americas. Under the colonialist gaze of the West, the predominant depiction of the mermaid was the epitome of the exoticised other. One of the most recent versions of the mermaid is the virtual, three-dimensional avatar. An avatar is a graphical representation of an online user or the user's alter ego. Avatars often take three-dimensional form in games or virtual worlds, or they are fantastic representations of a person's virtual self. Such representations facilitate the exploration of the virtual universe, taking viewers through appearances arising from the creator's imagination. Virtual avatar (body) painting can be used to channel Oshun, the goddess of beauty and adornment. Users can create or use 'skins' to change or enhance the appearance of their avatars. This creative process is similar to the Asega/Okunseinde body suit in the *Artifact_012* installation at MAMI and Senbanjo's *Sacred Art of the Ori* body painting in *Lemonade*.

The *Artifact:012* figure has a series of tubes that pump water from the Atlantic Ocean around its arms and legs. The suit features motors at the shoulders, elbows, knees and ankles that are synced to vibrate to the Atlantic Ocean's tidal patterns. These elements replace the traditional adornments of Mami Wata such as coiled snakes, mirrors and combs. Artists Rodan Tekle and Jacolby Satterwhite explore this imagery in the virtual realm. Tekle is a digital artist, animator, video editor and art director living and working in NYC via Sweden and Eritrea. Her work examines the screen environment within the African diaspora through motion and graphic design, 3D rendering, and game-engine-based design. (Figure 6). Satterwhite uses video, performance, 3D animation, fibres, drawing and printmaking to explore themes of memory, desire, personal and public mythology. Whereas a human actor can wear the Asega/Okunseinde mermaid suit, the actors in the Tekle and Satterwhite projects largely exist as virtual avatars, with Satterwhite directly interacting with the virtual environment and avatars in his work.

In her video *TFW Your Data* (2016), Rodan Tekle layered the content of her YouTube,

Figure 7 – Rodan Tekle 'TFW Your Data' (2016) (photo: Kearra Amaya Gopee).

Twitter, SoundCloud, Snapchat, Dropbox and Facebook accounts into a remixed self-portrait. Tekle staged this work as a "whirling eddy of data – a frenetic presence amid the internet's oceanic expanse" (Harakawa 2016: online) (Figure 7). In *Reifying Desire 6*, a video installation presented at the 2014 Whitney Biennial, Jacolby Satterwhite explores the narratives of his queerness in a surreal universe, mixing 3-D animation, digital drawings, and footage of himself performing in a spandex bodysuit and sculpted headpiece: "I wanted a gestation-cycle video where I get impregnated and give birth to a new language system," Satterwhite says; "All these elements create a friction, a thunderstorm" (Sauvalle 2014: online). In both examples, water is replaced with an ocean of data, bits and bytes. Their virtual works challenge the universalised archetype of the mermaid and demonstrate how African culture and belief systems have the capacity to respond to, shape and to incorporate virtual or digital elements, building on existing concepts and practices.

Yemoja, who is the mother of all Orishas including Oshun, is motherly, strongly protective and cares deeply for all her children, comforting them and cleansing them of pain and sorrow. The physical and virtual figures in Satterwhite's work channel Yemoja. In *Reifying Desire 6* and *Island of Treasure* (2016), maternity acts as an inspiration for much of the content. In Satterwhite's virtual realm, 3D-animated characters act out scenes of desire, or love without using dialogue. Satterwhite simulates and animates consumer products such as mirrors, cake or meat slicers, an egg scooper, apple pie table or travelling luggage. These artefacts come to life in new ways and populate the virtual world. The 3D avatars in this work battle with these objects and interact with each other in a sexual manner. A filmed performance of Satterwhite was overlaid onto a 3D model of a floating uterus on a beach:

> *Ordinary utilitarian objects become queered and repurposed in pursuit of defining a new utopian and non-political space for me to perform in. The result is an overlap of visual trajectories between my mother and I. Her private domestic documentations/inventions, and my public reactions to pop culture,*

Figure 8 – Jacolby Satterwhite 'Ghetto Diva' (screen grab) (2006) (courtesy of the artist).

art history, and political histories. A distorted simulacrum of reality. (Dreimann 2013: online)

Themes such as sexuality and maternity cross over from African belief systems to engage the material reality of technology in contemporary culture. Works such as *TFW Your Data* and *Reifying Desire 6* do not necessarily produce heritage artefacts but they show us how virtual reality can play a role in ritual-type performances. Embedded in their worlds are objects of desire and consumer culture. As with Mami Wata shrines, these virtual spaces reflect the mirroring of creative interpretation, with artists sampling, simulating and remixing objects from their experiences. Instead of traditional deities, such as Yemaya and Oshun, we see virtual goddesses that artists create to represent new, often hybrid realities. An imaginary environment populated with objects surrounds Satterwhite's vision of the mermaid as a 'ghetto diva', named here as such because of the way the avatar's parts are labelled in Unity3D, the software he uses to build the high-quality 3D worlds he creates (Figure 8). Satterwhite copies and repeats certain elements of his diva's dress that flow outward like droplets of water.

Technology allows artists to create virtual worlds of Mami Wata by creating avatars and skins, simulating objects, copying and remixing data from physical reality, or depicting

things that no longer have an original. Mami Water is 'other', a foreigner who provides alternatives to established or traditional cultural avenues. Her otherness and her independence together legitimise novel modes of action. Virtual 3D avatars represent African American artists' attempts at understanding or constructing meaning from their encounters with otherness. This representation resonates with the idea of Mami Wata as a foreigner or other. As a foreigner, Mami Wata provides alternatives to established cultural avenues. Her otherness and her independence together legitimise new modes of action. As the virtual mirrors that serve as boundaries between worlds or realities become more mobile, we can consider how past and present representations of mermaid culture merge into transcultural phenomena of remarkable proportions.

Conclusion

Mami Wata is a complex system with many resonances that feed the imagination, generating, rather than limiting, meanings and significances. Her presence draws inspiration from widely dispersed and diverse sources, from paintings, sculptures and installations, to live and recorded performances and virtual avatars. She comes in many forms: she is Oshun, the goddess of rivers and beauty; Yemoja, the mermaid goddess of creativity; and she is any number of old and new incarnations that rule over the oceans and waterways. Mami Wata is a hybrid being that mediates between the physical and virtual, the past, present and future. She represents the syncretism between European and Mediterranean cultures and African-Atlantic belief systems that artists and practitioners use to forge a uniquely African faith. In general, her devotees' works provide alternatives to established cultural avenues. Her otherness and her independence together legitimise new modes of production, such as sampling, remixing and assemblage. Processes of cultural production in popular art are shaped by technological invention and experimentation. Artists use Mami Wata and related mermaid images as inspiration for works that engage new technologies. Artists create, or maintain ritual acts, that shape cultural practices by collecting artefacts, combining fragments from diverse cultures and investing these artworks with meanings that re-create sacred symbols and performances. Dynamic systems of representation arise in continuing ritual and performance traditions, as these works suggest. Technologies, including Mami Wata and virtual reality, simulate progress, wealth and mastery. Imaginative and innovative uses of materials and software are even more evident in the creation of virtual avatars. Artistic syncretism is a complex and continuous process in which external influences constitute a subtle overlay on indigenous art forms. This process is evident in the images of technology that appear in continuing African and the African-Atlantic artistic traditions and/or postmodern art forms.

Notes

1. The call for submissions is online at http://citygalleryatwaterfrontpark.com/galleryexhibitions/previous-exhibitions/mermaids-and-merwomen-in-black-folklore-call-for-entry – accessed August 21st 2017.

2. See Raynor (1989) for further discussion.

3. Online at: https://www.youtube.com/watch?v=j-0ZbWUaD-4 – accessed August 17th 2017.

4. Available online at: https://www.nowness.com/story/wangechi-mutu-new-siren – accessed August 17th 2017.

5. See Grosz-Ngaté, Hanson and O'Meara (2014: online) for further discussion.

Chapter Eleven

Shoreline Revels: Perversity, Polyvalence and Exhibitionism at Coney Island's Mermaid Parade

Philip Hayward and Lisa Milner

Coney Island is a carnival, and, as at any carnival, the Lord of Misrule runs away with all of us, even the pure and the good. Everything is on edge or turned upside down; everything is unsettled. (Baker 2015: xv)

Introduction

Coney Island owes its existence to the sprawling metropolis to its north. At the time of the initial Dutch settlement of Manhattan Island in the 1600s, the area now known as Coney Island was a small group of sand islands whose shapes and divisions shifted under the influence of currents and weather events. Despite its name, the area is (now) an inverted T-shaped peninsula located at the southern edge of Brooklyn on the east side of New York's Lower Bay. The peninsula is the result of several centuries of landscape modification. The first phase involved the transformation of a small group of barrier islands into a single island in the 1700s, as a result of European settlers filling in inlets between the islands. The resultant entity was initially a sparsely inhabited agricultural area until 1829, when a bridge was constructed from the mainland and the

first hotels were established. The bridge, scheduled steamboat services from Manhattan and then the opening of a rail line from central Brooklyn facilitated a major boom in tourism from the mid-1840s onwards. By the 1860s, tens of thousands of tourists visited daily during the summer season, flocking to entertainment facilities clustered around the island's oceanfront. The island's first tourist attraction was a sea lion park that opened in 1895. More major attractions followed. Steeplechase Park opened in 1897. Luna Park, a highly elaborate complex that was constructed at a cost of around US$700,000, followed in 1903 and the similarly elaborate Dreamland opened in 1904 (before being destroyed by fire in 1911). As a result, local land values rose and in the 1920s and 1930s several stretches of the saltwater creek that continued to separate the island from the mainland were filled in, giving Coney Island the basis of the twin-pronged peninsular form it has retained to the present.

In addition to its amusement parks, an annual Mardi Gras Parade, that ran from 1903 to 1954, featuring floats and paraders in various elaborate costumes,[1] regularly attracted large crowds. While the event's unabashed populism had its critics,[2] and while the area became renowned for street crime, gang activities and prostitution, these aspects did not appear to deter visitors to any appreciable extent. From the mid-1890s on, entrepreneurs Barnum and Bailey organised a series of water carnivals on the island's south shore that combined swimming events, various forms of gymnastics and side-shows. Figure 1 reproduces the promotional poster for one such event (c1905), which represents a chaotic carnival that was somewhat at odds with contemporary accounts of actual activities. One aspect of the poster that is noteworthy is the representation of women (such as the green-clad diver at top right). Women's public and competitive swimming began to develop in the United States (US) in the 1870s and gained momentum towards the end of the century but remained controversial. The daring nature of female participation in events such as Coney Island's water carnivals is apparent in surviving photos from the period – with men shown removing cloaks from female participants immediately before the start of races, so as to preserve their modesty in the face of rows of male spectators (see, for instance, Bier 2001: 77). Women's public and competitive swimming rose in popularity in the next decade, boosted by interest in the high-profile career of professional swimmer, aquatic performer and actress Annette Kellerman. Kellerman was notable for both trailblazing practical one-piece swimwear for women and also for promoting the mermaid as a symbol of aquatically empowered femininity in her various cabaret and film performances.[3] Blurring the line between wholesome aquatic pursuits and the provocative nature of burlesque performance, Kellerman pushed the boundaries of acceptable appearance in public places. Despite her arrest in 1908 for indecent exposure, her swimming prowess and choice of attire were picked up on by women around New York and women's swimming races increased in number and popularity. Official concern about women's attire and behaviour in these pursuits resulted in sporadic police action at locations such as Coney Island in the 1910s and 1920s, including the arrest of women for wearing tight one-piece suits without skirts. Belatedly and ineffectually, an official ban on "swimming suits of the Annette Kellerman type" was declared on Coney Island in 1930 (Unattributed 1930: 28) but seemed to have had little impact.

While visitors continued to flock to the island during the Depression years, their decreased

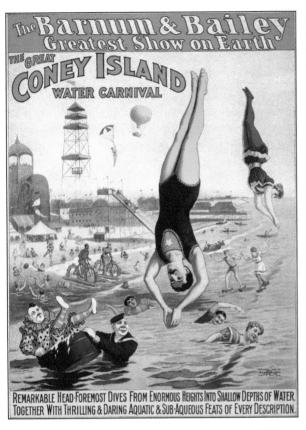

REMARKABLE HEAD-FOREMOST DIVES FROM ENORMOUS HEIGHTS INTO SHALLOW DEPTHS OF WATER, TOGETHER WITH THRILLING & DARING AQUATIC & SUB-AQUEOUS FEATS OF EVERY DESCRIPTION.

Figure 1 – Poster for Water Carnival at Coney Island (c1905).

spending power led the tourism industry into a continuing pattern of decline. Luna Park shut down in 1945, and while Steeplechase Park managed to struggle along until 1964, its closure effectively signalled the end of the grand era of Coney Island's mass entertainment culture. The 1970s were a particularly bleak period for the local community and local businesses, with street gangs such as Crazy Homicides Inc. operating in the area. Reflecting this situation, the island was memorably represented in two films. The documentary feature *Lefty: Erinnerung an einen Toten in Brooklyn* (1978), directed by Jens-Uwe Scheffer, depicts the seafront and backstreets of the area, and of Brooklyn more generally, and profiles the activities and lifestyles of the Homicides and other gangs within a context of inner-city decay. Tackling similar themes, Walter Hill's feature film *The Warriors* (1979), shows a fictional local gang (inspired by the Homicides) trying to return to home and safety after other gangs turn on them in the Bronx. When they return to the island one member declares, "when we see the sea we figure we're home." The film ends with the gang peacefully walking along the beach as the sun rises, suggesting the shoreline as offering some way out of the violent urban milieu depicted throughout the film.

The 1970s were also marked by disputes about the future of the peninsula and consequent delays about developing alternative industries and residential areas. At the same time – and despite local law and order issues – low rental costs for both accommodation and studio/performance spaces (particularly in contrast to those of Manhattan) led to the development of a local arts community that was happy to embrace the area's long history of amusement arcades, side-shows, performance venues and general bohemianism and licentiousness.[4] A growing body of interest in this nexus led to the establishment of the not-for-profit community arts organisation Coney Island USA (henceforth CIUSA) in 1980. The organisation's website identifies that it:

exists to defend the honor of American popular culture through innovative exhibitions and performances. Presenting and producing exciting new works, our approach is rooted in mass culture and the traditions of P.T. Barnum, dime museums, burlesque, circus sideshows, vaudeville, and Coney Island itself. Preserving and championing a set of uniquely American visual and performing art forms, we seek to create an international forum for cultural preservation and discourse, and where Coney Island represents these impulses, we strive to make it once again a center for live art and entrepreneurial spirit. (Coney Island USA nd: online)

CIUSA has sustained itself for close to four decades by dedicating itself to the traditional cultural pursuits identified above within a consciously counter-cultural and inclusivist context that has been guided by its co-founder and continuing artistic director, Dick Zigun.[5] Attracted by the area's cultural history and the then low rents, Zigun relocated to Coney Island in 1979 and began work on projects that led to the formation of CIUSA. The main activities the organisation supports include a museum of popular culture, an annual film festival, a Circus Sideshow and the area's most famous event, its annual Mermaid Parade. As the following sections document, the parade has developed as a community event with strong local roots (and city- and state-wide participation) that connects diverse communities through a costume carnival that pushes various boundaries of taste and identity.

I. Parade History

The first Mermaid Parade was organised by CIUSA in 1983 after it was denied permission to hold a Fourth of July event (due to the island's regular congestion with revellers on the nation's national holiday). Switching the intended date to the Summer solstice, in mid-June, Zigun chose a theme that might have been better entitled the Mermaid *and Neptune* Parade since it drew on local and regional expressions of the two figures. In terms of local inspiration, Coney Island had its Mermaid and Neptune avenues, featured mermaid and Neptune imagery in 1920s' buildings (such as Stauch's and Washington Baths[6] and Childs' Restaurant) and had a history of mermaid motifs in attractions in its amusement parks.[7] The other main influence was the Inter-City Beauty Contest first held in Atlantic City 1921, in which young women competed for the title of 'Golden Mermaid'. The winner appeared in ceremonial garb that included a triton like headdress and pearls and, in the early years at least, appeared in publicity shots with a patriarchal Neptune character holding a trident (Figure 2).

Drawing on the aforementioned traditions (and their pre-existent symbolism), Zigun identifies that the parade was founded with three goals:

it brings mythology to life for local residents who live on streets named Mermaid and Neptune; it creates self-esteem in a district that is often disregarded as "entertainment"; and it lets artistic New Yorkers find self-expression in public. (ibid: online)

Identifying the event as "the largest art parade in the nation", he describes it as:

A celebration of ancient mythology and honky-tonk rituals of the seaside [that] *showcases over 1,500 creative individuals from all over the five boroughs, opening the summer with incredible art, entrepreneurial spirit and community*

Figure 2 – Unidentified male in Neptune costume and Margaret Gorman, winner of the inaugural Golden Mermaid Award, at Atlantic City (1921) (Wikimedia Commons).

pride. The parade highlights Coney Island Pageantry based on a century of many Coney parades, celebrates the artistic vision of the masses, and ensures that the summer season is a success by bringing hundreds of thousands of people to the amusement area in a single day. (ibid)

He also emphasises that:

Unlike most parades, this one has no ethnic, religious, or commercial aims. It's a major New York holiday invented by artists! An American version of the summer-solstice celebration, it takes pride of place with West African Water Festivals and Ancient Greek and Roman street theater. It features participants dressed in hand-made costumes based on themes and categories set by us. This creates an artistic framework on which artists can improvise, resulting in the flourishing of frivolity, dedication, pride, and personal vision that has become how New York celebrates summer. (ibid)

Zigun has also acknowledged the transformative potential of the event. Interviewed by Robert Lyons for his 2011 documentary *Mermaid*, Zigun said:

If you want to experience transformed reality, people dancing in the streets, fantasy literally come to life, for one day a year, that is the day that Coney Island, where mermaids literally emerge from the ocean, and take to the streets, and take over the neighbourhood in such numbers that they're everywhere you look. You can't miss 'em.[8]

The parade has become established as an event that takes place on a Saturday in mid-June, starting on and moving along Surf Avenue, one block back from the seafront, before

turning south and winding up along the boardwalk. The event begins in early afternoon, around 1pm, and ends up around 4pm, with revellers remaining in the streets, on the boardwalk and in bars, cafes and clubs late into the night. Paraders are required to register, paying a small fee ($35 per adult marcher in 2017) and with higher fees for participants appearing on motorised floats, open top buses etc. Reflecting the uninhibited nature of many paraders' appearances and demeanours, there are now separate assembly areas for families with children and for adults who are preparing to march in very little clothing. Crowd numbers range from between 400,000 and 800,000 people – dependent on weather and other factors (I. Pereira 2017: online) – and include both costumed attendees (both human and animal[9]) and more conventionally attired individuals. Since its inception, the Parade has featured well-known local artists and/or community figures in ceremonial roles as Queen Mermaid and King Neptune. In its opening year, actress and new wave singer Alison Gordy and local winter swimming organiser Al Mottola took the roles, with increasingly well-known individuals coming onboard as numbers of participants and spectators swelled. Musical celebrities have often participated, with David Byrne appearing as King Neptune in 1998, Lou Reed and Laurie Anderson playing the royal couple in 2010 and Debbie Harry and Chris Stein appearing in 2017.[10] A review of the first parade emphasised that:

> It was the human scale and spirit of local boosterism that made the first Mermaid Parade special ... While the parade's mermaid theme commemorated Coney Island's faded glory, its heterogeneity paid tribute to the many people who still live and work there. (Cummings 1986: 90)

Karen Kramer's short 1990 film, *Coney Island Mermaid*, featuring interview material and footage of the second parade, in 1984, corroborates Cummings' review through documenting a lively and enthusiastic parade conducted in front of a small group of spectators in which the paraders' parading and their interaction with other paraders appear to be the primary activities (rather than putting on a spectacle for mass audiences, many of which, in recent years, have seemingly been attracted to it by its photo- and video-geneity). Interviews with participants reveal a blend of folkloric and popular cultural elements. While one glamorously dressed Caucasian parader announces that, "I'm a kind of glitzy mermaid, like Las Vegas," another, African American parader attempts to locate the event with an international context:

> Every culture does have a mermaid, and different deities. They're all mer-persons. Every culture has one, which leads me to believe they actually do exist. They're just few and far between these days. When you find one, hold on to it for good life.

The first Parade was promoted with a poster showing a mermaid with a fully piscine tail and unclad upper body. Variations of this image have largely been used through to the present.[11] One particularly notable design by Jamie Colville in 2008 combined a stylised mermaid reclining on the American national flag together with small versions of P.T. Barnum's famous Feejee Mermaid from the mid-1800s[12] (a replica of which is featured in the local Sideshow exhibition) in the top corners. But despite the Parade's standard visual motif, its central theme has been interpreted and enacted in a variety of ways by participants. It is significant in this regard that the parade started one year *before* the release of the Hollywood film *Splash* (Ron Howard, 1984), which re-popularised the mermaid in

Western popular culture, and six years before the release of Disney's *The Little Mermaid* (Ron Clements and John Musker, 1989), which prompted a stream of mermaid-themed films, television programs, fan art, cosplay and aficionado culture (see Hayward 2017a). As subsequent sections address, the Parade has been a significant incubator of, and stage for, a variety of re-imaginations and reconfigurations of the standard mermaid.

II. Sexuality, Exhibitionism, Display

There are a number of paradoxes within the Mermaid Parade that are suspended through the enthusiastic and inclusive nature of paraders' and spectators' participation. One set of paradoxes involves the nature of sexuality manifest at the event in terms of the range of identifications and potential pleasures available to participants. Reflecting on the nature of the parade in the late 1990s and her research with participants, Essig (2005) produced a reflective essay that combines astute and insightful analyses with characterisations that are increasingly ill-fitted for the nature of the event in subsequent years. Drawing on interviews and observations conducted in 2000, she identified female participants' "narcissistic kicks" at exposing themselves to the male gaze within this context (ibid: 159). With specific regard to the mermaid imagery which manifests in various forms at the parade, Essig provides a convincing account of the manner in which the parade encourages and enables a general "freakishness" (ibid: 161) and, through that, manages to make somewhat unattainably beautiful figures – such as *Splash's* Madison-the-mermaid and Disney's Ariel – accessible to participants and audiences. This perspective draws on Coney Island's history of "freak"/side-show attractions. While Essig specifies the pleasures of exhibitionism within the parade as having a "freakish" aspect she also identifies that "if the Mermaid Parade is about the celebration of freakishness, it is a freakishness firmly rooted in the normalcy of heterosexuality" (ibid) and, further, that it addresses a very specific demographic, in that paraders and spectators:

> can get caught in the act of being naughty, but it is a naughtiness that is rooted in their "normalcy" and "legitimacy" as middle-class, White, and most importantly, heterosexual members of American culture. (ibid: 161)

Since the 1990s female revellers have frequently worn minimal clothing, exposing their bodies, variously painted, draped, taped or obscured by other means to parade audiences (Figure 4). Such affronts to conventional standards of modesty did not escape the notice of authorities, with one notable incident occurring in 2001. When artist's model Amy Gunderson turned up to join the parade naked, apart from a thong and band aids across her nipples and covered in body paint, she was stopped by police, made to put a t-shirt on and was issued with a summons to appear in court on a charge of "exposure of a person". After two years of dispute, the City of New York agreed to settle a lawsuit bought by Gunderson for wrongful arrest, awarding her $10,000 in damages. Civil rights advocate Ronald Kuby led the legal case, which was based on the assertion that the parade was a form of public theatrical performance within which nudity was "an integral part" (Lueck 2013: online). News coverage predominantly supported Gunderson's case, in one instance identifying that "Arresting a naked mermaid at the mermaid parade is like arresting a fish for swimming" (Luewck 2003: online). Despite the arrests and controversy, the Parade

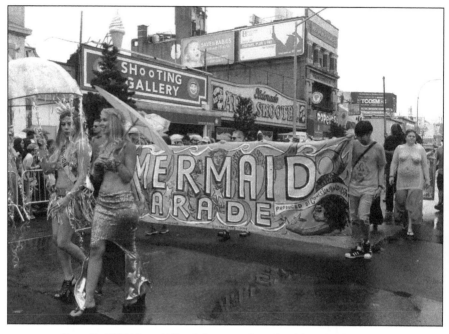

Figure 3 – 2017 Mermaid Parade banner and paraders (photo by Lisa Milner).

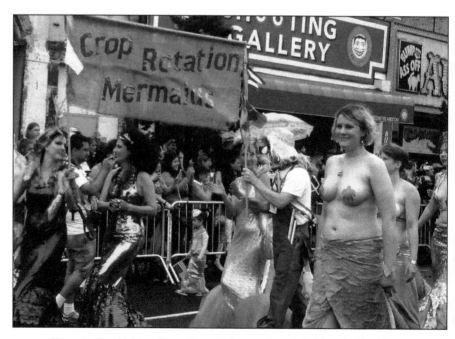

Figure 4 – Crop Rotation Mermaids and other paraders, 2017 (photo by Lisa Milner).

has long been a key tourist attraction for the area. As Brooklyn Borough President (2001–2013) Marty Markowitz boasted in Lyons' aforementioned 2011 documentary:

> The Mermaid Parade is certainly uniquely Brooklyn, and it's one of those special ways to welcome summer. In fact, summer doesn't really officially begin until Dick Zigun and his other freaks are out there, welcoming summer Brooklyn-style. And that's what the Mermaid Parade is all about.

The combination of female exhibitionism, heterosexual male perceptions of paraders' desirability and the symbolic safe space of parade day is ably reflected in Stephen Franciosa Junior's short film *A Mermaid's Tale* (2016).[13] In the first part of the film various female paraders comment on the liberatory aspect of role-playing for the day ("It's a lot of fun, everyone's on their kind of worst behaviour") and of mermaids' appeal to them as both waif-like innocents and threatening seductresses ("I love that thing like – we'll lure in the men and then just bite their heads off"). The film then shifts to a short fictional scenario featuring a male spectator and a parader dressed as Ariel. The film neatly sets up the interaction by including the male's own vox-pop comments before the interaction takes place. These take the form of a crude characterisation of some males' perceptions of the parade:

> I only love the top half, you know... the bottom half's fish, you can't really do too much with that... these girls in their skimpy outfits, you know, beautiful titties, man.

Foreshadowed by this declaration, the male is shown attempting to seduce the Ariel parader. Initially she seems welcoming, luring him down to the beach under the pier, only to disappear into the water. Puzzled, he wades in, looking for her, only for a monstrous mermaid to rear up and attack him. His fate is clarified when the end credits show his severed arm floating ashore. This sequence can be interpreted as a cautionary tale, giving the male his comeuppance for clumsily violating the safe space of the parade in which fantastic femininity is proudly shared in (what is meant to be) a safe, unthreatening context.

The erotic, carnivalesque elements of the parade also feature in Lana Del Ray's 2010 song and music video 'Mermaid Motel'. Based on a slow shuffle groove with whispered vocals and occasional samples, the song's lyrics refer to the locale, and reference Del Ray buying a "purple wig for my mermaid video". The video visualises these elements with dreamlike images of the singer posing glamorously in a motel room, intercut with excerpts from silent movie classics, shots of Elvis and the Pope and, in later sections, footage of the Mermaid Parade. Like several of her early video works, the atmosphere of the clip evokes the mythopoeic tone of 1950s' and 1960s' American avant-garde cinema and its slow-paced, trance-like meditations on mood,[14] elements that accord with Del Ray's explanation for Coney Island serving as a motif in her early work:

> Coney Island is a place people go to escape, but whatever you choose to be your reality is your reality. So, in a way it's just as real as anything else. I mainly let my imagination be my reality. Fantasy is my reality. (Sullivan, 2009: online)[15]

With regard to Essig's aforementioned characterisation of the racial and class profiles of paraders, her characterisations of the 2000 event accord with available photographic and video recordings of it, supporting her contention that the majority of the paraders

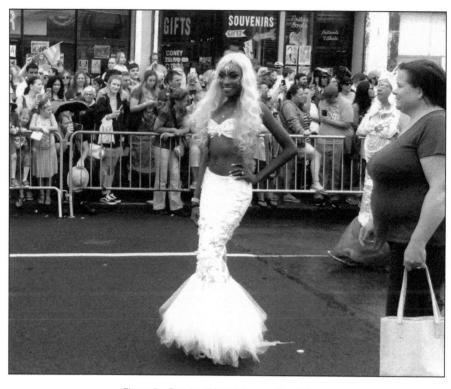

Figure 5 – Parader (2017) (photo by Lisa Milner).

appeared to be Caucasian. Our observations of subsequent parades and audiovisual records of these show that this pattern has continued, albeit with a greater proportion of Hispanic or African American participants in subsequent years (Figure 5), boosted to some extent by the choice of prominent black personalities such as Dante and Chiara de Blasio as the Parade's King and Queen in 2014.[16] As Zigun has expressed it "early parades were primarily attended by prototype Caucasian hipsters … it's now much more multi-cultural and diverse (p.c. September 16th 2017).

Another aspect of the parade that can be seen to support Essig's contention of its heterosexual normalcy concerns male roles within it. While the parade's name celebrates the mermaid, the Mermaid Queen's consort is usually a human-form (i.e. tail-less) male. The initial King Neptune in 1983, for instance, wore green swimming trunks, a crown, a long white beard and wig and grasped a wooden-handled green metallic trident. Subsequent kings have largely followed this pattern, wearing cloaks, crowns and/or beards to signify their patriarchal power. This duality of human male with mermaid reflects the predominant tenor of modern mermaid-themed fiction and the resultant marginalisation of the merman. As discussed by Hayward (2017a: 151-166), the mer*man* is problematic for patriarchal culture in that the very absence of genitalia from his fish tail problematises his masculinity in a very different way to that of the mermaid, who compensates for her similar

anatomical lack through an emphasis on her breasts and tresses as indexes of her sexual nature and inclination. The presence of human-form males as King Neptune thereby avoids this issue and keeps matters within the bounds of (masculine) 'normalcy'. It is notable in this regard that Essig (2005) identifies that some paraders and spectators have found male engagements with mer-ness as problematic. One insightful perspective recorded by Essig concerns the perceptions of Bambi, a professional burlesque artist with a long association with the parade, who has stated her dislike of men taking on mer-roles on the grounds that it undermines their masculinity (ibid: 157). Interviewed again in 2011, Bambi reiterated that she had a "sexist" attitude in that she perceived that those individuals interested in performing as mermen, in fact, wanted "to be mermaids," an aspect she found unappealing (Turgeon 2011: online). The 2017 parade revealed a particular solution to her impasse as a dedicated mermaid performer. During a pause in the parade she cemented her relationship with Chuck Varga, former member of the highly theatrical heavy metal band Gwar, in a ceremony conducted by Zigun. For this event Bambi was dressed in habitual mermaid garb while Varga's costume synthesised aspects of King Neptune with a unicorn (indicated by a high pointed headpiece and a protruding, fin-like codpiece). Identifying Varga's garb as a symbol of their relationship, Bambi informed a reporter "When you get married it should be to your unicorn, and Chuck is my unicorn" (Spivak 2017: online).[17]

Contrary to such fixed perceptions of masculine normalcy, one of the interesting aspects of Essig's (2005) essay in the above regards is the most colourful, boundary-pushing manifestation of heterosexual roles that she identifies. For all the "vanilla" normativity she documents, she also notes the presence of Patrick Bucklew at the 1998 parade, appearing in role as 'Fish Mangina' (ibid: 160). For this role Bucklew combined an aspect of temporary body-modification, with his scrotum contorted into a labia shape (hence his performance name) with a fish hat and a body suit that allowed him to show his unusual fleshly formation to anyone interested to see it. Interviewed by Essig, he contended that his heterosexuality was not diminished by this performance and he asserted that he still actively desired the mermaids he saw at the parade, regarding them as potential recipients of penetrative sex (ibid: 160–161). While Essig presented this performance as an outlier to the more conventional heteronormative tenor of the event, it can also be read another way, as an early manifestation of a more concerted play with potentially 'monstrous' re-imaginations and reconfigurations of bodies and sexualities within the terms described below.

III. Monstrosity and Perversity

However accurate Essig's characterisations of the late 1990s and 2000 parades may have been, our research into subsequent parades and, in particular, observations of participant behaviour and responses at the 2017 parade suggest that there has been a significant shift in intervening years. For all that many of the parade's participants and spectators may continue to be involved in a celebratory mass enactment of heterosexual display, the event also makes space for and facilitates various forms of gay/queer activities.[18] While it is difficult to ascribe sexual identities to paraders and spectators based on appearance alone, the identification of particular female performers as lesbian via signs, behaviour or subtler

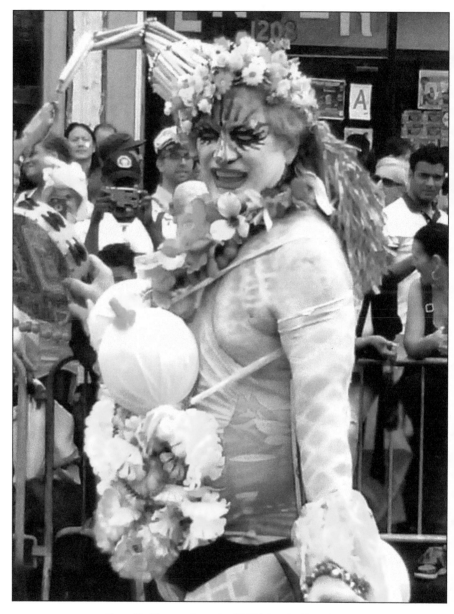

Figure 6 – 'Perverse' parader, 2017 (photo by Lisa Milner).

aspects of subcultural signification has become more obvious in the last decade and, with particular regard to mermaid paraders' manifesting 'butch' personas, has attracted adverse comment from those who perceive this to be pushing the event beyond the normative heterosexual boundaries Essig suggests.[19] There has also been evidence of more inclusive

engagements with lesbian identity, such as the (non-sexuality specific) Kostume Kult's performance of a dance routine to Liah Alonso's dance song 'Intergalactic Lesbian Mermaids' (whose lyrics refer to lesbian mermaids coming to the aid of humans who have polluted the oceans) at the 2016 parade. The performers' music video for the track[20] incorporates footage of the Kostume Kult's parade performances, associated footage of the day and other material, and can be understood as a musical/music video extension of core themes from the Parade. Regular performances by the Lesbian and Gay Big Apple Corps marching band at the parade have also underscored the connection between lesbian and gay groups and the event.[21]

The presence and prominence of various gay/queer participants over 10–15 years has, in turn, facilitated a major modification of the nature of the performed personae and affective solidarities of the event, with particular regard to the presentation of human bodies modified by make-up, costumes and/or props to transcend normalcy and offer various temporary imaginations of what personal form may appear as and/or symbolise (Figure 6). Such practices accord with and corroborate aspects of recent theorisation of such practices and their relations to concepts of the 'perverse' and/or 'monstrous'.

In his volume 'Perverse Desire and the Ambiguous Icon,' Allen Weiss discusses creative practices that conflate various sexual modes "within one ambiguous, polyvalent system" and refers to instances in which the "acting out" of such modes produces a "projection of corporeal contradictions onto the phantasmatic scenario" in which:

> *The multiple identifications and polyvalent erotic combinations specific to depersonalization are a sign of narcissistic plentitude, determining a coincidence of subject and object, inside and outside, passive and active, self and other. (1994: 107)*

While he refers to "acting out" within the particular context of a subject in psychoanalysis, his characterisation of temporary "depersonalization" arising from multiple identifications and experimentation with various roles and energies is pertinent to the nature of participation in the Mermaid Parade. Indeed, his reference to polyvalence is one that accords with characterisations of the mermaid's appeal to various creative constituencies as being premised on just such a polyvalence of potential signification. In this manner it reflects mermaids' (and mermen's) "peculiar combination of elements from different genera and consequent lack of fit with a symbolic order premised on and reflective of male and female (human) bodies as the physical indexes of gender difference and as the loci of hetero-, homo- and inter-sexual desire" (Hayward 2017a: 188). Reflecting the manner in which Weiss uses the term "perverse" in a non-pejorative, psychoanalytical sense, Patricia MacCormack's 2004 essay 'Perversion: Transgressive Sexuality and Becoming-Monster' picks up on some aspects of Weiss's work in ways that have considerable relevance for the subject of this chapter.

MacCormack's discussion of perversion identifies it as a practice that facilitates the "reconfiguration of binarily defined and fixed subjectivity, so that all subjects are acknowledged as unstable and metamorphic" (2004: online) and therefore being able to escape patriarchal-heteronormativity by "becoming monstrous" (ibid). MacCormack uses the latter term in the sense used by Braidotti, who contends that "monsters" represent the "in between, the mixed, the ambivalent as implied in the ancient Greek root of the word

monsters, *teras*, which means both horrible and wonderful, object of aberration and adoration" (1994: 77). Drawing on Braidotti, MacCormack identifies the monster as having the capacity to push us "outside symbolic integrity" and, drawing on Weiss, she attests that embracing such a position embraces difference in that "Becoming-monster" is "a challenge to the bifurcation between monster and not-monster, and the discursive act of defining these separately" (2004: online). With regard to women's embrace of such positions (through various means, including body modification) to distance themselves from patriarchal-heteronormativity, she makes a significant point that might be extended to women's taking on the appearance – and, specifically, glamour – of mermaids for various escapist purposes, in that:

> *If glamorisation involves defining one position from another (dominant) position, the best of intentions risks reaffirming traditional discursive paradigms, both because it spatialises what the monster is, and invests a certain value in the definition. (ibid).*

Participants in the Mermaid Parade – and particularly female and/or LGBTI (lesbian, gay, bi-sexual, trans and/or intersex) participants – dive into the depths of such issues through their performance and wrestle with the complexities and contradictions in various ways.

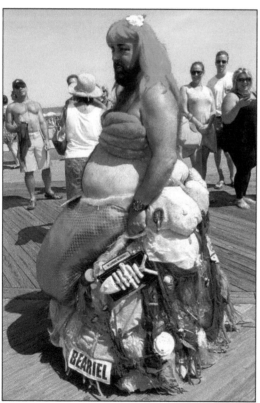

Figure 7 – Beariel, 2016 (photo by Eva Graham).

Overall, and in each iteration, the parade is full of a sense of *becoming* monstrous, as revelling in the in-between (at least for one day when the carnival allows and applauds such transgressions). Rather than the essentially safe, white, heterosexual "naughtiness" that Essig (2005) perceived in the parade's 20th Century practice, the event now fosters a greater exploration of transgressive roles based on the innate polyvalence of the mermaid (and merman). With regard to the latter, outside of the King Neptune roles easily performed by heterosexual males, there have also been a variety of other 'mer-masculinities' on offer (including, in 2017, gay "Queen Neptunes"). The latter have, in many ways, been the edgiest components of the parade, pushing the limits of heterosexuality and of the heterosexual imagination. The nature of male performance of mer-ness at the Parade in recent years ranges from attempts to combine a traditional

masculinity (appearing as mer*men*) and various forms of drag performance (as mer*maids*), either in comically grotesquely forms that appear to reject the embrace of femininity central to male drag acts, or as more stereotypically over-the-top, ultra-glam drag personas. A further subcategory is also been evident: that of less conventionally glamorous performances of mermaid roles by hirsute and/or larger-bodied males of the type often referred to as 'bears' within Gay culture. Similarly to Big Dipper's representation of such a persona in his 2015 *Vibin* music video,[22] in which his appearance was modelled on Disney's Ariel, a character signed as 'Beariel' was prominent at the 2016 parade, wearing a red wig, with painted stubble, a massive belly, a clam-shell bra and elaborate green tail piece mounted on a hoop frame. Like the aforementioned Big Dipper video, Beariel's glamour (Figure 7) was simultaneously subsumed in grotesquery (within patriarchal-heteronormative discourse) and can be regarded as liberatory in terms of the parader's particular body type and role.

IV. Issue Politics

Along with the complex identification politics outlined above, the Parade has become increasingly used as a forum for specific political positions. One notable act occurred in

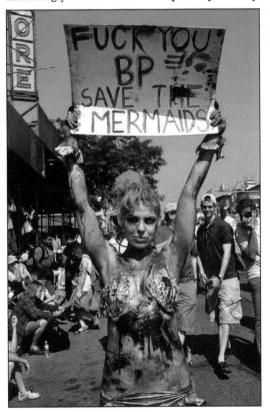

2008, for instance, when the year's Mermaid Queen, activist Savitri D[23] staged a hunger strike following the parade during which she stayed in a shop window on Surf Avenue, covered live on video, in a protest display that she identified in the following terms: "it is our freaky-monarchial [sic] DUTY to use this power to SAVE Coney Island from the gentrifying apocalypse of RETAIL ENTERTAINMENT HELL" (Robert 2008: online). Addressing a broader issue, in 2010 a number of participants modified their appearance in protest of BP's slow response to pollution from the Deepwater Horizon oil spill in the Gulf of Mexico in April, appearing in role as oil-coated pelicans or else smearing black paint across their mermaid costumes (Figure 8). In a similar vein, the 2017 parade included: mermaids with political agendas (for climate change recognition, in support of Russian anarcho-feminists Pussy Riot or against Donald

Figure 8 – BP Oil spill protest mermaid (photo by Lesley Ware, 2010).

223

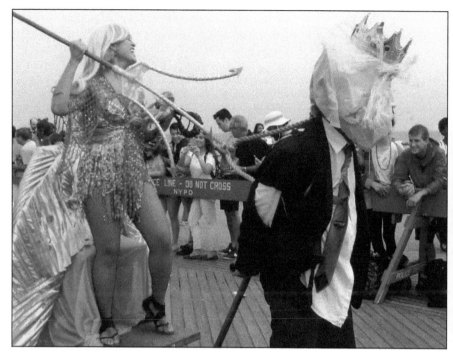

Figure 9 – Trident-wielding mermaid being hauled by crowned Donald Trump figure – 2017 Mermaid Parade (photo by Lisa Milner).

Trump – Figure 9); mermaids that were re-fashioned in goth, steampunk, zombie, boxer, hippie, suffragette and superhero styles; and even the three "Handmermaids of Gillead [sic]".[24] This variety of mermaids speaks to the ease of expressing popular cultural tropes via her polyvalence.

Contemporary reconfigurations, affected either through cross-dressing, hybridisation or otherwise, extend the mutability of the mermaid and merman and allow them to be deployed in various ways. Perhaps, in their own ways, these 'freaks' of Coney Island – part human, part mermaid, part something else – are finding their own ways to distil, in the Italian philosopher Giorgio Agamben's (2013) term, the "elemental spirit" of mermaids through their re-fashionings, through their taking on the role of creatures on the boundary of being human and non-human, a process through which, as Agamben writes, "generations entrust the possibility of finding or losing themselves" (ibid: 57). This, then, is the transformed reality that Zigun identifies in his Coney Island Mermaid Parade. For one day a year, the common anthropocentric view of the world, what Agamben calls "the anthropological machine" (2004: 37), breaks down. The carnival allows parade participants to explore the parameters of their selfhood for a few hours and indulge in fantasies such as making President Donald Trump – the ultimate personification of patriarchal normativity – subservient to a woman revelling in the temporary power of her glamorous monstrosity.

224

Conclusion

Unlike the concentrations of public mermaid imagery in locations such as California's Catalina Island (Hayward, 2013) and points along Australia's eastern seaboard discussed elsewhere in this volume, the centrality of public performance of mermaids and various related roles at Coney Island has resulted in a lively and pluralistic interpretation that is unique in the history of the folk-/media-loric figure. The particular enabled space of the annual parade and its extensive digital documentation via social media has allowed participants to explore various gender-specific and gender-ambiguous roles and sexual (and sexualised) personae through collective costumed performance. The event has been remarkably successful with both performers and audiences. The embeddedness of the event within a local countercultural milieu has enabled it to both maintain its tolerance and plurality, and be effectively organised and managed. As such, the Mermaid Parade has become a cultural phenomenon marked by the swirls of its energies as figures are configured and reconfigured in the imaginations of its participants in response to their socio-sexual positions and broader aspects of the global environment. This active interpretation of folk-/media-loric figures in various contexts is a powerful indication of the manner in which Coney Island's Mermaid Parade is *anything but* an artificial novelty event and is, rather, a thriving manifestation of public investment in symbols and symbolic performances. The mermaid acts as a central presence and motif whose totemic charisma enables various forms of exhibitionism and identity play and – to return to the quotation that prefaced this chapter – unsettles various aspects of normativity, prioritising freakishness over familiarity and allowing libidinal energy to circulate in a celebratory parade space.

Acknowledgements: Thanks to Dick Zigun for his assistance with research for this chapter and to Clarice Butkus and Paige West for their feedback on an initial draft.

Notes

1. During at least one of these events (in 1954) the parade featured a marine theme, with a group of paraders sporting fish-tails – see photo online at: http://www.nydailynews.com/new-york/coney-island-mermaid-parade-back-gallery-1.1100835?pmSlide=1.1100809 – accessed May 23rd 2017.

2. Reflecting back on Coney Island parades he attended in his youth, Joseph Heller commented that the event "epitomizes everything about parades that is sordid, debased and synthetic" (2003: 324).

3. See Woollacott (2011) and Hayward (2017a).

4. The later aspects being wryly acknowledged in an exhibition of Coney Island-themed artworks that ran in November 2015 under the title 'Sodom by the Sea'.

5. Zigun grew up in Bridgeport Connecticut, where circus king P.T. Barnum was once Mayor, and went on study a Master of Fine Arts at Yale University in the late 1970s.

6. See Coney Island History Project: http://www.coneyislandhistory.org/sites/default/files/neptune.wash_.baths_.4.jpg – accessed October 6th 2017.

7. Luna Park opened in 1903 with various themed buildings, including one inspired by Jules Verne's 1870 novel 'Twenty Thousand Leagues Under the Sea', which included sea creatures, water effects and a mermaid performer. While this set was replaced by subsequent ones, the mermaid re-emerged as a motif in the 1940s in the form of the Mermaid Tunnel attraction, where couples rode through a darkened space in ornamental chairs with mermaid figures on each side (which was depicted by New York artist Reginald March in a vivid drawing entitled 'Riders in a Mermaid Tunnel Boat' in 1946). In what might be considered as cultural 'looping', the popularity of the island's modern mermaid parade inspired a mermaid-themed ride at the revived Luna Park attraction that opened in 2010.

8. Robert Lyons shot footage at 15 consecutive Mermaid Day Parades for his film *Mermaid*. His 2011 version is online at: https://vimeo.com/22345369 – accessed June 27th 2017.

9. The 2017 parade included a troupe of mermaid-chihuahuas and a mer-chicken. In 2010 an elephant from the Ringling Brothers Circus joined the march.

10. For a complete list see 'Mermaid Parade Royalty': http://www.coneyisland.com/mermaid-parade-royalty – accessed May 20th 2017.

11. With some exceptions, in 1988, for instance, the mermaid was de-centred in a poster designed by Valerie Haller that showed a stilt walker with green skirt and bikini top and a parade band with a mermaid figure amongst the performers.

12. See Bondeson (1999: 36–63).

13. The film is currently available online at the Boneyard website: http://www.boneyardtales.com/copy-of-rellik – accessed May 20th 2017.

14. See Sitney (1974) for further discussion.

15. While Del Ray has not appeared in mermaid garb in any video or live performance she has become associated with mermaids by fans, most notably through fan artwork and videos that make comparisons between her and Ariel through montages and collages. Nameless Doll's video collage of images of Disney's Ariel and Peter Pan characters set to Del Ray's 2013 song 'Young and Beautiful' (https://www.you-tube.com/watch?v=dIDw7HoQXJE – accessed May 29th 2017) represents one aspect of this.

16. It should also be noted that Queen Latifah featured as Mermaid Queen in 1999.

17. As should be apparent, the unicorn's most defining feature has a phallic symbolism that is the reverse of the merman's lack of such an attribute.

18. Indeed, writing in 2016, Lynch identified that "there has long been a strong and welcome Gay Pride element to the day's proceedings" and that the 2016 parade had been marked by a heightened sense of support for Gay rights and issues (2016: online).

19. In 2010, for instance, one online poster responded to a news item about the forthcoming parade with the vituperative comment that, "every year the dykes and experimental lesbians get uglier than the previous" http://www.brooklynvegan.com/mermaid-parade-3/ – accessed May 23rd 2017.

20. https://www.youtube.com/watch?v=8hfA6VsDjgk – accessed May 26th 2017.

21. This aspect has not escaped the notice of conservative commentators. In June 2013, for instance, the Fox News program *The O'Reilly Factor* included an item on the parade. O'Reilly identified that the parade was attracting gays to what was not normally considered a gay area and asked location reporter Jesse Watters why it attracted so many gays.

22. See Hayward (2017a: 47-49) for further discussion.

23. Director of the project 'Reverend Billy and The Church of Stop Shopping' – see the organisation's website: http://www.revbilly.com/our_work – accessed May 20th 2017.

24. Referencing the TV adaptation of Margaret Atwood's dystopic novel *The Handmaid's Tale* broadcast in April–June 2017.

Bibliography

Agamben, Giorgio (2004) *The Open: Man and Animal*, Palo Alto: Stanford University Press

—— (2013) *Nymphs*, Kolkata: Seagull Books

Airmata Duyung (nd) 'Khasiat Minyak Air Mata Duyung Asli': http://www.supranaturaljokowi.com/2015/03/khasiat-minyak-air-mata-duyung-asli. html – accessed August 9th 2017

Akebon Haru (2013-2014) *Momoiro Ningyo Dessert* series: http://www.mangahere.cc/manga/momoiro_ningyo/ - accessed August 9th 2017

Al-Ahmadi, Fahd Amer (2005) 'Houryaat al-Bahr Bayin al-Khoraafa wa al-Asl', *Al-Riyadh* May 12th: www.alriyadh.com/63820 – accessed August 30th 2017

Al-Qazwini, Abu Yahya Zakariya ibn Muhammad (nd) *Aja'ib al-Makhluqat wa Ghara'ib al-Mawjuda*, Daar al-Afaaq al-Jadida

Altimari, Emily (2016) 'Mermaid's Grotto', *Okinawa Hai!*: https://okinawahai.com/ mermaids-grotto/ – accessed April 3rd 2017

Andaya, Barbara Watson (2016) 'Rivers, Oceans and Spirits: Water Cosmologies, Gender and Religious Change in Southeast Asia', *TRaNS: Trans-Regional and –National Studies of Southeast Asia* v4 n2: 239-263

Andersen, H.C (1837) 'Den lille Havfrue', Copenhagen: C.A. Reitzel, archived online by Det Kongelige Bibliothek: http://wayback-01.kb.dk/wayback/20101108104437/http://www2.kb.dk/elib/lit/dan/andersen/eventyr.dsl/hcaev008.htm – accessed May 15th 2016; (unattributed) - English translation (as 'The Little Mermaid') archived online by Project Gutenberg: http://www.gutenberg.org/files/27200/27200-h/27200-h.htm#li_mermaid – accessed December 22nd 2016

Anonymous (nd) One Thousand and One Nights (Volume 9) (translated by Burton, Richard Francis), archived online at: http://www.gutenberg.org/cache/epub/3435/pg3435 -images.html – accessed December 8th 2017

Aratare, X (2014) *The Merman Transformation* Volume 1, Chicago: Raythe Reign

Arras, Jean d' (1478) *Le liure de Melusine en frãcoys*, Geneva: A. Steinschaber

Arras, Jean d' (1489) *Historia de la linda Melosyna*, Toulouse: Juan Parix and Estevan Clebat

Art Gallery of New South Wales (nd) 'John Mawurndjul': https://www.artgallery.nsw.gov.au/collection/works/216.1985.1/ – accessed July 24th 2017

Bacchilega, Cristina (1993) "An Introduction to the 'Innocent Persecuted Heroine' Fairy Tale", *Western Folklore* v52 n1: 1–12

Bajaj, Kriti (2014) 'Indian artist Jayasri Burman on mythology and imagination – interview,' *Art Radar* March 14th:http://artradarjournal.com/2014/03/14/indian-artist-jayasri -burman-on-mythology-and-imagination-interview/ – accessed July 30th 2017

Baker, Kevin (2015) 'Foreword', in Parascandola, Louis J and Parascandola, John (eds) *Coney Island Reader: Through the Dizzy Gates of Illusion*, New York: Columbia University Press: xiii-xx

Baker, Tim and Grambeau, Ted (2011) *The Surfer and the Mermaid*, Gold Coast: self-published

Banerjee, Supriya (2017) 'Apsara: Deconstruction of the Spectacular', paper presented at 'Mermaids, Maritime Folklore and Modernity conference', Copenhagen, October 25th 2017

Barco Centenera, Martín del (1602) *Argentina y conquista del Rio de la Plata, con otros acaecimientos de los reynos del Perú, Tucumán, y estado del Brasil*, Lisbon: Pedro Crasbeeck, archived online at: https://archive.org/details/argentinayconqui00barc - accessed March 2nd 2017

Barragaño, Ramón (1985) 'La Mitologia Popular Asturiana', archived online at: https://repositorio.uam.es/bitstream/handle/10486/8255/44866_8.pdf?sequence=1 = accessed March 4th 2018

Barrie, J.M (1904) *Peter Pan or the Boy Who Would Not Grow Up*, archived online at: http://gutenberg.net.au/ebooks03/0300081h.html – accessed March 20th 2015

Beyer-Bagatsing, Charity (2017) 'Sirena Stories, the Mythical Mermaid of the Philippines', *Aswang Project*: https://www.aswangproject.com/sirena-mermaid-philippines/ - accessed March 4th 2018

Berger, Pamela (1985) *The Goddess Obscured: Transformation of the Grain Protectress from Goddess to Saint*, Boston: Beacon Press

Berman, Laine (2001) 'Comics as Social Commentary in Java, Indonesia', in Lent, John A (ed) *Illustrating Asia: Comics, Humor, Magazines, and Picture Books*, Honolulu: University of Hawai'i Press: 13-36

Bible [Basso Tedesco version] (c1478-1479) Cologne: Bartholomaeus de Unkel and Heinrich Quentell, on behalf of Johann Helmann and Arnold Salmonster in Cologne and Anton Koberger in Nuremberg

Bier, Lisa (2001) *Fighting the Current: The Rise of American Women's Swimming, 1870–1926*, Jefferson: McFarland & Co.

Bochenski, Natalie (2014) 'Queensland needs "Hobbits" to boost tourism: producer', *Traveller* April 24th, online at: http://www.traveller.com.au/queensland-needs-hobbits-to-boost-tourism-producer-374mx – accessed May 4th 2017

Bolton, Sharon C. and Laaser, Knut (2013) 'Work, Employment and Society through the Lens of Moral Economy', *Work, Employment and Society* v27 n3: 508–525

Bondeson, Jan (1999) *The Feejee Mermaid and Other Essays in Natural and Unnatural History*, Ithaca: Cornell University Press

Boonchote, Wichayant (2013) 'Songkhla Mermaid "not for prayers"', *Bangkok Post* October 21st: http://www.bangkokpost.com/print/381029/ – accessed July 11th 2017

Bórmida, M and Siffredi, A (1969) 'Mitología de los tehuelches', *Runa* n12: 199-245

Bose, Girindrasekhar (1999) 'The genesis and adjustment of the Oedipus wish', in Vaidyanathan, T.G. and Kripal, Jaffrey J (eds) *Vishnu on Freud's desk: A Reader in Psychoanalysis and Hinduism*, Delhi: Oxford University Press: 19-38

Bradbury, Ray (1951) *The Illustrated Man*, New York: Doubleday and Company

Braham, Persephone (2015) *From Amazons to Zombies: Monsters in Latin America*, Lewisburg: Bucknell University Press

Braidotti, Rosi (1994) *Nomadic Subjects: Embodiment and Sexual Difference*, New York: Columbia University Press

Brown, R.M (2012) *African-American Cultures and the South Caroline Lowcountry*, New York: Cambridge University Press

Bui, Tran Quynh Ngoc (2009) 'Structure and Motif in the "Innocent Persecuted Heroine" Tale in Vietnam and Other Southeast Asian Countries', *International Research in Children's Literature* v2 n1: 36–48

Bumi Langit (nd) 'Mandala': http://bumilangit.com/en/characterspods/mandala/ - accessed March 5th 2018

Bunson, Margaret R (2002) *Encyclopedia of Ancient Egypt* (Revised edition), New York: Facts on File

Burstein, Stanley M (1978) 'The *Babyloniaca* of Berossus', *Sources and Monographs from the Ancient Near East* v1 fascicle 5, Malibu: Undena

Cabrera, L (1980) *Yemayá y Ochún*, Eastchester: CR New York/Eliseo Torres

Canson, P.E (2017) 'Yemonja', *Encyclopædia Britannica* online: https://www.britannica.com/topic/Yemonja – accessed August 8th 2017

Capino, Jose B (2005) "Learning from, Darna, Dyesebel, Barbi, and Vampira: Notes on the Hybridity of Philippine National Cinema', *Ideya* v6 n2: 45-58

Caputo, J (2009) 'The Many Faces of Mami Wata', *Smithsonian Magazine* April 1st: http://www.smithsonianmag.com/smithsonian-institution/the-many-faces-of-mami-wata-44637742 – accessed July 30th 2017

Carvajal Godoy, J (1992) 'Reflexión sobre la influencia cultural africana en América', *Revista Universidad Pontificia Bolivariana* v41 n135: 81-89

Chertudi, Susana (1960) *Cuentos folklóricos de la Argentina, primera serie*, Buenos Aires: Ministerio de Educación y Justicia de la Nación Argentina, Instituto Nacional de Filología y Folklore

Chopra, Preeti (2011) *A Joint Enterprise: Indian Elites and the Making of British Bombay*, Minneapolis: Minnesota University Press

Chôsuke, Nagashima (2014–2015) *Ningyo Wo Kurau Shima*, Action Pizazz DX: https://hitomi.la/galleries/900425.html - accessed March 5th 2018

Chow, Low Lai (2014) 'Thai citizens show you how to render mermaid cosplay the budget way', *Lost at E Minor* July 20th: http://www.lostateminor.com/2014/07/21/thai-citizens-show-render-mermaid-cosplay-budget-way/ – accessed December 6th 2017

Christie, Connie (1939) *The Adventures of Pinkishell*, Melbourne: Specialty Press

——- (1946) *The Fairy Mermaid*, Melbourne: Digest Juvenile Productions

Coate, Ian (2011) *The Aborigine and the Mermaid*, Perth: Matilda Publishing

Coching, Francisco (1954-??) *Ang Mahiwagang Daigdig ni Pedro Penduko* series, *Liwayay*

Cockingham, James (1999) 'Vincent Van Go of Bondi', *Bizarrism* n7: 28-30

Columbus, Christopher (1893) *The Journal of Christopher Columbus (during His First Voyage, 1492-93)* (translated by Clements, R. Markham), London: Hakluyt Society

Coney Island USA (nd) 'About Coney Island USA': http://www.coneyisland.com/about-coney-island-usa – accessed May 20th 2017

Cooke, Grayson (2012) 'Kellerman: expanded: a live audio-visual performance in the Whitsundays', *Shima* v6 n1: 147-155

Cordero-Fernando, Gilda (2011) 'Urban Legends', *Philippine Daily Inquirer* December 18th 2011: http://lifestyle.inquirer.net/27843/urban-legends/ - accessed March 3rd 2018

Covarrubias, Sebastian (1611) *Tesoro de la lengua castellana o española*, Madrid: Luis Sánchez

Craik, Jennifer (1994) *The Face of Fashion: Cultural Studies in Fashion*, New York: Routledge

Cummings, Scott T (1986) 'Theater in Coney Island: The First Annual Mermaid Parade', *Theater* v15 n1: 87-91

Danish Enterprise and Construction Authority (2010) 'The Danish Pavilion in Facts and Figures': https://erhvervsstyrelsen.dk/sites/default/files/media/expo-2010-the-danish-pavilion-in-facts-and-figures_2010.pdf – accessed June 20th 2017

Darwin, Gregory (2015) 'On Mermaids, Meroveus, and Mélusine: Reading the Irish Seal Woman and Mélusine as Origin Legend', *Folklore* v126 n2: 123–141

Das, Varsha (1995) 'Cross-Culturalism in Indian Literature for Childerne' in Dasgupta, Amit (ed) *Telling Tales: Children's Literature in India*, New Dehli: Indian Council for Cultural Relations and New Age International: 43-53

Davisson, Zack (2015) 'Two tales of mermaid meat', *Hyakumonogatari Kaidankai*: https://hyakumonogatari.com/2015/09/24/two-tales-of-mermaid-meat/ – accessed April 7th 2017

de Jonge, H.J.M, Los, J.A, Knipscheer. R.J.J.L and Frensdorf, E.L (1984) 'Sirenomelia ('mermaid'), *European Journal of Obstetrics & Gynecology and Reproductive Biology*, v18 n1-2: 85-93

De Rosales, Diego (1877) *Historia General de el Reino de Chile, Flandes Indiano*, Valparaiso: Mercurio, archived online at: https://babel.hathitrust.org/cgi/pt?id=hvd. 32044012744934; view=1up;seq=385 – accessed January 10th 2018

De Vries, J.W (1988) 'Dutch loanwords in Indonesian', *International Journal of the Sociology of Language* n73: 121-136

Derrida, Jacques (1966) *Writing and Difference*, London and New York: Routledge

Deshpande, Alok (2013) 'Khada Parsi: Restoring the ruptured heritage', Parsi Khabar website: https://parsikhabar.net/heritage/khada-parsi-restoring-the-ruptured-heritage/6265/ – accessed July 10th 2017

Dian K (2017) *Legenda Putri Dyung*, Jakarata: Bhuana Ilmu Popular Folklore series

Dinnerstein, Dorothy (1976) *The Mermaid and the Minotaur: Sexual Arrangements and Human Malaise*, New York: Harper and Row

Dreimann, A (2013) 'Island of Treasure', *21st Century Digital Art: A Collaborative Survey of Digital Art Made Since 2000* May 2nd, online at: http://www.digiart21.org/ art/island-of-treasure – accessed July 30th 2017

Drewal H.J (1988a) 'Mermaids, Mirrors, and Snake Charmers: Igbo Mami Wata Shrines', *African Arts* v21 n2: 38–96

—— (1988b) 'Performing the Other: Mami Wata Worship in Africa', *TDR v32* n2: 160-185

—— (2008a) *Mami Wata: Arts for Water Spirits in Africa and Its Diasporas*, Los Angeles: Fowler Museum of UCLA and University of Washington Press

—— (2008b) *Sacred Waters: Arts for Mami Wata and Other Divinities in Africa and the Diaspora*, Bloomington: University of Indiana Press

—— (2008c) 'Mami Wata: Arts for Water Spirits in Africa and Its Diasporas', *African Arts* v41 n2: 60–83

Dunn, Cathy (nd) 'Victorian Fashions', Australian History Research website, online at: http://www.australianhistoryresearch.info/victorian-fashions/ – accessed 3rd May 2017

Durán, Diego (1574–1579 [1971] *Book of the Gods and Rites and The Ancient Calendar* (translated and edited by Horcasitas, Fernando and Heyden, Doris), Norman: University of Oklahoma Press

Durand, José (1950/1983) *Ocaso de sirenas* (2nd edition) México City: Fondo de Cultura Económica

Durdin-Robertson, Lawrence (1975) *The Goddesses of Chaldea, Syria and Egypt*, Enniscorthy: Cesara Publications

Dwyer, Rachel (2014) 'Why Bollywood gave the kiss a miss', *The Times of India* November 9th: http://timesofindia.indiatimes.com/home/sunday-times/Why-Bollywood-gave-the-kiss-a-miss/articleshow/45085156.cms – accessed July 14th 2017

Ebers, George (1866) *Die Nilbraut* (English translation published as *Bride of the Nile* [1887]), online at: http://www.gutenberg.org/cache/epub/5517/pg5517-images.html - accessed January 3rd 2018

Edmundson, William (2009) *A History of the British Presence in Chile: From Bloody Mary to Charles Darwin and the Decline of British Influence*, Basingstoke: Palgrave Macmillan

Eiichiro, Oda (1997–) *Wan Písu* series, *Weekly Shônen Jump*

Elsner, Jas (2007) *Roman Eyes: Visuality and Subjectivity in Art & Text*, Princeton: Princeton University Press

Elyon, Rebecca (2016) *Mating Mermen: An Unexpected Tail*, Amazon Digital Services

English, Khaosod (2014) 'State Petroleum Enterprise sued for Resort Island Oil Spill', Thai Visa: https://www.thaivisa.com/forum/topic/745072-koh-samet-state-petroleum-enterprise-sued-for-resort-island-oil-spill/ – accessed July 11th 2017

Ernee (2012) 'The Lost Works of Mars Revelo (And Some Extracts of His Unpublished Interviews)', *Ernee's Corner*, online at: http://erneelawagan.blogspot.com.au/2012/02/ lost-works-of-mars-ravelo.html - accessed December 11th 2017

Esau, E and Boeck Jr, G.G (1981) 'The Mermaid in Mexican Folk Creches', *Southwest Folklore* v5 n1:: http://www.esauboeck.com/index/The_Mermaid_in_Mexican_Folk_Creches# fn23 – accessed January 10th 2018

Essig, Laurie (2005) 'The Mermaid and the Heterosexual Imagination' in Ingraham, Chrys (ed) *Thinking Straight: The Power, Promise and Paradox of Heterosexuality*, Routledge: Taylor and Francis: 151-166

Fan, Xu (2016) 'Stephen Chow gives away nothing – as usual', *China Daily* February 4th: http://www.chinadaily.com.cn/culture/2016-02/04/content_23385646.htm – accessed June 20th 2017

FilipiKnow (2014) '9 things you probably didn't know about Dysesebel': https://www.filipiknow.net/interesting-facts-about-dysesebel/ - accessed March 4th 2018

Fleming, David (2014) 'The creative evolution and crystallisation of the "bastard line": drifting from the Rive Gauche into *Suzhou River*', *Journal of Chinese Cinema* v8: 135-147

Forth, G (1988) 'Apes and Dugongs: Common Mythological themes in Diverse Southeast Asian Communities', *Contributions to Southeast Asian Ethnography* n7: 189-229

Fraser, Lucy (2013) '*Lost Property Fairy Tales:* Ogawa Yôko and Higami Kumiko's Transformations of "The Little Mermaid"', *Marvels & Tales: Journal of Fairy-Tale Studies* v27 n2: 181–193

———- (2017) *The Pleasures of Metamorphosis: Japanese and English Fairy Tale Transformations of 'The Little Mermaid'*, Detroit: Wayne State University Press

Friedberg, A (2006) *The Virtual Window From Alberti to Microsoft*, Cambridge: MIT Press

Frykenberg, Robert E (2008) *Christianity in India: From Beginnings to the Present*, Oxford: Oxford University Press

Gadallah, Moustafa (2016) *Isis: The Divine Female*, Cairo: Tehuti Research Foundation

Gan Bao (nd) *Sou Shen Ji*, archived online at: https://archive.org/details/ soushenjivolume107260gut - accessed March 5th 2018

Gans, T.H (1984) *Misteri Airmata Duyung*, Bumi Langit

Garay, R and Vélez, I (2004) 'An Iberian Bestiary: The Medieval Imaginary in New World Literature', *Monographic Review* v20: 26-44

Garcia, J.N.C (2014) 'The City in Philippine Gay Literature', *The Journal of Contemporary Philippine Literature, Likhaan* n8: 161-184

Garciía Méndez, C. (1925) *Los mejores cuentos de Ándersen : narrados para los ninños de habla espanñola.* New York, Chicago: Rand McNally

Gaskins, Nettrice (2016) 'Deep Sea Dwellers: Drexciya and the Sonic Third Space', *Shima* v10 n2: 69-80

Gella Iturriaga, José (1968) 'La sirena en la literatura oral española', *Studi in onore di Carmelina Naselli*: 117-128

Gibbs, Emma, Gibbs, Margo and Wells, Doug (2017) *Sandy's Surfer's Paradise Adventure*, Gold Coast: Surfers Paradise Alliance Ltd: http://www.surfersparadise.com/__data/ assets/pdf_file/0016/10186/SPA_SS_KidsBook_Web-2.pdf – accessed June 15th 2017

Giesbers, H.W.M (1997) 'Dutch in Indonesia: Language Attrition or Language Contact?', in Klatter-Folmer, J and Kroon, S (eds) *Dutch Overseas: Studies in Maintenance, Shift and Loss of Dutch as an Immigrant Language*, Tilburg: Tilburg University Press: 163-188

Gilmore, Elizabeth (1947) *Literary Sources of Art History: An Anthology of Texts from Theophilus to Goethe*, Princeton: Princeton University Press

Goa Jazz (2012) '"Mermaid Garden" – What it was and What it is?': http://www. heritagejazz.com/Event-Mermaid-Garden-What-it-was-and-What-it-is-82.html – accessed July 2nd 2017

Gómez de Huerta, Jerónimo (1599) *Traducción De Los Libros De Caio Plinio Segundo, De La Historia Natural De Los Animales. Hecha Por El Licenciado Gerónimo De Huerta*, Madrid: Luis Sánchez, archived online at: http://alfama.sim.ucm.es/dioscorides/ consulta_libro.asp?ref=X532684949&idioma=0 – accessed June 10th 2018

Gómez López, N (2002) 'Las leyendas sobre sirenas en la costa de Almería', in *El libro de las sirenas*, Almería: Roquetas de Mar: 13-27

Gomez, Pablo (1966) *Miranda: Ang Lagalag na Sirena* series, Universal Komiks

Gopal (2003) 'Mermaid to revive Bhimili Glory?', *The Hindu* June 23rd: http://www.thehindu.com/thehindu/mp/2003/06/23/stories/2003062301030100.htm – accessed July 3rd 2017

Grayson, James Huntley (2001) *Myths and Legends from Korea: An Annotated Compendium of Ancient and Modern Materials*, Abingdon: Routledge

Green, Felicity (2007) *Togart Contemporary Art Award (NT) 2007*, exhibition catalogue, Darwin: Toga Group

Gripaldo, Rolando (2013) 'Roman Catholicism and the Filipino Culture' (revised edition) archived online at: Academia.edu: https://www.academia.edu/4487938/Roman_ Catholicism_and_the_Filipino_Culture_2009 – accessed December 12th 2017

Grosz-Ngaté, M, Hanson, J.H and O'Meara, P (2014) *Africa* (Fourth Edition), Bloomington: Indiana University Press

Gruzinski, Serge (2001) *Images at War: Mexico from Columbus to Blade Runner* (translated by MacLean, Heather), Durham: Duke University

Guamán Poma de Ayala, Felipe (1615) *Nueva corónica y buen gobierno*, archived online at: http://www.kb.dk/permalink/2006/poma/info/es/foreword.htm – accessed January 10th 2018

Guo Jingming (2003) *Huàn Chéng*, Shenyang: Chunfeng wenyi Press

Gutiérrez de Ángelis, M (2010) 'Idolatrías, extirpaciones y resistencias en la imaginería religiosa de los Andes Siglos XVII y XVIII', *Andes* n21: 61-94

Gutiérrez, Anna Katrina (2017) *Mixed Magic: Global-local Dialogues in Fairy Tales for Young Readers*, Amsterdam: John Benajmins Publishing Company

Guy, Rosa (1985) *My Love, My Love: or The Peasant Girl*, Minneapolis: Coffee House Press

Ha, Tae Hung (1970) *Folk Tales of Old Korea*, Seoul: Yonsei University Press

Haft, Adele J (2014) 'The Mocking Mermaid: Maps and Mapping in Kenneth Slessor's Poetic Sequence *The Atlas* Part Four', *Cartographic Perspectives* n79: 22-5

Haldankar, Arvind (2015) 'Towards Understanding Tribal Livelihood through Religion in Goa', *Research Process* v3n1: 11-20

Hale, Lindsay (2009) *Hearing the Mermaid's Song: The Umbanda Religion in Rio de Janeiro*, Albuquerque: University of New Mexico Press

Hallerton, Sheila (2016) 'Atlantis/Lyonesse: The Plains of Imagination', *Shima* v10 n2: 112-117

Hambly, Wilfrid D (1931) 'Serpent Worship in Africa', *Publications of the Field Museum of Natural History Anthropological Series* v2 n1: 1-85

Harakawa, M (2016) '"MAMI" The Knockdown Center', *ArtForum Reviews*: 284

Hayward, Philip (2001) *Tide Lines: Music, Tourism and Cultural Transition in the Whitsunday Islands (and adjacent coast)*, Lismore: Music Archive for the Pacific Press

——- (2011) 'Salmon Aquaculture, cuisine and cultural disruption in Chiloé, *Locale* n1: 87-110

——- (2012a) 'Aquapelagos and Aquapelagic Assemblages: Towards an integrated study of island societies and marine environments', *Shima* v6n1: 1-11

——- (2012b) 'The Constitution of Assemblages and the Aquapelagality of Haida Gwaii', *Shima* v6n2: 1-14

——- (2012c) 'Merlionicity: The twenty first century elaboration of a Singaporean symbol', *Journal of Marine and Island Cultures* v1 n2: 113-125

——- (2013) 'Englamoured: Mermaid iconography as a contemporary heritage asset for Catalina Island', *Contemporary Legend* series 3 v3: 39-62

——- (2016) 'Mermaid Horror', University of Technology Sydney seminal paper

——- (2017a) *Making a Splash: Mermaids (and Mermen) in 20th and 21st Century Audiovisual Media*, New Barnet: John Libbey and Co.

——- (2017b) 'Tanka Transitions: Shrimp Paste, Dolphins and the Contemporary Aquapelagic Assembly of Tai O', *Locale* n6: 1-19

Hayward, Philip and Hill, Matt (2018) 'Reflection, Dissonance and Doubling in *Lorelei* (1975)', Southern Cross University seminar paper

Hayward, Philip and Kuwahara, Sueo (2014) 'Takarajima: A Treasured Island: Exogeneity, folkloric identity and local branding, *Journal of Marine and Island Cultures* v3 n1: 20-30

Hayward, Philip and Li, John Fangjun (2011) 'Gilding the pearl: cultural heritage, sexual allure and polychromatic exoticism on Hainan Island', *Perfect Beat* v11 n2: 119-140

Heiner, Heidi Anne (2011) *Mermaid and Other Water Spirit Tales from Around the World*, Charleston: Createspace

Heller, Joseph (2003) 'Coney Island: The Fun is Over', in Bruccoli, Matthew and Bucker, Park (eds) *Catch as Catch Can: Selected Stories and Other Writings – Joseph Heller*, New York: Simon and Schuster: 319-341

Hernández, G (2002) 'Las sirenas en los mitos indígenas de los tehuelches, de los mapuches y de la isla de Chiloé', in *El libro de las sirenas*, Almería: Roquetas de Mar: 95-211

Hernandez, J (2016) 'The Many Meanings of Mami Wata Explored in New MAMI Exhibit' *Gallery Gurls* September 5th: http://gallerygurls.net/reviews/2016/9/24/the-many-meanings-of-mami-wata-mami – accessed July 30th 2017

Hill, Donald R (2013) 'Carriacou', in Taylor, P, Case, F and Meighoo, S (eds) *The Encyclopedia of Caribbean Religions*, Champaign: University of Illinois Press: 151–156

Hino, Hideshi (2007) *Ninygo no Zan'ei* – published in English translation as *Memories of the Mermaid*, in Hino, Hideshi (2012) *Art of Hideshi Hino*, Tokyo: Presspop Gallery: no pagination

Holford-Strevens, Leofranc (2006) 'Sirens in Antiquity and the Middle Ages', in Austern, Linda and Naroditskaya, Inna (eds) *Music of the Sirens,* Bloomington: Indiana University Press: 16–51

Hong, C (2016) '"The Legend of the Blue Sea" Answers Three Questions About Jun Ji Hyun's Mermaid Character', *Soompi,* November 21st: https://www.soompi.com/2016/11/21/legend-blue-sea-answers-three-questions-jun-ji-hyuns-mermaid-character/ – accessed September 27th 2017

Houlberg, Marilyn (1996) 'Sirens and Snakes: Water Spirits in the Arts of Haitian Vodou', *African Arts* v29 n2: 30–35

Hyun, Theresa (2015) 'Changing Paradigms, Shifting Loyalties: Translation of Children's Literature in Colonial Korea (1900-1940) and North Korea (1940-1960)', in Ankit, Ahmed and Faiq, Said (eds) *Agency and Patronage in Eastern Translatology,* Newcastle: Cambridge Scholars Publishing: 23-34

IRCJS (2002) 'International Research Center for Japanese Studies database': www.nichibun.ac.jp/YoukaiDB2 – accessed April 2nd 2017

Iryeon (2013 [1281]) *Samguk Yusa* (translated by Lee Min-Su), Seoul: Eullyu Munhwasa

Isidore (Barney, Stephen A et al [eds]) (2006) *The Etymologies of Isidore of Seville,* Cambridge: Cambridge University Press

Jaffa, Herbet C (1971) *Kenneth Slessor,* New York: Twayne Publishers

Jing, N and Rong, L (2010) 'City marketing from the perspective of Shanghai World Expo', paper delivered at 2010 International Conference on Management Science and Engineering, Monash University, Melbourne

Johnson, Buffie (1994) *Lady of the Beasts: The Goddess and Her Sacred Animals,* New York: Inner Traditions International

Jones, Steven Swann (1993) 'The Innocent Persecuted Heroine Genre: An Analysis of Its Structure and Themes', *Western Folklore* v52 n1: 13–41

Jones, Valerie (1999) 'The Phoenix and Resurrection' in Hassig, Debra (ed) *The Mark of the Beast: The Medieval Bestiary in Art, Life and Literature,* New York: Garland: 99-116

Jordaan, Roy (1984) 'The Mystery of Nyai Lara Kidul, Goddess of the Southern Ocean', *Archipel* n28: 99-116

——- (2001) 'The Causeway episode of the Prambanan Ramayana Reexamined', in Acri, Andrea, Creese, Helen and Griffiths, Arlo (eds) *From Lanka Eastwards,* Leiden: KITLV Press: 179-208

——- (2011) 'Rama, Ratu Kidul and the Buddha', in Manjushree (ed) *From Beyond the Eastern Horizon,* New Delhi: Aditya Prakashan: 253-267

Ju, Yeong-Taek (2012) 'Hwang-Ok Gongjuwa Dongbaekseom Ineosang', *Gukje* May 6th: http://www.kookje.co.kr/news2011/asp/newsbody.asp?code=0300&key=20120507.22025193552 – accessed October 26th 2017

Judgment of Paris (2005) 'Feminist disfigurement of mermaid's body': http://www.judgmentofparis.com/board/showthread.php?t=2050 – accessed July 30th 2017

Kalms, Nichole (2016) 'Meter Maids, promotional models and our disturbingly hypersexual cities', *The Conversation* July 28th: http://theconversation.com/meter-maids-promotional-models-and-our-disturbingly-hypersexual-cities-56438 – accessed May 2nd 2017

Kelemen, Pál (1967) *Baroque and Rococo in Latin America* Volume (2nd edition), New York: Dover

Kerala Tourism (nd) 'Jalakanyaka at Shanghumukham beach, Thiruvananthapuram': https://www.keralatourism.org/photo-gallery/jalakanyaka-shanghumukham-beach/6 – accessed July 19th 2017

Kerr, George (2000) *The History of an Island People* (revised edition), Hong Kong: Periplus editions

Kil, Sonia (2016) 'Gianna Jun and Lee Min-Ho to Star in Korean TV Series "Blue Sea"', *Variety.com* May 30th: http://variety.com/2016/tv/asia/gianna-jun-lee-min-ho-korean -tv-blue-sea-1201785394/ – accessed September 27th 2017

Kim, Ji-Won (2009) *Bada Gidam,* Paju: Cheong-A Publishing Co.

King, Heather (2011) *Mimih: The Mindil Beach Mermaid,* Sydney: Little Steps

Kirkpatrick, Peter (2015) 'Slessor: Selected Poems', Copyright Agency Reading Australia: https://readingaustralia.com.au/essays/slessor-selected-poems/ - accessed March 5th 2018

Klein, Alyssa (2016) 'Laolu Senbanjo Takes us Inside the Spiritual World of Afromysterics', *OkayAfrica* March 24th: http://www.okayafrica.com/culture-2/laolu-senbanjo- afromysterics-art – accessed July 30th 2017

Kochi Connect (2015) 'Kochi to have an iconic statue of the Mermaid Queen,' Kochi Connect Facebook item, January 7th: https://www.facebook.com/KochiKonnectOfficial/ photos/a.202771009807745.50763.202412496510263/760943033990537/?type=3

Kraicer, Shelly (2016) 'Under the Sea, Under the Censors', *Los Angeles Review of Books* May 6th: https://lareviewofbooks.org/article/sea-censors-mainland-success-stephen-chow/ – accessed June 21st 2017

Kreemer, J (1879) 'Blorong of de geldgodin der Javanen', *Mededeelingen van wege het Nederlandsche Zendelinggenootschap* n23: 1-12

Kudaka, Shoji (2017) 'Miyakojima: An island full of spectacle', *Stripes Japan* July 24th: https://japan.stripes.com/travel/miyakojima-island-full-spectacle - accessed March 5th 2018

Kumar, R Siva (2016) '"I am an artist activist, not an activist artist": Why KG Subramanyan (1924-2016) and his art matter', *Scroll.in* June 30th: https://scroll.in article/810875/i-am-an-artist-activist-not-an-activist-artist-why-kg-subramanyan-1924-2016-and-his-art-matter - accessed March 5th 2018

Kumari, M Krishna (1988) 'An Approach to the Erotic Sculpture of the Ramappa Temple', *Proceedings of the Indian History Congress* v49: 151-155

La Motte-Fouqué, F.H.K (1811/1823) *Undine* (translated by Soane, George), New York: Circulating Library and Dramatic Repostory

Lai, Racliffe, Perkins, Matthew, Ho, Kevin, Astudillo, Juan et al (2016) 'Hong Kong's marine environments: History, challenges and opportunities', *Regional Studies in Marine Science* v8 part 2: 259-273

Lazcano, R.L (2012) 'Nuestra Señora de Regla en la Historia Sacra, obra inédita de Diego de Carmona Bohórquez, OSA (1590-CA. 1653)', *Analecta Augustiniana* v75: 245–300

Leclercq-Marx, Jacqueline (1997) *La Sirène dans la pensée et dans l'art de l'Antiquité et du Moyen Âge: du mythe païen au symbole chrétien*, Brussels: Académie royale de Belgique

Lee, Joel (2016) 'Little Mermaid's replica statue unveiled in Seoul,' *Korea Herald*, October 31st: http://www.koreaherald.com/view.php?ud=20161031000768 – accessed October 3rd 2017

Lee, Sang-Guk (2015) 'Juk-Hyang, Joseonshidae Ineo Gongju', *Asian Economy* July 24th: http://www.asiae.co.kr/news/view.htm?idxno=2015072411162434419 – accessed October 8th 2017

Lee, Sung-Ae (2011) 'Lures and Horrors of Alterity: Adapting Korean Tales of Fox Spirits', *International Research in Children's Literature* v4 n2: 135–150

—— (2014) 'Fairy-Tale Scripts and Intercultural Conceptual Blending in Modern Korean Film and Television Drama', in Joosen, Vanessa and Lathey, Gillian (eds) *Grimms' Tales Around the Globe: The Dynamics of Their International Reception,* Detroit: Wayne State University Press: 275–293

—— (2016) 'The Fairy-Tale Film in Korea', in Zipes, Jack, Greenhill, Pauline and Magnus-Johnston, Kendra (eds) *Fairy-Tale Films Beyond Disney: International Perspectives*, New York: Routledge: 207–221

Lévi-Strauss, Claude (1964) *Le Cru et le Cuit*, Paris: Plon

Linnaeus, Carl (1768) *Systema Naturae*, archived online at: https://archive.org/ details/cbarchive_53979_linnaeus1758systemanaturae1758 - accessed 5th March 2018

Long, Daniel (2017) 'Ningyo, dugong and other related terms', (unpublished) Tokyo Metropolitan University research paper

Loven, Klarijn (2008) *Watching Si Doel: Television, language and cultural identity in contemporary Indonesia*, Leiden: KITLV Press

Lueck, Thomas L (2003) 'Mermaid forced to cover up settles with City for $10,000', *New York Times* April 23[rd]: http://www.nytimes.com/2003/04/23/nyregion/mermaid-forced-to-cover-up-settles-with-city-for-10000.html – accessed May 21[st] 2017

Lynch, Scott (2016) 'Nearly Naked Revellers Enjoying Glorious Mermaid Parade', *Gothamist* June 19th: http://gothamist.com/2016/06/19/100_photos_mermaid_parade_2016.php# photo-50 – accessed May 28th 2017

Lyne, Amy (2017) 'Mermaid makes splash stop in Toowomba', *The Chronicle*, January 21st: https://www.thechronicle.com.au/news/mermaid-makes-splash-stop-in-toowoomba/3134094/ – accessed June 15th 2017

MacCormack, Patricia (2004) 'Perversion: Transgressive Sexuality and Becoming Monster', *Third Space* v3 n2, archived online at: http://journals.sfu.ca/thirdspace/index.php/ journal/article/viewArticle/maccormack/174 – accessed June 28th 2017

Machimaya, Tomo (2005) 'The Illustrated Man: The Hideshi Hino Interview', *Comics Journal* 2005 Special Edition: 35-41

MacRitchie, John (2004) *The First Surf Carnival*, Manley: Manley Library

Madathara, Karnan (2017) 'Sculptures of Kanayai Kunhiraman': http://b3.zcubes.com/v.aspx? mid=205383&title=sculptures-of-kanayi-kunhiraman – accessed March 5th 2018

Malhotra, Rajiv (2007) 'The axis of neo-colonialism', *World Affairs* v11 n3: 36-67

Malayattoor Ramakrishnan (1967) *Yakshi*, New Kottayam: D.C. Books

Marine Foundation (nd) 'Amed Mermaid': http://themarinefoundation.org/projects/ amed-mermaid/ - accessed March 3rd 2018

Markus, Andrew L (1985) 'The Carnival of Edo: *Misemono* Spectacles from Contemporary Accounts', *Harvard Journal of Asiatic Studies* v45 n2: 499-541

Mason, David A (2014) 'Yongwang – Dragon King of the Waters – Supplementary Entries and Texts for the Encyclopedia of Korean Buddhism': http://www.san-shin.org/EKB-Yongwang-DragonKing.html – accessed September 8th 2017

Mattson, Kelcie (2014) 'TIFF Women Directors: Meet Shada Ameen – 'Eye & Mermaid', *IndieWire* September 13th: http://www.indiewire.com/2014/09/tiff-women-directors-meet-shahad-ameen-eye-mermaid-205871/ – accessed November 6th 2017

Mejía, Pedro de (1540/1673) *Silva de varia lección*, Madrid: Matheo de Espinosa y Arteaga, archived online at: http://www.bibliotecavirtualdeandalucia.es/catalogo/consulta/ registro.cmd?id=6710 - accessed March 4th 2018

Mena, Juan de (1989) *Obras completas* (Pérez, Priego [ed]), Barcelona: Planeta

Menez, Herminia (1996) *Explorations in Philippine Folklore* (1996), Quezon City: University of Manila Press

Moncayo, Raul (2012) *The Signifier Pointing at the Moon: Psychoanalysis and Zen Buddhism*, London: Karnac

Morgan, Mogg (2014) '"Bride of the Nile"- An Orientalist Myth about Egyptian culture?' *Astro Egypt* October 12th: https://mandoxegypt.wordpress.com/2014/10/12/ bride-of-the-nile-an-orientalist-myth-about-egyptian-culture/ – accessed September 2nd 2017

Morfaw, F.L.I and Nana, Philip N (2012) 'Sirenomelia in a Cameroonian woman: a case report and review of the literature', *F1000Research* v1 n6: https://www.ncbi.nlm.nih.gov/pmc/articles/PMC3917649/ - accessed March 2nd 2018

Moxley, Mitch (2016) 'Sunk: How a Chinese billionaire's dream of making an underwater fantasy blockbuster turned into a legendary movie fiasco', *Atavist Magazine*: https://magazine.atavist.com/sunk – accessed June 17th 2017

Mujica Pinilla, R (1999) '"Dime con quién andas y te diré quién eres." La cultura clásica en una procesión sanmarquina de 1656', in Hampe Martínez, T (ed) *La tradición clásica en el Perú Virreinal*, Lima: Universidad Nacional Mayor de San Marcos: 191-217

Murphy, Joseph M and Sanford, Mei-Mei (eds) (2001) *Osun across the Waters: A Yoruba Goddess in Africa and the Americas,* Bloomington: University of Indiana Press

Murphy, Joseph M (1993) *Santeria: African Spirits in America*, Boston: Beacon Press

Munro, Joyce Underwood (1997) 'The Invisible Made Visible: The Fairy Changeling as a Folk Articulation of Failure to Thrive in Infants and Children', in Narváez, Peter (ed) *The Good People: New Fairylore Essays*, Lexington: University Press of Kentucky: 251-283

Mustard, Wilfred P (1908) 'Siren-mermaid', *Modern Language Notes* v23 n1: 21-24

Nam, Sang-Hak (nd) 'Ineoui jeonseol ganjikhan seom Jangbongdo': http://www.poemlane.com/bbs/zboard.php?id=moeum&page=29&sn1=&divpage=1&sn=off&ss=on &sc=on&select_arrange=headnum&desc=asc&no=198 – accessed October 26th 2017

National Museum of Australia (nd) 'Yawkyawk sculptures': http://www.nma.gov.au/collections/highlights/yawkyawk-sculptures – accessed July 26th 2017

Nchee (2014) 'President Zuma Accused of Witchcraft! Mermaids found in Nkandla's "Fire Pool"!', Economic Freedom Fighters website August 14th: http://www.economicfreedomfighters.org/president-jacob-zuma-accused-of-witchcraft-mermaids-fou d-in-nkandlas-fire-pool/ – accessed March 28th 2017

Newling, Dan (2014) 'South African president Zuma reveals he used to practice witchcraft against white people', Daily Mail January 10th: http://www.dailymail.co.uk/news/article-2536513/South-African-president-Zuma-reveals-used-practice-witchcraft-against-white-p eople.html – accessed March 28th 2017

Nie Huang (1698/2014) Hai Cuò Tú, Beijing: Gu gong chu ban she

Nielsen AGB (2017) 'Top 20 List for TV Programs': http://www.nielsenkorea.co.kr/tv_terrestrial_day.asp?menu=Tit_1&sub_menu=1_1&area=00&begin_date=20170119 – accessed September 27th 2017

Nishimura, Sutezo (1884) Miyakojima Kyushi (archival document), publisher unknown

Noronha, Percival (1997) 'Old Goa in the context of Indian Heritage', in Borges, Charles, J and Feldmann, Herman (eds) Goa and Portugal: Their cultural links, New Dehli: Concept Publishing Company: 155-169

Nyoman Sedana, I. (2015) 'Contemporary extensions of ancient Bali-India Connections within Balinese traditional theatre', in Tripati, Sila (ed) Maritime Contacts of the Past: Deciphering Connections Amongst Communities, New Dehli: Delta Book World: 641-673

Okinawa Clip (nd) website (main page): http://okinawaclip.com/en – accessed April 4th 2017

—— (2014) 'National Natural Treasure Full of Mystery! "Toori-ike Pond" in Shimoji Island', Okinawa Clip October 21st: http://okinawaclip.com/en/detail/336 – accessed April 3rd 2017

—— Osamu Tezuka (1969-71) Umi no Triton series, Sankei Shimbun

Ouwehand, C (1964) Namazu-e and their themes: An interpretative approach to some aspects of Japanese Folk Religion, Leiden: Brill

Parayno, S.M (1997) Children's Literature. Hong Kong: Goodwill Trading Company

Park, Jin-Hai (2016) 'Legend of the Blue Sea is our own ancient mermaid story', The Korea Times November 14th: http://www.koreatimes.co.kr/www/news/culture/2016/11/201_218209.html – accessed September 26th 2017

Paxson, Barbara (1983) 'Mammy Water: New World Origins?', Baessler-Archiv, Neue Folge n31: 407–446

Payne-Jackson, A and Alleyne, M.C (2004) Jamaican Folk Medicine: A Source of Healing, Kingston: University of West Indies Press

Pedrosa, J.M (2015) 'Las sirenas, o la inmortalidad de un mito (una visión comparatista)', Revista Murciana de Antropología n22: 239-300

Pekeur, Aldo (2008) 'Mysterious "mermaid" rises from the river', IOL January 16th: http://www.iol.co.za/news/south-africa/mysterious-mermaid-rises-from-the-river-385945 – accessed March 28th 2017

Pereira, Ivan (2017) 'Coney Island Mermaid Parade needs thousands in donations to continue', AM New York: http://www.amny.com/news/coney-island-mermaid-parade-needs-thousands-in-donations-to-continue-1.13589530 – accessed May 22nd 2017

Pereira, Jose (1995) Baroque Goa: The Architecture of Portuguese India, South Asia Books

Perez, Julia (2016) 'Aston Sunset Beach, Gili Trawangan', Instagram post, October 15th, Julia Perez account: juliaperrezz

Pietsch, Theodore W (1991) 'Samuel Fallours and his "Sirenne" from the province of Ambon,' Archives of Natural History v18 n1: 1-25

Polo, Jaime B (1985) 'Of Metaphors and Men: The Binalayan Fishcorral ritual as a contract in a social spectrum', Philippine Sociological Review v33 n3/4: 54-63

PTI, Panaji (2013) "Mermaids to spread anti-abuse message in Panaji", GoaNews 9th May: http://www.goanews.com/news_disp.php?newsid=3526 – accessed March 5th 2018

Pupaka, Annchalee (2015) 'King Rama V's Travelogues: The Distribution of Modern Knowledge', Silpakorn University Journal of Social Sciences, Humanities and Arts v15 n1: 31-49

Queensland Government, Minister for Science, Information Technology, Innovation and the Arts (2014) 'Queensland's Mako Mermaids hooks TV viewers' (press release): http://statements.qld.gov.au/Statement/2014/4/23/queenslands-mako-mermaids-hooks-tv-viewers – accessed May 4th 2017

Rakotomalala, Jean Robert (2013) 'La Sirene, I ou A: Pragmatique D'un Mythe', Université de Nantes Research Paper, online at: hal.univ-nantes.fr/hal-01231365/document – accessed August 15th 2017

Ramos, Maximo D (1971) *Creatures of the Philippine Lower Mythology*, Quezon City: University of the Philippines Press

Rao, Sirishm Wolf, Gita and Shyam, Bhajju (2009) *The Flight of the Mermaid*, Chennai: Tara Books

Ravelo, Mars and Elpido, Torres (1952-1953) *Dyesebel* series, Pilipino Komiks

—— (1963-1964) *Anak ni Dyesebel* series, Liwayay

Raynor, V (1989) 'ART; The Antheneum Displays the Show it sent to France', *New York Times* June 11th: http://www.nytimes.com/1989/06/11/nyregion/art-the-antheneum-displays-the-show-it-sent-to-france.html – accessed July 30th 2017

Real Academia Española (1726-39) *Diccionario de autoridades* (vIV [1734] and vV [1737]), Madrid: Francisco del Hierro, archived online at: http://www.rae.es/recursos/diccionarios/diccionarios-anteriores-1726-1996/diccionario-de-autoridades – accessed January 10th 2018

Regnoni-Macera, C (1963) 'Review: *Cuentos Folkloricos de la Argentina: Introduccion, Clasificación y Notas* by Susana Chertudi', *Western Folklore* v22 n1: 59-60

Relke, Joan (2007) 'The Archetypal Female in Mythology and Religion; The Anima and the Mother', *Europe's Journal of Psychology* v3 n1, online at: http://ejop.psychopen.eu /article/view/389/html – accessed April 30th 2015

Reyes, Severino (1925/2011) 'Ang Sirena sa Uli-Uli ng Ilog Pasig,' in *Mga Kuwento ni Lola Bysyang*, Makati City: Tahanan Publishing

Richardson, Owen (2016) 'Aftermath of traumatic events in South Korea', *The Sydney Morning Herald* March 27th: http://www.smh.com.au/entertainment/books/m26booksrev1- 20160321-gnnj9t.html – accessed October 6th 2017

Robert (2008) 'And Now, a Coney Island "Mermaid Hunger Strike"', *Curbed New York*: https://ny.curbed.com/2008/6/19/10567498/and-now-a-coney-island-mermaid-hunger-strike – accessed May 20th 2017

Roberts, K and Downs, K (2016) 'What Beyoncé teaches us about the African diaspora in "Lemonade"' *PBS News Hour*, April 29th: http://www.pbs.org/newshour/art/what-beyonce-teaches-us-about-the-african-diaspora-in-lemonade – accessed July 30th 2017

Rodney (2010) 'Empires of the Deep Set Photos Online', *The Movie Blog* June 9th: http://www.themovieblog.com/2010/06/empires-of-the-deep-set-photos-online/ – accessed June 17th 2017

Rosenbaum, Jonathan (2000) 'The World is Watching: Suzhou River', *Chicago Reader* March 8th 2001: https://www.chicagoreader.com/chicago/the-world-is-watching/Content?oid =904820 - accessed March 3rd 2018

Rowan, Bernard (2017) 'Remember Dongbaekseom', *The Korea Times* August 2nd, online at: http://www.koreatimes.co.kr/www/opinion/2017/08/625_234007.html – accessed September 8th 2017

Rubinstein, Gillian (1999) *Mermaids of Bondi Beach*, Sydney: Hodder Children's Books

Russian Laboratory of Theoretical Folkloristics (2104) 'Conference "Mechanisms of Cultural Memory: From Folk-Lore to Media-Lore"', RANEPA website: http://www.ranepa.ru/eng/activities/item/604-cultural-memory.html – accessed July 10th 2015

Sallis, Eva (1999) *Sheherazade Through the Looking Glass: The Metamorphosis of the Thousand and One Nights*, London: Routledge

Salvador Miguel, N (1998) 'Las sirenas en la literatura medieval española', in Santonja, G (ed) *Sirenas, monstruos y leyendas (Bestiario marítimo)*, Segovia: Sociedad Estatal Lisboa n98: 87-120

Samuels, A.J (nd) 'Fish, Freud and Feminine Beauty in the Art of Ellen Gallagher', *The Culture Trip*: https://theculturetrip.com/north-america/usa/rhode-island/articles/fish-freud-and-feminine-beauty-in-the-art-of-ellen-gallagher – accessed July 30th 2017

San Martín, Herban (1961) 'La santería cubana', *Anales de la Universidad de Chile* n124: 150–156

Sanders, Noel (1982) 'Bondi The Beautiful': The Impossibility of an Aesthetic, The New South Wales Institute of Technology Media Papers n16

Sargent, Antwaun (2016) 'Afrofuturist Museum Mines Artifacts from the Future', Creators/Vice Magazine May 22nd: https://creators.vice.com/en_us/article/8qv34x/afrofuturist-museum-artifacts-from-the-future – accessed July 30th 2017

Sauvalle, Julien (2014) 'Hot List: Jacolby Satterwhite: Turning hardship into visual ecstasy', Out Magazine May 6th: https://www.out.com/out-exclusives/hot-list-2014/2014/05/06/hot-list-jacolby-satterwhite-queer-artist-turning-hardship – accessed July 30th 2017

Schmidt, Christine (2012) The Swimsuit: Fashion from Poolside to Catwalk, London: Berg

Schmidt, Christopher K (2009) 'Loanwords in Japanese' in Haspelmath, Martin and Tadmor, Uri (eds) Loanwords in the World's Languages: A Comparative Handbook, Den Hague: De Gruyter Mouton: 545-574

Sequeira, Isaac (1986) 'The Carnival in Goa', Journal of Popular Culture v20 n2: 167-173

Shibu, B.S (2016) 'Mermaid project dives into oblivion', New Indian Express October 26th: http://www.newindianexpress.com/cities/kochi/2016/oct/25/mermaid-project-dives-into-oblivion-1531792.html – accessed July 2nd 2017

Siffredi, Alejandra (1995) 'La atenuación de las fronteras entre mito e historia: la expresión del contacto en el ciclo de Elal', Cuadernos del Instituto Nacional de Antropología y Pensamiento Latinoamericano n16: 171-190

Sin, Ben (2016) 'Film review: Mermaid – Stephen Chow's environmental morality tale', South China Morning Post February 11th: http://www.scmp.com/lifestyle/film-tv/article/1911884/film-review-mermaid-stephen-chows-environmental-morality-tale - accessed March 5th 2018

Singh, Isha Priya (2014) 'Lucknow Ki Machhliya'n', Lucknow Observer November 5th: http://lucknowobserver.com/lucknow-ki-machhliyan/ – accessed July 17th 2017

Sitney, P Adams (1974) Visionary Film, Oxford: Oxford University Press

Slessor, Kenneth (1932) 'Atlas' in Cuckooz Contrey, Sydney: Frank Johnson

Somerset College (2017) 'Sandy's Surfers Paradise Adventure': http://www.somerset.qld.edu.au/news/senior/sandy-s-surfers-paradise-adventure/ – accessed June 15th 2017

Spivak, Caroline (2017) 'Shock-rocker and burlesque queen tie the knot at Mermaid Parade', Brooklyn Paper June 21st: http://www.brooklynpaper.com/stories/40/25/bn-mermaid-parade-wedding-2017-06-23-bk.html – accessed 28th 2017

Spurrier, Jeff (1989) 'Okinawa: Where emotions run deep', Islands September-October: 99-112

Stadtman, Todd (2013) 'Dyesebel,' Die, Danger, Die, Die, Kill! Blog: http://diedangerdiediekill.blogspot.com.au/2013/01/dyesebel-philippines-1953-and-dysebel.html – accessed December 14th 2017

Statistics Portal (2017) 'Philippines: Urbanization from 2006-2016': https://www.statista.com/statistics/455910/urbanization-in-philippines/ – accessed January 3rd 2017

Stevenson, Robert Louis (1883) Treasure Island, London: Cassel and Company

Stobart, Henry (2006) 'Devils, daydreams, and desire: siren traditions and musical creation in the Central-Southern Andes', in Naroditskaya, Inna and Austern, Linda Phyllis (eds) Music of the Sirens, Bloomington: Indiana University Press: 105-139

Sullivan, Felicia (2009) 'Interview: Singer/Songwriter Lizzy Grant on Cheap Thrills, Elvis, The Flamingo Trailer Parks, and Coney island,' Huffington Post Blog February 20th: http://www.huffingtonpost.com/felicia-c-sullivan/interview-singersongwrite_b_159346.html - accessed 2nd March 2018

Superle, Michelle (2011) Contemporary English-Language Indian Children's Literature: Representations of Nation, Culture and the New Indian Girl, New York: Routledge

Supot, Anawatkochakorn (2001–2006) Apaimanee Saga, serialised in Boom 2001-2006

Suwa, Juni'chiro (2012) 'Shima and Aquapelagic Assemblages: A Commentary from Japan', Shima v6 n1: 12-16

Swanson, Chang-Su (1968) 'Problems and Solutions: Korean Folktales and Personality', The Journal of American Folklore v82 n320: 121–132

Tafur, Pero (1874) *Andanças é viajes de Pero Tafur por diversas partes del mundo avidos: (1435–1439)* (Jiménez de la Espada, M [ed]), Madrid: Miguel Ginesta, archived online at: https://archive.org/details/andanasviajesde01tafugoog – accessed September 7th 2017

Tahiko, Kimura (2002-2010) *Seto no Hanayome* series, *Monthly Gangan Wing* (2002-2009) and *Monthly Ganagan Joker* (2010)

Takahashi, Rumiko (1984-1994) *Ningyo Shirîzu* series, *Weekly Shônen Sunday*

Taylor, Jean Gelman (1983) *The Social World of Batavia: European and Eurasian in Dutch Asia*, Madison: University of Wisconsin Press

Taylor, Lucien (2014) *Visualizing Theory: Selected Essays from V.A.R., 1990-1994*, New York: Routledge

Torquemada, Antonio de (1540/2012) *Jardín de Flores Curiosas* (Enrique Suárez Figaredo [ed]), *Lemir* n16 Textos: 605-834

Travel 67 (2009) 'Island Icons: Artist Naka Bokunen': https://travel67.com/2009/12/20/island-icons-artist-naka-bokunen/ – accessed April 5th 2017

Tsokhas, K (1996) 'Modernity, sexuality and national identity: Norman Lindsay's aesthetics', *Australian Historical Studies* v27 n107: 219-241

Turgeon, Carolyn (2011) 'Bambi the Mermaid: Queen of Coney Island', *I am a mermaid* website: https://iamamermaid.com/2011/03/02/bambi-the-mermaid-coney-islands-mermaid-queen/ – accessed May 27th 2017

Turino, Thomas (1983) 'The Charango and the "Sirena": Music, Magic, and the Power of Love', *Latin American Music Review/Revista De Música Latinoamericana* v4 n1: 81-119

Ulfstjerne, Michael (2016) 'The artyficial paradise: municipal face-work in a Chinese boomtown', in Keane, Michael (ed) *Handbook of Cultural and Creative Industries in China*, Cheltenham: Edward Elgar: 80-94

Unattributed (nd) Shān Hai Jîng, archived online at: https://ctext.org/shan-hai-jing - accessed March 4th 2018

—— (1930) 'Coney Island to Ban "Petting" This Summer', *The New York Times* May 13th: 28

—— (1960) 'Mermaid at Bondi (once there were two…)', *The Women's Weekly* June 1st: 3

—— (1996) 'Mermaids return to Bondi Beach', *Wentworth Courier* December 24th: 4

—— (2005a) 'Row over "mermaid sculpture" on Kollam Beach', *The Hindu* March 18th: http://www.thehindu.com/2005/03/19/stories/2005031908650300.htm – accessed July 2nd 2017

—— (2005b) 'Minister to unveil mermaid sculpture', *The Hindu* August 1st: http://www.thehindu.com/2005/08/01/stories/2005080101000200.htm – accessed July 2nd 2017

—— (2010) 'Mermaids in Distress', *The Hindu* February 3rd: http://www.thehindu.com/todays-paper/tp-national/tp-andhrapradesh/Mermaids-in-distress/article15977310.ece - accessed October 23rd 2017

—— (2011) 'Mermaids in Distress' (Updated), *The Hindu* June 30th, online at: http://www.thehindu.com/todays-paper/tp-national/tp-andhrapradesh/mermaid-in-distress/article21464 15.ece - accessed March 2nd 2018

—— (2015) 'Mermaid Queen: A Fitting Tribute to Kochi', *New Indian Express* January 7th: 1

—— (2017) 'Fotographer Ini Merinding saat memotret Julia Perez sebagai ny Roro Kidul, *Tribun Sumsel* June 14th: online at: fotografer-ini-merinding-saat-memotret-julia-perez-sebagai-nyi-roro-kidul – accessed March 1st 2018

Urban, Hugh (2003) *Tantra: Sex, Secrecy, Politics, and Power in the Study of Religion*, Berkeley: University of California Press

Valdes, Vanessa, K (2014) *Oshun's Daughters: The Search for Womanhood in the Americas*, New York: State University of New York Press

Valdez, Euden (2017) '3 tourist-friendly provinces that will teach us about water this summer', *Philstar* May 9th: http://www.philstar.com/travel-and-tourism/2017/05/09/1689866/3-tourist-friendly-provinces-will-teach-us-about-water-summer - accessed March 23rd 2017

van Stipriaan, Alex (2003) 'Watramama/Mami Wata: Three Centuries of Creolization of a Water Spirit in West Africa, Suriname and Europe', *Matatu–Journal for African Culture and Society* n27: 323–337

Vidal de Battini, Berta Elena (2010) *Cuentos y leyendas populares de la Argentina*, Alicante: Biblioteca Virtual Miguel de Cervantes (digital edition based on 1984 edition – Buenos Aires: Ediciones Culturales Argentinas), archived online at: http://www.cervantesvirtual.com/nd/ark:/59851/bmcz6139

Villena, Enrique de Aragaon (1776) *Arte cisoria, ó Tratado del arte de cortar del cuchillo, / que escrivió Don Henrique de Aragon, Marques de Villena*, Madrid: Antonio Marín, archived online at: hdl.handle.net/10481/34817

Virtue, Doreen (2005) *Goddesses and Angels: Awakening Your Inner Princess and "Source-eress"*, Carlsbad: Hay House

Viscardi, Paulo, Hollinsghead, Anita, MacFarlane, Riss and Moffatt, James (2014) 'Mermaids Uncovered', *Journal of Museum Ethnography v27*: 98–116.

Vistarini, A and Sajó, T (2012) *Studiolum*, online at: http://www.studiolum.com/ en/colophon.htm - accessed March 9th 2018

Wainaina, B and Edwards, A (2014) *Wangechi Mutu – Nguva Na Nyoka*, London: Victoria Miro Gallery

Warshaver, G.E (1991) 'On Postmodern Folklore', *Western Folklore v50 n3*: 219-229

Waverly Council (1997) 'Minutes C-9802.5': http://www1.waverley.nsw.gov.au/ council/meetings/minutes/980224/C9802.htm – accessed May 8th 2017

——- (nd) 'The Bondi Mermaids': http://www.waverley.nsw.gov.au/__data/assets/pdf_file/ 0005/8672/Bondi_Mermaids_The.pdf – accessed April 27th 2017

Weheliye, A.G (2005) *Phonographies: Grooves in Sonic Afro-Modernity*, Durham: Duke University Press

Weiss, Alan S (1994) *Perverse Desire and the Ambiguous Icon*, New York: State University of New York Press

Wenje, Li (2014) *A Study of Chinese Translations of H.C. Andersen's Tales*, Copenhagen: University of Copenhagen: https://curis.ku.dk/ws/files/113619680/Ph.d._2014_Li.pdf – accessed June 29th 2017

Wessing, Robert (1997) 'Nyai Roro Kidul in Puger: Local Applications of a Myth', *Archipel Année v53 n1*: 97-120

Wheeler, Karen (2012) 'Mermaids in the Karoo', *News 24* April 30th: http://www.news24.com/Travel/Mermaids-in-the-Karoo-20120430 – accessed March 29th 2017

White, David Gordon (2006) *Kiss of the Yogini: "Tantric Sex" in its South Asian Contexts*, Chicago: University of Chicago Press

Wilde, Oscar (1891) 'The Fisherman and his Soul', archived online at: http://www.eastoftheweb.com/short-stories/UBooks/FisSou.shtml – accessed October 17th 2017

Wilkins, W.J (1900) *Hindu Mythology, Vedic and Puranic*, London: Thacker, Spink and Co

Woollacott, Angela (2011) *Race and the Modern Exotic: Three 'Australian' Women on Global Display*, Melbourne: Monash University Press: http://books.publishing.monash.edu/apps/ bookworm/view/Race+and+the+Modern+Exotic%3A+Three+%E2%80%98Australian%E2%80%99 +Women+on+Global+Display/173/OEBPS/c01.htm - accessed March 2nd 2018

The Wugularr Aboriginal Community with Thompson, Liz (2010) *The Mermaid and Serpent*, Port Melbourne: Harcourt Education

Xiaoping Lin (2002) 'New Chinese Cinema of the 'Sixth Generation': A Distant Cry of Foresaken Children', *Third Text v16 n1*: 262-284

Yeosu Expo (2012) 'The Mermaid Legend of Geomundo to be revived by a master French director', *Expo 2012, Yeosu, Korea*: https://2012expo.wordpress.com/ 2011/12/08/the-mermaid-legend-of-geomun-do-to-be-revived-by-a-master-french- director/ – accessed September 7th 2017

Yokote, Michiko (2002-2005) *Māmeido Merodî Pichi Pitchi* series, *Nayoshi*

Young, Simon (2017) 'Against Taxonomy: The Fairy Families of Cornwall', *Cornish Studies n21*: 223-237

Yu, Mong-In (2006 [1621]) *Eou Yadam* (translated by Shin, Ik-Cheol, Lee, Hyeong-Dae, Jo, Yung-Hi, and No, Yeong-Mi), Seoul: Dolbege

Zhang, Xudong (2008) *Postsocialism and Cultural Politics: China in the Last Decade of the Twentieth Century*, Durham: Duke University Press

Zŏng, In-Sŏb (1982) *Folk Tales from Korea* (third edition), Seoul: Hollym

upanov, Ines G (2014/2015) 'The pulpit trap: Possession and personhood in colonial Goa', *Res: Anthropology and Aesthetics n65-66*: 298-315

Chronological catalogue of audiovisual productions featuring mermaids and mermen referenced in the volume

1911	*Siren of the Sea* (director unknown, USA)
1911	*The Mermaid* (director unknown, USA)
1914	*Neptune's Daughter* (Herbert Brenon, USA)
1916	*A Daughter of the Gods* (Herbert Brenon, USA)
1918	*Queen of the Sea* (John Adolfi, USA)
1924	*Venus of the South Seas* (James Sullivan, New Zealand)
1938	*Merbabies* (Rudolf Isling and Vernon Stallings, USA)
1941	*Ikan Doejeng* (Lie Tek Swie, Dutch East Indies)
1953	*Dyesebel* (Gerardo de Leon, Philippines)
1953	*Peter Pan* (Clyde Geronimi, Wilfred Jackson and Hamilton Luske, USA)
1954	*The Creature from the Black Lagoon* (Jack Arnold, USA)
1959	*Zhuîyú* (Ying Yunwei, China)
1964	*Ningyo* (Tezuka Osamu, Japan)
1966	*Miranda* (Richard Abelardo, Philippines)
1972	*Umi no Triton* (TV series, Japan)

1973	*Ang Mahiwagang Daigdig ni Pedro Penduko* (Celso Ad. Castillo, Philippines)
1973	*Si Dyesebel at ang Mahiwagang Kabibi* (Emmanuael Borlaza, Philippines)
1975	*Lorelei* (Danilo Santiago, Philippines)
1978	*Duyung Ajaib* (Benjamin Sueb, Indonesia)
1978	*Sisid, Dyesebel, Sisid* (Anthony Taylor, Philippines)
1979	*Sudsakorn* (Payut Ngaokrachang, Thailand)
1984	*Splash!* (Ron Howard, USA)
1985	*Arous al-Bohoor (episode of TV Series Alf Leilah w Leilah*, director unknown, Egypt)
1985	*Bangunnya Nyi Roro Kidul* (Muradi Indonesia)
1985	*Putri Duyung* (Atok Suharto, Indonesia)
1988	*Manhôre no Naka no Ningyo* (Hino Hideshi, Japan)
1988	*Si Baleleng at ang gintong sirena* (Chito Roño, Philippines)
1989	*Cherish* (Madonna music video, Herb Ritts, USA)
1989	*Pembasalan ratu pantai selatan* (H. Tjut Djalil, Indonesia)
1989	*The Little Mermaid* (Ron Clements and John Musker, USA)
1990	*Coney Island Mermaid* (Karen Kramer, USA)
1990	*Dyesebel* (Mel Chionglo, Philippines)
1991	*Laal Paree* (Hannif Chippa, India)
199?	*Arous al-bahr* (episode of TV series *Kan Yamam Kan* [1992-199], director unknown, Syria)
1994	*Rényú chuánshua* (Norman Law, Hong Kong)
1996	*Sahasa Veerudu Sagara Kanya* (K. Raghavendra Rao, India)
1997	*Densetsu no Māmeido* (Nagashime, Japan)
1999	*Sabrina Down Under* (Daniel Berendsen, USA)
2000	*Sûzhôuhé* (Lou Ye, China)
2001	*Halik na sirena* ('Kiss of the Sirena') (Joven Tan, Philippines)
2002	*Phra Aphai Mani* (Chalart Sriwanda, Thailand)
2004	*Ā! Ikkenya* (Kudo Naoki, Japan)
2004	*Marina* (TV series, Philippines)
2004	*Marinara* (TV series, Philippines)
2005	*Darna* (TV series, Philippines)
2006	*Aquamarine* (Elizabeth Arden, USA)
2006	*Da Adventures of Pedro Penduko* (TV series, ABS-CBN, Philippines)
2006	*Ngueak saw chao sanae* (Chachai Kaewsawang, Thailand)
2006	*Sudsakorn* (Krisom Buramasing, Thailand)
2006-2010	*H2O: Just Add Water* (TV series, Australia)
2007	*Sissy Si Putri Duyung* (TV Series, Indonesia)
2007	*Wang Ngang Ngueak* (Wichian Thain, Thailand)
2008	*Dashavatar* (Bhavik Thakore, India)
2008	*Gake no Ue no Ponyo* (Hayao Miyazaki, Japan)
2008	*Mars Ravelo's Dysebel* (TV Series, Philippines)
2008	*Putri Duyung & 100 kebaikan* (TV series, Indonesia)
2008-2009	*Dyosa* (TV series, Philippines)
2009	*In Search of Mermaids in the Karoo* (video documentary, South Africa)
2010	*Putri Duyung Marina* (TV series, Indonesia)
2011	*Arwah Kuntilanak Duyung* (Yoyo Subagyo, Indonesia)
2011	*Gancore Gu* (Apisit Opasaimlikit, Thailand)
2011	*Mermaid* (Robert Lyons, USA)
2011	*Mutya* (TV series, Philippines)

2011 *Pirates of the Caribbean: On Stranger Tides* (Rob Marshall, USA)

2012 *Mermaid Stories by Wugularr Upper Primary with Sharing Stories* (Video, Wugularr Aboriginal Community with Liz Thompson, Australia)

2012 *Mermaids: The Body Found* (Sid Bennett, USA)

2012 *Rak Nee… Hua Jai Mee Kreeb* (TV Series, Thailand)

2012-2013 *Aryana* (TV series, Philippines)

2013 *Houreya w Éin* (Shahad Ameen, Saudi Arabia)

2013 *Putri Duyung* (TV Series, Indonesia)

2013 *A Black Odyssey* (Romare Bearden, USA)

2013 *Zhuīyú chuánqí* (TV series, China)

2013–2016 *Mako Mermaids* (TV series, Australia)

2014 *Fiji Mermaid* (Russell U. Richards, USA)

2014 *Ingyeo Gongju* (TV Series, South Korea),

2014 *Kambal Sirena* (TV series, Philippines)

2014 *Mars Ravelo's Dysebel* (TV Series, Philippines)

2014 *Nguva* (Video, Wangechi Mutu, USA)

2015 *Duyung* (TV series, Indonesia)

2015 *Měirényú zhīhaidào láixí* (Qiu Haoqiang, China)

2015 *The Man Who Caught a Mermaid* (Kaitlin Tinker, Australia)

2016 *A Mermaid's Tale* (Stephen Franciosa Jr., USA)

2016 *Aliksah* (Moret, Indonesia)

2016 *Gara Duyung* (TV series, Indonesia)

2016 *Huànchéng* (TV series, China)

2016 *Meirényu* (Stephen Chow, China)

2016 *Mermaid in Love* (TV Series, Indonesia)

2016 *Real Mermaid Returns to the Ocean* (Instagram Video, Peachy Liv, Indonesia)

2016 *Rényú xiàohuā* (Ming, China)

2016 *TFW Your Data* (Video, Rodan Tekle)

2016 *Zàijiàn měirényú* (Gao Weilun, China)

2016-2017 *Mermaid in Love 2: The World* (TV Series, Indonesia)

2016–2017 *Pureun Badaui Jeonseol* (TV series, South Korea)

2017 *Putri Duyung Terdampar di Pantai Sanur Bali* (social media video, Indonesia)

2017 *The Ningyo* (Miguel Ortega, USA)

NB The Chinese film *Empires of the Deep* – discussed in Chapter 4 – commenced production in 2014 but had not been released at time of publication and is not listed above.

Index

CPSIA information can be obtained
at www.ICGtesting.com
Printed in the USA
BVHW021922100419
545180BV00023B/313/P